THE ART AND LIFE OF
MERRITT DANA HOUGHTON
IN THE NORTHERN ROCKIES,
1878-1919

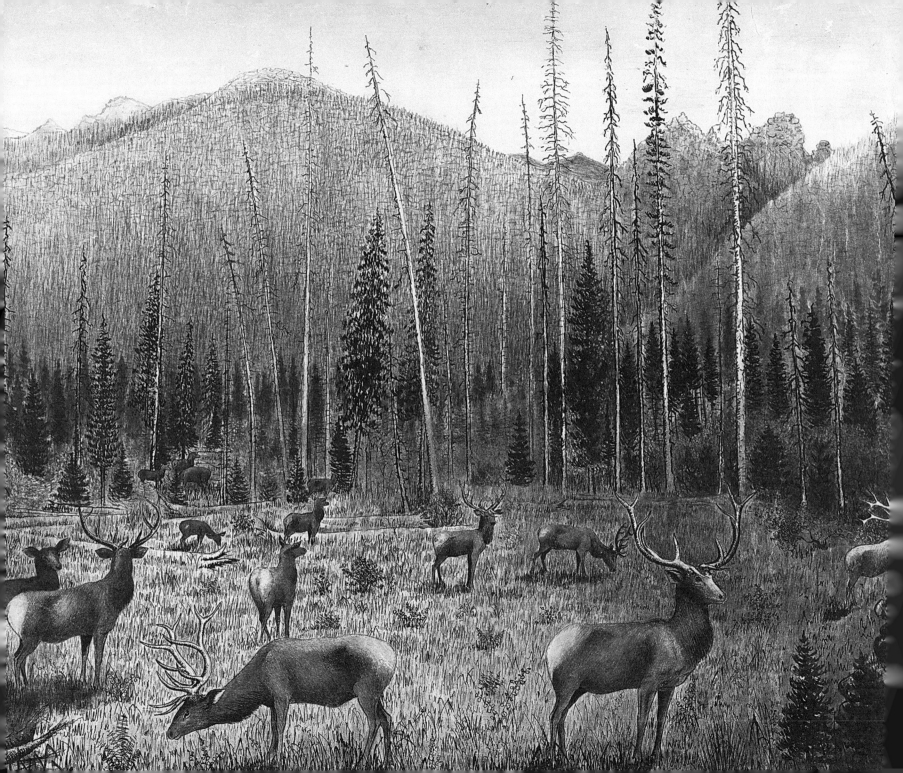

THE ART AND LIFE OF

MERRITT DANA HOUGHTON

IN THE NORTHERN ROCKIES,
1878-1919

MICHAEL A. AMUNDSON

UNIVERSITY OF WYOMING PRESS
Laramie

© 2023 by University Press of Colorado

Published by University of Wyoming Press
An imprint of University Press of Colorado
1624 Market Street, Suite 226
PMB 39883
Denver, Colorado 80202-1559

The University Press of Colorado is a proud member of Association of University Presses.

The University Press of Colorado is a cooperative publishing enterprise supported, in part, by Adams State University, Colorado State University, Fort Lewis College, Metropolitan State University of Denver, University of Alaska Fairbanks, University of Colorado, University of Northern Colorado, University of Wyoming, Utah State University, and Western Colorado University.

∞ This paper meets the requirements of the ANSI/NISO Z39.48-1992 (Permanence of Paper).

ISBN: 978-1-64642-365-1 (hardcover)
ISBN: 978-1-64642-366-8 (ebook)
https://doi.org/10.5876/9781646423668

Cataloging-in-Publication data for this title is available online at the Library of Congress.

The University Press of Colorado gratefully acknowledges the support of Northern Arizona University toward this publication.

Cover illustration: *Bird's-Eye View of Wheatland, Wyoming, 1905*. Courtesy, Department of State Parks and Cultural Resources, Wyoming State Museum, Cheyenne.

As this book was coming to press, my wife's grandmother, Barbara DeMuth, and my mom Joan Amundson both passed away. Both were public school librarians who loved reading and books. My mom was a third generation Wyomingite, the daughter and granddaughter of coal miners. We then lost our border collie Tessa, who stayed up with me many a night as I wrote.

This book is dedicated to their memory.

Contents

List of Illustrations ix

Acknowledgments xv

1. Introduction: Discovering Merritt Dana Houghton 3

2. Finding Vantage Points: 1846–1902 11

3. The Grand Encampment Boom: 1902–1904 51

4. New Horizons: 1905–1919 95

5. Drawing Conclusions: A Twenty-First-Century Perspective 125

Portfolio: Samples from the Houghton Portfolio 133

Notes 191

Bibliography 205

Index 211

Illustrations

Maps

1. *All known Houghton sketch locations, 1891–1915* . 7
2. *Houghton sketch locations, 1891–1902* 10
3. *Houghton sketch locations, 1902–1904*50
4. *Houghton sketch locations, 1905–1915*94

Figures

1.1. *Bird's-Eye View of Buffalo, Wyoming*. 2
1.2. *Fort Laramie in 1836 for C. G. Coutant's History of Wyoming* 4
1.3. *Ranch of K. P. Nickell* 5
1.4. *Bird's-Eye View of Fort Collins, Colorado, in 1899* 5
1.5. *Bird's-Eye View of Sheridan, Wyoming, 1905*. . . 5
1.6. *Lundquist "Wooden Shoe" Ranch* 5
1.7. Cover of *A Portfolio of Wyoming Views* 5
1.8. Cover of *Views of Southern Wyoming: Copper Belt Edition*. 6
1.9. *Relief Map of the Grand Encampment Mining Districts* 6
1.10. Former Saratoga newspaperman Dick Perue with the original 1903 engraving plate for the *Relief Map of the Grand Encampment Mining Districts* 6
1.11. *Sunset Farms, West Spokane* 8
1.12. *Topographical view of the Spring Creek Ranch of Christ King and Sons, Lewiston, Fergus Co., Mont.* 9
2.1. *"Photographic Rooms at Houghton's"* ad from the *Carbon County Journal* 14
2.2. *Washakie*. 15
2.3. *"Wee-a Wah" or Whitehorse at Fort Washakie* . . 16
2.4. Verso showing Houghton's imprint 16
2.5. *Attending the Indian Races* 16
2.6. *Methodist Church, Rawlins*. 17
2.7. *Bird's-Eye View of South Pass City*. 18
2.8. *Toll Gate, Green River*18
2.9. *Round Up Kitchen, Cowboys at the Chuckwagon*.18
2.10. Masthead from Houghton's short-lived *Wyoming Illustrated Monthly*. 21
2.11. *Residence of C. E. Carpenter* 21
2.12. *Residence of N. F. Spicer*22

2.13. *Keystone 20-Stamp Gold Mill.* 22

2.14. *Stamp Room, Keystone Gold Mill* 22

2.15. *Vanner Room, Keystone Gold Mill.* 22

2.16. *Woods Landing* 23

2.17. *Red Sandstone Rocks at Red Buttes* 23

2.18. *Merritt Dana Houghton in Laramie,*
 ca. 1900 25

2.19. *Map showing Houghton ranch drawing*
 locations in Albany County, Wyoming. . . . 26

2.20. *John Goetz Ranch showing the schoolhouse* . 27

2.21. *Lundquist "Wooden Shoe" Ranch showing its*
 schoolhouse 28

2.22. *Tatham Brothers Ranch* 28

2.23. *James Hardman Ranch on Sand Creek.* 29

2.24. *John Reid Ranch* 29

2.25. *M. E. Nellis Ranch.* 30

2.26. *Wolbol Ranch on North Fork* 30

2.27. *William Kenney Ranch on Cottonwood Creek.* . 31

2.28. *K. P. Nickell Ranch* 32

2.29. *Fort Caspar (Platte Bridge)* 32

2.30. *Fort Fetterman* 33

2.31. *Alcova Hot Springs* 34

2.32. *Bird's-Eye View of Saratoga, 1898* 34

2.33. *Old Fort Collins in 1865* 36

2.34. *Bird's-Eye View of Fort Collins, Colorado, in*
 1899 37

2.35. *Fort Laramie in 1889.* 38

2.36. *Bridger's Ferry* 38

2.37. *Jim Baker's Cabin, Dixon, Wyoming* 39

2.38. *The James May Ranch near Centennial,*
 Wyoming, 1899. 39

2.39. *J. M. McIntosh Ranch on the Sweetwater,*
 1899 40

2.40. *Sutton's "Boot Jack" Ranch on the Upper*
 Green River 40

2.41. *Ranch of T. E. Andrus* 40

2.42. *Ed P. Steele Ranch* 41

2.43. *Ranch of Harvy Dekalb* 41

2.44. *A. W. Smith Mule Shoe Ranch* 41

2.45. *A. W. Smith Old 67 Ranch* 41

2.46. *James Mickelson Circle Ranch* 42

2.47. *Ranch of D. B. Budd, Big Piney P.O. Green*
 River Valley, Wyo. 42

2.48. *Ranch of Roney Pomeroy.* 42

2.49. *Opal Ranch, C. F. Roberson (Proprietor),*
 (Opal, Wyo.) 43

2.50. *Fort Bridger in 1850* 43

2.51. *Fort Supply.* 44

2.52. *Fort Bridger as a U.S. Fort* 44

2.53. *Gold Hill in 1900* 45

2.54. *William Maxwell Ranch at Tie Siding, south*
 of Laramie 46

2.55. *Ranch of Mrs. J. D. Baily and Son* 46

2.56. *Herbert King Ranch on Rock Creek* 46

2.57. *Ranch of H. Ralph Hall* 46

2.58. *Bird's-Eye View of Laramie* 47

2.59. *Pen Sketch of Centennial* 47

2.60. *Planing Mills and Lumber Yard of the W. H.*
 Holliday Company, Laramie 48

2.61. *Mountain Sheep.* 48

3.1. *Early Pen Drawing of Encampment, 1902.* . . . 53

3.2. *The Town of Battle.* 54

3.3. *Tramway Station #2* 54

3.4. *The Ferris Haggarty Mine*55

3.5. *Reduction Works of the North American Copper Company, Grand Encampment, Wyoming*55

3.6. *The Copper Giant Mine* was owned in part by Buffalo Bill Cody56

3.7. This *Bird's-Eye View of Saratoga* updated Houghton's earlier 1898 sketch.56

3.8. *Ranch of N. K. Boswell* was one of Houghton's largest sketches to date57

3.9. *Elk in Wooded Country*58

3.10. *The Sheepherder's Home*58

3.11. *Breaking a Road, 1903*59

3.12. *The Early Storm, 1903*59

3.13. *Rocky Mountain Copper Company*60

3.14. *The Carbondale Coal Mines*60

3.15. *Dillon, Wyoming, in 1903* 61

3.16. *The Elk Mine*62

3.17. *The Moon Anchor Mine*62

3.18. Houghton's second sketch of *Grand Encampment* emphasizes the smelter63

3.19. *Relief Map of the Grand Encampment Mining Districts*64

3.20. *The Evening Star Mine*65

3.21. *The Vauxhall Mine*65

3.22. *The New Rambler Mine*65

3.23. *The Jessie Mines*66

3.24. *The Mohawk Mine*66

3.25. *Interior of the Copper Bar Shaft House* . . .66

3.26. *The Wolverine Mine*66

3.27. *The Sweede Mine*67

3.28. *Dam at the Head of the Pipeline*.67

3.29. *Cabin of M. Hanley, Purgatory Gulch*67

3.30. *Rambler, 1903*68

3.31. *Riverside*, labeled here incorrectly, was a small community just north of Encampment . . 68

3.32. *Ranch of A. H. Huston*69

3.33. *W. H. Wolfard Ranch*69

3.34. *The Big Creek Ranch*.69

3.35. *The D. Frank Crout Ranch*69

3.36. *The Ranch of George R. Brown*70

3.37. *Dr. Dunsmore's Ranch*70

3.38. *Andrew Olson's Ranch*, at the current location of the town of Elk Mountain70

3.39. *Duke, a Prized Hereford* 71

3.40. *Sheep Bridge / Mountain Sheep*. 71

3.41. *Antelope in Pass Creek Basin* 71

3.42. *Head-quarters of the Carbon Timber Co. on the Grand Encampment*72

3.43. *Fort Steele Tie Loading Plant of the Carbon Timber Company*72

3.44. *Peryam's Hotel*, Encampment73

3.45. *The E&H Building* in Encampment is one of the few surviving buildings from Houghton's time73

3.46. *Richmond's Livery Feed and Sale Stable*, Saratoga73

3.47. *The Hotel Wolf* remains a landmark in downtown Saratoga74

3.48. A cowboy vignette74

3.49. A miner's cabin vignette.74

3.50. *A Watering Hole* vignette74

3.51. The historiated letter "O," from *A Portfolio of Wyoming Views* 74

3.52. The historiated letter "C," from *A Portfolio of Wyoming Views* 74

3.53. The historiated letter "W," from *A Portfolio of Wyoming Views* 74

3.54. The historiated letter "T," from *A Portfolio of Wyoming Views* 74

3.55. Houghton's advertisement for his second book appeared in the *Grand Encampment Herald* just two weeks after his first book became available 75

3.56. The cover of Houghton's second book included one of the only two known photographs of the artist 77

3.57. Houghton included this photograph of mountain man Jim Baker that he had taken in Rawlins in 1879 77

3.58. *The Pearl Smelter* 78

3.59. *The Big Creek Mine* 78

3.60. *The Big Horn Mine* 79

3.61. *The Ben Hur and Black Foot Mines* 79

3.62. *The Independence Mining Company* 79

3.63. *The Magpie Mine* 79

3.64. *The Montezuma and the Almeda Mines* 79

3.65. *Jack Pot Mining and Milling Company property* 79

3.66. *The Pluto Mine* 79

3.67. *Sketch of Dillon, 1903* 80

3.68. *Sketch of Dillon, 1904* 80

3.69. *Bird's-Eye View of Wolcott,* Wyoming, the nearest station to Encampment 81

3.70. *The Battle Lake Basin* 82

3.71. *The Ranch of Jones and Williams* 82

3.72. *Anderson's Farm Gardens, Grand Encampment, Wyoming* 83

3.73. *The Home and Pole Camp of John Sublette* . . . 83

3.74. Houghton poked fun at his publisher, the *Grand Encampment Herald,* in this sketch of a small donkey munching on the paper . . . 83

3.75. The historiated letter "B" included a bucking bronco. 84

3.76. The historiated letter "C," from *Views of Southern Wyoming* 84

3.77. The historiated letter "M," from *Views of Southern Wyoming* 84

3.78. The historiated letter "R," from *Views of Southern Wyoming* 84

3.79. The historiated letter "S," from *Views of Southern Wyoming* 84

3.80. The historiated letter "T," from *Views of Southern Wyoming* 84

3.81. *The Beginning of a Prosperous Copper Mining Camp in the Encampment Copper District* . . . 85

3.82. *The Battle Lake Basin* 85

3.83. *Encampment from the Southwest* 86

3.84. *Flocks on the Red Desert* 87

3.85. *Dixon, Wyoming* 88

3.86. *Baggs, Wyoming.* 88

3.87. *Pearl, Colorado, in 1904* 89

3.88. *Walden, Colo., 1902* 90

3.89. *The Vyvex VX Ranch* east of Encampment . . . 91

3.90. *The Toothaker Ranch* 91

3.91. *Bird's-Eye View of the South Park Vegetable Gardens, Property of J. J. Wombaker Grand Encampment, Wyo.* 91

3.92. *View on the Ranch of Haglund Brothers, Carbon County, Wyo.* 92

3.93. *View of the UL Ranch* 92

3.94. *Topography of the El Ray Mining Property and Its Immediate Vicinity, 1904* 93

4.1. *Bird's-Eye View of Wheatland, Wyoming, 1905* . . 97

4.2. *Bird's-Eye View of Casper, Wyoming, 1905* . . . 98

4.3. *Bird's-Eye View of Sheridan, Wyoming, 1905* . . 99

4.4. This simplified sketch of Guernsey appeared in a 1907 issue of the *Wyoming Industrial Journal* 99

4.5. *Fairbanks* was a small community near Guernsey 100

4.6. *Bird's-Eye View of Buffalo, Wyoming, 1905.* . . 101

4.7. *Hole in the Wall* 101

4.8. *Big Horn City.* 102

4.9. *Dayton, Wyoming in 1905* 102

4.10. *Monarch, Wyoming in 1905* 103

4.11. *Dietz, Wyoming.* 104

4.12. *Munkers Coal Mine, 1905.* 104

4.13. *Trout Farm of S. H. Smith, Sheridan, Wyoming* 105

4.14. *Sheridan State Fish Hatchery District 2* . . . 107

4.15. *Bird's-Eye View of Big Timber, Montana, 1906* 108

4.16. *Topographical view of the Spring Creek Ranch of Christ King and Son, Lewistown, Fergus Co., Mont.* 109

4.17. Portrait view of the Christ King Ranch. . . 110

4.18. *Bird's-Eye View of Dillon Looking Southwest* . 112

4.19. *Mullan, Idaho.* 114

4.20. *Hunter Mining District, Chloride Hill, in the Coeur d'Alenes, 1907* 115

4.21. *The Dredge in its Artificial Lake* could have been made in Idaho. 115

4.22. *Five Mile Prairie, Washington.* 117

4.23. *The Empire Coal and Coke Company* 119

4.24. Houghton's *Valentine* sketch and poem showed his affection for his new home in Spokane 120

4.25. *Sunset Farms, West Spokane* 122

4.26. *West Spokane* 123

4.27. *Spokane, Wash. Relief Map of Northern and Central Portions, 1915* 124

5.1. *Ranch Scene* 128

5.2. *Greenacres, Washington* 129

5.3. *Helping the Messwagon* 131

Portfolio Plates

1. *Fort Collins, Colo. 1899.* 134

2. *Walden, Colo., 1902* 135

3. *Rambler, 1903.* 136

4. *Saratoga, Wyoming, 1903.* 137

5. *Flocks on the Red Desert, 1903* 138

6. *Grand Encampment from the South West, 1904* 139

7. *Wheatland, 1905.* 140

8. *Bird's-Eye View of Sheridan, 1905* 141

9. *Bird's-Eye View of Buffalo, Wyoming, 1905* . . 142

10. *Dietz, Wyoming, 1906* 143

11. *Bird's-Eye View of Dillon, Montana, 1906* . . 144

12. *Mullan, Idaho, 1907* 145

13. *Five Mile Prairie, Washington, 1908* 146

14. *West Spokane, 1910* 147

15. *Spokane, Wash. Relief Map of Northern and Central Portions, 1915* 148

16. *Keystone 20-Stamp Gold Mill, 1891* 150

17. *The Ferris-Haggarty Mine, Carbon Co. Wyoming, 1902* 151

18. *Reduction Works of the North American Copper Company, Grand Encampment, Wyoming* . . 152

19. *Head of the Encampment Pipe Line, 1902* . . . 153

20. *The Sweede Mine, Pearl Mining District, Colorado, 1903* 154

21. *The Discovery Shaft, ca. 1903* 155

22. *Topography of the El Ray Mining Property and Its Immediate Vicinity, 1904* 156

23. *Dredge in its Artificial Lake, ca. 1907.* 157

24. *Hunter Mining District, Chloride Hill, in the Coeur D'Alenes, 1907.* 158

25. *Empire Coal and Coke Company, ca. 1910* . . 159

26. *Unidentified Ranch, ca. 1904*161

27. *The J. M. McIntosh Ranch, 1899* 162

28. *Ranch of Roney Pomeroy, Fontenelle Uinta Co. Wyoming, 1899* 163

29. *Sutton's Boot Jack Ranch, Wyo., 1899* 164

30. *Ranch of K. P. Nickell, 1902.* 165

31. *Opal Ranch of C. F. Roberson, ca. 1902.* . . . 166

32. *Ranch of N. K. Boswell, Albany Co., Wyo.* . . 167

33. *Toothaker Ranch, Encampment, Wyoming, ca. 1903.* 168

34. *Topographical View of the Spring Creek Ranch of Christ King and Sons, Lewistown, Fergus Co. Mont., 1906* 169

35. *Trabing Commercial Co.'s Store, Laramie, Wyoming, 1891* 171

36. *Soda Works, Laramie, Wyoming, 1891* 172

37. *Bird's-Eye View of the South Park Vegetable Gardens, Encampment, Wyoming, 1903* . . . 173

38. *Head-quarters of the Carbon Timber Company on the Grand Encampment, 1903.* . 174

39. *Relief Map of the Grand Encampment Mining Districts, Wyoming, 1903* 176

40. *Sunset Farms, West Spokane, Washington, 1914* 177

41. *Fort Fetterman, from C. G. Courant's History of Wyoming, 1898* 179

42. *Dugouts and Log Houses of Carbon in 1876, ca. 1899* 180

43. *Fort Laramie in 1889, ca. 1899*181

44. *Deer Creek Station during the 1860s, ca. 1898* . 182

45. *Fort Bridger in 1889, ca. 1898* 183

46. *Elk in Wooded Country, 1902* 185

47. *Slaughtering Establishment of Harden and Hardman, Laramie, Wyoming, 1903* 186

48. *Breaking a Road, 1903* 187

49. *The Early Storm, 1903* 188

50. *Trout Farm of S. H. Smith, Sheridan, Wyoming, 1905* 189

Acknowledgments

This thirty-plus-year project, ending during a global pandemic, has only been completed because of the generosity and dedication of numerous archivists and curators, many of whom I have never met in person.

Thank you to Mariah Emmons at the Wyoming State Museum and Suzi Taylor at the Wyoming State Archives for providing more than forty scans of original Houghton photographs, sketches, and watercolors for this project at no cost. As one of the first publications of the new University of Wyoming Press, it says a lot that the state archives and museum were so generous with their materials.

Thanks also to Tim Nicklas, director of the Grand Encampment Museum, who rekindled this project by inviting me to give a presentation in 2018. That evening, Dick Perue of Saratoga brought his original copper Houghton engravings and Candy Moulton, local historian and officer of Western Writers of America, shared Houghton stories and encouraged me. Thanks, Dick and Candy.

A huge thank you also goes to Jonita Sommers of Big Piney, Wyoming, who not only provided Houghton images from her photograph collection but went out of her way to drive around and talk to area ranchers to find ranch locations for me.

Many thanks also to archivists and museum curators across the country who worked to bring every Houghton sketch they could to this project. In Wyoming, thanks to Sylvia Bruner of the Jim Gatchell Memorial Museum in Buffalo, Ashlee James at the Carbon County Museum in Rawlins, Lela Emmons at the Little Snake River Museum in Savery, Kenzie McPhie at the American Heritage Center at the University of Wyoming, and the staff of the Sheridan Museum at the Bighorns. Thanks also to the Wyoming Digital Newspaper Collection, sponsored by the University of Wyoming and the Wyoming State Library, the Laramie Plains Museum, and thinkWy for providing me with a research grant thirty years ago when thinkWy was the Wyoming Humanities Council. In Colorado, thanks to Kellen Cutsforth of the Denver Public Library, the North Park Pioneer Museum staff in Walden, and the Colorado Historic Newspaper Collection. In Idaho, thanks to Madeline Lowry at the Idaho State Historical Society Archives. In Montana, thanks to Kristen Larche at the Beaverhead County Museum in Dillon, Jean Chapel at the Crazy Mountain Museum in Big Timber, Montana Newspapers, the Montana Memory Project, and Diana Di Stefano at *Montana: The Magazine of Western History* for

letting me use Houghton views previously published there. Thanks also to former editor Chuck Rankin for publishing my Houghton article in the magazine in the first place. At the Amon Carter Museum of American Art in Fort Worth, Texas, thanks to Allison Olivarez and Selena Capraro for their help and generosity with Houghton images. In Washington state, thanks to Valery Wahl at the Northwest Museum of Arts and Culture in Spokane. At the Library of Congress, thanks much to Mike Klein of the Geography and Map Division for finding and scanning Houghton's last known sketch for me.

Thank you to Hannah Mellino, archives administrative and communications assistant at Olivet College Hosford History Center and Lawrence Archives in Olivet, Michigan, for searching her college archives and for connecting me to Ed Bentley and Ed Dobbins, who were also researching other artists who were Houghton's classmates. Thanks to you both for sharing your work with me.

My sincere thanks as well to Bud Reed of the 77 Ranch, Lance Creek, Wyoming, and Robert Nordby of Spokane, Washington, for helping me connect some long-lost dots. Thanks also to the many individuals who brought their Houghton original sketches to talks I gave in the 1990s and allowed me to photograph their treasures for my collection. Although we have lost touch over the last three decades, I hope you will be excited to see your images here.

At the University Press of Colorado, thanks to Darrin Pratt, Dan Pratt, Rachael Levay, Allegra Martschenko, Laura Furney, and Cheryl Carnahan for their patience and good work. As a UW alum, I am thrilled that this will be the first book published under its new imprint. I also appreciate Lynn Johnson Houze, Derek Everett, and another anonymous reviewer for their suggestions.

At Northern Arizona University, thanks to Derek Heng and Leilah Danielson for their support in making unused travel money available for research, images, and permissions. Thanks as well to Department of History chair Leilah Danielson, College of Arts and Letters dean Chris Boyer, and NAU vice president for research Jason Wilder for additional funding to support publication of this book.

Last but certainly not least, thanks to my family for their years of love and support. Thirty years ago, I was surprised to learn that my aunt Joanne and uncle Gary Zakotnik of Eden Valley, Wyoming, owned the Houghton sketch, the *Roney Pomeroy Ranch*. Thanks for sharing the sketch and for connecting me to Jonita Sommers. Thanks also to Rozanne and Doug Reachard of Cody who have supported my many Wyoming projects. My parents, Arlen and Joan Amundson, of Loveland, Colorado, have always been there no matter what I was doing. My mom grew up in Kemmerer, Wyoming, and all those drives to visit family there no doubt fostered my love for Wyoming. Thanks also to my sister, Kathy, for her support and to my Flagstaff family, Britt and Mary DeMuth, for being there, especially during the pandemic.

Finally, thanks to my wife, Lauren, and our border collie, Tessa, who listened to me talk about Houghton, put up with my late nights, helped with edits, and, most of all, pulled me away for walks in the forest.

THE ART AND LIFE OF
MERRITT DANA HOUGHTON
IN THE NORTHERN ROCKIES,
1878–1919

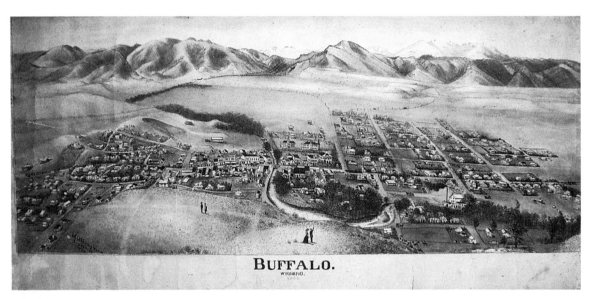

FIGURE 1.1. *Bird's-Eye View of Buffalo, Wyoming.* Courtesy, Jim Gatchell Memorial Museum, Buffalo, WY.

In the summer of 1988, I first discovered the work of Merritt Dana Houghton in the small northern Wyoming town of Buffalo while I was rephotographing a historic image of the town's Main Street made by Cheyenne photographer Joseph E. Stimson in 1903. Not quite able to figure out exactly where Stimson had positioned his camera, I ventured to the local Jim Gatchell Memorial Museum for help. While there, I discovered Houghton's pen and ink drawing of Buffalo made around the same time as Stimson's photograph (see figure 1.1). Unlike Stimson's view taken on Main Street, Houghton's image was a fanciful one, looking down at the town from a high vantage point. The drawing showed the distant Bighorn Mountains, and I could pick out Clear Creek running through town as well as the buildings in Stimson's photograph. This enabled me to locate exactly the correct location at which to re-shoot my photograph. As I worked on my rephotography project across the state, I found more Houghton town drawings as well as scenes of ranches, mines, forts, businesses, and animals. I also discovered that he published two small books of his work, in 1903 and 1904.

Three years later, in 1991, I spent my summer in Laramie working on a research grant from the Wyoming Council for the Humanities, locating and identifying every Houghton image I could, researching his life, and compiling it into a catalog of his work. In those days before the internet, this type of research required traveling to potential museums and archives to see the artwork and look through files. I knew that both of Houghton's booklets had focused on the southern Wyoming town of Encampment, so I was delighted to find more originals there plus a cache of research materials on Houghton's life. I found additional images and biographical material in nearby Saratoga, at the Carbon County Museum in Rawlins, and at the University of Wyoming. In Cheyenne, I discovered another trove of sketches including historical views of Wyoming forts and stage stations Houghton created for C. G. Coutant's 1899 *History of Wyoming* (see figure 1.2) and a biographical sketch made in the 1930s that described both Houghton and his wife, Fannie. There were also several beautiful Houghton watercolor paintings, including one of the infamous K. P. Nickell Ranch, where the stock detective Tom Horn had murdered young Willie Nickell (see figure 1.3).

I also discovered two enormous original bird's-eye views, one of Fort Collins, Colorado, made in 1899 and another of Sheridan, Wyoming, made in 1905.

https://doi.org/10.5876/9781646423668.c001

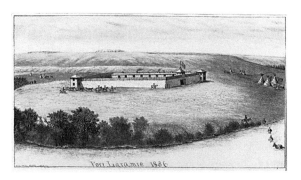

The Fort Collins drawing hung in a lawyer's office and depicted the city from high above the Cache La Poudre River, with today's Colorado State University and the Front Range easily located (see figure 1.4).

At four feet tall and eight feet wide, the Sheridan sketch is the largest Houghton image I found (see figure 1.5). Its vantage point is also an artificial one east of the town looking west where Main Street is clearly visible. A closer look reveals many local landmarks including the Sheridan Inn, Fort MacKenzie (today's Sheridan Veterans Administration Medical Center), plus the city cemetery, the County Courthouse, a railroad roundhouse, and a baseball park.

My Houghton research also unearthed the book *Wyoming's Pioneer Ranches,* a 1955 publication written by "Three Native Sons of the Laramie Plains": Robert Homer Burns, Andrew Springs Gillespie, and Willing Gay Richardson. Although this large volume does not cover the entire state, it does look closely at the many ranches around Laramie and includes more than a dozen Houghton drawings. While reading the book, I learned that Houghton had once worked as an itinerant schoolteacher, moving from ranch to ranch, sketching places where he taught.

Houghton's ranch drawings work a bit like the bird's-eye town views because they also look down on the homesteads and include people, wagons, ranch buildings, and pastures set in their surrounding landscapes. They also depict types of cattle as well as poultry and horses. In his sketch of the *Lundquist "Wooden Shoe" Ranch* southwest of Laramie, Houghton even placed a schoolhouse, clearly marked with "District 17," at the center of his drawing (see figure 1.6).

Houghton's two promotional booklets, *A Portfolio of Wyoming Views* (1903) and *Views of Southern Wyoming: Copper Belt Edition* (1904), contain more drawings (see figures 1.7 and 1.8). The first book featured over forty original sketches including views of towns, ranches, tie cutting, mines, animals, and businesses. Newspapers reported that it was a tremendous success and that all 1,000 copies sold in a few months.[1] Houghton responded with the second book the following year, with even more area drawings. I found original copies of these rare books in Cheyenne, Laramie, and Encampment.

The most spectacular find was an original copper engraving owned by Saratoga mayor Dick Perue, a former newspaperman who had been given the piece when he purchased the newspaper in the 1960s. According to Perue, a previous owner had hidden the plate during a World War II scrap metal drive because of its historical value. The image, *Relief Map of the Grand Encampment Mining Districts,* was amazing because it showed a topographical view of the Encampment area

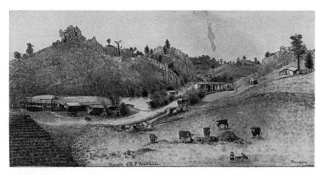

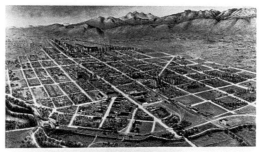

FIGURE 1.3. (LEFT) *Ranch of K. P. Nickell*. Courtesy, Department of State Parks and Cultural Resources, Wyoming State Museum, Cheyenne.

FIGURE 1.4. (RIGHT) *Bird's-Eye View of Fort Collins, Colorado, in 1899*. Courtesy, Geography and Map Division, Library of Congress, Washington, DC.

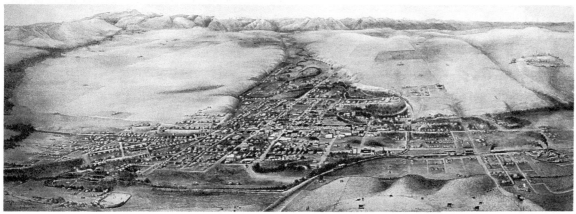

FIGURE 1.5. *Bird's-Eye View of Sheridan, Wyoming, 1905*. Author's collection.

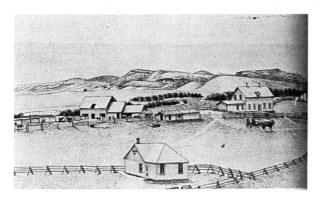

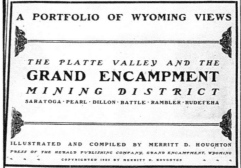

FIGURE 1.6. (LEFT) *Lundquist "Wooden Shoe" Ranch*, from *Wyoming's Pioneer Ranches*

FIGURE 1.7. (RIGHT) Cover of *A Portfolio of Wyoming Views*. Courtesy, Department of State Parks and Cultural Resources, Wyoming State Museum, Cheyenne.

FIGURE 1.8. (LEFT) Cover of *Views of Southern Wyoming: Copper Belt Edition.* Courtesy, Department of State Parks and Cultural Resources, Wyoming State Museum, Cheyenne.

FIGURE 1.9. (RIGHT) *Relief Map of the Grand Encampment Mining Districts.* Courtesy, Dick Perue/Bob Martin Collection, Historical Reproductions by Perue, Saratoga, WY.

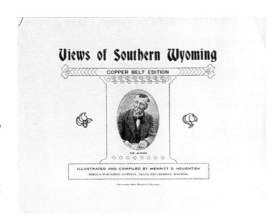

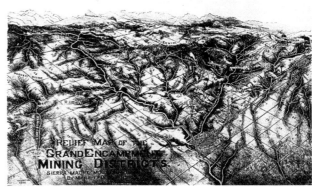

FIGURE 1.10. Former Saratoga newspaperman Dick Perue with the original 1903 engraving plate for the *Relief Map of the Grand Encampment Mining Districts.* Author's collection.

on which Houghton had placed the national grid as well as local features, including mines and the aerial tramway that brought copper ore to town (see figure 1.9). Perue could still make original prints from the ninety-year-old engraving (see figure 1.10).

By the end of summer 1991, I had compiled a catalog of 144 Houghton images including 26 town views, 32 ranch scenes, 33 mining drawings, 20 historical sketches, 9 topographical pictures, 4 images showing the tie and lumber industries, and another 20 miscellaneous views. For each, I included a list showing pertinent information and location. I also included a basic biography of Houghton's life and deposited a copy at the University of Wyoming library and kept another for myself.[2]

I updated my catalog the next year with 8 new town views, 2 mining scenes, and 15 new ranch drawings plus views found while on a trip to Spokane where Houghton died in 1919. On that trip, I conducted research at the county courthouse and visited what is today the Northwest Museum of Arts and Culture, where I discovered four more Houghton sketches of Spokane suburbs and another of Mullan, Idaho. One called *Sunset Farms, West Spokane* also included the national grid, farmers' names, and their main products and animals, such as Holsteins, alfalfa, and grain hay (see figure 1.11). The image also showed forests, streams, a rural high school, and, in the distance, Spokane stretching to distant mountains. In the clouds above the city, Houghton added "1910 Official Census Spokane 104102."

In autumn 1994, I published an article in *Montana: The Magazine of Western History* titled "Pen Sketches of Promise: The Western Drawings of Merritt Dana Houghton" that included 2 portraits, 2 watercolors, and 7 pen and ink sketches. The article was well received by the editors, and I was surprised to see in a later issue a letter to the editor about Houghton that showed 2 more sketches the artist had completed of a Montana ranch near Lewistown (see figure 1.12).

By 1995, I believed I knew all I could ever reasonably know about Houghton and put the topic aside.[3]

Twenty-five years later, the director of the Grand Encampment Museum emailed asking if I would come back and give a presentation on Houghton. I agreed, thinking that it would be interesting to see if the internet, which did not exist in 1993, could offer any new information. After scanning my original slides into a power point presentation, I began researching Houghton online and was shocked by how much new information and how many new images I discovered. Using primarily ancestry.com, I found Houghton and his wife, as well as important siblings, in Michigan, Illinois, Nebraska, Wyoming, and Washington State. Astonishingly, I also found Houghton's college records during the US Civil War and his Omaha, Nebraska, marriage license. Using digitized newspapers, I traced the artist as he conducted his work across the northern Rockies. Additional stories highlighted his efforts in Wyoming politics and uncovered a whole new illustrated newspaper Houghton had created including new images I had never seen. More searching uncovered Houghton photographs from the 1880s and even more original drawings. In short, it seemed as though I learned as much about Houghton following the 1994 article as I had prior to its publication.

Over these same three decades, scholars of the American West have revised and expanded their understanding of the West's visual culture that helps us better contextualize Houghton. When I first discovered his work, the dominant approach to understanding

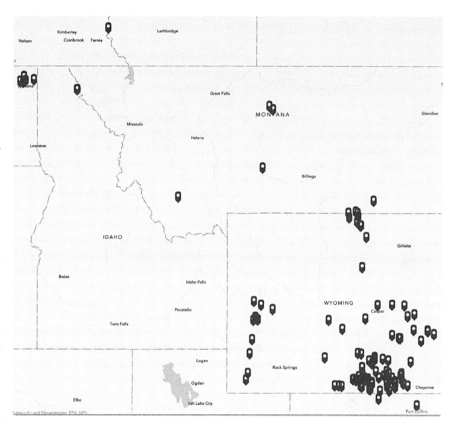

MAP 1. All known Houghton sketch locations, 1891–1915

the area was the century-old Turner Frontier thesis that examined the region as the meeting ground between civilization and savagery and looked at how the frontier experience made Americans innovative, democratic, and free. This view saw Houghton's work as highlighting the brave pioneer homesteaders and miners who used innovative new techniques to find copper or raise cattle and how the frontier brought the West up from savagery.[4]

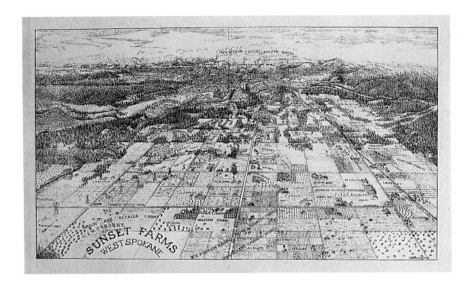

FIGURE 1.11. *Sunset Farms, West Spokane.* Courtesy, Northwest Museum of Arts and Culture/Eastern Washington State Historical Society, Spokane

The upstart paradigm of the late 1980s—which now dominates the field—is known as New Western History and discards the Turner thesis as an ethnocentric, racist theory of white privilege. Instead, New Western History suggests an approach that leading historian Patricia Limerick dubbed the 4Cs: how the conquest of the region and the environment shaped the West; the convergence of many peoples and cultures; a sense of continuity, that the forces shaping the West did not end with the frontier in 1890; and a feeling of complexity, that the full story was more complicated than Turner's theory. These historians might see Houghton's sketches as showing the conquest of nature, the continuity of western development in the twentieth century, the complexity of his town views, or the convergence of new settlers on western lands.[5]

Still another approach is that of World Systems Theory, which suggests that the dominant theme of New Western History is the global expansion of capitalism and how westerners removed Native peoples from the land, repopulated the region, and then brought its bounty into national and international markets. Within this field I would place John W. Reps, the authority on bird's-eye view drawings of America who has shown how such images were sold as booster visual culture. These historians would see Houghton's work for what he intended: local propaganda to show potential investors what the mines, ranches, and towns had to offer.[6]

Finally, a still newer view is that of Settler Colonialism, an idea that focuses on the replacement of Native peoples on the land of the West with a settler society that reconstructed the land for its own purposes. Scholars of this school of thought will find similarities between Houghton's photographs of Native peoples in 1880s Wyoming and those of Edward S. Curtis's "vanishing Indian." They might also see his ranch, mine, and town views—as well as the absence of Native peoples—as clear illustrations of a settler society remaking the West.[7]

I also consider Houghton's work a form of documentary illustrated boosterism because he used his artistic skills not simply to document what he saw before him but also to promote it for potential investors. This is clearly evident in nearly every image Houghton made. Looking closely, one sees only clean, orderly ranches set against bountiful fields amid beautiful scenery; mines and smelters

with men at work and smoke belching into the sky; well-laid-out towns and cities with manicured lawns, shade trees, and interesting buildings. There is never old machinery lying against ranch buildings or clutter in the fields. The mines and smelters are never shown shuttered or dirty. The towns and cities never have unpaved streets, litter lying about, or dilapidated buildings ready to be razed.

This promotional artistry was also present in Houghton's contemporary, Cheyenne photographer Joseph E. Stimson, who photographed Wyoming and the West around the same time as Houghton. Working for railroads and the state, Stimson took photos of dazzling landscapes that promoted tourism and of interesting streetscapes that brought investment. His photographs were documentary, but he was also always trying to promote, with mansions described as typical houses, for instance. But as a photographer, Stimson was limited to what he saw. As an artist, Houghton had the advantage because he could sketch exactly what he saw but then add smoke pouring from factories, fields ripe with grains, businesses busy with customers. Knowing this, we can read his sketches as promotions but also as documents because they might be the only firsthand account made that shows how some of these places appeared.[8]

This combination of new artwork, new biographical information, and new ways of looking at them warrants

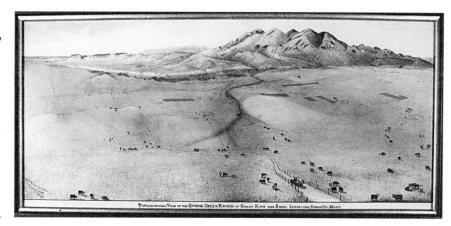

FIGURE 1.12. *Topographical view of the Spring Creek Ranch of Christ King and Sons, Lewiston, Fergus Co., Mont. Courtesy, Montana: The Magazine of Western History.*

another examination of Merritt Dana Houghton's life and art. What follows are three biographical chapters that trace his life from his birth in 1846 to 1902, to his two most productive years in Encampment, and then to his journey north to Montana, Idaho, and finally Spokane, where he lived until his death during the 1919 influenza epidemic. Along the way, these chapters will be illustrated with sketches, photographs, and ephemera related to his life and art. Following these biographical chapters, a short conclusion looks at how Houghton connects to our time. A portfolio of his best-preserved works—organized into the fields of bird's-eye views, mining drawings, ranch illustrations, business sketches, topographical views, historical scenes, and animal pictures—is then provided.

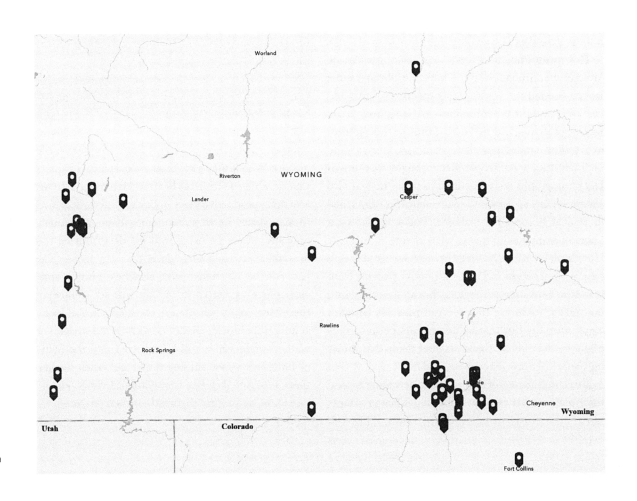

MAP 2. Houghton sketch locations, 1891–1902

Merritt Dana Houghton was born on May 31, 1846, to Rufus and Lucy Houghton on a farm near Otsego, Allegan County, Michigan. By the time the census taker recorded the family in 1850, his father was listed as age 55; he worked as a tanner and hailed from New York. His 42-year-old mother was from Canada West, now Ontario. In addition to Merritt, age 4, the family included Lewis, age 23, who also worked as a tanner, and 17-year-old Edward who worked as a laborer, presumably for his father and brother. Additional children included Anna, 15, Olive, 13, Daniel, 11, George, 8, Lydia, 7, and Julia, age 5 months in 1850.[1]

According to a newspaper account of brother George L. Houghton, Merritt's closest sibling, Civil War hero, and a pioneer of Deadwood, South Dakota, the family had been in the coastal town of Yarmouth, Nova Scotia, when he was born in 1841 and left for Michigan in 1845, where Merritt was born the following year. The newspaper stated that George moved again in 1857, to a farm in Illinois. By 1860, the census recorded that George, now 19, worked as a farm laborer for a man named John C. Davis and his wife in the town of Brookfield, Illinois, a small prairie community thirteen miles west of Chicago. With George were Lydia, 16, Merritt, 14, and Julia, 12. It is not known where their parents were residing at this time or why the younger children set out on their own.[2]

Although his brother George served in the US Civil War,[3] Merritt spent most of the early 1860s not on the battlefield but in school. He reached the minimum age of 18 in which volunteers fought for the Union, but he was not of the conscription age of 20 until the war had ended. This may explain why, instead of joining his brother, Merritt moved back to western Michigan where in 1864 he enlisted in the Preparatory Department at Olivet College. Olivet was founded in 1844 by abolitionists who believed education should be available to "anyone regardless of gender, race, or financial means." In 1859 the school received a state charter and graduated its first class in 1863. When Merritt entered the school in 1864, it boasted a president and 9 faculty members who oversaw 19 male students and 32 females plus another 137 men and 126 women, including Merritt's younger sister Julia, in preparatory work. Although Merritt remained in the Preparatory Department for all of his three years at Olivet, he spent his last two years in the Middle Class and did not advance to Senior Class. Nevertheless, he would have completed training in Latin and Greek, arithmetic, English grammar—with specialized classes on

https://doi.org/10.5876/9781646423668.c002

such topics as Homer, Virgil, and Cicero—ancient history and geography, elocution, and orthography. The school catalog for 1866 stated that "the course of study and instruction . . . is designed *thoroughly* [original emphasis] to prepare students for admission to the College Department of this Institution, or to any other College in the country."[4]

Although it is not clear whether Merritt enrolled in any art classes while in school, Miss Sarah Anna Benedict had graduated from the school in its first class in 1863 and served as an "Instructor in Drawing and Painting" at Olivet from 1864 to 1869. Interestingly, two of Houghton's classmates later became regional artists: Michigan photographer John Harvey Scotford and bird's-eye–view artist Czar J. Dyer, who, like Houghton, had been born in Michigan in 1846 and made similar drawings in Arizona Territory between 1884 and 1893.[5] After three years at Olivet, Merritt and Julia returned to Illinois and enrolled at the LaSalle County normal school, completing coursework in teacher training in 1868.[6]

Only a few significant events are known about Houghton's life between the time he completed school in Illinois in 1868 and his arrival in Wyoming a decade later. The first mention of Houghton's drawing ability appears in a newspaper in Ottawa, Illinois, on September 16, 1871, reporting that "M D Houghton" received a first-place award for his pencil drawing at the county fair.[7] Second, sometime in 1872, he moved 400 miles west to Omaha, Nebraska, where the twenty-six-year-old was listed in a city directory as living and working with his brother George, who owned a nursery.

George had gone to Omaha in 1869, the year it became the eastern terminus of the first transcontinental railroad, and by 1872 the elder Houghton had established a nursery at the corner of Sixteenth and Dodge Streets, in the town's major commercial corridor. City directories show the two sharing quarters at 303 Dodge Street in 1872 and at the Tremont House two years later. By 1876, sister Julia Houghton was also in Omaha, where she taught school.[8]

Apparently, Merritt had more than nursery work on his mind because on July 22, 1875, he married "Miss Fanny Apley" of Omaha at the Methodist Episcopal Church in Omaha. Miss Fanny, or Frances, was born in Ohio in May 1850. Her father, Lorain, was born in Connecticut in 1809, and the 1850 census listed him as a watchmaker. Her mother, Mary, had been born in Ohio in 1811. By the 1870 census, "Fannie" had moved west to Omaha, where she lived with older sister Sarah Creed, twenty-nine; her husband, and infant son Charles; nineteen-year-old "Fannie" appeared as a "school teacher."[9]

At some point during the next three years, Merritt and Frances moved west to Wyoming. According to an interview he gave in 1906, Merritt said he arrived in Cheyenne in 1875 and moved to Laramie a few years later, though there are no corroborating records in the census or newspapers.[10] We do know that brother George, in an 1880 newspaper account, stated that he left Omaha in early 1876 and arrived in Cheyenne on February 3, when he joined a group of prospectors who traveled to the Black Hills of South Dakota and helped found the town of Deadwood.[11] In the

Houghton portfolio is a sketch called *Dugouts and Log Houses of Carbon in 1876*, so it is possible that Merritt and Fanny moved to that Union Pacific coal mining town, where he most likely taught school. Carbon in 1876 had a population of about 500 people, nestled on the sagebrush plains about halfway between Laramie and Rawlins. It is not clear exactly when the Houghtons arrived there, but two Laramie newspaper notices from early 1878 mention that a "Mrs. Houghton" had visited Laramie from Carbon in late February 1878 and that Merritt had addressed the teacher's institute at the University of Wyoming in May 1878.[12]

The Wyoming Territory that greeted the Houghtons in the 1870s boasted only 21,000 residents by 1880. The largest city, Cheyenne, had just 3,400 citizens; Laramie had only 3,000 and Rawlins just under half that number. The Union Pacific Railroad (UP), the reason Wyoming existed, dominated the southern half of the territory while large ranches began bringing cattle onto the open range after the Plains Indian Wars. Over the next two decades, coal mining, government, and ranching joined the UP in southern Wyoming while cattle ranching, tourism, and irrigated farming developed in the north. According to state historian T. A. Larson, the late 1890s were the start of a period of "optimism, belief in progress . . . and eagerness for economic development [that] possessed Wyoming citizens as never before nor since." Indeed, this eagerness was met with increased numbers of sheep and cattle, farms, railroad tracks, oil production, and copper mining. The federal government's role also grew with the creation of Yellowstone National Park in 1872,

Shoshone National Forest in 1891, and Devil's Tower National Monument in 1906. Not surprisingly, Wyoming's population also expanded, reaching 60,000 in 1890, 92,000 by 1900, and 146,000 by 1910.[13]

An alternative storyline suggests that Merritt might have traveled along the Cheyenne to Deadwood route in 1877, perhaps to visit George in the Black Hills. In a letter written in 1914, Merritt wrote that one of his sketches was *Cantonment Reno on Powder River drawn in 1877 while it was in process of construction*. This was not the famous Fort Reno built on the Bozeman Trail in 1865 but a second supply post established by General George Crook in September 1876, four miles south and upriver from the original fort. The US Army later renamed this post Fort McKinney and moved it west along Clear Creek near what would become Buffalo, Wyoming, in 1878. Houghton also noted a drawing *Antelope Springs military outpost drawn while Cantonment Reno was being built in 1877*. According to guidebooks, Antelope Springs was another stop on the Cheyenne to Deadwood route, though there are no references to it being a military outpost as Houghton suggested. Nevertheless, both locations were on the Cheyenne to Deadwood route in 1877, a fact which suggests that Houghton perhaps drew them at that time. But Houghton was also an expert re-creator at sketching historic locations, so it is possible that he made both views later. Although we will never know for sure, the fact that he stated that he drew both locations in 1877, referred to the first site as Cantonment Reno rather than Fort McKinney, and mentioned the obscure Antelope Springs location suggests that

he indeed may have been at both locales at the time. Further, Deadwood's *Black Hills Daily Times* reported on May 31, 1878, that George L. Houghton "starts this afternoon on a prospecting tour to Powder River." Perhaps he was meeting Merritt, his favorite brother, former roommate, and business partner, somewhere along the way.[14]

Regardless of these possible storylines, by October 1878 we know that Merritt Dana Houghton was living in Rawlins and had entered the election for the Carbon County superintendent of schools position.[15] Houghton ran on the Republican ticket[16] and won, and in May 1879 the *Laramie Sentinel* reported that at the annual teacher's institute, he was mentioned as the Carbon County school superintendent. In this first public statement, Houghton discussed the importance of teachers exchanging experiences and ideas with colleagues and then introduced Territorial Governor John Hoyt to the audience.[17]

When the 1880 census taker found Houghton in Rawlins on June 4, he was thirty-three years old and Frances was twenty-eight; a three-year-old adopted son named Charles was living with them. When and where they adopted Charles, who was born in New York, is unknown, and the boy was never listed again as part of their family. According to a later source, Charles "did not turn out well. They never spoke of him."[18]

Although Houghton only served as school superintendent until January 1, 1881, a scandal in the fall of 1880 provides insight into his personality. Apparently, Superintendent Houghton had refused to hire a music teacher named H. F. Belcher, despite school board

approval. Belcher appealed to the Wyoming territorial school superintendent, who reappointed him. Soon after, the Rawlins newspaper ran a story about the incident and Houghton responded with a letter to the editor subtitled "A Lucid Concise Statement of His Side of the Case." In the letter, Houghton denied that he held any grudge against Belcher but wrote that he opposed the idea of giving music teachers contracts based solely on the performance of a few students. Houghton worried that this could lead to "introducing and initiating the practice of selecting favorites and specialties, and dwelling upon them for his own regulation as a teacher." He further called out Belcher, stating that "if this literary-inclined individual has anything to make public, and will publish it over his own signature, instead of reporting it as town gossip, he will receive more credit for honest intentions and confer a favor upon the public." Despite Houghton's efforts, Belcher kept his job, but Houghton was out as superintendent of schools by January 1881.[19]

Houghton had also established a photographic studio in Rawlins, and the 1880 census listed his primary occupation as that of "photographist." Indeed, as early as January 17, 1880, the *Carbon County Journal* ran ads reading "Photographic Rooms at Houghton's" and noting that he offered "all kinds of Photographic Work including photographs, views, Ferrotypes," and enlargements (see figure 2.1).[20]

After his school district work ended in 1882, Houghton turned to photography as his main profession. In the March 24, 1883, issue of Evanston, Wyoming's *Uinta Chieftain* newspaper, the editor wrote that Houghton

FIGURE 2.1. "Photographic Rooms at Houghton's" ad from the *Carbon County Journal.* Courtesy, Wyoming Digital Newspaper Collection.

had photographed Shoshone and Arapahoe Indians near Fort Washakie over the past year and produced some "very fine pictures of prominent Indians, among which is an excellent picture of the venerable Washakie, chief of the Shoshones." He also noted that Houghton had photos of "Indians in camp, and at their horse-races" and that he was working near Evanston, photographing the Almy coal mines.[21] By June, a blurb in Rawlins's *Carbon County Journal* noted "views of Rawlins, Indian pictures, and general photographic work at Houghton's."[22] In December 1883, the paper reported that Houghton had photographed a convicted murderer in the county jail who had been sentenced to death, as well as "pictures of Indians, cattle, ranches, branding views, antelope, mountain lions, sage hens, etc." Houghton's own advertisement promoted "photographs taken in the highest style of the art. Views of mountain scenery, Indians, public buildings, and local scenery. A large assortment at low rates."[23]

Fewer than fifty original Houghton photographs remain, including portraits of Native peoples, local street scenes, and landscapes. Houghton's photographs of Native Americans are the largest extant subgroup and include both studio portraits and images of Shoshone and Arapahos taken on the Wind River Reservation in central Wyoming. Perhaps the most famous is a studio portrait of the Shoshone chief Washakie, taken in 1882 when Washakie was about seventy years old (see figure 2.2). Another portrait is of the Shoshone man Wee-a-wah, or Whitehorse (see figure 2.3). The reverse shows Houghton's imprint as well as his notable left-leaning handwriting (see figure

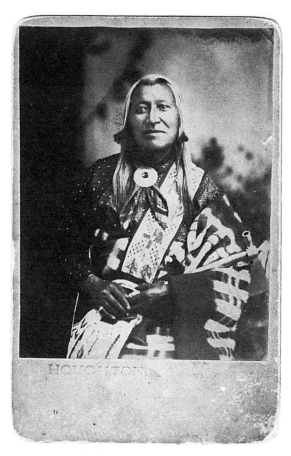

FIGURE 2.2. *Washakie.* Courtesy, Department of State Parks and Cultural Resources, Wyoming State Archives, Cheyenne.

2.4). The scene depicted as "attending the Indian races" in the March 1883 Evanston newspaper shows four men sitting astride two horses (see figure 2.5). Houghton's town views include his 1881 photograph

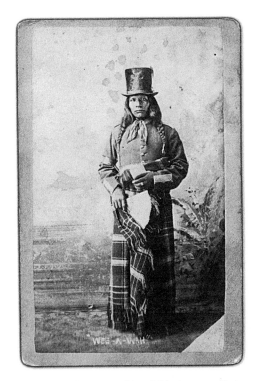

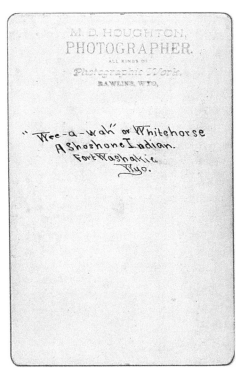

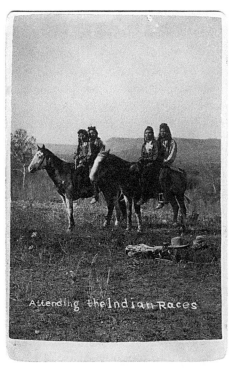

FIGURE 2.3. *"Wee-a Wah" or Whitehorse at Fort Washakie.* Courtesy, Edward Garcia Collection, Soldiersofthequeen.com.

FIGURE 2.4. Verso showing Houghton's imprint. Courtesy, Edward Garcia Collection, Soldiersofthequeen.com.

FIGURE 2.5. *Attending the Indian Races.* Courtesy, Department of State Parks and Cultural Resources, Wyoming State Archives, Cheyenne.

of the new Methodist Church in Rawlins (see figure 2.6), an overview of the gold mining town South Pass City (see figure 2.7), and a landscape scene labeled *Toll Gate, Green River,* taken among the bluffs near the Wyoming town of the same name (see figure 2.8).[24]

In January 1884, Houghton left his Rawlins studio for new opportunities in the northern Wyoming town of Buffalo. The Rawlins paper had hinted a month earlier that Houghton "would be gone for several months." Then, on January 12, 1884, it noted that "Messrs Baker[25] and Houghton, photographers, will probably leave for Buffalo today" and added in another story that "we can confidently recommend them as gentlemen and artists." Along their route, locals spotted the pair near Pine Mountain west of Casper, and the Buffalo *Echo* acknowledged that they arrived there

Methodists Church Rawlins Wyo.

FIGURE 2.6. *Methodist Church, Rawlins.* Courtesy, Carbon County Museum, Rawlins, WY.

at the end of January and "opened a photograph gallery . . . on south Main street." It added, "They are spoken of by persons who know them as men who understand their business thoroughly. They will no doubt receive a liberal patronage while in Buffalo."[26]

Their new home, located at the base of the Bighorn Mountains where the old Bozeman Trail crossed Clear Creek, was just three years old in 1884. Houghton probably saw the location as a scenic improvement over Rawlins's Red Desert locale and figured that the new community would provide a lot of work for a photographer. He must have started taking pictures as soon as he arrived because within six months, he had placed an ad in northern Wyoming's first newspaper, the *Big Horn Sentinel*, that advertised "MY ROUND-UP VIEWS and Landscape Scenery taken in this section

FIGURE 2.7. *Bird's-Eye View of South Pass City*. Courtesy, Department of State Parks and Cultural Resources, Wyoming State Archives, Cheyenne.

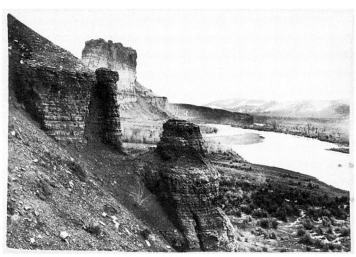

FIGURE 2.8. *Toll Gate, Green River, Wyoming*, n.d., albumen silver print, Amon Carter Museum of American Art, Fort Worth, Texas, P1967.1810.

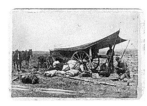

FIGURE 2.9. *Round Up Kitchen, Cowboys at the Chuckwagon*. Courtesy, Department of State Parks and Cultural Resources, Wyoming State Archives, Cheyenne.

are now FOR SALE" (see figure 2.9). He further stated, "I ask but an inspection of my work to convince you that in point of artistic workmanship it excels any other in the country."[27]

Although Houghton ran this same ad until October 1886, his work as a photographer was not financially viable. Life as an itinerant photographer was difficult. Economic possibilities were tied to the prosperity of the communities in which one worked, and the novelty of a photograph waned over time or if crop or cattle prices dropped. The markets in both Rawlins and Buffalo already seemed saturated.[28] Further, the area around Buffalo soon became enmeshed in the battle for control between Wyoming's large cattlemen and homesteaders. The conflict eventually exploded in the famous Johnson County War of 1892.[29] Whether the growing problem contributed to Houghton's decision to leave northern Wyoming is not known, but by the end of 1886 he was described as a "traveling photographer" and had moved south to Laramie. In the Gem City, he talked with the local paper about venturing west to the Platte River Canyon near Alcova to become the first person to photograph the deep canyon that could only be traversed in winter when the river froze. Whether Houghton indeed hiked and photographed "the Ice Walk" in early December 1886 is not known.[30]

With its newly opened University of Wyoming established earlier that year, Laramie was a good choice for the college-educated Houghton; he and Frances settled down and lived in the city for the next

two decades. While there, she immersed herself in the town's society clubs, ran a store, underwent two cataract surgeries in Denver, and participated in literary clubs. He ran for office several times, returned to teaching off and on, and began a new career sketching local businesses. Houghton also started his own illustrated newspaper and made sketches for a history of Wyoming. A year after proposing his ice walk, he again contacted the local paper, the *Daily Boomerang*, about a unique town view he was completing. Under the headline "Bird's Eye View of Laramie," the newspaper reported that "M.D. Houghton, the photographer who has made so many fine ranch views on the plains, has been at work for the past five weeks in getting up a complete and handsome bird's-eye view of the city of Laramie, which he now expects to have finished by the end of the month. The view will be photographed from a drawing and the photo will be 18 × 22 inches in size. It will show the entire city, including railroad buildings, shops, roundhouse, mills and factories, Undine park and the University, with the Black Hills in the background."[31] The editor must have been impressed because he concluded that "this will be something everybody will want for their own use as well as to send to friends and judging from a proof of the photo shown the reporter today Mr. Houghton will have no trouble in disposing of these views."[32]

Historians suggest that these types of bird's-eye view sketches, also known as panoramic maps, perspective maps, and aero views, were popular in the late nineteenth and early twentieth centuries because new towns were springing up on the frontier while older communities were growing in size. Local booster clubs, newspapers, and real estate businesses hired artists to capture their urban growth, and both local and itinerant artists filled the bill. Americans clamored for images of their progress and these aerial views, reproduced through lithography and photoengraving, showed everything from a perspective not obtainable for ordinary citizens until the democratization of air travel in the mid-twentieth century. All told, artists produced over 5,000 such sketches, covering more than 2,400 communities.[33]

According to historian John W. Reps, artists who made bird's-eye views would first visualize which direction they would work and at what angle above the ground. They then walked the streets sketching every building and noting its juxtaposition to others while also carefully recording specific architectural details of iconic local buildings. If a city map existed, they used it to lay out the buildings, re-sketching them onto the new grid in correct size and perspective. Once done with a draft, the artists often showed it to townspeople for feedback before making a larger, more finished product.[34]

According to several sources, this is basically what Houghton did. When a nearby hill was accessible, the artist simply went to the top, sat down, and sketched his subject. In a 1904 view he made of the El Ray mining property in Wyoming's Sierra Madres, Houghton even included himself in the sketch, sitting on a rock re-creating the scene below him (see plate 23). In another account, a man recalled how as a boy he watched Houghton sitting on a hill overlooking the

family ranch, sketching the main elements of the scene in pencil. Houghton then moved down to the yard to add detailing, including sketching the young boy. After completing the picture in pencil, he traced over it with pen and ink.[35] In many sketches Houghton also used ink wash, a watered-down India ink applied with a brush similar to watercolor paints, with more passes providing darker areas for a gray-scale effect. For a historical scene such as old Fort Fetterman, which had been abandoned and neglected for sixteen years when Houghton sought to sketch it in 1898, a period newspaper reported:

> There being no photograph or drawing of old Fort Fetterman, he visited the famous spot with old frontiersmen, unearthed the foundations of the old huts and the stone fire places, the only things left whereby one could secure an understanding of the buildings as they stood. Then Mr. Houghton, being told the description of each building, drew a pencil sketch of it. Criticized and corrected, a new sketch was drawn and submitted to other patriarchs of the plains of years and years ago, until finally completed and approved even in the most minute detail, it was worked into a fine large India ink drawing.[36]

For a city view that offered no available hillsides, such as Sheridan, a period newspaper reported that Houghton spent two weeks making preliminary sketches of every house in town before compiling the work into his sketch.[37]

In 1891, Houghton launched a new monthly newspaper, the *Wyoming Illustrated Monthly*, that celebrated the state just six months after statehood and featured illustrations and stories. Often overlooked as part of his portfolio, this publication featured twenty-six sketches of ranches, prominent homes, businesses, scenic landscapes, mining areas, and public buildings, along with thirty stories boosting Laramie and the new state. Of these sketches, Houghton contributed six new originals, with the other twenty coming from existing sources, mostly an 1889 *Bird's-Eye View of Laramie* drawn by a J. A. Ricker that the Laramie City Council had commissioned for $200. Houghton's images included the paper's masthead, two local houses, an exterior scene of the Keystone stamp mill west of town plus two interior views, a sketch of the small community of Woods Landing on the Laramie River, and another view at Red Buttes, south of town. With its promotional tone of community boosterism, the paper also set the tone of much of Houghton's later work. A closer look at this first publication, especially its articles and illustrations, shows the beginnings of this effort.[38]

Although the tone of the sketches in *Wyoming Illustrated Monthly* (WIM) foreshadows his later works, their style appears to be very different. Because of its 1891 publication date, they were reproduced as line engravings rather than the half-tones popular by decade's end. Most likely steel or copper engravings, this process was similar to old woodcut works in which artists created shading with individual black lines, spaced close together for darker regions and set farther apart for lighter areas. This method produced a darker overall image than the later half-tone process

and is especially noticeable in his images of clouds and rock details. Nevertheless, the themes of residences, mines, landscapes, and businesses are typical of Houghton.[39]

This promotional ethos started from his hand-drawn masthead (see figure 2.10), which presented the paper's name and within it the "Great Seal of the State of Wyoming," with a badge containing three scenes: a train passing through mountains, a farmer's plow, and a disembodied arm holding a saber. At the top is the Latin phrase "*Cedant Arma Toga*"—Let Arms Yield to the Toga or Let Military Yield to Civilian Power. This is indeed Wyoming's motto, but the badge is actually the Territorial Seal as it was approved in 1882. Wyoming did not create a new state seal until the summer of 1891 and adopted it in 1893, so Houghton's masthead from January 1, 1891, depicted the old Territorial Seal posing as the new state one.[40]

Houghton's other sketches reveals the artist's boosterism of Laramie. For the residences, he included a drawing of Judge C. E. Carpenter's house (see figure 2.11) and another of Mayor N. F. Spicer's home (see figure 2.12). Both blend in seamlessly with the other sketches from the 1889 view. Each substantial home features a unique architectural style and is surrounded by trees and landscaping, a difficult task on the High Plains. The only way to clearly identify them as Houghton drawings is by locating his signature, including the Carpenter house view where Houghton placed his signature in a sidewalk crack.

Houghton also included his sketch of the *Keystone 20-Stamp Gold Mill* (see figure 2.13), located thirty-five

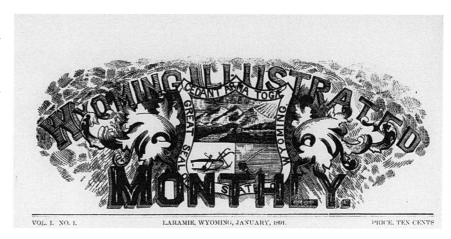

VOL. I. NO. 1. LARAMIE, WYOMING, JANUARY, 1891. PRICE. TEN CENTS.

FIGURE 2.10. Masthead from Houghton's short-lived *Wyoming Illustrated Monthly*. Courtesy, Wyoming Digital Newspaper Collection.

miles to the west, drawn from a photograph made by someone named Hayes. In the illustration, the mill rises from a pile of rocks above a small community of cabins. He also features two interior sketches including the *Stamp Room* (see figure 2.14) and the *Vanner Room* (see figure 2.15), depicting the inner workings of the mill.

By comparison, Houghton's two purely landscape views appear to have been composed and created solely by him. In his view of *Woods Landing* (see figure 2.16), a small community twenty-four miles southwest of Laramie, the words "Photographed and drawn by Houghton" can be found in the left foreground. The scene looks over a small hill toward one or two ranches, with mountains rising in the background. Likewise, his sketch of *Red Sandstone Rocks at Red Buttes* (see figure 2.17) depicts a scene ten miles south of town and shows two horses standing in front of several large rock pillars, with plains and then distant

FIGURE 2.11. *Residence of C. E. Carpenter.* Courtesy, Wyoming Digital Newspaper Collection.

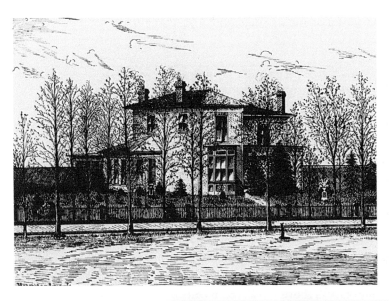

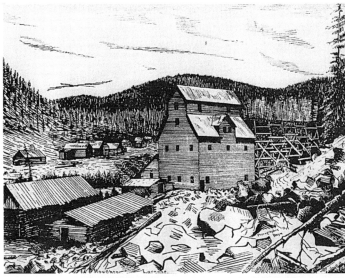

FIGURE 2.12. (TOP LEFT)
Residence of N. F. Spicer.
Courtesy, Wyoming Digital
Newspaper Collection.

FIGURE 2.13. (TOP RIGHT) *Key-stone 20-Stamp Gold Mill.*
Courtesy, Wyoming Digital
Newspaper Collection.

FIGURE 2.14. (BOTTOM LEFT)
*Stamp Room, Keystone
Gold Mill.* Courtesy, Wyo-ming Digital Newspaper
Collection.

FIGURE 2.15. (BOTTOM RIGHT)
*Vanner Room, Keystone
Gold Mill.* Courtesy, Wyo-ming Digital Newspaper
Collection.

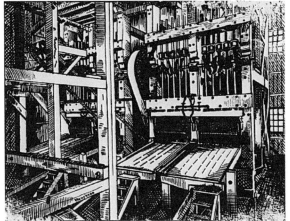

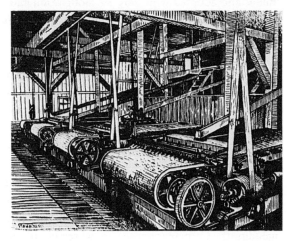

mountains. In the foreground are both "Houghton" and "MDH." These appear to be among Houghton's oldest known works.[41]

An examination of the articles shows Houghton's boosterism. In his page 8 editorial, Merritt stated that his paper would address neither politics nor religion but "will be devoted exclusively to the illustration of western scenery, western life and western enterprise, adhering with strict fidelity to facts and figures, and without exaggeration and without prejudice." Then, after welcoming the state's new governor, legislature, and all citizens to his paper, Houghton promoted Wyoming's churches, schools, literacy, mineral wealth, agricultural promise, ranches, and scenic beauty, including Yellowstone National Park. He concluded by stating that his paper's aim was to "set forth the capabilities as well as the attractive natural features of the state, to present its advantages in such a manner as to encourage immigration, and to induce capitalists to bring their money here where it will earn the most in a given time and at the time benefit the whole public."[42]

Among the remaining thirty headlined articles, Houghton wrote about Laramie and its nearby plains, the University of Wyoming, the townspeople, public schools and churches, and the nearby plaster mines, oil fields, and ranches. He also discussed Wyoming more broadly, including the Keystone gold region, iron and coal mines, horse breeding, and the status of surgery. Expanding south into Colorado's remote North Park region, Houghton described the Teller City silver camp south of Walden and Pinkham's Castle, a noted area log structure.[43]

Other Wyoming newspapers wrote very favorable reviews of the new publication. The *Laramie*

FIGURE 2.16. (ABOVE, LEFT) *Woods Landing.* Courtesy, Wyoming Digital Newspaper Collection.

FIGURE 2.17. (ABOVE, RIGHT) *Red Sandstone Rocks at Red Buttes.* Courtesy, Wyoming Digital Newspaper Collection.

Boomerang praised it as Wyoming's "first illustrated periodical" and called it a "handsome publication." The *Buffalo Bulletin* said it contained "many fine pictures of buildings and notable scenic points" around Laramie, and the *Carbon County Journal* of Rawlins wished Houghton "success in his new venture." The *Laramie Weekly Sentinel* provided the longest description, telling its readers that Houghton intended to provide a new edition every month with new "cuts and illustrations" and that "every man, woman, and child should buy from ten to 100 copies and then send them all over the country, east and west." "If this is done," it concluded, "this publication will work more benefit to Laramie than anything we have ever done."[44]

Despite the praise, concerns also arose about the paper's sustainability. In his own editorial, Houghton suggested that "*Wyoming Illustrated* is sent forth to float if it can, to sink if it must," and other papers shared similar concerns. The *Newcastle News* concluded that Houghton "need be proud if he can maintain its present typographical appearance," while the *Laramie Boomerang* worried whether there was "sufficient business to sustain the work."[45]

Over the next several months, Houghton traveled to old haunts in Carbon and Rawlins trying to scare up subscriptions while a suggestion emerged that the next issue focus on boosting Buffalo. But it was to no avail. The artist produced no February issue and on April 22, former territorial governor and University of Wyoming president John W. Hoyt purchased the *Wyoming Illustrated Monthly* and the *Laramie Times* and merged the two into a new publication, the *Wyoming State Journal*. Hoyt made himself editor and manager of the new endeavor and hired Houghton as "artist and general manager." Similar fanfare from the state's papers followed this merger, with the *Carbon County Journal* in Rawlins offering the new venture success, "which it must certainly achieve, with two such energetic men at its head."[46] Unfortunately, the *Wyoming State Journal* did no better that the *Wyoming Illustrated Monthly* had, and by year's end, it too had failed. With two unsuccessful newspapers in one year behind him, Houghton turned to teaching in the Laramie area for the next five years and made several attempts to get into local politics.[47]

Houghton's return to teaching probably provided some stability for Frances and him. The couple settled into a house at 517 South Seventh Street, a block south of Laramie High School; by 1900 they had two female lodgers, one of whom was a teacher.[48] Until they left in 1907, the Houghtons made their home in Laramie where they celebrated Frances's fiftieth birthday and their twenty-fifth wedding anniversary and faced a health scare when Frances required two eye surgeries in Denver to remove cataracts.[49] A friend and neighbor, Ida Purdy Harrell, later wrote that the couple had a large library but was usually hard up for money. Harrell said they were both "well educated, had high ideals, and [were] the best friends and neighbors one could wish for." She further described Merritt this way: "Mr. Houghton was a rather small man and while not husky he did any work that presented itself. This being rather unusual for the artistic temperament. He made a wonderful instructor and was much in demand. School districts felt very lucky when they could secure his services.

He was a fine example to the youth as he was a very moral man. He did not drink or use tobacco, and no one ever heard him use bad language" (see figure 2.18).[50]

It is not clear where Houghton taught each year, but in fall 1894 he listed Laramie as his home. The next spring he worked at Woods Landing and then returned to Laramie in 1896. Woods Landing or Jelm, southwest of Laramie near the Colorado border on the Big Laramie River, had been started by Colonel Samuel Woods in 1883 and served as a stopping point for lumberjacks, miners, freighters, and stage drivers.[51]

In the 1890s, Houghton also dabbled unsuccessfully in local reform politics. Recall that when he ran for Carbon County school superintendent in 1878, he did so as a Republican. In autumn 1892, the Albany County Democratic Party in Laramie nominated Houghton as one of three men to run for county surveyor; he placed third.[52] The following spring the People's Party nominated Houghton and three other men to run as the party representative to the Laramie City Council; once again, Houghton placed last in votes among his party.[53] In 1896, Albany County Democrats named Houghton as an alternate delegate to the state convention for Laramie's Second Ward. Finally, in 1902, county Socialists nominated Houghton to run for that party's nomination as representative to the state legislature, but again the artist fared poorly, finishing fourth out of five Socialist candidates and seventeenth out of eighteen total candidates in the county election.[54]

While Merritt taught and played in politics, Frances also began building a life in Laramie. Ida Purdy Harrell later provided an interesting characterization:

Mrs. Houghton was full six feet tall, but frail and had very poor health. I think she had been a pretty girl as she had had a nice complexion and naturally curly hair. But when they came to Laramie she was stooped, her face was colorless, and she had lines from pain, worry, and eye strain. She rode a bicycle, wore bloomers, a visor cap, and very thick glasses. I suppose she did present quite a figure for mischievous boys hooted at her and little girls giggled. I have heard their parents criticize her appearance. It made me indignant for I knew her real worth. After all, what is a little shabbiness in comparison to a brilliant mind, and a kind loving disposition, combined with a pronounced sense of humor? She never seemed to hear them, nor did she ever speak about it, and no one did to her for fear of hurting her feelings, in fact it never seemed worthy of notice, it was too much like criticizing a star.[55]

In the decade and a half the Houghtons resided in Laramie, Frances often appeared in the local society pages. She was an energetic supporter of women's suffrage, and a member of the Alpha Literary Society, giving presentations over the years on such topics as "women as journalists," "a historical outline of India," and the "contemporary history of America." She also attended meetings of the Current Events and Social Science Department of the Woman's Club, where her presentations also ranged from talks about the Roycrofters to the municipal affairs of Boston. She hosted both the Woman's Missionary Society and the Women's Christian Temperance Unions at her home. She started a Psychology Club, organized night classes for

FIGURE 2.18. This portrait shows Merritt Dana Houghton in Laramie, ca. 1900. Courtesy, Department of State Parks and Cultural Resources, Wyoming State Archives, Cheyenne.

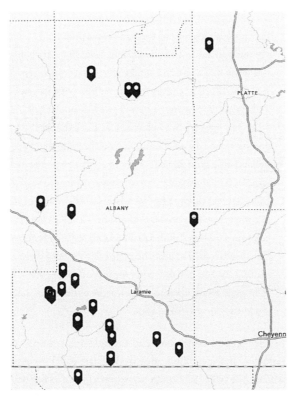

FIGURE 2.19. Map showing Houghton ranch drawing locations in Albany County, Wyoming. Author's collection.

those who could not attend the university during the day, and even attended a séance. In short, it seemed as though she kept herself quite busy with friends and activities as Merritt roamed the countryside as an itinerant teacher and artist.[56]

Beginning in 1891, Merritt began sketching ranches around Laramie and Albany County as he moved from one teaching job to another. Between 1891 and 1901, Houghton made at least twenty ranch illustrations plus several more watercolor ranch paintings. Beginning with the Williams Ranch on Dale Creek southeast of Laramie in 1891, he traveled throughout the county (see figure 2.19).

The last decade of the nineteenth century was an important one in the history of western ranching. The domination by powerful wealthy ranchers that had epitomized the Open Range period had been brought down by the brutal winter of 1886–1887 and the ill-fated 1892 Johnson County War. In its place, small ranchers resettled the new state, focusing their efforts along reliable water sources and raising hay to feed their imported Hereford cattle. As they did so, many families also built one-room schools on their ranches and hired teachers like Houghton to stay with them and teach their children. Two Houghton sketches in particular from this period capture his work as an itinerant teacher and artist.

The first image is the *John Goetz Ranch*, located on Sand Creek on the Laramie Plains southwest of town. In this view, Houghton showed all of the things that were important to a homesteader, including cows, horses, poultry, a fenced garden, a haystack, extensive fencing, barns, and outbuildings. A nice house complete with trees planted in the front yard and smoke rising from its chimney sits next to a small log cabin. Finally, Houghton has not forgotten his reason for being there: the building at lower right is the schoolhouse, where the artist most likely worked (see figure 2.20).

The second sample shows the *Lundquist "Wooden Shoe" Ranch* on Sand Creek, further southwest of

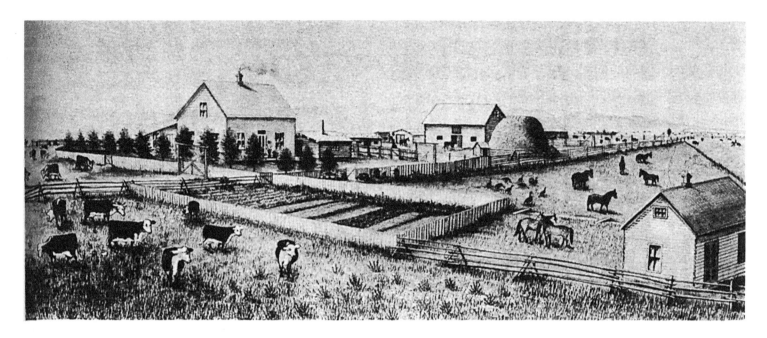

FIGURE 2.20. *John Goetz Ranch* showing the schoolhouse. From *Wyoming's Pioneer Ranches.*

Laramie near Camel Rock and the Colorado border. Unlike the previous image, this view is more intimate, set within the ranch grounds with four people atop a horse and buggy to the right. The main house sits behind them and Sand Creek flows behind the house, with the foothills of the Colorado Rockies rising on the distant horizon. Although Houghton includes few livestock in this image, he placed the schoolhouse in the center of the image, with a "Dist 17" sign clearly visible (see figure 2.21).

Although the whereabouts of these sketches is unknown today, both appeared along with eleven others from the 1890s in the 1955 book *Wyoming's Pioneer Ranches*, written by three sons of pioneer ranchers on the Laramie Plains: Robert Homer Burns, Andrew Springs Gillespie, and Willing Gay Richardson. The sketches may remain in the hands of descendants. And although the quality of reproduction is not as good as that from originals, they attest to Houghton's many travels across the Laramie Plains and his attention to detail in documenting the settler society's ranches (see figures 2.22, 2.23, 2.24, 2.25, 2.26, and 2.27).[57]

The final image from this period showcases Houghton's artistry and sense of history. This watercolor painting depicts the *K. P. Nickell Ranch*, located thirty-two miles northeast of Laramie at Iron Mountain. With its small house and outbuildings, Houghton showed the meager existence of such small

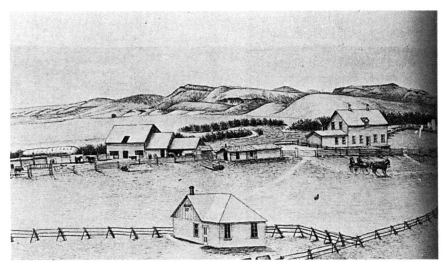

homesteaders. The presence of water at the center suggests its importance in this arid land, while the irrigated field at left shows how the desert can be remade. The small children at play in the lower right is both reassuring to the casual viewer that this is a family home but also distressing to the student of Wyoming history who knows that this ranch was the site of the infamous murder of fourteen-year-old Willie Nickell that led to the trial and execution of Tom Horn, who had been hired by large ranchers to drive the Nickells and others from the range (see figure 2.28).[58]

Around 1896, Houghton's sketches brought the artist to the attention of newspaper publisher Charles Griffen Coutant, who had begun working on a three-volume history of Wyoming and hired Houghton to illustrate it. Coutant had come to Cheyenne in 1890 and worked in Laramie and then Lander, where he edited the *Clipper*. The *Laramie Daily Boomerang* reported on January 5, 1897, that Coutant had organized his history by counties—to enroll subscribers to reduce costs—with Albany County the first to be completed by the end of February. To accomplish this, Coutant had been in Laramie for the past two weeks "securing material." The paper also wrote that "the work will be illustrated with views of natural scenery throughout the county, public buildings, and portraits of many pioneers."[59]

At the end of June, the *Laramie Republican* reported that Coutant had reorganized his history into a more traditional narrative focusing on early explorers, fur trappers, the Oregon Trail, the construction of the Union Pacific, and the organization of Wyoming Territory. The paper also noted that the book would be

FIGURE 2.21. (ABOVE) *Lundquist "Wood Shoe" Ranch* showing its schoolhouse. From *Wyoming's Pioneer Ranches.*

FIGURE 2.22. (BELOW) The *Tatham Brothers Ranch* had been started in 1897 on the Big Laramie River in Colorado just over five miles south of the border. Until recently, this ranch was known as the Laramie River Dude Ranch and still maintained several of the buildings seen in Houghton's sketch. From *Wyoming's Pioneer Ranches.*

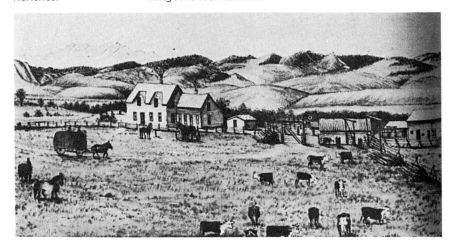

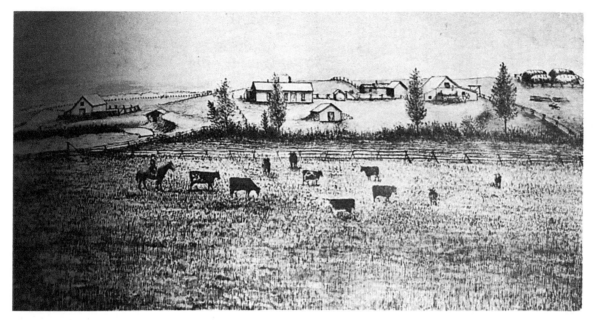

FIGURE 2.23. The *James Hardman Ranch on Sand Creek* was just downstream from the Wooden Shoe and John Goetz Ranches. Englishman James Hardman had come west to Colorado's Greeley Colony in 1871 before moving north to the Laramie Plains in 1877. From *Wyoming's Pioneer Ranches*.

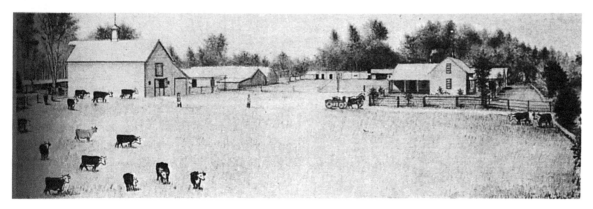

FIGURE 2.24. The *John Reid Ranch* was the home of Scottish immigrant John Reid, who came to Laramie to work in its rolling mills making rails for the Union Pacific. In 1884, he purchased this ranch twenty miles west of town on the Little Laramie River, where he raised British Shorthorn dairy cattle.

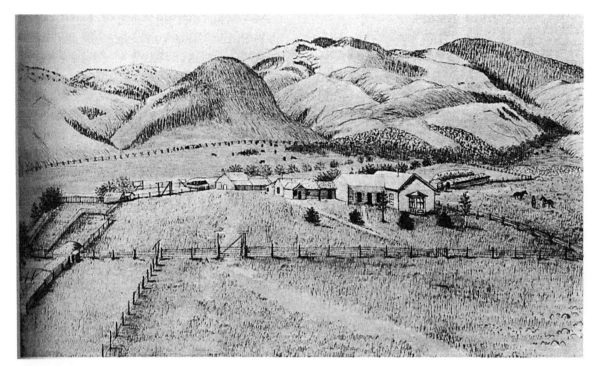

FIGURE 2.25. The *M. E. Nellis Ranch*, on Mill Creek, was homesteaded by Ed Nellis and then operated by his son, Martin E. Nellis. Mill Creek is the first creek north of the Little Laramie River, which flows east from the Medicine Bow Mountains. From *Wyoming's Pioneer Ranches*.

FIGURE 2.26. The *Wolbol Ranch on North Fork* (of the Little Laramie River). Danish immigrant Mads Wolbol settled on this ranch a few miles south of the later village of Centennial, Wyoming, in 1878. From *Wyoming's Pioneer Ranches*.

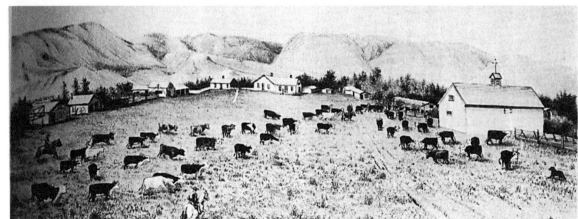

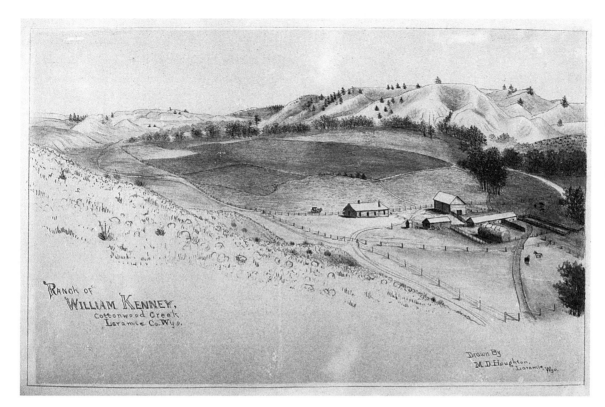

profusely illustrated with images from John C. Fremont's official report. Finally, the paper stated that Coutant planned to get subscribers to fund the three 800-page volumes, each containing 250 illustrations.[60]

The first mention of Houghton related to Coutant's history occurred in Casper's *Wyoming Derrick* newspaper on December 9, 1897, when it noted that "Colonel Coutant, author of the history of Wyoming, accompanied by Mr. Houghton of Laramie who is doing the drawing and engraving for the history, arrived

in Casper Saturday and remained until Thursday." The *Derrick* went on to explain that Houghton had made a full-page 14 inch × 26 inch drawing of Casper Mountain and the Platte River (see figure 2.29) from the north side of the river, "a little north-west of the old emigrant bridge, giving a view of Old Fort Caspar as the post was in 1864–65, and Casper Mountain beyond."[61]

The *Cheyenne Daily Sun-Leader* was so impressed with Houghton's work that it described the image

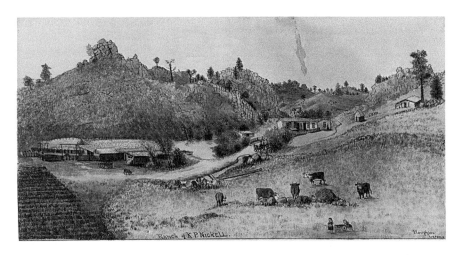

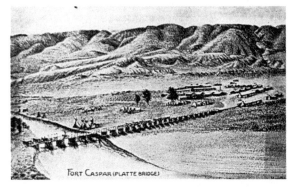

the historic structure into his view of the landscape. Merritt also had with him four "old timers who lived at Fort Caspar in its palmy days" and described the bridge and all of the fort's buildings to the artist. The result, according to the *Newcastle News-Journal*, was a sketch "as perfect as though it were from a photograph which had been taken of the place." Finally, the Cheyenne paper reported that Houghton planned to send the completed drawing to three other men who had worked at the fort for verification. It noted that Houghton had already completed a similar "striking picture of Fort Laramie in its most active days" and planned to visit and sketch Fort Fetterman next.[62]

The Wyoming newspapers followed Houghton back into the field the following year as the artist continued to make historical sketches for Coutant and contemporary ranch drawings on the side. On February 18, 1898, the *Wheatland World* reported that Houghton had "been doing work along the Platte," and on March 17, Casper's *Wyoming Derrick* reported that its editors had seen Houghton's new sketch of Fort Fetterman as well as a drawing of the V R Ranch near Glenrock and the Jim Abner Ranch on Little Box Elder Creek, about halfway between Douglas and Glenrock. The Casper paper also stated that Houghton had sold a large version of the Fort Fetterman sketch to a local man and planned to come back the following summer to make a bird's-eye view of Casper; at that time, he "may be induced to make some drawings for some of our prosperous nicely improved ranches, besides restoring the historic scenes and views of the palmy days in Wyoming."

FIGURE 2.28. (ABOVE) *K. P. Nickell Ranch.* Courtesy, Department of State Parks and Cultural Resources, Wyoming State Museum, Cheyenne.

FIGURE 2.29. (RIGHT) *Fort Caspar (Platte Bridge)*, from Coutant's *History of Wyoming.* Courtesy, Department of State Parks and Cultural Resources, Wyoming State Archives, Cheyenne.

under the headline "Fort Caspar Restored" and explained how the artist re-created the post on paper using what today would be described as basic historical archaeology, landscape analysis, and oral history. The paper noted that although the "old post and bridge long ago disappeared," Houghton had located what remained of the bridge's piers and the foundations of the fort's buildings, allowing him to properly place

Unfortunately, the existence or whereabouts of any of these ranch drawings is not known today.[63]

The sketch of Fort Fetterman (see figure 2.30), however, appeared in Coutant's *History of Wyoming* and also elicited a lengthy newspaper account of Houghton's process for making the image that paralleled his work at Fort Caspar. First appearing in the *Laramie Daily Boomerang* on March 21, 1898, the report stated:

> Mr. M.D. Houghton of Laramie, who is traveling through Wyoming visiting the sites of old landmarks and restoring to view old posts that have been destroyed for years, is in Casper. There being no photograph or drawing of old Fort Fetterman, he visited the famous spot with old frontiersmen, unearthed the foundations of the old huts and the stone fire places, the early things left whereby one could secure an understand of the buildings as they stood. Then Mr. Houghton, being told the description of each building, drew a pencil sketch to fit. Criticized and corrected, a new sketch was drawn and submitted to other patriarchs of the plains of years and years ago, until finally completed and approved even in the most minute detail, it was worked into a fine large India ink drawing. It is the only picture known to be in existence.

The article then mentioned several other places in the area Houghton had sketched, including Old Fort Caspar, Slade's Horseshoe Ranch, and Deer Creek Station (see plate 44), which "have in this way been *restored* by Mr. Houghton" (emphasis added).[64]

On April 14, the *Wyoming Derrick* reported that Houghton had come to Casper after a three-week drawing trip to the west where he "made sketches in the Grand Canyon and on Bates' Creek, and did work for A.J. Bothwell, Tom Sun, Boney Earnest and others" before immediately leaving "on his wheel for the Muddy." The Grand Canyon (see figure 2.31) here is the Grand Canyon of the Platte, the site of today's Pathfinder Reservoir near Alcova. Napoleon Bonaparte "Boney" Earnest had a ranch near there, while Bothwell and Sun were on the Sweetwater River nearby at Devil's Gate. Both Bothwell and Sun had been involved in the infamous lynching of "Cattle Kate" Ellen Watson and James Averill in 1889, so this might have been a historical trek for Coutant as much as it was another opportunity for Houghton to sketch Wyoming's pioneer ranches. Unfortunately, the only image from this trip that survives today is a

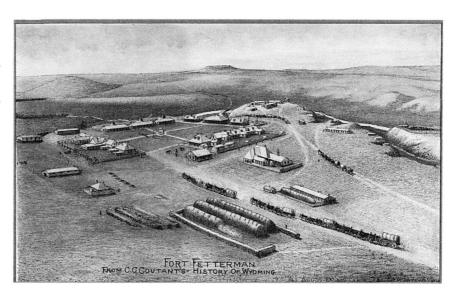

FIGURE 2.30. *Fort Fetterman*, from Coutant's *History of Wyoming*. Courtesy, Department of State Parks and Cultural Resources, Wyoming State Museum, Cheyenne.

FIGURE 2.31. *Alcova Hot Springs.* Courtesy, Department of State Parks and Cultural Resources, Wyoming State Archives, Cheyenne.

photograph of Houghton's sketch of the Alcova Hot Springs on the north side of the Grand Canyon of the Platte.[65]

Houghton's historical sketches of Oregon Trail stations and forts caught the eye of the editor of the *Cheyenne Daily Sun Leader* in late June 1898 when he wrote, under the headline "Painting Landmarks," that Houghton was visiting the capital city. In the brief article, the editor opined that Houghton was "performing the duty of sketching the ruins of old military forts, pony express stations, and historic Indian haunts for Coutant's History of Wyoming." He then noted that the artist "has frequently to supplement existing relics by a description given by the old-timers who knew them before they had been crumbled by decay's effacing fingers."[66]

Houghton seemed to stay closer to home in 1898, making only research and sketching trips to nearby Saratoga. Perhaps this was because he was helping Coutant with the final edits on his book, or maybe it was due to the tensions that led to the Spanish-American War that spring. At almost fifty-two, Houghton was too old for military service, but it is

possible that the international affairs gave him pause. July found the artist in the Saratoga valley where newspapers noted that he planned to spend a month there collecting historical data, making a sketch of Saratoga "and other prominent points," and seeking subscriptions for Coutant's history, which was expected to come out soon. This bird's-eye sketch, the first of several Merritt made of Saratoga, was Houghton's first such image. The sketch looks southeast over the North Platte River and shows the Hotel Wolf, Bridge Street, and the beginnings of the town to the north but mostly open land to the south. The local *Saratoga Sun* urged its readers to help Houghton with his research and to buy subscriptions for the book (see figure 2.32).[67]

Merritt and Frances spent the 1898 holiday season in Fort Collins, Colorado, with her nephew Charles Creed, and Merritt made several sketches of the northern Colorado town. The December 22, 1898, *Larimer County Independent* reported that Houghton was "an excellent sketch artist" and was "engaged on a large pen sketch of Fort Collins, which he hopes to complete soon after the new year opens." On January 14, 1899, the *Fort Collins Express and the Fort Collins Review* newspaper noted that the artist had finished both a historical bird's-eye view of old Fort Collins and another, contemporary panoramic view of the city. It called them "very creditable pieces of work," adding that Houghton was selling photographic prints of the originals and that they were "neat works of art" that should serve as good souvenirs to send to people back East. The paper further wrote that Merritt was

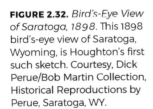

FIGURE 2.32. *Bird's-Eye View of Saratoga, 1898.* This 1898 bird's-eye view of Saratoga, Wyoming, is Houghton's first such sketch. Courtesy, Dick Perue/Bob Martin Collection, Historical Reproductions by Perue, Saratoga, WY.

continuing his historian's research work for Coutant by interviewing "old-time citizens who took part in the trans-continental and pioneer struggle in the early days of Wyoming." It concluded that the artist was looking for a place to make "final disposition of the original drawings of these pictures." Two weeks later, the *Fort Collins Review* wrote that Houghton had completed a third sketch in Fort Collins, this one a "handsome bird's eye sketch of the State Agricultural College grounds and buildings." This was the last mention of Houghton making sketches or doing research for Coutant until volume I of the history came out in March 1899.[68]

Although the sketch of the State Agricultural College (now Colorado State University) is not known, Houghton's two views of Fort Collins merit further comment. First, the sketch showing the original fort in 1865 was most likely completed in a manner similar to his images of Wyoming forts: by talking to locals who had seen the original post, doing historical archaeological work at the site, and surveying the 1899 landscape to situate it properly against the foothills and mountains. Indeed, a story appeared in a local paper six months later describing a Fort Collins justice of the peace named John H. Mandeville who was one of Houghton's "old timers" who helped the artist with the details. According to the story, Mandeville had been a young officer with the Twenty-first New York Cavalry when, after several Civil War battles, he was sent to Fort Collins in 1865. It is likely that Mandeville assisted Houghton, who then gave the old soldier the original sketch (see figure 2.33).[69]

The view of modern Fort Collins in 1899 is 26 inches × 48 inches in size and takes almost the same vantage point, looking southwest down Linden Street, as the view of Old Fort Collins in 1865, though from a higher position (see figure 2.34). The Front Range of the Rocky Mountains makes up the far horizon, with the northern Colorado landmark Long's Peak clearly rising in the distance, Horsetooth Mountain closer to town, and the Cache La Poudre River snaking along the foreground. The original town plat, developed from Old Fort Collins (today's Old Town), is in the foreground at an angle from the grid beyond. The Larimer County Courthouse is clearly visible, as is the campus of today's Colorado State University. Modern College Avenue stretches from right to left across the image, fading into the distant open range.

The sketch is important for a few reasons. First, it is one of Houghton's few illustrations of a western town that became a larger modern city. Second, its four-foot length makes it one of the largest drawings the artist had made to that date. Third, the level of detail, from the distant mountains to specific buildings on campus and in town, clearly attests to Houghton's attention to detail and his artistic abilities. Finally, unlike the many historical drawings that had equivalent details and varieties of components, those sketches could only be corroborated by a few individuals whom Houghton enlisted for the project. The bird's-eye view of Fort Collins, however, instantly served as an aerial map for the 3,000 city residents who must have scrutinized the sketch from the beginning.

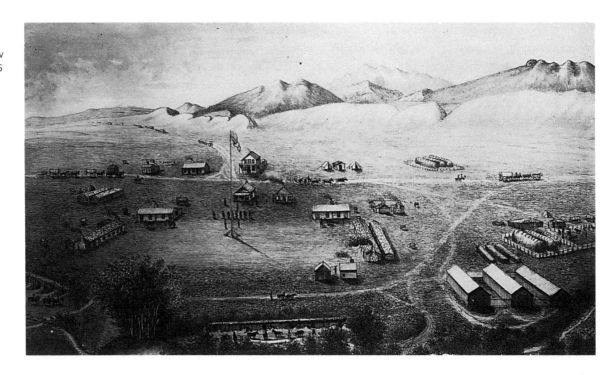

Just a month after Houghton returned to Laramie from Fort Collins, Charles Coutant's 712-page *History of Wyoming from the Earliest Known Discoveries, Volume I* was released. The *Laramie Daily Boomerang* reprinted the first review from the *Denver News*, which noted that "it was known that the author would bring industry, research, ability as a writer, and enthusiasm" to the work. Calling it a "romance," the reviewer further stated that each chapter "is a dramatic recital of the period of which it treats." As expected, Coutant had reorganized the work into a grand narrative that followed the state's history from Spanish and American explorers to the fur trade, the Oregon Trail and the building of forts, the Plains Indian Wars, the construction of the Union Pacific, and finally the creation of Wyoming Territory. The review further stated that Coutant had handled these topics "in a manner that leaves nothing to be desired, either as to correctness of historic detail, evident painstaking research, or graphic composition" and concluded by describing the work as a "simple but vivid narrative of Wyoming's heroic period."[70]

The newspaper also noted that the work was "illustrated with pictures of pioneer hunters and explorers,

sketches of old trading and military posts, and maps." In his preface, Coutant praised Houghton: "Most of the illustrations along the Overland trail are by the Wyoming artist, M.D. Houghton, who produced them after much study and investigation. They are not mere ideal drawings, but were made with the assistance of pioneers who took the trouble to visit, with the artist, the locality, and explain the forts, buildings, bridges, etc. These drawings have stood the test of critical examinations on the part of many old timers who were familiar with the appearance of everything along the Overland road in the old days." Coutant included eleven Houghton drawings, all historical "recreations," in his *History*, including *Bridger's Ferry, Deer Creek Overland Station, La Bonte Stage Station on the Overland,* a generic Pony Express station, *Fort Caspar (Platte Bridge), Fort Laramie in 1836, Fort Laramie in 1889, Fort Fetterman, Old Fort Reno, Jim Baker's Cabin,* and the *Arrival of John Philipps at Horse Shoe Station* (after the Fetterman Massacre).[71]

A closer look at these sketches allows one to distinguish between the Overland Trail scenes of forts and stage stations, which take a wide-angle bird's-eye view, versus a more intimate, close-up vantage point in the scenes of *John Philipps, Jim Baker's Residence,* and the Pony Express station. The panoramic landscape view is indicative of Houghton's city sketches. This technique places the posts in their wider contexts of river valleys and mountains rather than the personal view of Alfred Jacob Miller's famous painting made from inside Fort Laramie, which provided an interior view of what might be going on within the stockade's walls. In

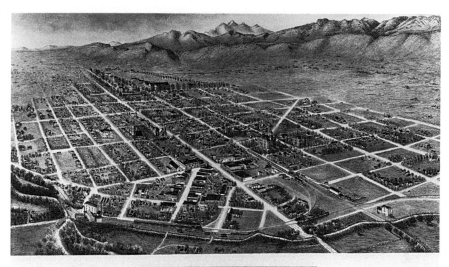

ORT COLLINS, COLO. 1899.

FIGURE 2.34. *Bird's-Eye View of Fort Collins, Colorado, in 1899.* Courtesy, Geography and Map Division, Library of Congress, Washington, DC.

contrast, all of Houghton's drawings are exterior landscape scenes made long after their heyday. Although such panoramic views may seem impersonal, they do reflect Houghton's attention to contextual detail as he tried to re-create lost structures by looking for foundations and talking to old-timers about where buildings should be in the landscape before him. Conversely, the other three drawings, the Pony Express station and the Baker residence in particular, show just one or two buildings, allowing Houghton to take an up-close view and to provide more intimate details, such as their construction techniques, rather than just their general look. Figures 2.35, 2.36, and 2.37 are Houghton drawings from Coutant's *History of Wyoming*.[72]

Just a week after Coutant released his book, Houghton was back in the field making sketches for volumes

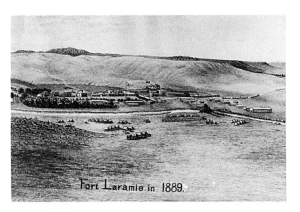

Fort Laramie in 1889.

II and III. The *Laramie Daily Boomerang* noted on March 16 that Houghton was on an extended visit to the western part of the state; three months later the *Wyoming Press* in Evanston reported that the artist had "been in the vicinity for some time soliciting orders and getting sketches for the History of Wyoming." Although no further news reports explain Houghton's movement during this time, a closer look at his known illustrations provides a sense of where he was and what he was doing. The existence of several watercolor paintings from western Wyoming also suggests that he was experimenting in this medium on this trip.[73] Although Houghton probably took the Union Pacific across the state, it is clear from his images that he detrained and traveled to remote places to sketch local ranches. One illustration, dated 1899, shows the *James M. May Ranch* on the Little Laramie River with Sheep Mountain in the distance, just east of Centennial (see figure 2.38). Two others, dated 1899, are watercolors: the *Harper A47 Ranch* north of Rawlins near Muddy Gap and the *J. M. McIntosh Ranch* on the

Sweetwater, just west of today's Jeffrey City. Much more than a ranch portrait, the 14 inch × 42 inch *McIntosh Ranch* image is really a scenic view of the ranch in its natural settings (see figure 2.39). In the painting, the unique rock formations and the winding Sweetwater dominate while the ranch buildings, though in the center, are small. White-faced cattle and horses range freely in the foreground, and two cowboys can be seen at work.

From the McIntosh Ranch, Houghton traveled west into what was then northern Uinta (today's Sublette) County and the Upper Green River country. Over the next four weeks, he made eight drawings and two watercolor illustrations as he worked his way south. All of these illustrations are tablet-sized at 11 inches × 19.5 inches and are more typical of the intimate ranch views showing cattle grazing in the foreground, ranch buildings and fencing in the center, and hills, mesas, and mountains rising in the distance. Interestingly, Houghton provided actual dates for two of the sketches, and so, with the help of local historian Jonita Sommers, I have mapped the locale where each ranch was located, providing a sense of where and how Houghton traveled. The first dated image is a watercolor of the William Sutton *"Boot Jack" Ranch on the Upper Green River*, signed June 11, 1899 (see figure 2.40). Sutton had lived in Carbon in 1877, so perhaps Houghton had known him there. Sommers locates this ranch just southeast of today's Daniel, Wyoming. Other nearby depicted ranches include the *Ranch of T. E. Andrus* northwest of Daniel (see figure 2.41) and the *Ed P. Steele Ranch* about twenty miles east of

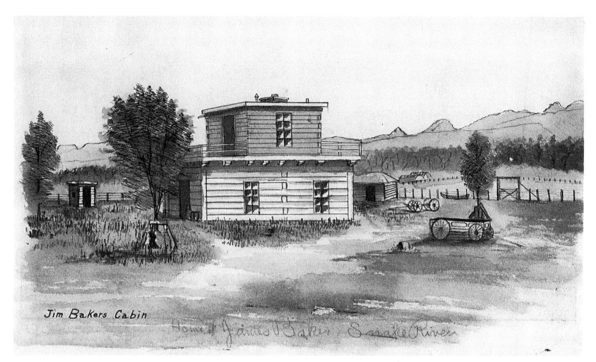

Jim Bakers Cabin

the Boot Jack near the town of Boulder (see figure 2.42). About fourteen miles west, Houghton painted a watercolor of the *Ranch of Harvy Dekalb*, showing the snow-capped Wyoming Range in the distance (see figure 2.43). Sixteen miles south, near Big Piney, Houghton drew the *A. W. Smith Mule Shoe Ranch* (see figure 2.44) and the *A. W. Smith Old 67 Ranch* (see figure 2.45), as well as the *James Mickelson Circle Ranch* to the west (see figure 2.46). At Big Piney, Merritt sketched the *Ranch of D. B. Budd, Big Piney P.O. Green River Valley, Wyo.* (see figure 2.47), including his pet elk front and center. About thirty-two miles south, Houghton

FIGURE 2.38. *James May Ranch* near Centennial, Wyoming, 1899, from *Wyoming's Pioneer Ranches*

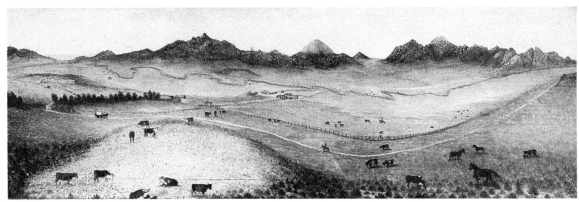

FIGURE 2.39. *J. M. McIntosh Ranch* on the Sweetwater, 1899. Author's collection.

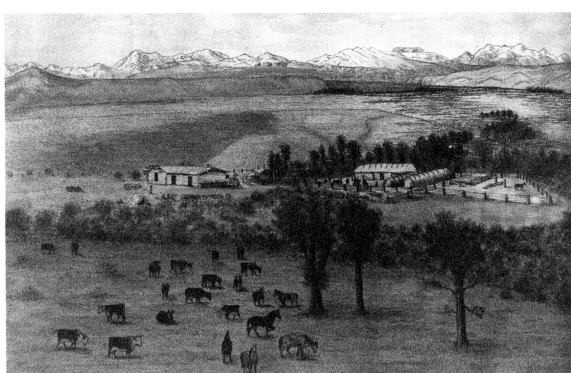

FIGURE 2.40. *"Boot Jack" Ranch on the Upper Green River.* Courtesy, Jim and Margaret Noble; Jonita Sommers Photograph Collection.

FIGURE 2.41. (BELOW) *Ranch of T. E. Andrus.* Courtesy, Jonita Sommers Photograph Collection.

drew the *Ranch of Roney Pomeroy, Fontenelle, Uinta Co.* and dated it July 8, 1899 (see figure 2.48). With these locations and dates, it is thus possible that if Houghton traveled over South Pass from the McIntosh Ranch, over the next four weeks he could have visited the Steele Ranch first, then the Boot Jack on June 11, and the Andrus and Dekalb Ranches, all near Daniel. He then moved south to the Big Piney area where he sketched the Budd, Mickelson, Mule Shoe, and Old 67 Ranches. Finally, he traveled another thirty-two

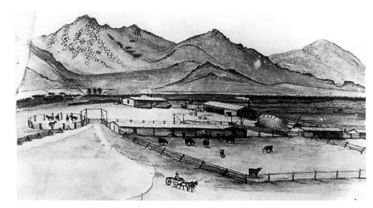 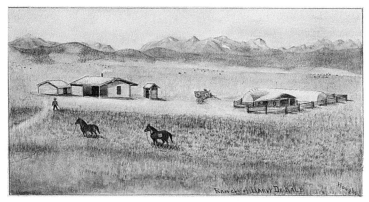

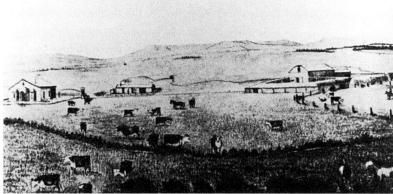 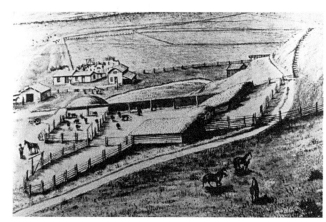

FIGURE 2.42. (TOP LEFT) *Ed P. Steele Ranch. Courtesy* Jonita Sommers Photograph Collection.

FIGURE 2.43. (TOP RIGHT) *Ranch of Harvy Dekalb.* Courtesy, Northwest Museum of Arts and Culture/Eastern Washington State Historical Society, Spokane.

FIGURE 2.44. (BOTTOM LEFT) *A. W. Smith Mule Shoe Ranch.* Courtesy, Jonita Sommers Photograph Collection.

FIGURE 2.45. (BOTTOM RIGHT) *A. W. Smith Old 67 Ranch.* Courtesy, Jonita Sommers Photograph Collection.

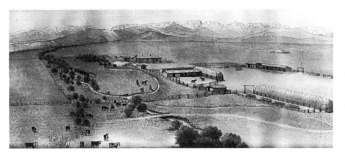

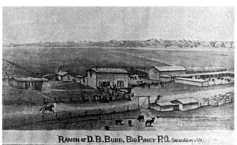

FIGURE 2.46. (TOP LEFT) *James Mickelson Circle Ranch.* Courtesy, Mike and Tara Miller, 67 Ranch on the Circle Place; Jonita Sommers Photograph Collection

FIGURE 2.47. (TOP RIGHT) *Ranch of D. B. Budd, Big Piney P.O. Green River Valley, Wyo.* Courtesy, Jonita Sommers Photograph Collection.

FIGURE 2.48. *Ranch of Roney Pomeroy, Fontenelle, Uinta Co.* Courtesy, Gary and Joanne Zakotnik; Jonita Sommers Photograph Collection.

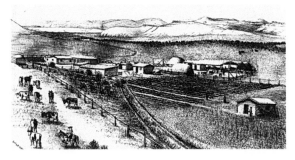

miles to the Pomeroy Ranch at Fontenelle, sketching it on July 8, 1899.[74]

From the Pomeroy Ranch on Fontenelle, Houghton traveled another twenty or so miles south to the Oregon Short Line Railroad, where he sketched *Opal Ranch, C. F. Roberson (Proprietor), (Opal, Wyo.).* Unlike any other Houghton ranch drawing, this illustration merged the artist's two ranch sketch styles into one illustration. In the top part, Houghton sketched Opal with the railroad passing through the town amid the Ham's Fork valley of southwestern Wyoming. Like his painting of the McIntosh Ranch, this image encompasses the wide view, with emphasis placed on seeing the entire valley as if one was

looking through a wide-angle camera lens, so that the town itself and the ranch beyond are just small dots set amid the wilds of the frontier. But just below this sketch, Houghton placed a portrait, close-up view of the ranch akin to many of his sketches, including those on the Upper Green River. This bottom portion of the drawing thus shows several cowboys at work herding a small band of white-faced cows with the ranch's main house to the right and its barns and outbuildings in the distance. Together, the juxtaposition of these two views of the ranch merged into one piece of art is unique in the Houghton portfolio (see figure 2.49).

From Opal, Houghton could have traveled by train to the station of Carter, from which it was just another ten miles by wagon to Fort Bridger, to sketch two other historical forts for Coutant: *Fort Bridger* as it existed in 1850 and then again in 1889 and *Fort Supply* in 1853. These two posts were located on the Oregon Trail. Mountain Man Jim Bridger had established his namesake trading post on Blacks Fork in 1842, and it became a stopover spot for travelers taking

the Oregon Trail to Salt Lake City. In 1853, Brigham Young sent a party to arrest Bridger, who the Mormons accused of selling liquor to the nearby Indians. Not finding him, the Mormons constructed their own post a dozen miles to the south, which they named Fort Supply. Two years later the church purchased Fort Bridger, though the mountain man denied that the sale was legitimate. During the so-called Mormon War of 1857, the Mormons burned both locations to slow the advancing US Army. In 1858, the army rebuilt Fort Bridger and maintained the post until abandoning it in 1890.[75]

Houghton probably made his historical images of Forts Bridger and Supply the same way he sketched Forts Fetterman and Casper: by traveling to the location, studying the landscape, doing basic historical archaeological examinations, and talking to old-timers who had seen the posts at the time Houghton was envisioning. Interestingly, he has margin notes on his sketch of Fort Bridger in 1850, including labels for each building at the bottom and, in the right margin, a summary of what he had learned about the building "as it appeared when completed during the days of the overland travel. What it was when purely an Indian Trading Post we do not know, but are told except that the buildings were poorly constructed, of the shed style with roofs sloping outward to the outer walls." His India ink sketch shows the entrance to a simple small stockade. Four Native Americans on horseback, including two pulling travois, are about to enter at left while two mounted American fur traders enter in the right foreground. In the distance are two tipis

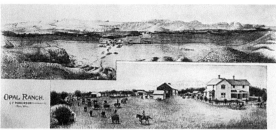

FIGURE 2.49. *Opal Ranch, C. F. Roberson (Proprietor), (Opal, Wyo.).* Courtesy, Jonita Sommers Photograph Collection.

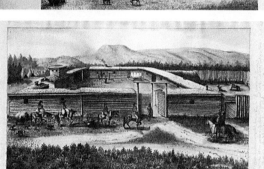

FIGURE 2.50. *Fort Bridger in 1850.* Courtesy, Department of State Parks and Cultural Resources, Wyoming State Museum, Cheyenne.

just outside the fort while a man works a horse in the stockade (see figure 2.50).

The second pen and ink illustration is of *Fort Supply in 1853* (see figure 2.51), and it shows a larger stockade with small buildings erected against the inner wall. A few covered wagons are inside the fort, and a couple of ox-drawn wagons are outside. A field of stacked grain sits in the foreground, and trees and bushes make up the background. Although no Native peoples can be found in this sketch, several other people are working in and about the stockade.

Houghton also made two watercolor paintings of Fort Bridger at the end of its active life, one titled *Fort Bridger as a U.S. Fort* (see figure 2.52) and the other

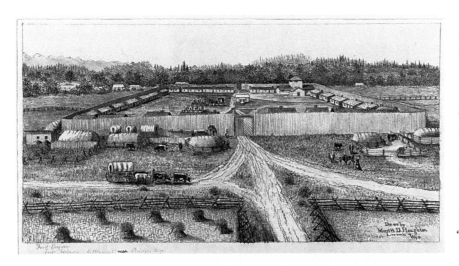

FIGURE 2.51. *Fort Supply.* Courtesy, Department of State Parks and Cultural Resources, Wyoming State Museum, Cheyenne.

FIGURE 2.52. *Fort Bridger as a U.S. Fort.* Courtesy, Department of State Parks and Cultural Resources, Wyoming State Museum, Cheyenne.

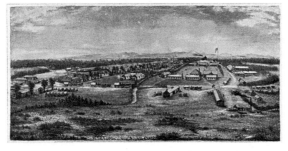

Fort Bridger in 1889. Although subtle differences can be spotted, the two paintings are basically identical. Each depicts Fort Bridger more as a community of individual buildings than as a stockaded post. The scene focuses in on the main parade ground with a flagpole at right. More than fifty buildings can be seen, as well as several horse- or mule-pulled wagons. A stream runs through the center, and trees and mountains are visible in the distance.

Houghton's images of Fort Bridger and Fort Supply were never published in Coutant's second and third volumes of his *History of Wyoming* because those volumes never made it to print. Apparently, Coutant's subscriptions did not cover costs past the first volume. Additional Houghton historical sketches, including *Fort Sanders near Laramie*, the small town of *Baggs at the time of the Meeker Massacre* (1879), and the *Sulphur Springs Stage Station*, remained with the artist. In a letter many years later, Houghton revealed that his relationship with Coutant was complicated when he wrote to Mrs. Mary Bellamy on January 26, 1914, that "I have several valuable sketches that were not turned in to Mr. Coutant when I found that I would have to make a clear present of them if I did." Instead of writing a three-volume history, Coutant worked as the Wyoming state librarian from 1901 to 1905, served as secretary of the Wyoming Industrial Convention, and then took a trip to Alaska before resettling in Grants Pass, Oregon, in 1908, where he edited the local paper until his death in 1913.[76]

Back in Laramie at the start of the new century, Houghton again turned his attention to area ranches. In February 1900, the *Laramie Daily Boomerang* described the artist as a "special representative" working for the paper—visiting various ranches on the Laramie Plains collecting subscriptions, taking orders for advertising and printing, and making sketches of and writing features about places of interest. The paper noted that he was "rarely excelled as a landscape artist" and that it hoped to publish some of his illustrations from his trip. In April, the paper reported that he had been among

the ranchmen on the Big Laramie River and in the Centennial Valley thirty miles west of Laramie. One story even suggested that Houghton considered writing a brand book, while another in May stated that the artist was an investor in a narrow-gauge railroad to be built to Gold Hill near Centennial. Although there is no record of such a cattleman's book coming to print, there is an October 1900 Houghton sketch of *Gold Hill*. Like his ranch drawings, this view looked from a neighboring prominence to a small cluster of buildings set in a grove of pines aside a small mountain. A few horses graze below, and a wagon with team can be seen heading up to a small smelter above a lake behind the buildings. This was probably Houghton's first mine drawing, but it was certainly not his last (see figure 2.53).[77]

In December 1901, the *Laramie Republican* published a special *Industrial Edition* that boosted the natural and economic resources of Laramie and its hinterlands. Houghton contributed fifteen drawings to this publication, including a panorama of Laramie from east of the university, sketches of downtown businesses, eleven ranch illustrations, and an animal drawing. This was his most intense publication of current views since his failed *Wyoming Illustrated Monthly* newspaper a decade earlier and was indicative of the genres the artist would continue to pursue. In its overview, editor W. E. Chaplin wrote that the "illustrations are as good as a camera and engraver can make and present Wyoming in a way that will leave a life-long impression upon the minds of our readers." A review of Houghton's work provides further insight into the artist at this point of his career.[78]

FIGURE 2.53. *Gold Hill in 1900.* Author's collection.

The eleven ranch drawings were spread throughout Albany County and show the extent to which Houghton traveled to do his work. From Laramie, he journeyed twenty miles south to Tie Siding, thirty miles west to Centennial, and north fifty-five miles to the tiny hamlet of Garrett, northeast of Medicine Bow near Laramie Peak. For the most part, all the drawings are ranch portraits showing the main house and its surroundings with cattle and horses grazing in fenced fields. Several show cowboys working their herds or using machinery to tend fields or put up hay. In that sense, these images are significant as evidence of how this settler generation was remaking the Laramie Plains. For example, in his sketch of the *William Maxwell Ranch at Tie Siding* (see figure. 2.54), Houghton shows the main house set amid ten outbuildings. In the far distance can be seen the Medicine Bow Mountains with Jelm Mountain at the far left. A person watches a cattle herd in the foreground, another drives a wagon, and still another works hay in the right mid-ground. In the distance, more cattle are enclosed by fences while a few horses are present nearby. Just beyond the ranch, a horse and buggy are

on the road to Laramie. His view of the *Ranch of Mrs. J. D. Baily and Son* (see figure 2.55) shows a similar set of buildings and fenced fields just south of Centennial. To the north, the *Herbert King Ranch on Rock Creek* (see figure 2.56) presents a still smaller operation on the plains east of Arlington and about halfway across the county. Finally, the artist's view of the *Ranch of H. Ralph Hall* (see figure 2.57) at Garrett demonstrates yet another variation on this theme, this time more than fifty miles north.

Ranch scenes that appeared in the 1901 *Laramie Republican Industrial Edition*

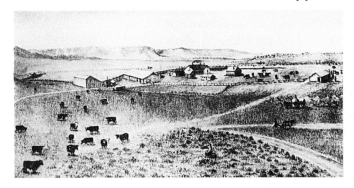

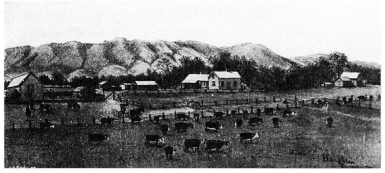

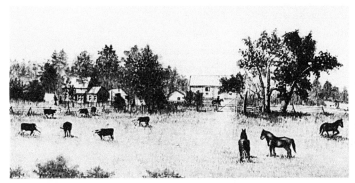

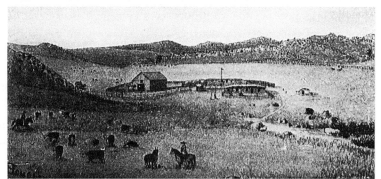

FIGURE 2.54. (TOP LEFT) *William Maxwell Ranch at Tie Siding*, south of Laramie. Courtesy, Wyoming Digital Newspaper Collection.

FIGURE 2.55. (TOP RIGHT) *Ranch of Mrs. J. D. Baily and Son*. Courtesy, Wyoming Digital Newspaper Collection.

FIGURE 2.56. (BOTTOM LEFT) *Herbert King Ranch on Rock Creek*. Courtesy, Wyoming Digital Newspaper Collection.

FIGURE 2.57. (BOTTOM RIGHT) *Ranch of H. Ralph Hall*. Courtesy, Wyoming Digital Newspaper Collection.

In addition to ranches, Houghton also included two town sketches. The first is a bird's-eye panorama of Laramie, along the lines of his views of Saratoga and Fort Collins, though less detailed. With an eastern vantage point, Houghton placed the original three buildings of the University of Wyoming in his foreground and then stretched the town westward, with the territorial prison in the distance and the Medicine Bow Mountains on the horizon. After the university, Houghton clearly drew the Union Pacific Railroad. In an age when billowing smoke represented not pollution but industrial might, Houghton shows no fewer than a dozen black smoke plumes across the town along the tracks. Beyond these features, the rest of the town is rather nondescript, with few buildings or areas especially detailed (see figure 2.58).

The second community illustration is of the tiny hamlet of Centennial, located west of Laramie at the foot of the Medicine Bow Mountains (see figure 2.59). Essentially a ranch portrait, the sketch shows one man plowing a field while another drives up in a cart. Behind them, a small ranch house is featured, with several adjacent outbuildings. In the distance, foothills give rise to the distant Medicine Bows. The only clue that this is more than a ranch sketch is in the caption, which reads "Pen Sketch of Centennial, Wyoming. End of the First Division of the Laramie, Hahn's Peak and Pacific Railway Which is Expected to Become a Great Tourist and Pleasure Resort." The absence of any trains or even a depot is not surprising, since the railroad did not actually reach Centennial until 1907, six years after this image appeared.

FIGURE 2.58. (LEFT) *Bird's-Eye View of Laramie.* Courtesy, Wyoming Digital Newspaper Collection.

FIGURE 2.59. (RIGHT) *Pen Sketch of Centennial.* Courtesy, Wyoming Digital Newspaper Collection.

Town sketches that appeared in the 1901 *Laramie Republican Industrial Edition*

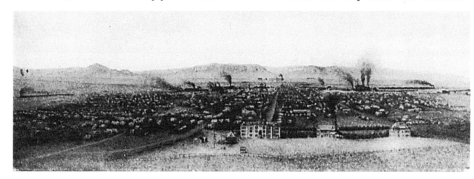
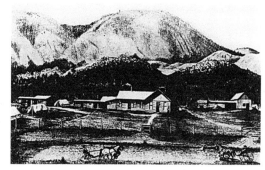

Houghton also included sketches of a Laramie business and one animal portrait. The business view is a close view of merchant W. H. Holliday's planing mills and lumber yard, complete with three different lumber wagons leaving the massive yard as two buggies filled with customers arrive. Like the bird's-eye view,

Houghton has shown the mill at work, with smoke emanating from its stacks. The site covers an entire city block, and eleven people are on the sidewalks (see figure 2.60). The animal portrait shows a small herd of mountain sheep scaling a rock formation (see figure 2.61).

Business and animal sketches from the 1901 *Laramie Republican Industrial Edition*

FIGURE 2.60. (RIGHT) *Planing Mills and Lumber Yard of the W. H. Holliday Company, Laramie.* Courtesy, Wyoming Digital Newspaper Collection.

FIGURE 2.61. (ABOVE) *Mountain Sheep.* Courtesy, Wyoming Digital Newspaper Collection.

Evanston's *Wyoming Press* published a *Special Illustrated* issue of its own on May 3, 1902, that discussed the economic opportunities in the southwestern part of the state, including ranches, mines, businesses, and the nascent oil industry. For its discussion of the Upper Green River Valley, the paper featured biographies of area pioneers and included Houghton's sketches *Ranch of D. B. Budd* at Big Piney, *A. W. Smith Mule Shoe Ranch* and *A. W. Smith Old 67 Ranch*, and *Opal Ranch, C. F. Roberson (Proprietor), (Opal, Wyo.).*[79]

By late spring 1902, Merritt Dana Houghton had come a long way in his first fifty-six years of life. He had grown up in Michigan and Illinois, escaped the ravages of the US Civil War by attending college, and completed his degree to become a teacher. He then moved with his Civil War hero brother to Omaha, married, and relocated again with his bride to the Wyoming frontier. There, he worked as a teacher and school superintendent and then remade himself into a photographer and newspaperman, living in the communities of Carbon,

Rawlins, Buffalo, and Laramie. He had photographed Native Americans and cowboys on the range. Houghton then tried his hand as the artist and publisher of Wyoming's first illustrated newspaper; when that failed, he went back to teaching as an itinerant ranch educator and sketch artist, creating heirloom sketches and watercolors of family ranches across southern Wyoming. This success led him to illustrate historical sketches of forgotten forts and stage stations for a book, and he did this very well. He visited the sites to better understand their landscapes in situ, conducted historical archaeology, and asked old-timers about how they remembered places. Houghton sent them his work for edits and redrew sketches as directed so well that newspapers said he was *restoring* history, not just representing it. Following this, he again taught in one-room ranch schools and sketched increasingly remote locations before once again publishing his views in more illustrated newspapers. These many views serve as historical documents and show how this settler society was reorganizing the land and importing exotic cattle and horses. By all accounts, Merritt Dana Houghton had completed a lifetime of work by 1902, but his best and most productive days were still ahead, at a little community west of Laramie called Grand Encampment where a copper boom was just beginning.

MAP 3. Houghton sketch locations, 1902–1904

It is not clear when Merritt Dana Houghton first set foot in the Grand Encampment region of southern Wyoming. Perhaps he had ventured south from Carbon or Rawlins when he first arrived in the territory in the late 1870s. He did travel to the region in 1898 promoting Coutant's *History* and made his first bird's-eye view of Saratoga. Most likely, though, Houghton probably gave serious thought to the Upper North Platte region only when prospectors found rich copper deposits in the Sierra Madres. Regardless of why he first appeared, we do know that Houghton spent about two-and-a-half years in southern Wyoming, from the summer of 1902 to late 1904, sketching towns, mines, smelters, ranches, and businesses; drawing animals both wild and domestic; and creating unique aerial topographic studies of mining districts. During those years, he traveled extensively around Encampment, south into Colorado's Pearl Mining district and North Park, west to Baggs and Wamsutter, Wyoming, and north to Elk Mountain and Fort Fred Steele. In several places, he returned to sketch the growth that had occurred since his last depiction. His images appeared in local newspapers, in mining and railroad prospectuses, and in two self-published books: *A Portfolio of Wyoming Views: The Platte Valley and the Grand Encampment Mining District* (1903) and *Views of Southern Wyoming: Copper Belt Edition* (1904). Houghton's work helped create the Grand Encampment copper boom, and it cemented his reputation as an artist, booster, and visual documentarian.

The Upper North Platte region of southern Wyoming had always been a place of natural beauty and resources. Ute bands lived in the area; by the 1830s, American fur trappers had penetrated it as well. After the Civil War, lumbermen cut railroad ties for the Union Pacific and floated them down rivers to Fort Fred Steele, where the iron road met the river. The railroad also brought ranchers who settled the area in the 1870s and 1880s, bringing 10,000 cattle and sheep. The town of Saratoga grew up around its warm springs, and in the 1880s George Doane discovered copper near Battle Lake in the Sierra Madres and founded his Doane-Rambler Mine. But it was Ed Haggarty's discovery of a rich vein of copper ore in 1897 that ignited a boom. The town of Encampment was organized that same year, and by the close of the century Haggarty's mine employed 250 men who shipped 80,000 pounds of copper ore a day to a Colorado smelter. In 1898, Houghton visited and sketched Saratoga. In 1901, the North American Copper Company purchased

https://doi.org/10.5876/9781646423668.c003

Haggarty's mine for $1 million and negotiated with the Boston-Wyoming Company to build a smelter in town on the bluffs above the Encampment River. The next year, it built a sixteen-mile-long aerial tramway to move ore from the mountain mine to the smelter. These two projects encouraged the development of other mining prospects, and it was probably the opportunity to sketch these remote locations that brought Encampment and southern Wyoming to Houghton's attention.[1]

Houghton also might have been introduced to the copper boom through his interest in the budding Laramie, Hahn's Peak and Pacific Railroad. Recall that a Laramie newspaper had stated in May 1900 that he might be involved in a plan to build a narrow-gauge railroad west to the Centennial Valley and Gold Hill.[2] Two years later, the *Laramie Republican* reported that Houghton had completed a topographical sketch of the area for the railroad. The lost drawing was reportedly forty inches long and twenty-four tall and showed "all the topographical features of the plain lying between Laramie and the mountains to the west, including the great basin, the line of the railroad, the county roads, streams, canals, and farming lands watered thereby, the mountains with the principal places marked thereon and a comprehensive bird's-eye view one would get were he several hundred feet high and looking downward." A week later, the *Semi-Weekly Boomerang* added that the sketch showed "the elevations of the land in fine shape."[3] Despite this effort, the railroad did not reach Centennial until 1907 and then, instead of continuing west to Gold Hill, it turned south to the coalfields near Walden, Colorado.[4]

Houghton spent the summer of 1902 traveling and sketching copper prospects in the Sierra Madres and the Encampment area. His work over the next two years became nearly a weekly feature in the local *Grand Encampment Herald*. On August 1, 1902, the paper wrote that the artist had made a "very fine pen drawing of the city of Grand Encampment" for the mayor (see figure 3.1) and had another sketch under way of the third tramway camp. The paper went on to praise Houghton, saying he was an "exceptionally fine artist in his line" and that he expected to stay in town for "some time." It added that he made drawings of "ranches, mining properties, towns, etc.," and that he could be reached at the New Bohn Hotel. Two weeks later the *Herald* noted that Houghton had sketched the town of Battle, located nineteen miles west of Encampment on the Continental Divide at 10,000 feet elevation. The paper added that the artist also had drawings of the second power station on the aerial tramway as well as "other smaller ones."[5]

Houghton's *Early Pen Drawing of Encampment, 1902,* the first of several of the town, looks down on the street grid (see figure 3.1), suggesting mastery over nature. Houghton focuses on the main commercial buildings on Main Street, the new smelter at lower left, and the tramway snaking into town at the right. In later views, the artist shifted his focus and placed the smelter clearly in the center of his image, just as its business was the center of the community.

Like his ranch and bird's-eye view sketches, Houghton placed both the hamlet of Battle (see figure 3.2) and the tramway station (see figure 3.3) in

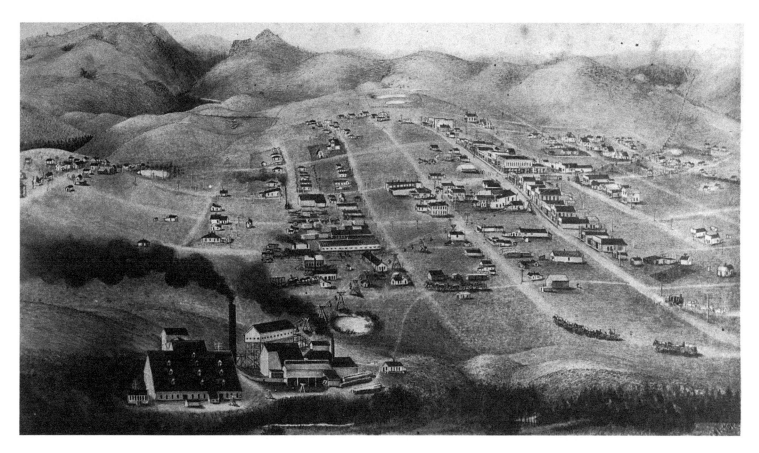

their forest environments, also showing the hand of man at work. In the Battle scene, a small main street of false-front buildings is visible, and several teamsters can be found hauling goods. Likewise, the tram station shows a series of towers leading to several large buildings rising out of the trees, with smoke wafting over the landscape. Unlike his other views made from high vantage points, these two drawings could have been made on nearby hills. Indeed, each seems to peek through the forests, with nearby trees both upright and fallen framing the view of man starting a beachhead in the wilderness.

Houghton continued to work in the area, and his sketches soon became noticed by the Wyoming press. The *Grand Encampment Herald* noted that he made a sketch of the Encampment Mining Company's

FIGURE 3.1. *Early Pen Drawing of Encampment, 1902.* Courtesy, Lora Webb Nichols Papers, Accession Number 01005, Box 16, #16759, American Heritage Center, University of Wyoming, Laramie.

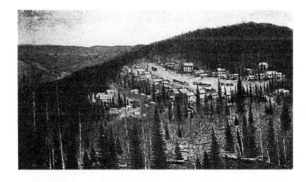

FIGURE 3.2. *The town of Battle,* from *A Portfolio of Wyoming Views*

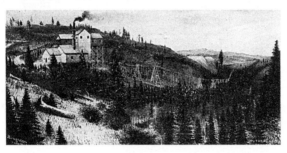

FIGURE 3.3. *Tramway Station #2,* from *A Portfolio of Wyoming Views*

tunnel and South Fork Canyon on September 5, then it published his view of the Ferris Haggarty Mine three weeks later, noting it was one of the artist's "popular drawings."[6] Laramie's *Wyoming Industrial Journal* published Houghton's Grand Encampment sketch on November 1.[7] In January 1903, the *Saratoga Sun* called attention to Houghton's "India Ink pen drawing" of the Encampment smelter used on an advertising piece for its owner, the North American Copper Company. The paper praised the artist's accuracy, saying that it "far excels any photo ever made of the company's big plant. The drawing is complete in

every detail and produced in half tone is indeed *beautiful*" (emphasis added).[8]

An examination of surviving Houghton images of the Ferris Haggarty Mine (see figure 3.4) and the North American Copper Company's smelter reveals an interesting take on turn-of-the-century nature and industrialization. Houghton centered the Ferris Haggarty Mine as the region's economic driver by placing the mine buildings clearly at the center of his image, between two hills. Several crude roads can be seen, all leading to the mine or emanating from it, while the first tramway station building sits on the right with the towers and cables leading off into the distance. Unlike the scenes of Battle and Tramway Station Two, this one shows a denuded forest that has been timbered for the many buildings and operations in the image. Smoke bellows from the mine's stack, also alluding to the work of man, though no people can be seen in the image. It is clearly an industrial sketch showing man transforming the wilderness into production.

Houghton also placed Encampment's smelter at the center of his industrial portrait (see figure 3.5), showing the plant spread out on a hill above the brush-lined Encampment River. Emerging from the distant hills are the tramway's two tall stacks billowing smoke into the air. A man and team with a wagon are visible on the road above the river. In the caption, Houghton included facts about the plant and labeled the various buildings' operations, including the Encampment Office, the sampler, Tramway Terminal, Converter, Briqueting Plant, Smelter, Roaster,

Power and Electric Plant, and Concentrator. This hint of operations located within reminds one of the grain elevators William Cronon discussed in his classic study *Nature's Metropolis* as almost a revealing of how man was turning nature into commodity. But to call this industrial landscape *beautiful* requires a warped merging of the machine in the garden metaphor.[9]

Newspapers soon touted Houghton's work and hinted at more things to come. The January 15 article from the *Saratoga Sun* noted that the artist had been "in and about Grand Encampment since early summer and has made a collection of drawings which have won for him fame and considerable fortune. His presence here has been appreciated and he has had constant employment at a good figure." The article concluded that Houghton expected to spend 1903 at work "principally" around Encampment. The following week, the *Grand Encampment Herald* printed two more of Houghton's sketches: the *Coldwater Mine* property near Pearl, Colorado, and the *Copper Giant*, famously owned by Dr. D. Frank "White Beaver" Powell and his friend William F. "Buffalo Bill" Cody. Houghton sketched this property as simply a collection of small buildings set against a large mountain. Three days later, the *Laramie Republican* noted that Houghton was thinking about publishing an "illustrated magazine" at Grand Encampment.[10]

Houghton next focused his attention on the town of Saratoga. On February 6, the *Grand Encampment Herald* reported that the artist was spending a week in the community; six days later, the *Saratoga Sun* ran a new bird's-eye view Houghton had sketched of the

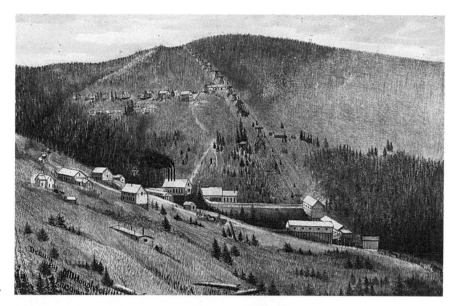

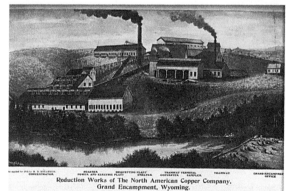

Reduction Works of The North American Copper Company, Grand Encampment, Wyoming.

FIGURE 3.4. *The Ferris Haggarty Mine.* Courtesy, Department of State Parks and Cultural Resources, Wyoming State Museum, Cheyenne.

FIGURE 3.5. *Reduction Works of the North American Copper Company, Grand Encampment, Wyoming.* Courtesy, Grand Encampment Museum, Encampment, WY.

town (see figure 3.7). The sketch again looks down on the town from the northeast and features the North Platte River running left to right through the town,

FIGURE 3.6. (RIGHT) The *Copper Giant Mine* was owned in part by Buffalo Bill Cody. From *A Portfolio of Wyoming Views.*

FIGURE 3.7. (BELOW) This *Bird's-Eye View of Saratoga* updated Houghton's earlier 1898 sketch. Courtesy, Dick Perue/Bob Martin Collection, Historical Reproductions by Perue, Saratoga, WY.

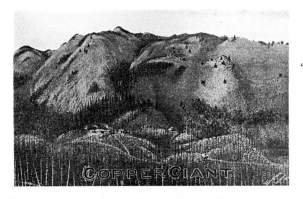

and communication connections, schools, industries, resources, water system, and others. The paper added to the boosterism with a small paragraph that read "just glance over the picture on this page of the *Sun*, of the city in which we live, and if you who do not live here don't feel like pulling up stakes and moving to Saratoga, you certainly should." It described Houghton as in the "front rank of his profession," adding that he had "spared no pains to make this picture as nearly an exact representation as it is possible to do." The article concluded by noting that Houghton had printed a number of cards with this image for sale and that "you cannot do better than to get a number of them and send to your friends." Four days later, the *Laramie Republican* wrote that the "well-known artist" had returned to Laramie for about ten days after leaving Saratoga with the noon temperature at 31° below zero. While in town, he joined his wife for a social event at which he read an original poem. He returned to Saratoga on March 9.[11]

In April 1903, the *Saratoga Sun* reported that Houghton had been sketching beyond the mining district and completed a "very fine" picture of N. K. Boswell's ranch on the Big Laramic River southeast of Encampment on the Colorado-Wyoming border. Boswell was the first sheriff of Albany County. The massive sketch is 27 inches × 70 inches and looks down on the ranch from the northeast. Houghton's experience as a photographer can clearly be seen because the extensive river valley has the curved distortion of being viewed through a wide-angle lens. As in the other ranch illustrations, Houghton shows cows

with a clear view of the town grid spread across the landscape. The Hotel Wolf and Bridge Street are there, as is much more development to the south than is shown in the 1898 view. Below the sketch, Houghton included promotional facts about the community, including elevation, population, transportation

and horses scattered throughout the hillsides within fences while haystacks dot the river valley. In many ways, this is a bird's-eye view of the Big Laramie Valley, with Boswell's ranch occupying only a small part of the lower left side. The main house, barns, outbuildings, and bridge are overwhelmed by the expanse of nature in the scene. The *Sun* called the work "one of the most striking and inviting that this country has to offer to the sight-seeing public. This picture is one that should commend Mr. Houghton's work as that of an artist" (see figure 3.8).[12]

At just under six feet wide, the massive size of the Boswell Ranch drawing showed that Houghton was thinking "outside the box" for his illustrated magazine project, and his next area of focus—animals— continued that trend. On April 26, 1903, the *Laramie Boomerang* noted a story from the *Saratoga Sun* editor stating that Houghton was at work on a series of "beautiful animal pictures," including ones of elk, deer, mountain sheep, sheep, and other animals, for his

"Portfolio of Saratoga Valley" project. According to the editor, these sketches were "very fine" because they combined the animal images with mountain scenery, "representing the animals in their native haunts."[13] Several of these animal scenes survive and today represent useful illustrations in the new field of animal history. This emerging scholarship documents the lives of historical animals as an intrinsically valuable history through which we can better understand nonhumans and ourselves. To do this, historians examine such things as how animals changed over time and space and how we can find evidence of animals in human-centered archives. They urge us not to think of animals as static beings but rather about how they "mark the historical record without knowing they are doing so" and how to view history from their perspective. In essence, these scholars suggest that understanding animals will help us better understand "the nature of human control, consumption, and destruction of animals that characterizes modernity." Houghton's

FIGURE 3.8. *Ranch of N. K. Boswell. Albany Co., Wyo.* was one of Houghton's largest sketches to date. Courtesy, Department of State Parks and Cultural Resources, Wyoming State Museum, Cheyenne.

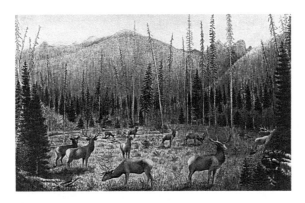

FIGURE 3.9. *Elk in Wooded Country.* Courtesy, Department of State Parks and Cultural Resources, Wyoming State Museum, Cheyenne.

FIGURE 3.10. *The Sheepherder's Home,* from *A Portfolio of Wyoming Views*

animal views show how people in the Encampment copper boom era worked with and depicted their fellow creatures.[14]

Four period animal sketches illustrate these points. In *Elk in Wooded Country* (see figure 3.9), Houghton shows a small herd of native Rocky Mountain elk grazing in a forest opening. No humans are in sight, and the view represents how close the wilderness was to the Encampment copper boom. The second shows a sheepherder's wagon in a blizzard, surrounded by a flock of sheep. Again, no people are present, but silhouetted against the wagon is the trusty sheep dog, at work while the master waits out the storm (see figure 3.10). The third, *Breaking a Road, 1903,* depicts a winter scene in which men are trying to clear a road by using horses to pull a dead tree through the snow, followed by a large herd of sheep that trample down the snow to make the road passable (see figure 3.11). Finally, in the watercolor *The Early Storm, 1903,* Houghton placed a cow and her calf against a high-country grove of pine trees as wind and snow beat down upon them (see

figure 3.12). Drawings such as these provide a visual mark for scholars of animal history.

By early May 1903, Houghton was back in the high country sketching properties for his illustrated "Saratoga art portfolio." The previous October, the *Grand Encampment Herald* ran Houghton's pen drawing of the *Rocky Mountain Copper Company* (see figure 3.13), and now it featured the *Mohawk Mine* located on the North Fork of the Encampment River (see figure 3.24). Then, on May 7, the *Saratoga Sun* reported that the "artist and photographer" had traveled to Copperton, the Rudefeha Mine, and the town of Dillon, which he reported as "thriving," with "bright prospects before it." It also noted that he had good success "taking orders for his Portfolio." The next day, the *Grand Encampment Herald* recorded that Houghton had been in Dillon for a week, "preparing a series of pictures of people, buildings, and scenes." The paper added that he also "took pictures" and drew sketches of the Carbondale Coal Camp (see figure 3.14).[15]

Since no individual illustrations of the "people, buildings, and scenes" of Dillon exist and because Houghton often made smaller working pictures as part of a larger landscape work, it is likely that these individual sketches were work sheets for the larger bird's-eye view of Dillon that Houghton completed in June 1903. Dillon had been created as an "open town" for the miners who worked at the Ferris Haggarty Mine, to compete with the company's "dry town" of Rudefeha. It had its own paper, the *Dillon Doublejack,* as well as several hotels and bars. In this sketch, Houghton placed a bustling Dillon in the foreground

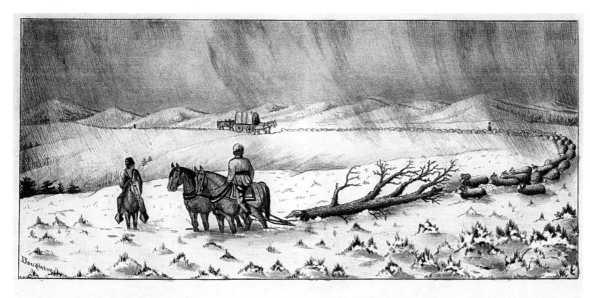

Breaking a Road

FIGURE 3.11. *Breaking a Road, 1903.* Courtesy, Department of State Parks and Cultural Resources, Wyoming State Museum, Cheyenne.

FIGURE 3.12. *The Early Storm, 1903.* Courtesy, Department of State Parks and Cultural Resources, Wyoming State Museum, Cheyenne.

with the mine and its company town in the distance. The aerial tramway climbs the heavily timbered hill. On the main street, several pack trains pull wagons between the false-front buildings as other teams ascend the road to the mine. Miners' cabins dot the forest while the town and the distant mine sit within a heavily timbered area (see figure 3.15).

A week later, Houghton returned from the mountains. The *Saratoga Sun* reported that he was back at work on animal illustrations, "spending several days the latter part of last week sketching two thoroughbred bulls," including "Duke, the herd bull," and "Rex, an 18 months-old youngster." The paper reported that both views were "excellent."[16]

In July 1903, the *Grand Encampment Herald* reported that the artist was now in Riverside. Houghton showed the editor sketches of the Aetna mining

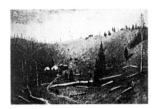

FIGURE 3.13. *Rocky Mountain Copper Company.* Courtesy, Wyoming Digital Newspaper Collection.

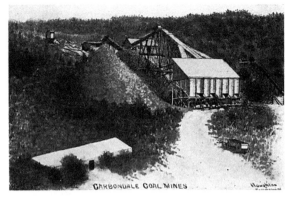

FIGURE 3.14. *The Carbondale Coal Mines,* from *A Portfolio of Wyoming Views*

property as well as the "fine pen drawing of Dillon and the Ferris Haggarty, the first made of that country."[17]

Houghton also announced that July that he was preparing work for a book that would feature a collection of views of southern Wyoming. According to the *Herald*, the "collection will embrace illustrations of the industries and resources of this section of Wyoming and will include many sketches and snap-shots of western life." It mentioned that Houghton, "whose work needs no introduction to the people of Wyoming," was preparing illustrations for the collection. The long list of subjects reads like an index to the many places Houghton had visited, sketched, and photographed over the last two years, including the "Smelter at Grand Encampment, Interior of Smelter, Tramway Station No. 2, Tramway Snap-Shots, Grand Encampment, Battle Lake, Rambler, Dillon, Ferris Haggarty Mine, Tie Camp, Riverside, Huston's Ranch, Andrew Olson's Ranch, Tie Drive Snap Shots, Tie Industry at Ft. Steele, Stage Line of C.M. Scribner, Snow Shoeing, Handsledding on Continental Divide, Antelope in

Pass Creek Basin, Haunts of the Elk, Mountain Sheep, Sheepherder's Home, A Sheep Bridge in the Mountains, Carbondale Coal Co.'s Banks, Saratoga Coal Banks, Town of Saratoga, Hotel Wolf, Forest Scenes, winter and summer; Timber of the Sierra Madre, Fishing Scene, Interior Copper Bar Shaft House, and many others." The article concluded by stating that Houghton "will get up a collection that everyone will want, and has already taken many orders."[18]

On August 21, the *Grand Encampment Herald* reported that Houghton was "securing a large patronage" for the one dollar book that would consist of about "forty half tones, illustrating the Saratoga Valley and the Grand Encampment mining district." It suggested that the volume would not be a "general advertising scheme" but would include "all the leading features which go to make up this great camp." The paper further detailed that the artist had made a new drawing of Grand Encampment and that the book would include a foldout relief map of the mining district, which "alone will be worth the price." It noted that Houghton had invested much time and travel in the project and that he was a "genuine artist of experience and good reputation" whose work had appeared in the *Herald* and other Wyoming papers.[19]

A week later, the first advertisement for Houghton's book appeared in the *Grand Encampment Herald*. Titled *A Portfolio of Wyoming Views*, the book promised to be published "this season," with "half-tone engravings from photos and sketches of Wyoming's Leading Industries and Resources." Houghton assured readers that "Animal Portraiture, Snap-Shots

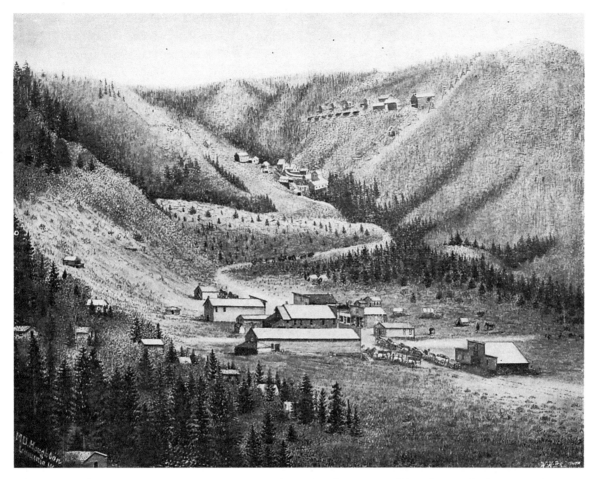

FIGURE 3.15. *Dillon, Wyoming, in 1903,* from *A Portfolio of Wyoming Views*

of Western Life and Western Scenery Are Among the Artistic Features of this Work." The ad closed by suggesting that mine owners who wanted illustrations of their properties or readers interested in ordering the book could inquire in Encampment at the Bohn Hotel or the *Herald* office. Interestingly, the previous day, the owner of the Elk Mine had journeyed to Saratoga to discuss his property with the local editor and brought along his newly drawn Houghton sketch of his property (see figure 3.16).[20]

Houghton spent the next four months traveling, sketching, and releasing a few images to local papers

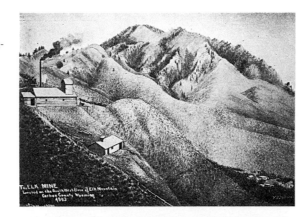

T. ELK MINE.
Located on the South West Base of Elk Mountain
Carbon County Wyoming
1903

FIGURE 3.17. (BELOW) *The Moon Anchor Mine*, from *A Portfolio of Wyoming Views*

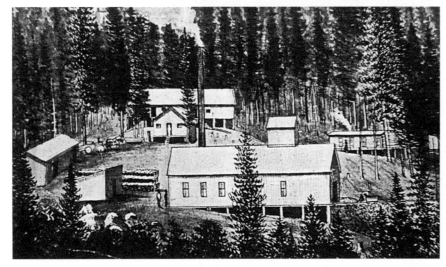

to keep interest in his project alive until it appeared just before the holidays in December 1903. Based on the scenes depicted in the book as well as in period news stories, the artist went north to Fort Fred Steele on the Union Pacific, east to the Snowy Range, west

to the Continental Divide and the Battle Lake area, and south to the Pearl Mining District in Colorado. Along the way, he sketched ranches, mining properties, animals, unique topographical views, and other businesses and industries.[21] Papers in the region promoted the work and occasionally printed sketches given to them by the artist. For example, the *Grand Encampment Herald* published a sketch of the *Moon Anchor Mine* (see figure 3.17) on August 28, the *Rambler Mining Company's Tunnel* on September 11, a close-up view of the Encampment smelter on September 18, and a year-old sketch of the Ferris Haggarty Mine. On December 18, it printed Houghton's new drawing of Grand Encampment (see figure 3.18) and compared it to a photo taken a year earlier to show how much the town had grown. In this story, dubbed "Yesterday and Today," the editor noted that the photograph preceded construction of the smelter and the aerial tramway. Indeed, he suggested that Houghton's illustration was a "true depiction" of the town, which it dubbed the "Hub of Progress in southern Carbon County, Wyoming." The paper reminded its readers that the depiction of the smelter and electrical plant of the North American Copper Company—which Houghton had placed in the center of his illustration—was an "exact likeness" while also noting the presence of telephone and electrical lines along the streets and alleys as well as the "towers of the longest aerial tramway ever built on earth." Finally, the editor concluded that "the people of Grand Encampment are proud of their town" while also noting snidely that "there is not a tree on the townsite big enough to cast a shadow a foot wide."[22]

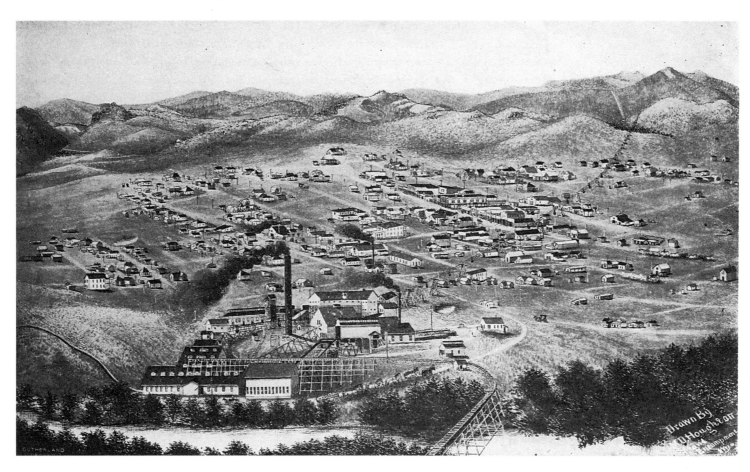

Houghton's book was available on New Year's Day 1904. With its full title *A Portfolio of Wyoming Views: The Platte Valley and the Grand Encampment Mining District: Saratoga, Pearl, Dillon, Battle, Rambler, Rudefeha*, the forty-seven-page book featured over ninety images, including several Houghton photographs made two decades earlier. It had thirty-nine large original sketches, including thirteen mining properties, six town views, seven ranches, and thirteen images of businesses and animals. The book was an instant success, with the *Herald* reporting that it was "selling like hot cakes" the first month.[23]

FIGURE 3.18. Houghton's second sketch of *Grand Encampment* emphasized the smelter. From *A Portfolio of Wyoming Views*.

An examination of the book attests to its popularity. As Houghton stated, his *Relief Map of the Grand Encampment Mining Districts* was a unique bird's-eye view of the entire region, with the national grid superimposed over the land showing specific township numbers as well as the area's natural features and specific mines and towns. Folded within, the map served as both an overview of the region and an indicator of Houghton's extraordinary skill (see figure 3.19).

The *Portfolio* also contained eleven drawings of mining properties. For Wyoming, Houghton repeated the sketches *Tramway Station #2*, the *Copper Giant*, and the *The Elk Mine* (see figure 3.16) plus new views of *The Evening Star Mine* (see figure 3.20), *The Vauxhall Mine* (see figure 3.21), *The New Rambler Mine* (see figure 3.22), *The Jessie Mines* (see figure 3.23), *The Mohawk Mine* (see figure 3.24), and the *Interior of the Copper Bar Shaft House* (see figure 3.25). For Pearl, Colorado, Houghton included *The Wolverine Mine* (see figure 3.26) and *The Sweede Mine* (see figure 3.27). He also added sketches of the dam on the Encampment River that provided water to the smelter (see figure 3.28) and a miner's cabin, labeled *Cabin of M. Hanley, Purgatory Gulch* (see figure 3.29).

Mining sketches from *A Portfolio of Wyoming Views* (FIGURES 3.19–3.29)

FIGURE 3.19. *Relief Map of the Grand Encampment Mining Districts* was included as a foldout map in each copy of Houghton's first book. Courtesy, Dick Perue/Bob Martin Collection, Historical Reproductions by Perue, Saratoga, WY.

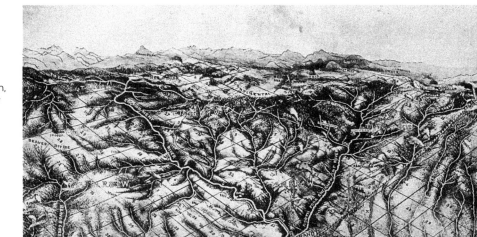

FIGURE 3.20. (LEFT) *The Evening Star Mine*, from *A Portfolio of Wyoming Views*

FIGURE 3.21. (RIGHT) *The Vauxhall Mine*. Courtesy, Department of State Parks and Cultural Resources, Wyoming State Archives, Cheyenne.

FIGURE 3.22. *The New Rambler Mine*, from *A Portfolio of Wyoming Views*

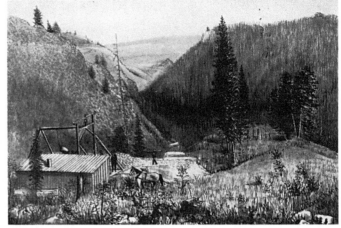

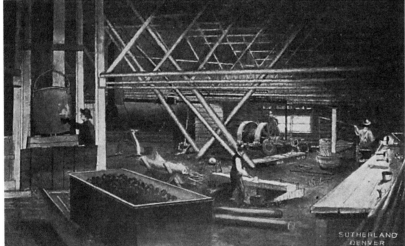

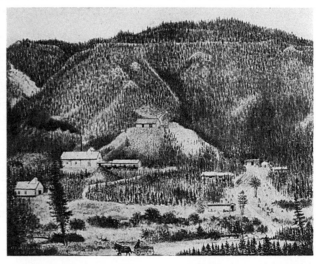

FIGURE 3.23. (TOP LEFT) *The Jessie Mines, from A Portfolio of Wyoming Views*

FIGURE 3.24. (TOP RIGHT) *The Mohawk Mine, from A Portfolio of Wyoming Views*

FIGURE 3.25. (BOTTOM LEFT) *Interior of the Copper Bar Shaft House, from A Portfolio of Wyoming Views*

FIGURE 3.26. (BOTTOM RIGHT) *The Wolverine Mine, from A Portfolio of Wyoming Views*

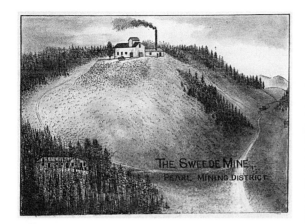

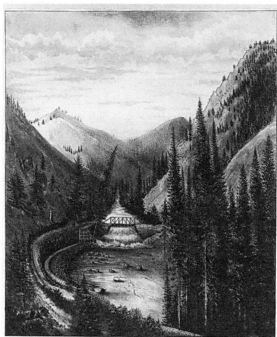

FIGURE 3.27. (TOP LEFT) *The Sweede Mine.* Courtesy, Department of State Parks and Cultural Resources, Wyoming State Museum, Cheyenne.

FIGURE 3.28. (RIGHT) *Dam at the Head of the Pipeline.* Courtesy, Department of State Parks and Cultural Resources, Wyoming State Museum, Cheyenne.

FIGURE 3.29. (BOTTOM LEFT) *Cabin of M. Hanley, Purgatory Gulch,* from *A Portfolio of Wyoming Views*

An examination of the mining illustrations shows that Houghton placed all the operations in their mountainous surroundings. The accompanying captions reveal that the artist produced a geographic sampling from throughout the districts, with mines from Pearl, Elk Mountain, the Medicine Bows, Hog Park, and the Sierra Madres. His sketch of the famous Ferris Haggarty Mine was not included, but Houghton did have a photograph of it. Further, in most of the drawings he made people and their structures much smaller than the surroundings, suggesting the power of nature. On close inspection, however, nearly all the scenes show smoke billowing from the stacks, indicating that man is at work, transforming nature into commodity. Just how small these operations actually were also becomes apparent, with never more than a few people depicted

in any one scene. Finally, many of these sketches are the only known images of these sites, reminding us of their historical significance as primary visual sources.

Houghton also included six bird's-eye view drawings of the area's towns, including his sketches of Battle, Saratoga, Dillon, and Grand Encampment (see figures 3.2, 3.7, 3.15, and 3.19) plus new ones of the mining town of Rambler (see figure 3.30) and Riverside, a small community just north of Encampment (see figure 3.31). The views of Grand Encampment, Saratoga, and Riverside all fall into the traditional bird's-eye view pattern, with their well-defined street grids, business blocks, residential areas, utilities, and other elements—suggesting an orderly mastery over nature, though Riverside with its one main street is quite a bit smaller than Encampment. Conversely, Houghton depicted the mining camps of Dillon, Rambler, and Battle as all roughly hewn from the wilderness that surrounds them. At the same time, the presence of people and horse teams indicates work while the false fronts suggest an air of civilization and permanence. But like the mines, many of these camps were short-lived, so these images are important as visual primary documents of this time and place.

Town views that first appeared in *A Portfolio of Wyoming Views*

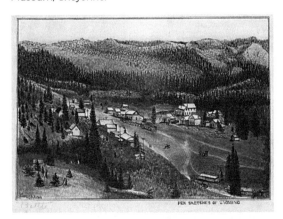

Houghton also included ranches of the Upper North Platte Valley in his book. He had been sketching and painting such scenes around the state since the early 1890s. For the book, he included the *Ranch of A. H. Huston* (see figure 3.32), the *W. H. Wolfard Ranch* (see figure 3.33), *The Big Creek Ranch* (see figure 3.34), *Ranch of D. Frank Crout* (see figure 3.35), *George R. Brown's Ranch* (see figure 3.36), the *Reverend H. Charles Dunsmore's Ranch* (see figure 3.37), and *Andrew Olson's Ranch* (see figure 3.38). A

glance at these illustrations shows them to be typical Houghton ranch drawings, featuring both the nearby landscapes and the physical buildings themselves. All of them show cowboys and cattle as well as the fencing and efforts to raise feed typical of the post–Open Range period. The lack of clutter and broken-down machines or buildings hints at Houghton's boosterism.

Ranch views from *A Portfolio of Wyoming Views* (FIGURES 3.32–3.38)

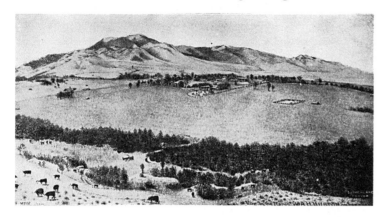
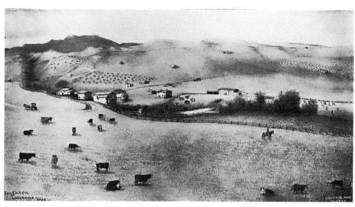
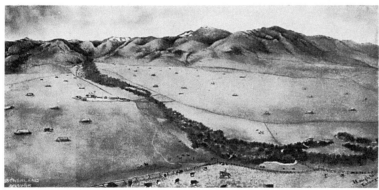

FIGURE 3.32. (TOP LEFT)
Ranch of A. H. Huston

FIGURE 3.33. (TOP RIGHT)
W. H. Wolfard Ranch

FIGURE 3.34. (BOTTOM LEFT)
The Big Creek Ranch

FIGURE 3.35. (BOTTOM RIGHT)
Ranch of D. Frank Crout

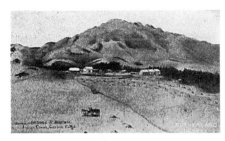

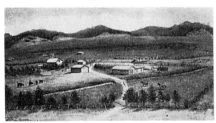

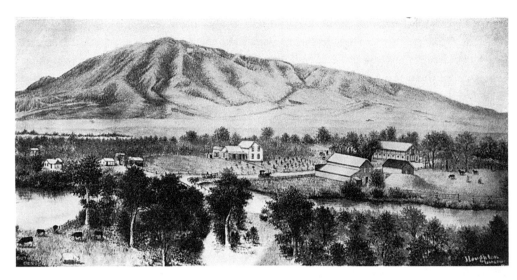

FIGURE 3.36. (TOP LEFT) *The Ranch of George R. Brown*

FIGURE 3.37. (BOTTOM LEFT) *Dr. Dunsmore's Ranch*

FIGURE 3.38. (RIGHT) *Andrew Olson's Ranch*, at the current location of the town of Elk Mountain

As his advertisement had suggested, Houghton also included animal portraits in *A Portfolio of Wyoming Views*. For the most part, these were domesticated animals including sheep and cattle, such as the sketch of *Duke, a Prized Hereford* (see figure 3.39), which included the animal's registration number, and *The Sheepherder's Home* (see figure 3.10), which showed a sheep dog and was situated above a poem about a sheepherder's life. His animal images also juxtaposed wild nature with domestic life, as in the drawing *Sheep Bridge / Mountain Sheep*, in which a sheepherder and his dog are moving a band of sheep across a mountain stream using a wagon bed that has been placed in the water on half of the sketch while on the other a band of wild mountain sheep make their way up a crag (see figure 3.40). Likewise, *An Unexpected Storm* (see image with a different name in the portfolio, plate 49) is a remake of *The Early Storm, 1903*, showing a cow and calf caught in an early- or late-season high-country blizzard. All of these portraits hint at the imposition of new valuable stock into Wyoming. Perhaps the most interesting is *Antelope in Pass Creek Basin* (see figure 3.41), which shows four pronghorn (antelope) Houghton had sketched north of Saratoga in 1895. Although the animals are virtually lifelike in the sketch, what makes them interesting is Houghton's caption, which reads "At present the basin is occupied by valuable stock ranches, and antelope have disappeared." Although all of the animal portraits hint at settler colonialism—the takeover of nature by an exotic—this one explicitly suggests that the beautiful wild animals shown in this sketch are gone and have been replaced by more valuable, domestic ones.[24]

Animal portraits first appearing in *A Portfolio of Wyoming Views*

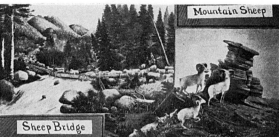
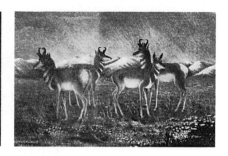

Houghton also included drawings of a local timber company and a few other local businesses. His two lumber sketches focus on the workings of the Carbon Timber Company, which was owned by Andrew Olson, whose ranch Houghton also included. In the first view, the artist pictured the company headquarters as a bucolic camp of about ten log buildings set in a forest opening, with several horses grazing nearby (see figure 3.42). But in the second scene, *Fort Steele Tie Loading Plant of the Carbon Timber Company*, Houghton captured a stunning view of men at work (see figure 3.43). In this sketch, set east of Rawlins where the Union Pacific intersected the North Platte, a dozen men capture logs that have been floated down the river to a boom and then move them up a ramp to other men who load them onto a series of train cars. In the distance can be seen the railroad bridge over the Platte and the remains of Fort Fred Steele.

Houghton also included four area businesses, presumably book sponsors, including *Peryam's Hotel* (see figure 3.44) and *The E&H Building* in Encampment (see figure 3.45) and *Richmond's Livery Feed and Sale Stable* (see figure 3.46) and *The Hotel Wolf* in Saratoga (see figure 3.47). These drawings are similar to ones in his 1891 *Wyoming Illustrated* newspaper because they are basically close-cropped portraits of the businesses alive with customers. Three are of area hotels and the other is of a livery company, not surprising given Houghton's extended travels.

FIGURE 3.39. (LEFT) *Duke, a Prized Hereford*

FIGURE 3.40. (MIDDLE) *Sheep Bridge / Mountain Sheep*

FIGURE 3.41. (RIGHT) *Antelope in Pass Creek Basin*

Other businesses pictured in *A Portfolio of Wyoming Views*

FIGURE 3.42. *Head-quarters of the Carbon Timber Co. on the Grand Encampment.* Courtesy, Department of State Parks and Cultural Resources, Wyoming State Museum, Cheyenne.

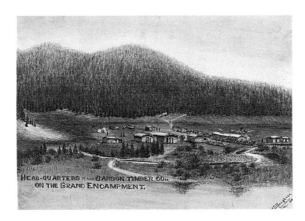

FIGURE 3.43. *Fort Steele Tie Loading Plant of the Carbon Timber Company,* from *A Portfolio of Wyoming Views*

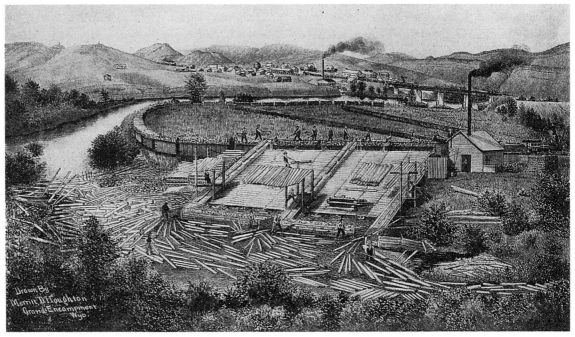

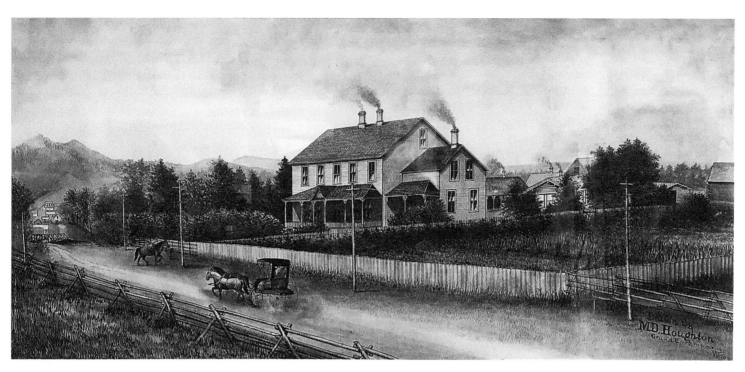

FIGURE 3.44. (ABOVE) *Peryam's Hotel in Encampment*. Courtesy, Grand Encampment Museum, Encampment, WY.

FIGURE 3.45. (LEFT) *The E&H Building* in Encampment is one of the few surviving buildings from Houghton's time. From *A Portfolio of Wyoming Views.*

FIGURE 3.46. (RIGHT) *Richmond's Livery Feed and Sale Stable*, Saratoga. From *A Portfolio of Wyoming Views.*

Finally, Houghton included a miscellaneous assortment of western scenes that appear to be simply space fillers but also reflect the artist's deeper understanding of print media. First, he included three vignettes of western life including a cowboy, a cabin and horse, and a watering hole. Second, he included four historiated letters, or drop caps—large single letters that begin a paragraph and include an embedded illustration. Such features go back to the illuminated manuscripts of the Medieval period and show not only Houghton's creativity and western focus—a cow, a longhorn, a wolf, and a cowboy—but also his cultural awareness of his craft.

Vignettes and historiated letters from *A Portfolio of Wyoming Views*

LEFT TO RIGHT:

FIGURE 3.48. A cowboy vignette

FIGURE 3.49. A miner's cabin vignette

FIGURE 3.50. *A Watering Hole* vignette

FIGURE 3.51. The historiated letter "O"

FIGURE 3.52. The historiated letter "C"

FIGURE 3.53. The historiated letter "W"

FIGURE 3.54. The historiated letter "T"

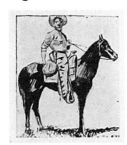

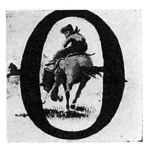

A *Portfolio of Wyoming Views* enjoyed quick success and encouraged Houghton to create a second, larger volume as quickly as possible. Advertisements for this new version appeared within two weeks of *A Portfolio*'s release, suggesting that it would be printed by summer 1904 and be "much superior to the first edition." Six weeks later, the *Saratoga Sun* said the first book was still "selling like strawberries at a church fair in December" and had sold nearly its entire 1,000 copies. By June, it was completely sold out.[25]

Houghton was soon back in the field making new drawings for the second book. In February, the *Laramie Republican* suggested that Rawlins would be included in the new edition and in April, the paper stated that Houghton was at work sketching the tie camp. In May, the *Grand Encampment Herald* wrote that the artist was thinking about creating a relief map of Colorado's Pearl Mining District "if he can secure sufficient financial support to warrant his putting in the time necessary to get out a map of that character." As of June, the *Herald* reported that the artist had "completed several pieces of pen work," which he left at the Bohn Hotel for people to see and to drum up business for the second volume.[26]

On July 1, the *Herald* ran an illustration of the Fort Steele tie operation from the first book and reported that Houghton's second edition would be out soon. The paper recapped the story that Houghton had sold all 1,000 copies of the *Portfolio* and promised that the "new book will contain many new pictures, illustrating the mining, agricultural, and other resources of southern Wyoming, together with pictures of town, etc." It

FIGURE 3.55. Houghton's advertisement for his second book appeared in the *Grand Encampment Herald* just two weeks after his first book became available. Courtesy, Wyoming Digital Newspaper Collection.

reported that "Mr. Houghton is busy making drawings for the new work" and that the artist planned to triple his production and print 3,000 copies of the second book.[27]

By this point, Houghton had been at work on the new edition since January, yet no new stories emerged after July 1 about him making new sketches. Indeed, only a few reports about Houghton appeared that summer and fall. The *Rawlins Republican* stated that he was visiting there on September 10.[28] Meanwhile, the *Grand Encampment Herald* continued running advertisements for the second edition.[29] Then, in late October, the paper said the artist was back home in

Laramie where the *Boomerang* reported that he had been nominated to run on the Prohibitionist ticket for the office of Albany County surveyor.[30] Recall that Houghton had first appeared in 1880 on the Republican ticket, had switched to the People's Party in the 1890s, and now was running on the Prohibitionist ticket in 1904. The following week the paper noted that Houghton was certain to satisfy the people as county surveyor because he was "well and favorably known in the county."[31] But it was not to be. Houghton lost again, finishing a distant fourth after gaining only 64 votes of the 2,330 cast.[32] Interestingly, the same day the election results appeared, the *Saratoga Sun* noted that Houghton, "the artist, who is engaged with illustrating and advertising this country," had passed through that city on his way to Encampment, where his second book was ready for release.[33]

On November 11, 1904, *Views of Southern Wyoming: Copper Belt Edition* became available and area editors praised it. The *Grand Encampment Herald* told its readers that "everyone who takes pride in the Encampment district should assist" in selling the book. It reminded them that although the book sold for one dollar, Houghton offered lower prices for bulk purchases. The *Herald* concluded that the volume was much improved and that copies were "going fast."[34] On November 24, the *Saratoga Sun* described the book as "much larger and more complete" than the earlier version and a "work of rare value," not only as a souvenir but "as an advertisement of delightful resorts, wonderful resources, and development of this new country." The paper stated that the book focused on

mines "both developed and undeveloped," towns, and ranches and was "interspersed with catchy little side pictures which portray western life among the miners and cowboys." The paper noted that neighboring Colorado got behind its authors and urged its Wyoming readers to "take hold and push this thing. Mr. Houghton is engaged in excellent work and should be encouraged by the hearty patronage of everyone in this section of Wyoming."[35]

Regional papers concurred. A few days later, the *Rawlins Republican* noted that the artist was distributing copies of the second book there and called it a "very handsome piece of work. His sketching is of the highest order and all of his views show the rugged hills perfectly." On December 1, the *Wyoming Industrial Journal* in Laramie agreed, suggesting that "if you wish to send your friends . . . a worthy present regarding Wyoming you could certainly send them nothing finer than this work of art." Ads for the book continued to run through the 1904–1905 holiday season.[36]

A closer examination of the second book shows that although the project did include some new images, a fair amount was repetition. More specifically, the artist duplicated seventeen sketches from the first book, including three of the first four images: *Grand Encampment, Andrew Olson's Ranch,* and *Fort Steele Tie Loading Plant of the Carbon Timber Company.* Other drawings making a second appearance included *The Wolverine Mine, The New Rambler Mine,* and *The Mohawk Mine* as well as several of his vignettes. Also, whereas the first book contained the foldout map of the Encampment mining district, the new book

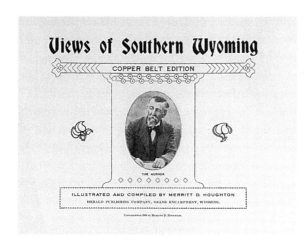

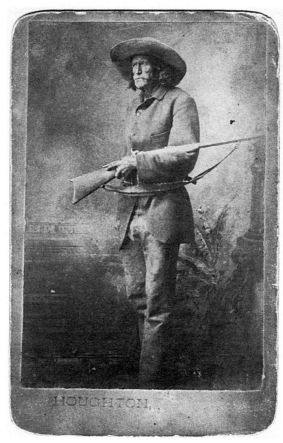

FIGURE 3.56. (LEFT) The cover of Houghton's second book included one of only two known photographs of the artist. From *Views of Southern Wyoming: Copper Belt Edition*.

FIGURE 3.57. (RIGHT) Houghton included this photograph of mountain man Jim Baker that he had taken in Rawlins in 1879. Courtesy, Department of State Parks and Cultural Resources, Wyoming State Archives, Cheyenne.

contained two more traditional bird's-eye views of the Battle Lake and Jack Pot mining areas. Conversely, the new book featured an original photograph of Houghton on the inside cover, one of only two known images of the man (see figure 3.56). It also included a photograph of the mountain man Jim Baker (see figure 3.57), who had posed in Houghton's Rawlins studio in 1879. A closer look at the new sketches Houghton included in *Views of Southern Wyoming: Copper Belt Edition* reveals more about the artist and the fate of the Encampment copper boom.

As in the first book, mining properties figured prominently in the second publication, and Houghton included a dozen new sketches. Most notably, the artist featured his sketch *The Ferris Haggarty Mine* (see figure 3.4), which was the center of the district and the beginning of the great aerial tramway. He had included a photo of this location in the first book, but his drawing was the clearest indication of its ongoing prosperity, with multiple buildings in use, over-cut hillsides, and smoke belching from its stacks. Interestingly, for a book with Wyoming in its name, Houghton featured an entire page devoted to Colorado's Pearl Mining District, with its industrial portrait sketch of *The Pearl Smelter* (see figure 3.58), as well as drawings of two area mines, *The Big Creek Mine* (see figure 3.59)

and *The Big Horn Mine* (see figure 3.60), both fairly typical Houghton sketches. Additional mining illustrations included *The Ben Hur and Black Foot Mines* (see figure 3.61), *The Independence Mining Company* (see figure 3.62), *The Evening Star Mine* (see figure 3.20), *The Magpie Mine* (see figure 3.63), *The Montezuma and the Almeda Mines* (see figure 3.64), *Jack Pot Mining and Milling Company property* (see figure 3.65), and *The Pluto Mine* (see figure 3.66). Houghton also repeated images of *The Wolverine Mine* and the *Cabin of M. Hanley, Purgatory Gulch* (see figures 3.26 and 3.29). Beyond the Ferris Haggarty and perhaps the New Rambler properties, none of the mines included in the second book ever accounted for much. Houghton

took a broad view of all of them, encompassing the mountains and forests surrounding them to the point that in a few, such as the *Big Creek*, the *Montezuma and the Almeda*, and the *Pluto Mine* sketches, one must look closely to see any human-made objects. For the Jack Pot property, Houghton noted in his caption that the drawing was made prior to the erection of any buildings. As promotional drawings most likely made on subscription by the mine owners, these seem instead almost like illustrations made for the US Forest Service because so little development is shown. But because many were so short-lived and these might be the only images depicting them, it makes their historical significance even greater.

FIGURE 3.58. (LEFT) *The Pearl Smelter, from Views of Southern Wyoming: Copper Belt Edition*

FIGURE 3.59. (RIGHT) *The Big Creek Mine, from Views of Southern Wyoming: Copper Belt Edition*

Mine drawings from *Views of Southern Wyoming: Copper Belt Edition* (FIGURES 3.58–3.66)

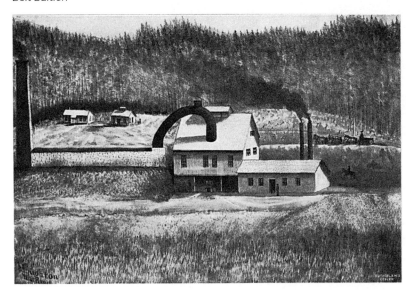

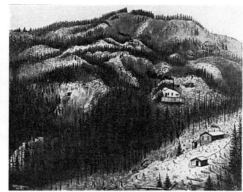

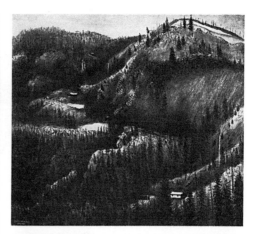

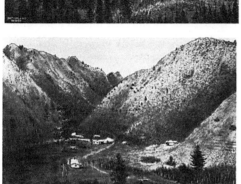

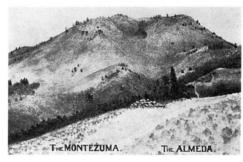

THE MONTEZUMA. THE ALMEDA.

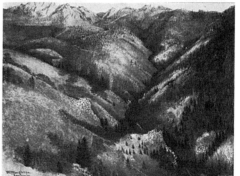

FIGURE 3.60. (TOP LEFT) *The Big Horn Mine, from Views of Southern Wyoming: Copper Belt Edition*

FIGURE 3.61. (TOP CENTER) *The Ben Hur and Black Foot Mines, from Views of Southern Wyoming: Copper Belt Edition*

FIGURE 3.62. (TOP RIGHT) *The Independence Mining Company, from Views of Southern Wyoming: Copper Belt Edition*

FIGURE 3.63. (MIDDLE LEFT) *The Magpie Mine, from Views of Southern Wyoming: Copper Belt Edition*

FIGURE 3.64. (MIDDLE CENTER) *The Montezuma and the Almeda Mines, from Views of Southern Wyoming: Copper Belt Edition*

FIGURE 3.65. (MIDDLE RIGHT) *Jack Pot Mining and Milling Company property, from Views of Southern Wyoming: Copper Belt Edition*

FIGURE 3.66. (BOTTOM RIGHT) *The Pluto Mine, from Views of Southern Wyoming: Copper Belt Edition*

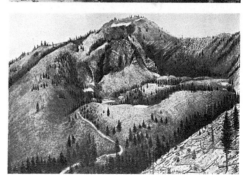

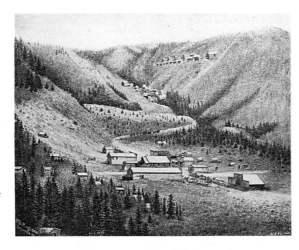

FIGURE 3.67. (RIGHT) *Sketch of Dillon, 1903, from* A Portfolio of Wyoming Views

FIGURE 3.68. (BELOW) *Sketch of Dillon, 1904, from* Views of Southern Wyoming: Copper Belt Edition

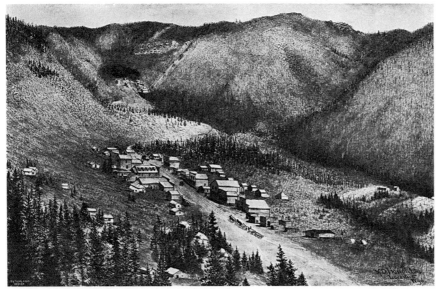

Houghton's six bird's-eye pen sketches of area towns are also historically significant. As in his first book, the artist started the second one with his illustrations of *Bird's-Eye View of Saratoga, 1898* and *Grand Encampment* (see figures 3.7 and 3.18). He did update his view of *Dillon, Wyoming, in 1903,* using the same vantage point as his earlier view but with a slightly wider angle to show the many buildings added to the community. When compared side by side, the images represent a "before-and-after" documentation of the town.

Houghton also recycled views of *Laramie* and *Riverside* (see figures 2.58 and 3.31) and produced a new sketch of *Wolcott,* the nearest—and tiny—railroad station on the mainline Union Pacific to Encampment. For this small station, usually spelled Walcott (see figure 3.69), Houghton added a paragraph explaining that this location handled as much freight of copper going out and goods coming in as a city of ten thousand. Such a statement was needed because Houghton's view showed little more than a smattering of buildings hugging the railroad against a backdrop of sage-covered hills. Small structures, a few windmills, a train or two, and several horse teams can be seen, but no people are shown. When the Saratoga and Encampment Railway was finally completed in 1908, it connected to the Union Pacific at Walcott.

Rather than a foldout topographical view, Houghton included in his second book a two-page drawing of *The Battle Lake Basin* with the rather pedestrian description "A Pleasant and Interesting Spot in the Sierra Madre Mountains of Wyoming." This view (see figure 3.70) looks to the south to Battle Lake almost

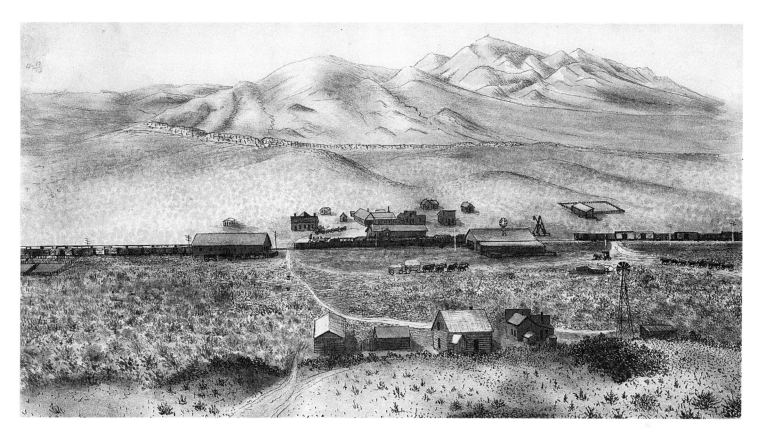

from today's Wyoming State Highway 70. Houghton labeled the town of Rambler as well as mining properties, including the Doane, Rambler, Cuprite, Axis, Portland, Big Divide, Last Fraction, and Umslopogus (the Zulu king from writer's H. Rider Haggard's 1892 book *Nada the Lily).* A horse and buggy, representing his own conveyance, can be seen plying the road at left. The effects of all this activity are evident in the cutover forests.

One of the biggest surprises in the second book was the inclusion of only one ranch drawing, *The Ranch of Jones and Williams.* Ranch scenes had been one of Houghton's staple businesses for more than a decade, and their absence in *Views of Southern Wyoming: Copper Belt Edition* was probably due to the many mines included and the effort it took to reach them, which left little time to do the same for ranches. Houghton's view of the Jones and

FIGURE 3.69. *Bird's-Eye View of Wolcott,* Wyoming, the nearest station to Encampment, as it appeared in *Views of Southern Wyoming: Copper Belt Edition.* Courtesy, Department of State Parks and Cultural Resources, Wyoming State Museum, Cheyenne.

FIGURE 3.70. *The Battle Lake Basin,* from *Views of Southern Wyoming: Copper Belt Edition*

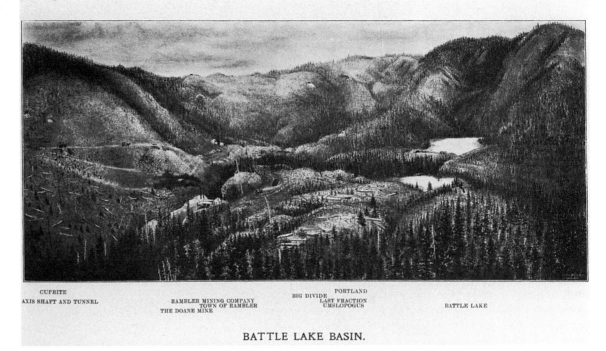

A PLEASANT AND INTERESTING SPOT IN THE SIERRA MADRE MOUNTAINS OF WYOMING.

CUPRITE PORTLAND
AXIS SHAFT AND TUNNEL RAMBLER MINING COMPANY BIG DIVIDE LAST FRACTION
 TOWN OF RAMBLER UMSLOPOGUS BATTLE LAKE
 THE DOANE MINE

BATTLE LAKE BASIN.

FIGURE 3.71. *The Ranch of Jones and Williams,* from *Views of Southern Wyoming: Copper Belt Edition*

Williams property west of Encampment shows the main house at left and the fenced fields and outbuildings spread across Calf Creek's floodplain. The ubiquitous horse and buggy are parked at the gate (see figure 3.71).

Houghton did add another interesting agricultural endeavor in what could best be described as the "other business" category. This scene, labeled *Anderson's Farm Gardens, Grand Encampment, Wyoming* (see figure 3.72), shows a riparian location along the Encampment River above the town where a small commercial garden was kept. Houghton's caption read "the business of market garden in the deep and sheltered canons of the Encampment River is rapidly becoming an

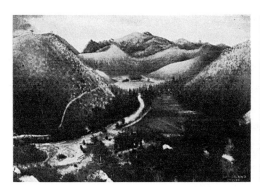

extensive and profitable occupation. Mr. Anderson's farm is one of the picturesque environments of Grand Encampment."

Houghton included just two other new business sketches in his second volume, *The Home and Pole Camp of John Sublette* (see figure 3.73) near today's town of Elk Mountain, which supplied railroad ties and mining timbers, and the recycled *Lumber and Building Department of the W. H. Holliday Company of Laramie*, which he had labeled the *Planing Mills and Lumber Yard of the W. H. Holliday Company, Laramie* in the 1901 *Laramie Republican Industrial Edition*. Both images show men working with teams and wagons moving lumber. Again, like the paucity of ranch drawings, the lack of business sketches might be due to the short turnaround Houghton had for the second book and the travel time needed to do mine drawings.

New animal sketches are also scarce in Houghton's second book except for one tongue-in-cheek drawing of a small donkey eating a copy of the *Grand Encampment Herald*—Houghton's publisher—from a

US mailbox (see figure 3.74). Other repeated animal scenes appear as vignettes, including *Elk in Wooded Country*, *The Sheepherder's Home*, A miner's cabin vignette, and *A Watering Hole* vignette (see figures 3.9, 3.10, 3.49, and 3.50). Photographs of animals do appear in the book, including one of a pet deer and another of horses wearing snowshoes.

One feature that Houghton did expand on in *Views of Southern Wyoming: Copper Belt Edition* is his use of historiated letters. In his first book, the artist included four such drawings, and he created six new ones for the second. Four of them were animal sketches. The drawings included a bucking bronco for the letter "B," a hiker carrying a backpack for "C," a miner with pick for "M," a longhorn steer for "R," a dog herding sheep for "S," and a wolf holding a letter "T" in his mouth. Perhaps their increased presence is simply because they were imaginative illustrations that could be created anywhere at any time rather than specific illustrations of actual places that had to be created after much study in the field.

FIGURE 3.72. (LEFT) *Anderson's Farm Gardens, Grand Encampment, Wyoming,* from *Views of Southern Wyoming: Copper Belt Edition*

FIGURE 3.73. (MIDDLE) *The Home and Pole Camp of John Sublette,* from *Views of Southern Wyoming: Copper Belt Edition*

FIGURE 3.74. (RIGHT) Houghton poked fun at his publisher, the *Grand Encampment Herald,* in this sketch of a small donkey munching on the paper. From *Views of Southern Wyoming: Copper Belt Edition.*

Historiated letters from *Views of Southern Wyoming: Copper Belt Edition*

FIGURE 3.75. (LEFT) The historiated letter "B"

FIGURE 3.76. (MIDDLE) The historiated letter "C"

FIGURE 3.77. (RIGHT) The historiated letter "M"

FIGURE 3.78. (LEFT) The historiated letter "R"

FIGURE 3.79. (MIDDLE) The historiated letter "S"

FIGURE 3.80. (RIGHT) The historiated letter "T"

Viewed collectively, *A Portfolio of Wyoming Views* and *Views of Southern Wyoming* represent the high point of Merritt D. Houghton's illustrating career. In just under two years, the artist created more than sixty new pen sketches, including twenty-three mine drawings, ten bird's-eye views of towns, nine ranch illustrations, ten business portraits, six animal sketches, a handful of western vignettes, and eleven historiated letters. All of this in a two-year period in a climate where travel was severely restricted by heavy snow for at least six months of the year, if not ten. All in all, it was a remarkable achievement for an artist whose work is basically unknown.[37]

In addition, a few existing Houghton sketches of the area around Encampment were not published in either of his books and also need to be mentioned.

First, around 1905, promoters published an illustrated book about the proposed Saratoga and Encampment Railway to entice investors to build a railroad to the Encampment smelter. Although the line was not completed until 1908, the book, *Saratoga and Encampment Railway Company: A Railroad Operated in the Interest of Local Development, Photographic Views and Description of the Upper Platte River Valley*, used several uncredited Houghton illustrations, including an updated sketch of *The Battle Lake Basin* topographical view. This suggests that the artist had actively contributed to the project rather than just letting the promoters use his work. Also included were the bird's-eye views of Saratoga and Encampment and the second Dillon sketch. Mines shown were the Carbondale coal mines and the Copper Giant, Moon Anchor, Big Horn, and

New Rambler Mines. The book also featured Houghton's sketch of the *Carbon Timber Company Headquarters*. The only new image was an unknown mine simply labeled *The Beginning of a Prosperous Copper Mining Camp in the Encampment Copper District* (see figure 3.81). Although the view is unknown, it is a typical Houghton mining sketch, and his initials MD are just visible in the lower right corner. The topographical view of *The Battle Lake Basin*, here simply *The Battle Basin* (see figure 3.82), was essentially the same landscape Houghton used in *Views of Southern Wyoming* but with added features, including new mines named the Ingomar, New Years, Dill, Axis, Rio Tinto, Hercules, Hawkeye, West Virginia, and Wyoming prospects.

Like his two views of Dillon, these "then-and-now" sketches of the Battle Lake region show the growth that occurred over just two years and are important visual documents.

In addition to the railroad promotional book, several unpublished individual Houghton sketches of scenes in and around Encampment have survived to this day. These might have been drawings that he made and then edited out of his publications, or perhaps they were commissioned works that Houghton created and then sold to the property owner, who kept them in private hands. This had occurred before when the artist worked for Coutant and made additional images—both historical and current—for individuals.

FIGURE 3.81. *The Beginning of a Prosperous Copper Mining Camp in the Encampment Copper District.* Courtesy, Department of State Parks and Cultural Resources, Wyoming State Museum, Cheyenne.

FIGURE 3.82. *The Battle Basin.* Author's collection.

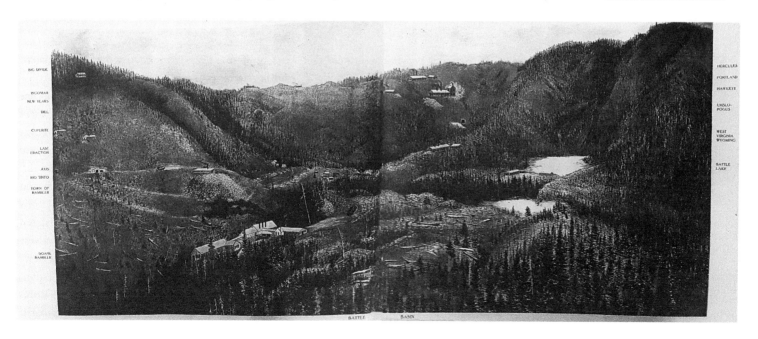

FIGURE 3.83. *Encamp-
ment from the Southwest.*
Courtesy, Department of
State Parks and Cultural
Resources, Wyoming State
Museum, Cheyenne.

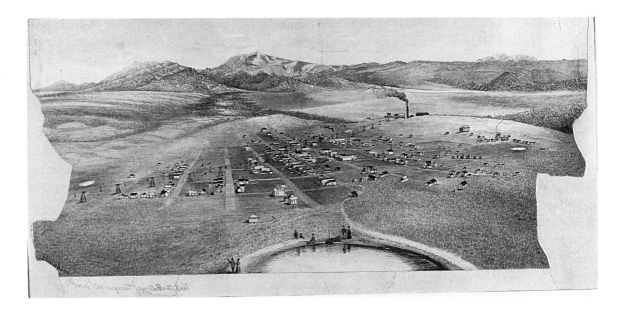

A quick survey of these images provides a glimpse of other places Houghton ventured.

The first is a view of Encampment from the southwest (see figure 3.83), with the focus not on the copper smelter but on a small pond. By simply shifting the focal point, Houghton remade Encampment from an industrial town into a pastoral one. The bucolic pond adds to the picturesque view, as do the background hills, forests, and mountains. Even though the smelter can be seen, it is partially hidden behind a hill, and the tramway seems smaller as it snakes through town. On the streets, no people or wagons are present, though there are several couples, one of which looks to be Merritt and Frances Houghton, around the pond. It almost seems as if it is a Sunday morning in

Encampment, a very different view than the industrial one used in his books.

Five additional views are of communities on the outskirts of the Encampment boom, including three on the west side of the Sierra Madres—Washakie Station (now Wamsutter), Baggs, and Dixon—and two northern Colorado towns: Pearl and Walden. Of these, Houghton labeled the one of Washakie Station *Flocks on the Red Desert* (see figure 3.84). The sketch shows three herds with their attendant sheepherder wagons plus the railroad and a railroad wye. The derricks atop the small structures are for water.[38] Houghton probably visited Washakie Station during a trip to the Sierra Madres because a road from Baggs goes north to this location. It is most likely one of the

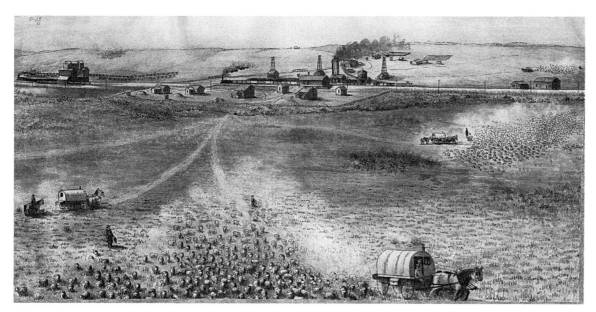

FIGURE 3.84. *Flocks on the Red Desert.* This was known as Washakie Station and is now the small community of Wamsutter. Courtesy, Department of State Parks and Cultural Resources, Wyoming State Museum, Cheyenne.

earliest illustrations of the community that became Wamsutter.

Houghton most likely made his sketches of Dixon and Baggs (see figures 3.85 and 3.86) during the copper boom, as they were also outlier towns, west of the Continental Divide in the Little Snake River Valley, south of Washakie Station. Both are typical of his other town sketches, drawn using a low aerial angle looking toward the main street. They are also probably some of the earliest images of these communities and therefore important documents for historical preservation.

The final town views show two northern Colorado communities on the southern edge of the Encampment boom: Pearl and Walden. Recall that Houghton had visited and sketched mines around Pearl as well

as its smelter in each of his books. Since this illustration is dated 1904, it is unclear why he did not use the sketch in *Views of Southern Wyoming.* Perhaps it made the community seem too sparse, especially if printed small, and so he used other mine views instead. Then again, the artist had hinted in the May 6, 1904, *Grand Encampment Herald* that he might use a topographical image of Pearl in his second book *if* he could "secure sufficient financial support to warrant his putting in the time" to complete it. Perhaps he had completed this sketch but did not get that financial help, so he refused to include it. Regardless, it is an excellent early illustration of this community (see figure 3.87).[39]

Houghton's 1902 view of Walden (see figure 3.88), located about twenty-five miles southeast of Pearl,

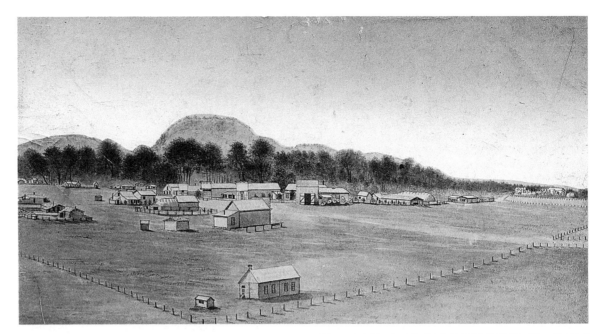

FIGURE 3.85. *Dixon, Wyoming.* Courtesy, Little Snake River Museum District, Savery, WY.

FIGURE 3.86. *Baggs, Wyoming.* Courtesy, Dick Perue/Bob Martin Collection, Historical Reproductions by Perue, Saratoga, WY.

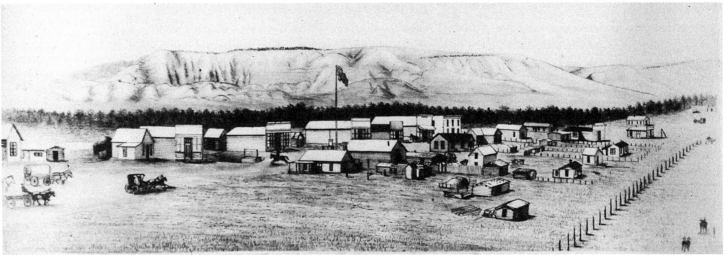

would have been the extreme southern edge of the Encampment copper boom. Walden had been discussed as a station on the Laramie, Hahn's Peak and Pacific Railroad that the artist had been interested in 1901, but the railroad did not actually reach the town and the nearby Coalmont coalfields until 1911. Houghton's 1902 bird's-eye view is one of his best, as it looks down on the small community center and includes the Methodist Episcopal Church, merchants, a windmill, the Mosman Mercantile with its Oddfellows Hall, and several irrigated yards. The remains of a drawn-on compass can be seen in the lower right, a rare occurrence of such a locator on any Houghton sketch.

Two Houghton ranch views from the Encampment area that were not included in either of the books have also survived: *The Vyvey VX Ranch* (see figure 3.89) and *The Toothaker Ranch* (see figure 3.90). Interestingly, both are located east of town in the Beaver Creek area, and both survived through the families that still ranch in the area. They are typical Houghton ranch portraits, looking down on the main houses, outbuildings, and fenced fields with livestock. Unlike his wide-angle scenes, these give a closer view of each house, with the details of the fields smaller in size. In the Toothaker sketch, Houghton included several people who seem to be looking up at the artist as he worked. Oral histories exist with family members who remembered when Houghton visited their ranches and made the illustrations. In a 1983 *Casper Star-Tribune* article, writer Candy Moulton described how her relative, Fox Vyvey, explained that his mother "recalled the artist coming to their ranch to sketch. Houghton sat on a

FIGURE 3.87. *Pearl, Colorado, in 1904.* Courtesy, Department of State Parks and Cultural Resources, Wyoming State Archives, Cheyenne.

PEARL, COLO. 1904.

hill above the main buildings and drew the panorama." Moulton also wrote how neighbor Wilbur Toothaker was only five or six years old when Houghton visited his ranch, and he pointed to the small boy in the drawing and said "that's me." Toothaker described how "Houghton sat on a hill above the ranch buildings and sketched the scene with a pencil. After getting the main elements of the ranch layout, Houghton moved down to the yard to put in detailing, including farm tools and the people, including Toothaker as a small boy. After the picture was done in pencil, Houghton went over it in pen."[40]

Similar to his view of the Anderson Farm Gardens included in *Views of Southern Wyoming* is the surviving Houghton sketch titled *Bird's-Eye View of the South Park Vegetable Gardens, Property of J. J. Wombaker Grand Encampment, Wyo.* In a charming article that appeared in the August 15, 1902, issue of the *Grand Encampment Herald* under the headline "The Vegetable Man," it was explained that Wombaker's 100 acre ranch was less than a mile from town at the junction of the North and South Forks of the Encampment River but hidden by hills. It

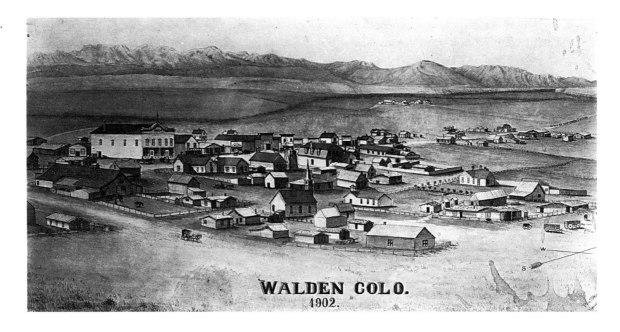

FIGURE 3.88. *Walden, Colo., 1902.* Courtesy, Special Collections, Denver Public Library, Denver, CO.

WALDEN COLO.
1902.

seems that Wombaker came to the area during the 1899 gold rush and settled on his ranch. He cleared trees and planted radishes, lettuce, cabbage, beans, peas, turnips, parsley, spinach, pumpkins, squash, cucumbers, beets, celery, and potatoes. He used a sub-irrigation system that allowed water to seep from a pond on his property into the fields, assuring the right amount for each crop. The article concluded that in 1901, Wombaker grew thirty-five tons of vegetables; his gardens were a "welcome sight from the big hills surrounding it" and an "oasis in the desert" (see figure 3.91).[41]

Houghton's view captures this sense and the garden's relationship to Encampment and its industry. His sketch looks north over the gardens, with the barren hills framing the verdant farm. The town of Encampment spreads across a hill in the distance, and the smoke from the smelter billows from a barely visible stack—a constant reminder of why the town is there.

If Walden was the southern edge of Houghton's travels, the Elk Mountain area was the northern one. In his two books, Houghton included views of the *Fort Steele Tie Loading Plant of the Carbon Timber Company* and *Andrew Olson's Ranch*, in the small community of Elk Mountain. Olson, a Norwegian immigrant, was also the owner of the Carbon Timber Company. Two additional ranch sketches have survived, *View on the Ranch of Haglund Brothers, Carbon County, Wyo.* and *View of the UL Ranch*. The Haglunds were two Swedish

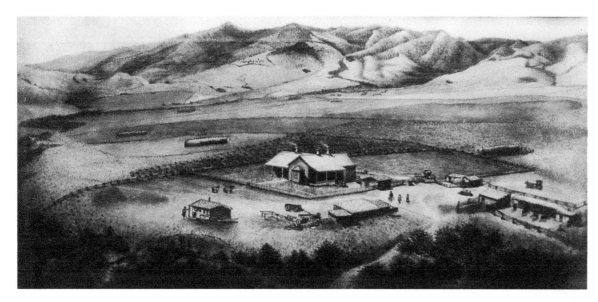

FIGURE 3.89. *The Vyvex VX Ranch* east of Encampment. Courtesy, Betty M. Vyvey, Encampment, WY.

FIGURE 3.90. *The Toothaker Ranch.* Courtesy, Candy Moulton, Encampment, WY.

FIGURE 3.91. *Bird's-Eye View of the South Park Vegetable Gardens, Property of J. J. Wombaker Grand Encampment, Wyo.* Courtesy, Grand Encampment Museum, Encampment, WY.

immigrant bachelor brothers, Erick and Hans, who also worked in timber and had a ranch just south of Olson's. Houghton's sketch of this ranch—preserved at the Carbon County Museum in Rawlins—shows the river in the foreground, a handful of buildings with cattle grazing about, and Elk Mountain looming in the distance. Englishman Edward Cheeseborough started the UL Ranch in 1885 on Pass Creek Road, just three miles southwest of the Haglund brothers' place. He had first settled at Carbon, so perhaps he knew Houghton from there. The artist's view shows Elk Mountain from the southeast, with the houses and barns in the center and a band of sheep on the foreground hill.[42]

The final surviving sketch not included in any period publication is a topographical illustration of the El Ray mining region near Encampment (see figure 3.94). What makes this drawing most interesting, and a fitting conclusion for this chapter, is that in addition to showing the usual mining scene of forest, hillsides, and a few buildings, Houghton placed himself at work on a hill overlooking the scene. Indeed, in

the only known image of the artist at work, we can see a man wearing a hat sitting on a rock, sketching the scene before him.

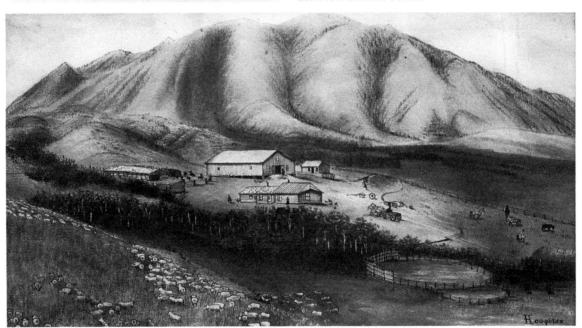

FIGURE 3.92. *View on the Ranch of Haglund Brothers, Carbon County, Wyo.* This ranch was just south of the town of Elk Mountain, with the Medicine Bow River in the foreground and Elk Mountain looming in the distance. Courtesy, Carbon County Museum, Rawlins, WY.

FIGURE 3.93. *View of the UL Ranch.* Author's collection.

VIEW ON THE RANCH OF HAGLUND BROTHERS, CARBON CO. WYD.

Although these last sketches were not included, *Views of Southern Wyoming: Copper Belt Edition* continued to be sold through the winter and spring of 1905 in the Encampment and Saratoga newspapers. On January 5, the *Saratoga Sun* ran a large advertisement that promoted the book's boosterism under the heading "Advertise Wyoming": "The Resources of Southern Wyoming are strikingly set forth in the second edition of views just published by Merritt Dana Houghton. This edition is much larger and more elaborate than the first and will be a much-appreciated souvenir by your eastern friends. You cannot find a better means for advertising your state than to distribute a few of these books."[43]

Likewise, the *Grand Encampment Herald* published a small ad in January 1905 that described the book as "forty-four pages of pictures of the mining district," while a larger ad that ran until mid-April noted that it sold for a dollar per copy, but there was a "special discount in lots of 25 to 100 copies." It also suggested that the book "makes a handsome holiday present." The long sales time—unlike the first edition, which sold out in weeks—could be accounted for because of slumping copper prices, the region's limited market, and simply because Houghton had printed 3,000 copies of the second book—three times the number of the first volume.[44]

On November 26, 1904, the *Rawlins Republican* reported that "Mr. Houghton is going to the north part of the state where he has a number of engagements for work and will be absent for several months."[45] Indeed, by late spring 1905, Houghton was at work in Wheatland and then further north in Buffalo and the Sheridan area, making bird's-eye views of several of the small communities in the region. Within another year, he and Frances left Wyoming for new horizons in Montana, Idaho, and, eventually, Spokane, Washington, where they resettled in 1908.

Houghton never explained his reasons for leaving Encampment, but one has to suppose that he simply ran out of work. After all, since arriving in the Upper North Platte Valley in the summer of 1902, he had completed more than seventy sketches, written and compiled two books, and traveled hundreds of miles through very tough terrain. Perhaps as well, the deteriorating copper market had dried up demand for

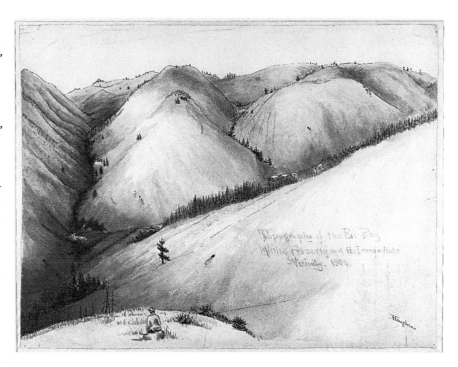

sketches of new properties. Indeed, copper prices had fallen in 1902, and mining company owners were "showing signs of pessimism" by October 1903. The great smelter was sold in late 1904 and its assets were auctioned off at prices below the new company's needs, furthering the decline. As someone dependent on new prospects that he could boost through his sketches, perhaps Houghton sensed the trouble ahead and began making arrangements for future work elsewhere. The Encampment boom had been a boon to Merritt Dana Houghton, but his future looked to new horizons to the north.[46]

FIGURE 3.94. *Topography of the El Ray Mining Property and Its Immediate Vicinity, 1904.* Courtesy, Department of State Parks and Cultural Resources, Wyoming State Museum, Cheyenne.

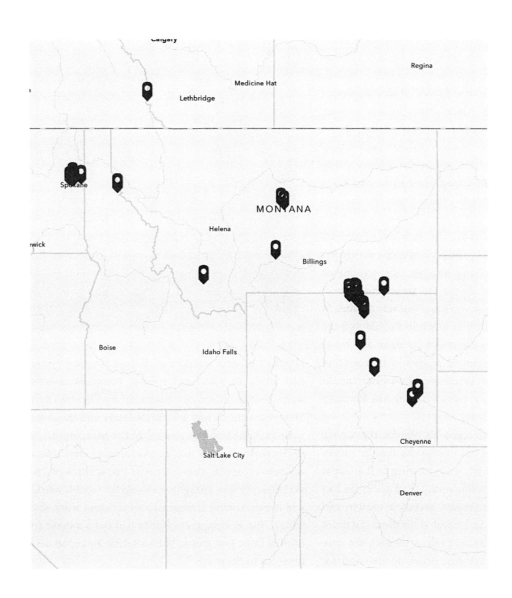

MAP 4. Houghton sketch
locations, 1905–1915

By late 1904, Merritt Dana Houghton had been in Wyoming for almost thirty years. He had taught school, worked as an itinerant photographer, run unsuccessfully for several political offices, and started a monthly newspaper that lasted one issue. He also worked on his own across the southern half of the state as an artist sketching ranches and historical sites for a history book. He then taught school again before working feverishly over an eighteen-month span—traveling hundreds of miles through rough terrain, sketching, researching, and eventually producing two small, illustrated books about the Encampment copper boom. As prospects there began to wane, Houghton looked first to northern Wyoming to continue his trade but then decided to leave the state. He tried Montana for a while before settling in northern Idaho, where he called for Frances to join him. The couple then moved to Spokane, Washington, arriving during that city's biggest boom, a perfect location for Merritt to continue to make his magical aerial views—this time of the Inland Empire. But unlike Encampment, where he compiled his work into two books, Houghton created no such northern portfolio, so much of his art and life story remains locked in rare newspaper accounts and scattered across the region's local museums, state archives, and individual collections. Unlocking those accounts and finding those sketches is the focus of this chapter.

Houghton's decision to leave his home in Laramie after almost fifteen years began to form when the artist returned from Encampment and Rawlins in late 1904. He had been busy trying to sell the 3,000 copies of his second book, and as winter approached, he settled in with his wife, Frances, in their Laramie home. In January 1905, Frances visited friends in Fort Collins, Colorado, and in late March, she hosted a drawing class by another local artist. It is not clear what Merritt was doing until April because he does not appear in any newspapers and he produced no new sketches. Perhaps, after two years of strenuous work in Encampment, he was simply resting. More likely, he was starting to make contacts for future work that unfolded over the next year. The one time Merritt, or M. D. as he was referred to in the press, appeared in the newspaper was in late April 1905 when his favorite brother, George L. Houghton, the Civil War hero with whom he had once lived and worked in Omaha in the 1870s, stopped with his wife for a visit on their way to Portland, Oregon. According to the story, George had been a resident of the Black Hills of South Dakota for

https://doi.org/10.5876/9781646423668.c004

almost thirty years but had sold everything there and was moving to the coast to pursue new interests, one of which was a special globe he had invented. He showed this to local schools and at the university and was well received. Perhaps seeing his brother again after almost three decades and learning that the sixty-three-year-old was uprooting and moving on to new opportunities inspired the fifty-nine-year-old Merritt to do the same because within two weeks, Merritt headed north, never to work in southern Wyoming again.[1]

Houghton began his new adventure seventy miles north of Cheyenne, in Wheatland. On May 15, he started making his first sketches in two years outside of the Encampment boom area. For this job, Merritt was working for the Wyoming Development Company, a private irrigation enterprise founded by US senator Francis E. Warren and Judge Joseph Carey, among others, to divert water from the Laramie River and Sybille Creek into several large reservoirs and then onto the Wheatland Flats for homesteaders. Irrigation began in 1883, the Cheyenne and Northern Railway reached the area in 1887, and town lots went up for sale in 1894. The town of Wheatland incorporated in 1905, which is perhaps why the company hired Houghton to make his sketch.[2]

In his bird's-eye view, Houghton situated his viewer just east of the railroad and looked down and west across the community toward Laramie Peak to the northwest (see figure 4.1). The artist included the railroad and a developed business district complete with brick buildings. Canal Number Two is visible through the town, and its effect on the land is evident in the

form of distant fields, trees, and grazing cows. Farmers can be seen bringing in heavily loaded wagons, and a new schoolhouse rises at right. Houghton made Wheatland appear to be a neat, orderly community—just as the local newspaper reported when it said the artist was making a "pen drawing of the city, which is to be used by the Development company for advertising purposes."[3]

From Wheatland, on May 29, Houghton traveled sixty miles north to Douglas, where he also did some sketching. Houghton had been through Douglas before, in 1898, when he drew the remains of nearby Fort Fetterman for C. G. Coutant. This time, he completed a "perspective sketch of the city" by June 7 and then left for John M. Carey's SO Ranch at nearby Careyhurst, sixteen miles west. Unfortunately, no Houghton sketch of Douglas or of the SO Ranch is known to exist.[4]

Four days later, Houghton moved again, this time traveling about forty miles west to Casper, where he arrived the night of June 11, planning to stay a few days.[5] As with Douglas, Houghton had been to Casper previously, in 1898 to do a sketch of historic Fort Caspar. According to the *Wyoming Derrick*, this time Houghton was "drawing a picture of Casper, the view taken from the northwest. The picture will be so sketched to show all the buildings in town, and more particularly the business blocks."[6]

Compared to his earlier view of Fort Caspar, Houghton had moved about two miles to the northeast for his bird's-eye view of the city (see figure 4.2). In this sketch, he looks southeast across the North Platte

River to Casper Mountain at the distant right and Laramie Peak on the horizon. The "business blocks" the paper noted run mostly left to right on Center Street. The building at left marked "Laundry" is the Casper Steam Laundry, and the one marked "C & N W" along the tracks is the Chicago and North Western depot. In between, Houghton labeled the Grand Central Hotel, the Natrona Hotel, the Webel Commercial Company, and the Richards & Cunningham Company. The artist also included smokestacks on locomotives and businesses belching smoke into the air.[7]

From Casper, Houghton went 150 miles north to Sheridan, where sometime after Independence Day 1905, the artist began his largest known illustration: a massive 4 foot × 8 foot bird's-eye view of Sheridan. On July 25, the *Sheridan Post* reported in a story titled "A Fine Picture of Sheridan" that "Artist M.D. Houghton has been working the past two weeks making preliminary sketches of every house in Sheridan, and is now engaged in compiling the work into a large design for his picture of the town." The paper then described Houghton's vantage point—and its own viewpoint—when it wrote that "it promises to be a very fine picture. No photographer's camera can give a correct idea of the topography of Sheridan, but when completed Mr. Houghton's picture will convey to the eye a true representation of the appearance of the most beautiful town in the state." The paper congratulated the artist, writing "Mr. Houghton's appreciation of Sheridan's business advantages, its beautiful homes, its flowers and gardens, streams, and natural parks is not wholly from an artist's standpoint, but is the result of

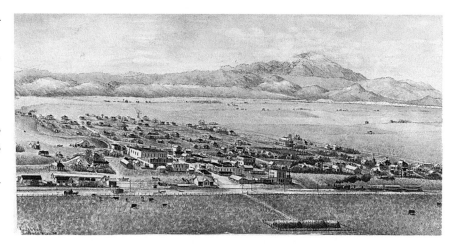

FIGURE 4.1. *Bird's-Eye View of Wheatland, Wyoming, 1905.* Courtesy, Department of State Parks and Cultural Resources, Wyoming State Museum, Cheyenne.

many years' acquaintance with Wyoming towns and western industries."[8]

Bird's-Eye View of Sheridan (see figure 4.3), which today hangs in the Sheridan City Hall and is also available as a reprint on the internet (though incorrectly dated 1906), is truly Houghton's Wyoming magnum opus. This is due not only to its massive size, which leads us to wonder how the artist completed it, but also because of the level of detail he included. By choosing an eastern vantage point, Houghton focused viewers' eyes first on the front range of the Bighorn Mountains that span the distant horizon. From there, Big Goose Creek dominates the image center as it winds its way to the town. Little Goose Creek at the far left and Soldier Creek at right not only frame the sketch, but their convergence in Sheridan also pulls the eye to the center. The town's layout is clearly marked by the grid of streets, which is superimposed on the landscape while the railroad

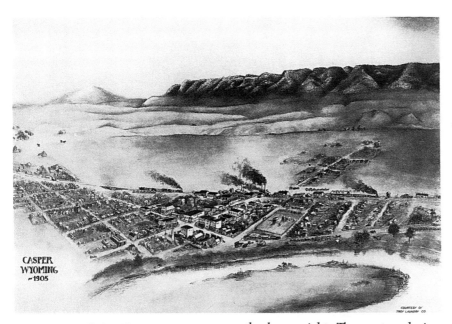

CASPER
WYOMING
~1905

COURTESY OF
TROY LAUNDRY CO

FIGURE 4.2. *Bird's-Eye View of Casper, Wyoming, 1905.* Author's collection.

moves across the lower right. The westward view also highlights facades along Main Street. Local landmarks visible include Fort MacKenzie (today's Sheridan Veterans Administration Medical Center) at the far right, the Sheridan Inn and Depot at lower right, and the Sheridan County Courthouse at the junction of Main Street and Coffeen Avenue at center left. Period landmarks no longer present are also interesting, including the railroad roundhouse at lower right and the baseball field at lower left. Because Houghton made his sketch prior to the construction of John B. Kendrick's Trail End home, its absence among the bends of Big Goose Creek is also noticeable. If in fact Houghton spent two weeks sketching every house in town, then this view should be a guide to the historical preservation of Sheridan residences and neighborhoods. Finally, a close look reveals that Houghton placed himself and Frances, both well dressed, on a hill at bottom center, guiding viewers into the landscape.

In the lower left corner, Houghton signed the piece "Drawn by M.D. Houghton Sheridan Wyo." This description is important because Houghton stayed in Sheridan for a week doing commission drawings. On August 1, the *Sheridan Post* reported that the artist had completed a "fine pen picture" of E. C. Williams's brick yard and of Sim H. Smith's trout farm. Both views were on display in store windows in town, and the paper noted that Houghton was "open to engagements from private parties who wish sketches made of their ranches, business houses or homes." The paper further praised him as having "the artistic talent to transfer to paper a true representation of the landscape such as no photographer's camera can produce." It noted that his prices were "very reasonable" but urged that anyone who wanted pictures should act soon because he would not remain in town very long.[9]

Although Merritt included his wife in the Sheridan panorama, Frances Houghton remained in Laramie while her husband traveled north. Newspaper accounts from the time note that she hosted a surprise birthday party for one of her social groups on August 1, attended a reception on September 2, and went to a meeting of the Woman's Missionary Society of the Laramie Union Presbyterian Church on September 23, where she agreed to give a talk the following March on "Far Formosa."[10]

While his wife participated in society events back in Laramie, Merritt continued to travel and sketch in northern Wyoming. Two weeks after advertising to draw whatever Sheridanites wanted, Houghton appears to have traveled back to Douglas, where the August 16 newspaper advertised that it was selling large photographic prints of his sketch of that community for fifteen cents each. There is no mention of him anywhere in the state again until October 26, when the *Guernsey Gazette* reported that the artist was there. Although this original also has not been found, a drawing based on it appeared in the *Wyoming Industrial Journal* in the summer of 1907 (see figure 4.4). The rough copy shows the town's main street, its railroad connections, and the North Platte River and surrounding hills. Finally, the *Buffalo Voice* reported on December 16 that Houghton, "an artist of ability," had completed a "pen picture of the city of Buffalo, which is being very much admired by the people generally." It noted that the artist had "gotten out a number of illustrated views representing various sections of Wyoming scenery."[11]

This view of Buffalo (see figure 4.6) is special to me because it was the first Houghton sketch I saw. Recall that Houghton had practiced photography in Buffalo in the 1880s. Like his view of Sheridan, this one takes a vantage point above the hills to the east and looks west to the main street, with Cloud Peak and the Bighorn Mountains in the distance. He has also placed well-dressed images of himself and Frances at bottom center, in this instance with him holding up a walking stick, visually guiding us to look at the scene. Notable

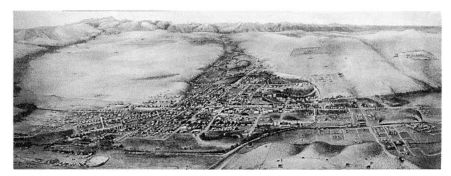

FIGURE 4.3. *Bird's-Eye View of Sheridan, Wyoming, 1905.* Author's collection.

in the view is the winding course of Clear Creek as it cuts through town and the imposition of the grid upon the undulating terrain. The business district is clearly visible, as are churches, a school, houses, and fenced ranges to the west.

Houghton seemed to have remained at work in the northern part of the state in the fall and winter of 1905–1906. There is no known correspondence between him and Frances or any mention of him in the papers there. On the contrary, there are several undated, unpublished surviving sketches of northern Wyoming locales, which suggests that he might have stayed in the area after finishing his Sheridan sketch in mid-July. Records indicate that he completed the

FIGURE 4.4. This simplified sketch of Guernsey appeared in a 1907 issue of the *Wyoming Industrial Journal.* Courtesy, Wyoming Digital Newspaper Collection.

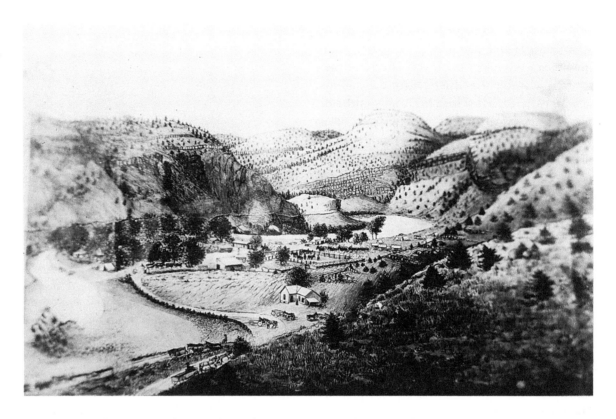

Guernsey sketch in late October and the Buffalo drawing in early December, as well as the Sheridan County Courthouse and another of the "Great Western Hotel" in downtown Sheridan by January 19, 1906.[12] There are also at least seven surviving additional illustrations from locales from Guernsey north, which, combined, could account for this time. Further, Houghton often signed his sketches with the locality in which he was working; many of his Encampment drawings listed that locale rather than his home in Laramie. Likewise, most of these northern sketches are signed "Sheridan" rather than "Laramie." Finally, news accounts from beyond January 1906 place him even further north, in Montana, so it seems logical that these other northern Wyoming sketches are from this period. Moving from south to north, these illustrations include the small community of Fairbanks near Guernsey, the famous Hole in the Wall of Butch Cassidy fame west of Kaycee, and the Munkers coal mine near Buffalo. Closer to Sheridan, there are bird's-eye sketches of the two

small ranching hamlets of Big Horn City and Dayton and the coal towns of Dietz and Monarch. Finally, there are two sketches of Sheridan-area fish hatcheries. A look at these various images provides a glimpse into what the artist was doing in late 1905 and early 1906.

Houghton's views of Fairbanks and Hole in the Wall look as much like ranch drawings as community illustrations. Fairbanks, located about a mile east and downriver of where the Guernsey Dam is now, was a small ranching and mining community with a short-lived copper smelter. Houghton's view shows the North Platte River snaking through sparsely wooded hills. A team pulling a wagon can be seen at lower center as well as several small ranches in the river bottoms (see figure 4.5).

Hole in the Wall would have been known in Wyoming in 1905 because of the infamous Hole in the Wall gang of cattle rustlers that used the box canyon west of Kaycee as its hideout. Houghton's sketch shows several cows grazing in the near field as a man drives a wagon toward a small ranch. Another man can be seen on a horse in the distant right. Rather than a rustler's escape, Houghton's image with its small fields and deciduous trees looks more like a small homestead (see figure 4.7).

Houghton used a wide angle to sketch the hamlet of Big Horn City and the Little Goose Creek. Located nine miles southwest of Sheridan, Big Horn City is the route into northern Wyoming's dude ranch country. Recall that Houghton had advertised his photographic business in the first issue of the *Big Horn Sentinel* when he relocated to Buffalo in 1884. So perhaps the wider angle and placement of the town at the far right reflect

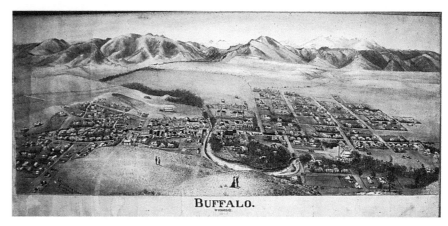

his effort to capture the area's growth since he last saw it. The building housing the former Wyoming Collegiate Institute—a short-lived college in the 1890s—can be seen at right center above the small business district, which includes the false-front Big Horn Mercantile, the first business in the community and one Houghton would have remembered. The heavily wooded Little Goose Creek occupies much of the mid-foreground, and many small ranches are visible spread throughout the countryside (see figure 4.8). Interestingly, not visible in the illustration are the big ranches of Oliver Wallop, Malcolm Moncreiffe, and his brother William Moncreiffe, who formed the core of a polo-playing elite subculture in Big Horn at this time.[13]

Dayton, located at the base of the Bighorns seventeen miles northwest of Sheridan, was home to ranches and farms as well as J. H. McShane and Company, which operated a timber camp in Tongue River to the west and a log flume that brought materials to Dayton. The town incorporated in 1906, so perhaps Houghton's

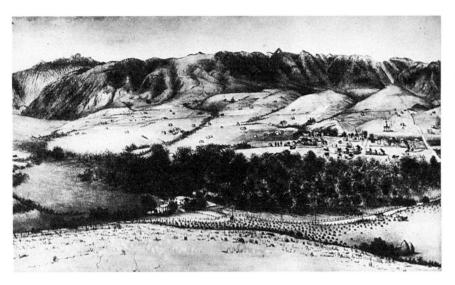

FIGURE 4.8. *Big Horn City.* Houghton had advertised his photography business in the first issue of the Big Horn City newspaper in 1884 and returned to sketch the village in 1905. Author's collection.

sketch, which takes a much tighter focus on the community than his view of Big Horn, might have been prepared as part of that achievement. The main business section is visible, with a church and the many residences scattered among the trees. Both the telephone poles and the neat, tidy yards attest to Dayton being a modern and growing community (see figure 4.9).

FIGURE 4.9. *Dayton, Wyoming in 1905.* Author's collection.

In contrast to the two picturesque ranching communities, the coal mining camp of Monarch, located east of Dayton and downstream on the Tongue River, was a company town begun in 1903 by the Wyoming Coal Mining Company (see figure 4.10). The Chicago, Burlington, and Quincy Railroad had constructed its line through the area in 1892, and several coal towns developed along the way. By 1905, Monarch had sixty houses, a school, a newspaper, and a store. Houghton's view looks northwest over a speeding passenger train whose billowing smoke and train divide the view, with pastoral cattle and grazing lands to the right and the creeping industrialization of Monarch's large coal tipple, freight yard, company store, and company housing visible to the left.[14]

Dietz, located a few miles southeast of Monarch in the Big Goose Valley, was created in 1894 as the community of Higby but was renamed in 1901 for the Dietz brothers who developed the coal mine. The town consisted of two separate camps that worked in five different mines. Many of the town's 1,500 or so people were immigrants from Poland. Houghton's view looks to the southeast, and the two camps can clearly be differentiated. Merritt used the black billowing smoke from the mines, as well as the snaking railroad, to separate the industrial development at left from the neat, orderly town to the right. In the distance, more smoke from distant mines is also visible (see figure 4.11).[15]

Unlike the company coal towns of Dietz and Monarch, Munkers's coal mine was a family-run operation east of Buffalo. George W. Munkers and his brother-in-law and partner Eugene B. Mather had brought the

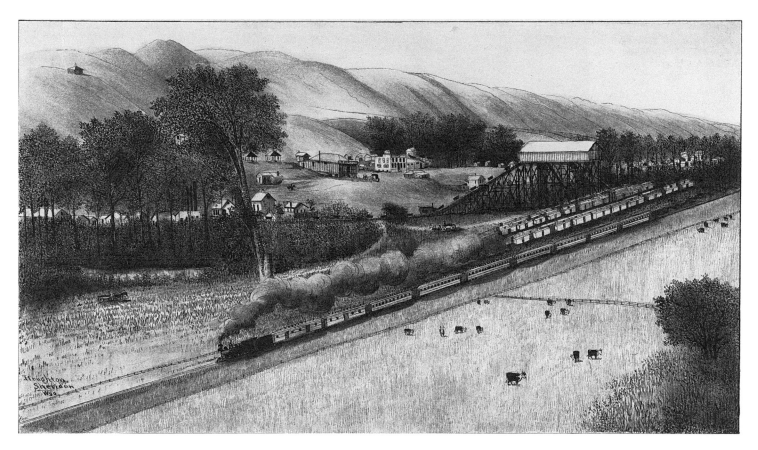

first load of goods into Buffalo in 1882 and established a general merchandise store in town in 1891. Two years later, they developed the Munkers coal mine east of town and began selling coal locally to ranchers and to Fort McKinney. Sometime in 1903, a fire began underground; by October 1906, about a year after Houghton likely made his sketch, news reports stated that the mine might have to be abandoned after a dozen

men were "overcome by smoke and gas" while trying to build a masonry wall in one of the tunnels to control the fire's spread.[16]

Houghton's sketch (see figure 4.12) focused on the aboveground part of the mine; because it was typical Houghton boosterism, none of the fire story is included. Instead, it is a typical ranch-style portrait, with a main house at center with laundry on the line

FIGURE 4.10. *Monarch, Wyoming in 1905.* Courtesy, Department of State Parks and Cultural Resources, Wyoming State Museum, Cheyenne.

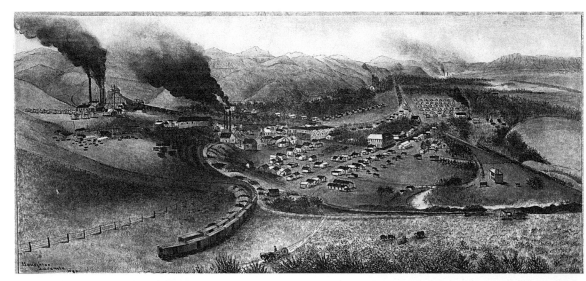

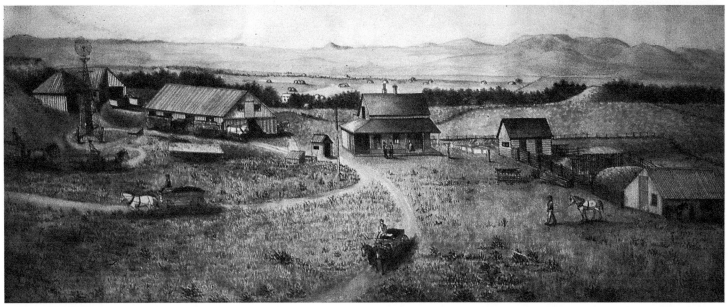

TROUT FARM OF S.H.SMITH SHERIDAN WYOMING.
SIX POOLS ARE LOCATED HERE AT THE HOME RANCH AND 22 ON THE PINEY.

FIGURE 4.13. *Trout Farm of S. H. Smith, Sheridan, Wyoming.* Courtesy, Department of State Parks and Cultural Archives, Wyoming State Archives, Cheyenne.

outside. A woman stands on the porch while two men talk nearby. Corrals and barns are visible at right, with several men working horses. On the left, the mine entrance can be identified, with a miner pushing a loaded cart out along a small track toward a warehouse. Two horse-drawn wagons loaded with coal can be seen at the warehouse and in the foreground while two empty wagons appear in front of the windmill. The scene is one of controlled industry, without a hint as to what was happening underground.

Perhaps the most interesting images from Houghton's Sheridan portfolio are the two fish hatcheries.

Incorrectly labeled "about 1884" in the Wyoming State Archives, Houghton's drawing titled *Trout Farm of S. H. Smith, Sheridan, Wyoming* (see figure 4.13) was mentioned in the August 1, 1905, *Sheridan Post* as hanging in the window of the Sumption and Kay insurance office. According to a newspaper story the previous year, Sheridan pioneer businessman Simeon H. Smith sold his business in early 1904, bought a ranch on Upper Prairie Dog Creek about fifteen miles southwest of town near the hamlet of Banner, and established a private fish hatchery. There, he constructed six separate ponds where he raised half a million Eastern Brook

and native trout that he sold to anyone he could ship to using the railroad. The 1907 *Sheridan City Directory* labeled Smith a "Fish culturist," and he probably hired Houghton to make the sketch. Recall that Merritt had previously undertaken "animal portraits" in Encampment; even though there are no trout profiles in the sketch, it is likely that the artist was fascinated by the business, including a subhead to his drawing's label explaining that "six pools are located here at the home ranch and 22 on the Piney." His sketch has the appearance of a typical ranch scene, but instead of grazing cows in fenced-off fields, the artist includes Prairie Dog Creek cutting in through the brush at left as well as three ponds at center. Several ranch buildings can be seen behind the ponds, and the foothills of the Bighorns rise off into the distance.[17]

In addition to the Smith trout farm at Banner, Houghton also traveled west to Wolf and sketched the *Sheridan State Fish Hatchery District 2*, which was located at that date on the Eaton Brothers Ranch, the country's first dude ranch. Here, timing is critical because the state hatchery, started in 1894, was located at Wolf until 1909 when it moved south to Story, where it remains today, still using some of the original 1909 buildings. That year, the state sold the buildings pictured here as well as the land they occupied to the Eatons. Houghton had already relocated to Spokane by 1907, so this sketch has to be the Wolf location. This makes the Houghton view one of the few known images of this hatchery. And similar to the Sim Smith trout farm view, Houghton sketched the scene like one of his ranch drawings, replacing

fenced fields with ponds. A feeder canal is visible and a horse and flagpole stand next to the central pond, with nearby buildings surrounded by brush and trees (see figure 4.14).[18]

What makes these two fish hatchery images interesting is their tie to animal history. As discussed earlier, along with Houghton's images of herders using horses and a band of sheep to break through a snowy road or his caption explaining that the antelope pictured in the sketch had been replaced by cattle, these early Wyoming fish hatcheries attest to how people in the state were already starting to transform their natural habitat into a hybrid one by replacing native fish with exotics, just as they had replaced native bison with Hereford cattle. Further, Houghton's inclusion of both a state hatchery and a private trout farm shows how the government and private enterprise were utilizing the historical animal in early twentieth-century Wyoming.[19]

After examining these additional images, it is not difficult to imagine that Houghton did in fact stay in the north through fall 1905 until early 1906. Although seven of these sketches are in the Sheridan area, they are each a day's buggy drive to and from the main city. The *Sheridan Post* reported on January 19, 1906, that the artist was sketching Sheridan's Great Western Hotel, and it is conceivable that he had remained in the area and that there are even more images still to discover.[20]

On February 20, 1906, the *Sheridan Post* announced that it was going to give every new subscriber a 14 inch × 32 inch print of Houghton's bird's-eye view of Sheridan. It further stated that Houghton himself would canvass the town recruiting subscribers, both old

Sheridan Hatchery Dist. No. 2.

FIGURE 4.14. *Sheridan State Fish Hatchery District 2.* This hatchery was located at the Eaton Brothers Dude Ranch near Wolf, Wyoming. Courtesy, Department of State Parks and Cultural Resources, Wyoming State Archives, Cheyenne.

and new. The paper went on to describe the illustration, saying that it contained a sketch of every house in town, that there could be "nothing finer in the way of a picture of this kind," and that the prints could easily sell for two dollars each (about sixty dollars in 2021) in town. The paper also boasted Houghton by surmising that "we bespeak for Mr. Houghton every courtesy. His reputation as an artist, his residence of more than a quarter of a century in Wyoming and his gentlemanly bearing all entitle him to respect."[21]

Two months later, Houghton left Wyoming, and there is no record that he ever returned. It is interesting that there is no trail of him west of the Bighorns, either in the Bighorn Basin or further west in the Yellowstone country or Jackson Hole. The reasons are not clear. Perhaps the presence of other artists working the area discouraged him. Or possibly, the push for preservation in the nation's first national park and first national forest nearby undermined the economic development he needed in his business. Or it might

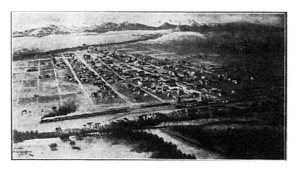

FIGURE 4.15. *Bird's-Eye View of Big Timber, Montana, 1906.* Houghton made his sketch two years before a fire destroyed one-third of the town. Author's collection.

simply be that the places he did go—Montana, Idaho, and Spokane, Washington—were like the locales in Wyoming he had already worked, and so there were known opportunities that felt comfortable.

Regardless of why he left, Houghton traveled more than 320 miles across Montana over the next fourteen weeks, stopped in three major towns, and completed several town and ranch drawings. As he did so, local papers again reported on his work. The first place was Billings. On April 27, 1906, the *Billings Gazette* reported that "M.D. Houghton of Sheridan, Wyo., who has been engaged in making some very excellent drawings of country scenes in the vicinity of that city, is spending a few days here." There are no records of him making any sketches in Billings or its environs, and there are no known illustrations.[22]

Two weeks later, the artist had moved eighty-five miles west, and the *Big Timber Pioneer* reported that "M.D. Houghton of Laramie, Wyo., is here for the purpose of sketching a pen portrait of Big Timber." The next week, the *Pioneer* noted on May 17 that M. D. had completed his drawing, stating that "the picture proves Mr. Houghton an artist of exceptional talent. The

details have been largely eliminated which brings into more prominence the more essential features of a picture and is by far the best and most complete picture of Big Timber ever produced." The view first appeared in the December 13, 1906, issue of the *Pioneer*.[23]

Founded by the Northern Pacific Railroad in 1882, Big Timber became a leading wool shipping point within a decade and the seat of Sweet Grass County when it organized in 1895. Houghton's 1906 view from above the Yellowstone River (see figure 4.15) emphasizes the town's railroad origins, with its typical "T" organization with main streets running perpendicular to the railroad tracks. In the distance, the Absaroka Mountains rise from the plains. The main business district is visible on McLeod Street. Interestingly, Houghton showed many other blocks that appear undeveloped, an unusual feature in his sketches. Two years later, a fire sparked by a passing locomotive destroyed one-third of the city, including every building on McLeod Street except the Grand Hotel, whose dark roof is visible in Houghton's sketch. Like his drawings of long-gone Wyoming copper towns, the Big Timber view thus is an important one for preservationists who want to see how the town once appeared.[24]

Five weeks later, Houghton appeared 100 miles north in Lewistown, where the *Fergus County Democrat* misspelled his first initial when it reported on July 3 that "W.D. Houghton, a sketch artist from Laramie, Wyoming, is in the city with the intention of sketching the city. It is almost impossible to secure an accurate photographic picture of Lewistown and many would like to see it sgetched [*sic*] by a competent

artist as Mr. Houghton appears to be." Six weeks later, the paper reported that Houghton had completed "several sketches of the ranches of Chris King and Sons and John Branger on Little Rock creek. An excellent sketch was also made of the Camastral and Kindschy ranch on the Judith. Mr. Houghton is now engaged in making a sketch of the city of Lewistown." The following week, on August 21, the newspaper reported that "Merritt D. Houghton has completed a topographical sketch of the city of Lewistown. It is an excellent piece of work and is especially adapted for engravement or photographing." Two weeks later, the paper still did not get Houghton's correct initials when it reported that "H.M. Houghton was a passenger for Helena last Wednesday, after having completed a number of pen and brush sketches of Fergus County cities and ranches."[25]

Of these works, only three sketches are known to exist today: the bird's-eye view of the Camastral and Kindschy Ranch on the Judith and a pair of drawings depicting the Spring Creek Ranch of Christ King, west of Lewistown. There are no records of either the bird's-eye view of Lewistown or the illustration of the John Branger Ranch. For the Camastral and Kindschy Ranch, I have a thirty-year-old slide of the original framed drawing with my reflection coming off the glass but no information about it. I believe it was probably brought to a presentation I made in Sheridan three decades ago. The scene depicts a small ranch in a wooded valley set amid a vast plain with mountains in the distance. Cattle and a horse and buggy can be seen in the foreground.

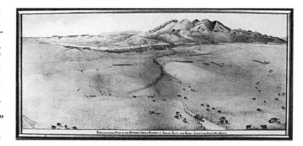

FIGURE 4.16. *Topographical View of the Spring Creek Ranch of Christ King and Son, Lewistown, Fergus Co. Mont.* Courtesy, *Montana: The Magazine of Western History.*

For the King Ranch, Houghton created both a topographical view of the fields and landscape and a closer, portrait sketch of the ranch. The first image is very similar to other Houghton wide-angle ranch drawings, with cattle grazing here and there and a small country road cutting through the scene (see figure 4.16). A wagon pulled by horses is approaching and, in the distance, the Moccasin Mountains rise above the plains. The ranch is just barely seen along Little Rock Creek. The close-up sketch (see figure 4.17) is the same size as the other but focuses in on the ranch buildings as seen from the air. Houghton includes several individuals putting up hay in the foreground. The main house and barn, several outbuildings, and a shelterbelt of trees are also shown.

Why Houghton chose these ranches is unknown. John Camastral had a large ranch on the Judith and in April 1905, his only daughter, Ursula, married Emil Kindschy, who had come to the area three years earlier to teach school. The couple started a ranch near the bride's parents on the Judith, and this must have been the one Houghton drew. The nearby Spring Creek Ranch had been started by Chris King in 1881. After

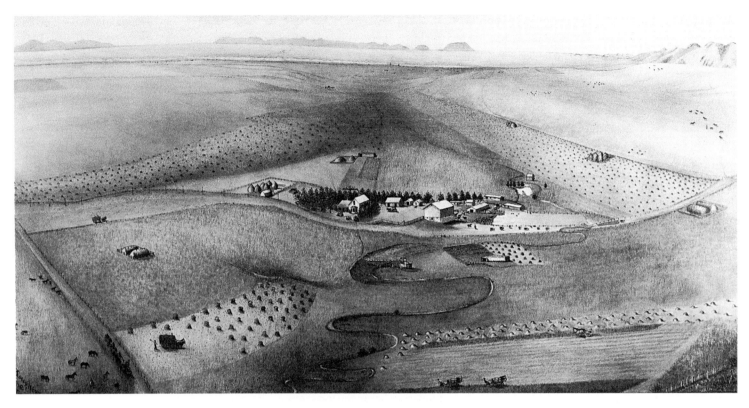

FIGURE 4.17. Portrait view of the Christ King Ranch. Courtesy, *Montana: The Magazine of Western History.*

my article on Houghton's life appeared in the autumn 1994 issue of *Montana: The Magazine of Western History*, Marjoric W. King wrote a letter to the editor that appeared in the winter 1995 issue, accompanied by photographs of the two drawings of the ranch that used to belong to her family. It was the first Houghton drawing I had seen of a Montana ranch. She mentioned that she was aware that the neighboring Branger family also had a Houghton drawing, confirming that sketch's existence. The King family had

sold the ranch in 1935 to Hutterites, who formed the King Ranch Colony, which it remains today.[26]

Although the Lewistown paper said Houghton was bound for Helena, on September 5, the *Butte Daily Post* featured an article titled "Noted Artist Here" that provided an extensive interview with Houghton in which he fully explained what possibilities he saw for Montana and why he had left Wyoming. Because it is one of the very few primary sources that includes Houghton's own voice and because of the gravity of

that voice, it is quoted here extensively. In the interview, Houghton stated:

> Montana looks very good to me . . . after about thirty years of a country which has progressed very little, and if I can find enough to do here I shall locate. It seems as though the mining companies, real estate people and folk of that sort might be in need of just the sort of work I can do, and I'm hoping such work will come my way in quantity sufficient to make it worth my while to remain.
>
> Wyoming is standing still and has been for years. It is a rich state with plenty of resources, but capital stays away. There are places in Wyoming where ore has been picked up which is so rich you can see the yellow metal with the naked eye, yet half of these mineral resources have been undeveloped. Much of the land is filled with prospect holes or small shafts forty or fifty feet down, but deep mining requires capital, and capital won't come.
>
> Chief among the reasons for this is the route of the Union Pacific, practically the only road. When the U.P. was built it went straight to the coal lands, disregarding everything else, and laid its tracks through the desert. There are hundreds of rich farms in Wyoming, but you can go clean through the state on the U.P. and never see a bit of farm land. I know of men who have come out to Wyoming with the intention of investing money and when they went through that bleak desert shook their heads and gave up the project.[27]

The article also addressed Houghton's abilities as an artist, noting that he had with him a "portfolio of sketches made at odd times in years past," with some of them "executed carefully and with exact attention to detail" while others were "rapidfire pen and inks made on hurry orders." The paper summarized the portfolio as "excellent, particularly the landscapes, which are done in wash." Houghton then explained his work: "These have been made in the broiling sun, out in the fields, on the mountain sides, from train windows and every possible place . . . of late years my eyes have troubled me some and I have had to be more careful about my way of doing work, for sunlight on white paper is bad for weak eyes. I thought I was going to make some sketches when on the Jawbone [the Montana Railroad from Lewistown] a few days since, but I decided I wouldn't when I found my sketchboard doing triple summersaults on my knees."[28]

The artist then commented on Montana as a prospect: "Montana is a picturesque and beautiful country and aside from its prosperity and the promise it extends to a man, it is a pleasure to make pictures of its mountains and cities. Best of all I should like to stay in Butte picturing the peculiar, the quaint and queer in this bustling mining city." Unfortunately, there are no known Houghton images of Butte.[29]

The reactions to these comments back in Wyoming were mixed. On September 9, the *Cheyenne Daily Leader* ran the article verbatim but added the briefest of comments in its selection of headlines that said "Houghton on Desert Strip/ Well Known Sketch Artist Boosts Wyoming in Montana/ Says Great Drawback Has Been that Union Pacific Penetrates Only Ugly Part of the State."[30] To suggest that Houghton was "boosting" Wyoming here is a narrow reading of the article. The *Laramie Republican* on September 12,

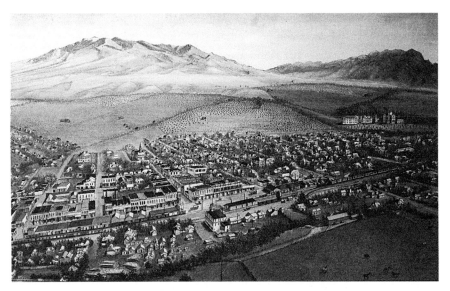

FIGURE 4.18. *Bird's-Eye View of Dillon Looking Southwest.* Courtesy, Beaverhead County Museum, Dillon, MT.

It stated that the picture would soon be engraved and published in the *Dillon Tribune* and that "all subscribers to the picture fund" would receive a "copy printed on fine paper."[32]

On December 21, 1906, the *Dillon Tribune* ran Houghton's *Bird's-Eye View of Dillon Looking Southwest* (see figure 4.18) on its front page. The original remains today in the community's Beaverhead County Museum; at nearly four feet wide and two feet high, the view is comparable to Houghton's best city sketches: Fort Collins and Sheridan. A traditional railroad "T" town, Dillon is primarily east of the tracks, which allowed Houghton to take a theoretical vantage point just to the west and look back across the rails with the main business district in the foreground, the residential district behind that, and the State Normal College (now the University of Western Montana) on the outskirts. In the distance, the Ruby Range and Blacktail Mountains rise from the plains. Local landmarks shown in the drawing include the Beaverhead County Courthouse, left center, and the Hotel Metlen, with its distinct Second Empire mansard roof, center foreground. Notice as well that under Houghton's signature at lower right, he provided just the year, "1906," but no location (see figure 4.18).[33]

The lack of a place in his signature makes one wonder if Merritt had planned to return to life in Laramie with his wife, Frances, after publication of the Butte interview in which he had complained about Wyoming, his home of three decades. As he traveled through northern Wyoming and southern Montana through the spring and summer of 1906, Frances had

1906, also quoted the Butte article verbatim, though it too provided some editorial opinion in its headline, which read "GIVES STATE HEARTY RAP/ ARTIST M.D. HOUGHTON FINDS MUCH TO COMPLAIN OF IN WYOMING SITUATION/ Says State is Standing Still and Has Been for Years and One Can Travel Entirely Across It Without Seeing Bit of Farming Lands—Hundreds of Prospect Holes." It described the Butte story only as a "remarkable interview."[31]

On October 19, a story appeared in Dillon, sixty-five miles due south of Butte, reporting that Houghton had completed a large bird's-eye sketch of the town. The paper called Houghton a "sketch and newspaper artist" from Laramie and described the view as a "fine piece of work" that "gives a better idea of the town than could possibly be given by a photograph."

been back at their home in Laramie, where she kept busy. She participated in numerous society events, donated two copies of *Views of Southern Wyoming* to the local Carnegie library, attended a Presbyterian Missionary Society meeting, rode the train to northern Colorado to visit friends in Fort Collins, and attended a Women's Relief Corps meeting in Greeley. She also took in the daughters of a friend from Pearl, Colorado, who were in Laramie to attend summer school at the university. At the time of her husband's Butte interview, she was at the start of a three-week visit with friends in Dale Creek, between Laramie and Cheyenne. After her return home on September 20, she did not appear in the newspaper again until December 18, when she ran an advertisement for five straight days wanting to sell her household goods. Then, right before the New Year, Frances appeared in one more society page story.[34]

It was only in early January 1907 that Merritt and Frances's decision to leave Laramie became apparent. On January 19, the *Laramie Boomerang* ran a headline "Old Residents Leave," which stated that "Mrs. M.D. Houghton leaves on the No. 3 today for Wallace, Idaho, where she will remain for a few months with her husband. From there Mr. and Mrs. Houghton go to Missoula, Mont., where they will reside in the future. Mr. Houghton is a commercial artist and is sketching mines, etc., for European syndicates."[35]

In fact, Merritt had not returned to Laramie from Montana but had instead pushed on northwest through Butte and Missoula to the Idaho panhandle and then past the small mining town of Wallace to Mullan, eight miles west. The Idaho State Historical Society has a Houghton print of an Idaho mine that shows it was received by the Library of Congress on April 26, 1907. Then, on May 24, 1907, the *Laramie Boomerang* reported that the couple had reunited, saying that "although the country is rough and strange," they "like it very well." The paper also noted that rather than settling in Missoula as planned, the Houghtons had "purchased some suburban property near Spokane, Wash."[36]

Houghton's temporary choice of the Idaho panhandle towns of Mullan and Wallace made sense for an illustrator of mines. These two towns were the center of Idaho's "Silver Valley," the forty-mile-long area east of Lake Coeur d'Alene and home to one of the West's biggest mining booms. The region had started in gold mining in the 1860s and turned to silver in the 1880s. The 1890s were a period of violent labor strife and martial law that crushed the labor unions and left the area more at peace by the time Houghton arrived in 1907.[37]

Houghton apparently spent the spring and summer of 1907 working in the northern Idaho panhandle. On July 11, the *Wallace Miner* ran a story about Houghton's work under the headline "Mine Sketches from Nature," where it reported that

> The *Miner* has lately seen some new and beautiful specimens of the pen and ink sketches from nature of Merritt D. Houghton of Mullan. That enterprising and realistic artist has now made large drawings of most of the notable mines in the district which are to be seen at the head offices of the respective companies where they

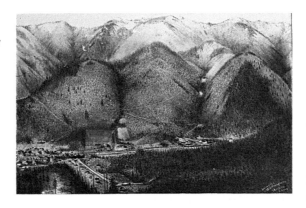

FIGURE 4.19. *Mullan, Idaho*. Courtesy, Northwest Museum of Arts and Culture/ Eastern Washington State Historical Society, Spokane.

constitute most interesting and valuable wall decorations. Lately he has had a number of these pictures photographed cabinet size. These photos are for sale and should have a large circulation among non-resident stockholders as they will give them a better idea of the location and surrounding of the properties they are interested in than any map could possibly do.[38]

From July 25 to August 8, Houghton ran ads for his "pen and ink drawings" as a "mine and landscape illustrator" from his temporary home in Mullan. The details stated: "Nothing will help promoters more to interest eastern investors than a sketch of their mines, adapted for photoengravure or engraving purposes—That's my business."[39]

If Houghton really did draw most of the large mines of the region and his ad produced many customers, the products of those agreements that have survived number only two or possibly three. First, there is a 16 inch × 26 inch bird's-eye view of Mullan (see figure 4.19) owned by the Northwest Museum of Arts and

Culture in Spokane. In this scene, Houghton looks north to the high mountains from the south side of the valley. Trees are everywhere, and the small clusters of houses that make up Mullan seem overwhelmed by nature. The sketch looks as much like one of his mine drawings as it does a town view. Houghton signed the view in the lower right corner, giving Mullan, Idaho, as his home.[40]

The second known Houghton sketch in northern Idaho is *Hunter Mining District, Chloride Hill, in the Coeur d'Alenes*, owned by the Idaho State Historical Society in Boise (see figure 4.20). In this view, Houghton also looks over Mullan to the twenty-five mining areas he has labeled A–Y in the caption below. Like his topographical mining sketches in Encampment, this view is clearly a guide to prospective investors, as confirmed by the title at the top, "Compliments of the Cuban Republic Mining Co., Ltd. Wallace, Idaho," and a key that helps viewers distinguish one mine from another while the town's buildings are too nondescript to do the same. The fact that Houghton signed the picture at lower left but another person copyrighted it at lower right confirms that he had produced and sold this image.[41]

The third possible Houghton Idaho drawing is labeled *The Dredge in its Artificial Lake* and has no date or location provided (see figure 4.21). The Wyoming State Archives in Cheyenne purchased the sketch after Houghton's death. Dredges are boats equipped with excavation machinery, trommels, and sluices that float on water, dig up sediments, extract gold, and then return all of the "washed rocks" in piles as they march

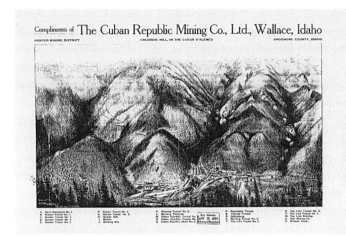

Compliments of The Cuban Republic Mining Co., Ltd., Wallace, Idaho

HUNTER MINING DISTRICT · CHLORIDE HILL, IN THE COEUR D'ALENES · SHOSHONE COUNTY, IDAHO

The Dredge in its Artificial Lake

their way through a river. Houghton would not have found them in either Encampment, Wyoming, or Pearl, Colorado. If he had ventured further south into central Colorado, he would have seen them in use, but there is no record that he did so. Idaho, however, was rife with gold dredging, and historian Clark C. Spence has detailed that two dredges had been in use near Houghton's location and were most likely left wherever they had stopped working, meaning he could have sketched them there in 1907. Another arrived in 1917, so Merritt might have gone back to Idaho from Spokane later to make the sketch.[42]

Houghton's drawing *The Dredge in its Artificial Lake* looks to be almost a sample representation for another possible commission. It is basically a portrait of the immense machine floating in its reservoir, with brush in the near background and a range of mountains rising in the distance. There is a horse and buggy beyond the water, but not a single person is in sight; further, the dredge is not working. The bucket ladder excavator can be seen on its front (right) side, and a gangplank connects to the land in the rear. A typical Houghton illustration would have had this machine belching out smoke if steam-powered or electric, at least churning up a river with its deposit of rocks trailing behind. Instead, it appears idle, perhaps one of the machines formerly used in the area or the returned one awaiting its duties.

After ten months with Merritt in Idaho, Frances wrote to her Laramie friends in early November that the couple had relocated ninety miles west, to property in Spokane, Washington. The November 5, 1907, *Spokane Review* noted that "M.D. Houghton has bought from Broberg and Schuler a four-room house on the south side of Courtland Avenue, between Perry and Morton Streets, for $1050." The next year, the *Spokane*

FIGURE 4.20. (LEFT) *Hunter Mining District, Chloride Hill, in the Coeur d'Alenes, 1907.* Courtesy Idaho State Archives, Hunter Mining District, Chloride Hill, in the Coeur D'Alenes, MAP G4272. H1 C63 1901.

FIGURE 4.21. (RIGHT) *The Dredge in its Artificial Lake* could have been made in Idaho. Courtesy, Department of State Parks and Cultural Resources, Wyoming State Museum, Cheyenne.

City Directory listed Merritt as a "landscape gardener" residing at E1228 Courtland Ave. Although they moved several times thereafter, the Houghtons remained in the Spokane area for the rest of their lives.[43]

The question as to why Houghton chose Spokane contains several possible answers. One story suggests they moved there for Frances's health, while another poses that it was because Merritt's brother, George, worked for a school in Orting, Washington, near Tacoma. Recall that Merritt and George had lived together in Omaha thirty-four years earlier and that George had visited Merritt right before the latter left Laramie. Perhaps the brothers dreamed of retiring near each other. But M. D. did not retire there; instead, he continued to sketch Spokane and its environs.[44]

Houghton most likely relocated to Spokane simply because the city was booming with possibilities for his work. Reminiscent of Encampment's role as a processor feeding off its hinterlands, Spokane had grown from a small town of 20,000 in 1890 to a city of 104,000 twenty years later, and it was the economic center of the "Inland Empire." Similar to Chicago's growth a century earlier, railroads had reoriented trade in eastern Washington from a river-based economy focused on the Columbia to the Inland Empire, a transportation hub that tapped into hinterlands in all directions. The transformation had begun during the Couer d'Alene mining rush in the 1880s and continued with smaller strikes in the Colville and Metaline districts. Rails then branched out into the region's great white pine forests, making them easily exploitable. Tracks soon entered the Palouse country and the Columbia's Big Bend region, bringing wheat, livestock, and agricultural products. Entrepreneurs then pushed new railroads into Canada and brought its minerals and timber into the city by the falls. From its place as a hinterland, Spokane had transformed into the center core of the new empire.[45]

At the seat of this new Inland Empire, Spokane's leaders had nurtured the expansion and re-created the community as a new "city beautiful." Along with the new construction, the city planted 80,000 shade trees, expanded streetcar systems and their associated suburbs, and irrigated new orchards. In 1910, city building permits totaled an all-time high, including Spokane's first skyscraper, the fifteen-story Old National Bank. With all this expansion, Spokane and its empire were ripe areas for Houghton and his pen.[46]

Soon after he and Frances settled into their Spokane home in 1908, Merritt created a bird's-eye view of *Five Mile Prairie, Washington*, a rural neighborhood that got its name because it was about five miles north of downtown Spokane. The area occupies a small bluff above the surrounding countryside and had a Grange Hall starting in the 1880s. Residents constructed the area's first school in 1901, near the only four-way intersection in the sketch. The Five Mile Development League, a coalition of farmers and other residents who advocated for better roads and an electric streetcar line to connect the area to Spokane, copyrighted the image. Houghton's view looks south down Five Mile Road toward Spokane, which spreads out across the far horizon. Individual farms and ranches cover the prairie, and one can

even pick out what crops were grown by each farmer. Today, this area is a growing suburban neighborhood, so Houghton's view is an important snapshot of the area's rural past (see figure 4.22).[47]

Although they had purchased a home in Spokane, in the late spring of 1908 the Houghtons moved to Hillyard, a small community northeast of town where they had bought property. The *Laramie Boomerang* ran a short blurb in April announcing the move, and the society page featured a story that included a letter from Mrs. Houghton telling her friends how much she and Merritt enjoyed their new home. Hillyard had been constructed to house the Great Northern Railroad shops and soon filled with a growing population of immigrant railroad workers. Although Great Northern's James J. Hill had built his facilities outside Spokane to avoid taxes, the residents wanted greater control, so in 1904 they incorporated the community but left the shops out. One Spokane historian suggests that "with all that union labor, Hillyard had developed a socialist political bent by 1910." With a similar political background, Houghton probably chose this community specifically and likely found it very welcoming.[48]

From his new home in Hillyard, Houghton was soon back in the field drawing, this time east of the city along the Spokane River as it flowed west from Lake Coeur d'Alene. A short article in the Rathdrum, Idaho, *Tribune* (a small town nine miles inside the Idaho border) on February 12, 1909, reported that "M.D. Houghton of Spokane has been making sketches of the Spokane valley, following the river

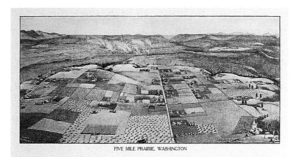

FIVE MILE PRAIRIE, WASHINGTON

from Spokane east. He has the sketch completed as far as this place." The article then mentioned a second sketch, suggesting that Houghton's "birds eye view of Post Falls and vicinity embraces the town and the valley north, south, east, and west of it, [and] shows the 18,000 horsepower electric plant on the middle channel of the Spokane river." Unfortunately, neither of these sketches could be found.[49]

The artist was also mentioned in the Spokane newspaper in 1909 when he entered a drawing for lands being taken from the Coeur d'Alene Reservation to the east. Beginning in 1906, the federal government had appropriated the last of fifteen annual payments to the tribe in the Treaty of 1889 and started granting each man, woman, and child 160 acres, with any remaining land opened for white settlement. Such dispossessions were typical of the Dawes Act era when the United States sought to "civilize" Native peoples by breaking communal tribal landholdings into individual plots. After the allotments were finalized in July 1909, optimistic homesteaders had about a month to register for the lottery that would pick 1,350 whites

eligible for the land that had been taken. More than 104,000 people applied. Government officials drew 1,350 names plus another 1,150 extras in case there was "extra land" or someone selected proved ineligible. According to the *Coeur d'Alene Evening Press*, "M.D. Houghton of Hillyard, Wash." drew number 2029, meaning it was very unlikely that he would get a homestead.[50]

Although Houghton continued to advertise as an "illustrator of mines," there is only one known sketch of a mine drawing after he left Idaho, labeled *Empire Coal and Coke Company*. A possible reason for this dearth of known Northwest mining drawings is simply the fact that he did not publish a collection of sketches in Spokane, as he had in Encampment. Certainly, the slow sales of his second book might have contributed to this, plus he may not have been producing many such images. But these were commission sketches made in remote areas, and they most likely went to mine owners who kept them in private hands. The one image that does exist, *Empire Coal and Coke Company*, has long been a puzzle that only intense newspaper research has explained to be an interesting story that hints at these various concerns.

Newspaper records show that in April 1909, businessmen incorporated the Empire Coal and Coke Company in Spokane with a capitalization of $1.5 million. The company planned to mine coal on land it had purchased seven miles north of the Crowsnest, a low, 4,500-foot pass through the Canadian Rockies between British Columbia and Alberta northeast of Spokane. One of its biggest investors was Spokane land developer R. G. Belden.[51] On September 4 of that year, newspapers reported that a man named C. A. Bryan had left his position with the Oregon Railroad and Navigation Company to become the "traveling agent" for Empire Coal and Coke, with his office in Freewater, Oregon, a small town near Walla Walla, Washington.[52] On December 15, the Spokane *Spokesman-Review* reported under the headline "To Develop Coal Lands" that the company shareholders had recently met in Freewater and "development is already underway. The camp has been built and the tunnel is now being driven." It further noted that Bryan was a director and that two of the largest investors were Belden and developer A. E. Wayland of Spokane.[53]

This is probably where Merritt Dana Houghton entered the story because sometime between 1909 and 1912, he seemed to have gone to the Canadian Rockies and sketched the property. He would have been able to travel all but the last 7 of the roughly 300 miles on trains, taking the Great Northern from Spokane to the border and then the Canadian Pacific to the Crowsnest. His sketch is hand-labeled "Empire Coal and Coke Company, See C.A. Bryan" across the bottom. The mountains are unlike any other place he had drawn, and his view confirms the news story because it shows multiple routes into the peaks as well as several small collections of buildings. It would seem that Houghton completed a sketch of this mine just as he had with previous sketches many other times in his life, and his signature at lower right and the handwritten note at the bottom confirm the connection (see figure 4.23).

But this enterprise was different. On April 10, 1912, the *Spokesman-Review* reported that a suit had been filed against Belden claiming that Empire Coal and Coke stock was valueless. Ten months later, 13,000 shares of the company's stock sold for a penny each at a sheriff's sale, and in January 1914, federal indictments were brought against Belden and Wayland, saying that the "defendants organized one company after another [including the Empire Coal and Coke Company], returned large blocks of the stock, which they sold for their own benefit[,] and . . . all the properties . . . were known by them to be worthless." In fact, in April 1914, the prosecuting attorney stated that Belden and Wayland had capitalized the Empire Coal and Coke Company for $1.5 million but had only spent $500. He concluded, "The Empire, the acquisition of which the defendants represented to have cost $40,000, but for which they actually expended about $500, had no value as coal property, although they represented that it contained millions of tons of coal and timber rights worth its cost, which also was not true. In this company the defendants sold of their own individual personal or promoters' stock shares for which they received in money, real estate, notes, and other property $163,478.78."[54]

The case went to federal court in May 1914, and the jury took less than twenty-four hours to convict both men of "fraudulent use of the mail in the promotion of their mining properties and fiscal agencies." The prosecuting attorney argued for jail time, suggesting that fines would not deter others from taking similar steps. Although the jury disagreed and recommended

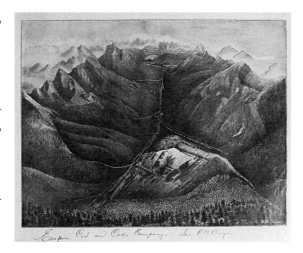

FIGURE 4.23. *The Empire Coal and Coke Company.* Courtesy, Northwest Museum of Arts and Culture/ Eastern Washington State Historical Society, Spokane.

clemency, the judge first denied the two men a new trial and then sentenced Belden to serve one year and one day at the McNeil Island federal penitentiary in Puget Sound and Wayland to serve six months in the Spokane County jail.[55]

No one knows if this ruling affected Houghton, but it does raise many questions. Had he sketched the scenery and then added the trails and buildings based on what someone told him rather than what he saw? Had he even been to the Crowsnest, or had he just imagined what the place looked like from a description provided by Belden, Wayland, or Bryan? Was he complicit in the fraud, either legally or morally? Had he created similar sketches back in Idaho or Wyoming for mine owners who hoped their properties would soon look like what Houghton had drawn? There is nothing in the newspapers connecting either Houghton or Bryan to the convicted men and no way of even

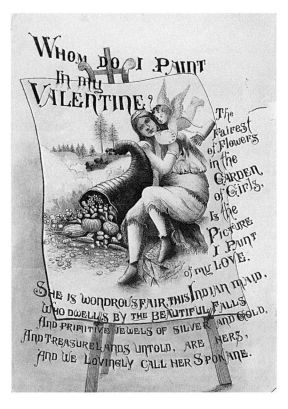

As all of this was playing out, Houghton continued to live and sketch in and around Spokane. The 1910 US census listed Merritt as a sixty-three-year-old artist and illustrator and his wife, Frances, as fifty-nine. A year later, the *Spokane Directory* showed that the couple had moved to the Morgan's Acres neighborhood west of Hillyard and listed Houghton simply as an artist, while the 1912 edition listed them as living at "east side Dixwell 5 north Weile av." and called Merritt an "Illustrator of Mines and Real Estate Tracts." The couple had three acres of land and, according to one account, raised "all kinds of things" after having spent so many years in Wyoming where nothing grew.[57] Frances also resumed her society doings, mostly hosting and attending parties, probably while Merritt was sketching in the field. In addition, M. D. engaged in civic work, serving as a polling place judge in 1912, a poll clerk in 1916, and county draft registrar in 1917 and 1918. The Houghtons were reportedly very happy in Spokane,[58] and Merritt completed a Valentine sketch dedicated to his new home. The drawing features an Indian maiden sitting on the bank of the Spokane River. A cupid hovers nearby, and the maiden reclines against an overflowing cornucopia. Houghton's love for Spokane is evident in both the drawing and the verse that accompanies the sketch (see figure 4.24). It reads:

> Whom Do I Paint in my Valentine?
> The Fairest of Flowers in the Garden of Girls,
> Is the Picture I Paint of My Love.
> She is wondrous Fair, This Indian Maid

knowing if the artist had provided his sketch to the promoters. Regardless, it makes for an interesting discussion about the use of sketch artists versus photographers for promotional work and whether it is right to think of Houghton's work as a visual representation of the world he saw, what was told to him, or simply a figment of his imagination. The answer probably lies somewhere in between, though this is the only instance of such a thing occurring in Houghton's long history as an artist.[56]

Who Dwells by the Beautiful Falls
And Primitive Jewels of Silver and Gold
And Treasurelands Untold, Are Hers
And We Lovingly Call her SPOKANE.[59]

In 1910, Houghton completed a second neighborhood drawing, this one of Greenacres, a small community east of town being developed by the Spokane Valley Land Company. This area was owned by businessman and City Beautiful promoter Aubrey Lee White, who wanted to attract settlers along the Coeur d'Alene and Spokane Railway. Houghton was probably hired to illustrate this land, and his view looks west down on farms and fields, the bending Spokane River, and the railroad. Antoine Peak rises in the distance. Today's Greenacres Park would be at the center bottom of Houghton's sketch. This view was privately owned; it hung in Marlene's Restaurant in Spokane for a number of years and now hangs in the offices of St. Joseph Cemetery in the community of Spokane Valley (see figure 5.2).[60]

Two years later, Houghton completed a much more detailed and complicated bird's-eye illustration of another Spokane neighborhood, *Sunset Farms, West Spokane*. Like his other Spokane views, this one also appears to have been created for promotion. As indicated just to the right of the Sunset Farms heading, this area was part of the "N.E. Portion Hazelwood Irrigated Farms/ Orchard and Garden Homes." Hazelwood Farms was a Spokane dairy whose owners subdivided and sold their lands beginning in 1906. Neely and Young, land sales agents who had developed

Greenacres, handled the deal. To improve the land, they brought water from Silver Lake; by 1908, 1,500 of 2,500 irrigated acres had been sold. In 1911, a group of fifty-five men in the New York City government formed a company known as Sunset Farms and purchased 100 acres of this project for $32,000 to improve the ground for a commercial orchard. Either Neely and Young or this company must have hired Houghton to depict their project.[61]

Comparable to his amazing *Relief Map of the Grand Encampment Mining Districts*, this depiction of Sunset Farms also superimposes the national grid and its section numbers, as well as land ownership details and major crops, onto a view looking toward Spokane from this western suburb. At least four railroads are visible, as well as Fort Wright, several parks, a cemetery, power lines, Sunset High School, Five Mile Prairie, and Hillyard. The Coeur d'Alene Mountains rise in the distance, and within the clouds, Houghton included "Official 1910 Census: 104102 . . . Probable Population 120,000 for 1914." The level of detail required for this map and the sense of space to be able to put it all together again show Houghton's skills (see figure 4.25 and plate 40).

This view is an important visual document of Spokane's history. It looks east down West Sunset Boulevard from the eastern edge of what is now called Airway Heights. Anyone with Google Maps or Google Earth can locate section numbers on Houghton's drawing and see what has become of each property over the last eleven decades. The sketch is truly an invaluable tool for the history of urban planning, historical preservation, and regional history.[62]

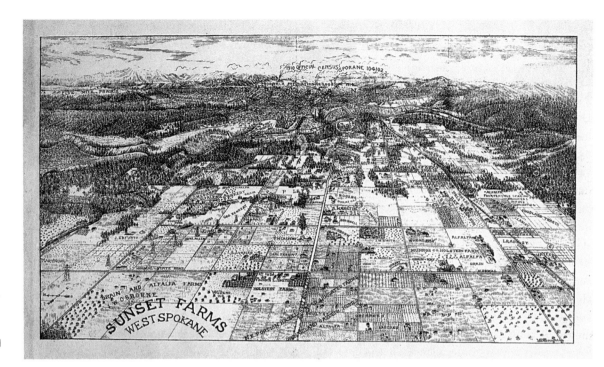

FIGURE 4.25. *Sunset Farms, West Spokane*. Courtesy, Northwest Museum of Arts and Culture/Eastern Washington State Historical Society, Spokane.

The following year, 1915, Houghton completed two more sketches around Spokane: *West Spokane*, available at art websites, and *Spokane, Wash., Relief Map of Northern and Central Portions* which is housed at the Library of Congress. In the first view (see figure 4.26), Houghton centered his vantage point about five miles to the southeast, with Windsor Gardens, which can be seen at the distant right in *Sunset Farms*, at the center. The scene looks to the northeast toward the city, with Mount Spokane on the far horizon. While the sketch is more refined, with a painted wash giving it the look of a black-and-white photograph, it lacks much of the specific detail of *Sunset Farms*, including the section numbers, landowner names, and local landmarks. It makes up for the lack of these specifics with a more artistic look that includes more details of houses, fields, forests, and other features. Like *Sunset Farms*, *West Spokane* could be an invaluable research tool to study how these lands have changed over time.

In early 1915, Houghton copyrighted another drawing, titled *Spokane, Wash., Relief Map of Northern and Central Portions* (see figure 4.27), and deposited a copy at the Library of Congress on May 25. This is the last known Houghton sketch and, if so, it is a spectacular

closing act. The view looks north from Spokane's southern neighborhoods, perhaps about at today's Twenty-ninth Avenue. Spokane Valley stretches off to the right and Nine Mile Falls to the left. Mount Spokane looms over the far horizon. Looking closer, Houghton focused on the city's central business district as it hugs the river through town. Like his Sheridan, Wyoming, view, it seems that Houghton sketched every individual building while leaving perimeter ones more generic. In addition, he drew in hundreds of trees plus the major roads and railroads. Visible landmarks include the newly finished (1911) Latah Creek Bridge at lower left, Spokane City Hall, the Great Northern Railroad Depot and Clock Tower, Union Station, and Gonzaga College (left to right, at center). All in all, there are hundreds of unique buildings, bridges, and houses present in the sketch, which serves as an important visual document in Spokane's history.

Although Merritt continued to be listed in the *Spokane City Directory* as an artist who lived in the Morgan Acre Tracts of Hillyard, little is known of his or Frances's life until the couple contracted influenza in the spring of 1919.[63] The disease had first been detected the previous spring at a military base in Kansas, and soldiers going to Europe spread it during the Great War. Influenza gained notoriety in neutral Spain that summer; by fall, the now "Spanish Influenza" appeared on America's East Coast and in military camps across the country.[64] In early October 1918, the first cases surfaced in Spokane; over the next five months an estimated 11,000 Spokane residents, or 11 percent of the population, contracted the virus. The

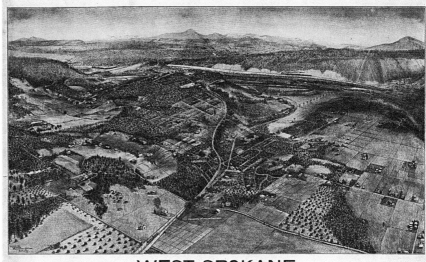

WEST SPOKANE

epidemic soon overran Spokane's hospitals, forcing the city to establish a makeshift one in a downtown hotel. Officials banned public gatherings and required residents to wear gauze masks. Historians suggest that Spokane experienced three distinct 1918 flu spikes—first in late October, then again a week later, and a third time in December—before it finally began to wane in February 1919.[65]

Sometime in the epidemic's last few weeks, both Frances and Merritt contracted influenza. She had been in poor health for some time. Her niece, Mrs. Beryl Satter of Salt Creek, Wyoming, had come to care for the couple. By the end of February, the Houghtons must have felt that the end was near because they deeded their house and lots to Satter.[66] Merritt died in

FIGURE 4.26. *West Spokane.* Author's collection, courtesy, Old Print Shop, New York City.

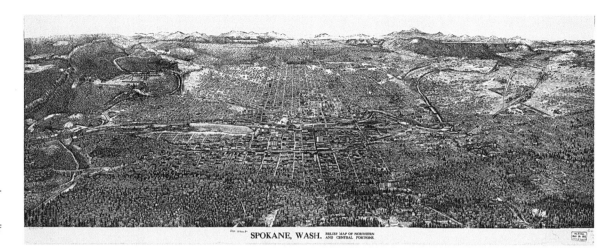

SPOKANE, WASH. RELIEF MAP OF NORTHERN AND CENTRAL PORTIONS.

FIGURE 4.27. *Spokane, Wash., Relief Map of Northern and Central Portions,* 1915. Courtesy, Geography and Map Division, Library of Congress, Washington, DC.

the late evening of Wednesday, March 5, and Frances died the following afternoon. Satter told the newspapers that "it was a happy ending for the couple, who had often expressed the opinion that they would both pass away at the same time." A double funeral was held for the couple on Monday, March 10, and they were buried in Riverside Park Cemetery in Spokane.[67]

Since leaving Laramie in 1905, Merritt Dana Houghton had made more than thirty sketches that survive to this day and possibly double that number overall. He made drawings in northern Wyoming, Montana, Idaho, Washington State, and in the Canadian Rockies. Although his subjects were mostly bird's-eye views of towns, he also drew mines, ranches, and local businesses. Two of his most important

sketches were made during this time: his massive aerial view of Sheridan, Wyoming, and his bird's-eye view of the central and northern portions of Spokane. He also explained why he had left southern Wyoming, his home for three decades, and expressed his love for his new home in Spokane. Because he and Frances died within hours of each other, we lost not only the couple but also perhaps a more reflective interview or an oral history if one of them had survived. Houghton's contemporary William Henry Jackson, for example, lived to be ninety-nine and provided posterity with an autobiography two years before he died. For Merritt Dana Houghton, it took a century and a pandemic before this biography of his life and work could be written.[68]

Drawing Conclusions A Twenty-First-Century Perspective **5**

A look back at Merritt Dana Houghton and his work a century after his death must start with the similarities between the great influenza epidemic in which he died and the COVID-19 pandemic that has enveloped our country since spring 2020. In the last six months of Houghton's life, Spokane closed its restaurants, bars, and schools to try to control the spread of the flu. Eleven percent of the city's 110,000 residents caught the virus, overrunning city hospitals and forcing the city to create a makeshift hospital in a local hotel. Nearly 600 residents died.[1] As I revise this final draft from Flagstaff, I look back over the last thirty-one months of the COVID-19 pandemic and recall that at one point Arizona led the world in the number of new COVID cases per 100,000 population. Restaurants and businesses closed, my workplace at Northern Arizona University shut down for a time, and I taught two entire years remotely on Zoom. Since March 2020, my county has reported nearly 50,000 COVID cases, with almost 500 deaths. Frankly, it has been a bit chilling to write about someone who died during the last great American epidemic.

At the same time, it has been thrilling to return to Houghton and trace his life and work across seven decades and thousands of miles. The amount of material available now is amazing, and one process I have most enjoyed has been tracking down locations of ranch sketches. To do this, I first look up the homesteader's name online through General Land Office records. These records provide the legal descriptions of the deeded land in township, range, and section numbers. I then translate these numbers into GPS coordinates at another site and enter them into Google Earth, which takes me to the site of the original ranch. Because many of them are very remote, "street-level" real-time photographs are not available, but the replication of the digital landscape compared to Houghton's original view confirms the location. I then pushpin the spot and map all the sites Houghton spent days traveling to and sketching. Similar processes can also be used to locate his city, mining, topographic, and historical views. Of course, we are lucky to have any of Houghton's views at all.

Apparently, at the time of his death, Merritt still had some sketches with him that he had made throughout the years. We know this from a 1914 letter he wrote to Mrs. Mary G. Bellamy[2] in which he listed the drawings he retained, suggesting that he would have had to gift them to C. G. Coutant if he had let the author see

https://doi.org/10.5876/9781646423668.c005

them. He listed the following sketches as still in his possession:

> Fort Bridger as a traders camp; Fort Bridger as a Mormon fort; Fort Bridger as a U.S. Fort; Fort Supply a Mormon Fort in the center of a system of fields and gardens, burned and abandoned by the mormons [sic] when Johnston and his army approached on their way to Salt Lake; Old dugout homes of Carbon; Cantonment Reno on Powder River drawn in 1877 while it was in process of construction; Antelope Springs—a military outpost while Cantonment Reno was being built in 1877; Many of the original pencil drawings from which Coutant's history was illustrated. The towns of Dixon, Baggs, Monarch, Dietz, Wamsutter as a Sheepherder's watering place, Fossil, Old Sketches of the sheep industry, Antelope, Elk, Mountain Sheep, Breaking Roads among the tie choppers. Photos of Jared Bullock, prominent Mormon pioneers. Photo of Kit Carson, Old John Baker, a sketch of Hole in the Wall, and a great many sketches of interest but probably not of importance for a single volume history like the one Miss Hebard is writing.[3]

It is likely that Houghton still had these sketches five years later when he died in early March 1919. Six days after his death, a burglar risked "influenza and asphyxiation [when he] . . . invaded the home of Mr. and Mrs. Merritt D. Houghton on the Morgan Acre Tracts." Apparently, city officials had lit three formaldehyde candles to fumigate the house after the couple's deaths, and they were burning when the burglar broke in. Missing items included "a tablecloth and seven napkins, 15 quarts of fruit, eight glasses of jelly, 12 pairs of women's silk hose, three waists, and two pieces of Mexican drawn work linen." Although no mention was made of any drawings, the newspaper article did note that some of the items belonged to the couple's niece (Mrs. Satter) who was living at the home of a neighbor. Four months later, on July 29, 1919, the Wyoming Historical Board purchased ten Houghton sketches, including *Flocks on the Red Desert, Dugouts and Log Houses of Carbon, Monarch Coal Camp, Hole in the Wall, Breaking a Road, The Early Storm, Baggs, The Dredge in its Artificial Lake, Fort Supply*, and the watercolor *Fort Bridger as a U.S. Fort*.[4]

Today, the Wyoming State Museum and the Wyoming State Archives in Cheyenne hold the largest number of Houghton sketches and watercolors, having added to their original collection through more purchases and donations. The Grand Encampment Museum also has a handful, as do the American Heritage Center at the University of Wyoming, the Carbon County Museum in Rawlins, and the Denver Public Library. The Northwest Museum of Arts and Culture in Spokane owns six illustrations and one painting. Repositories with fewer Houghton images span the continent, including three at the Library of Congress in Washington, DC, and one each at the Amon Carter Museum of American Art in Fort Worth, Texas, the Big Timber Museum in Montana, and the Jim Gatchell Memorial Museum in Buffalo, Wyoming, where I first stumbled upon a Houghton drawing thirty-four years ago. Many more are prized possessions of individuals and families. In addition, Jonita Sommers in

Pinedale, Wyoming, has a photograph collection of Houghton drawings in western Wyoming, and I possess an almost complete photographic set of Houghton illustrations.

Four interesting examples of the merging of my research and the preservation of these images occurred during the writing of this book. The first concerns a Houghton ranch drawing I found online at the Amon Carter Museum in Fort Worth, which been labeled a "Ranch Scene." I emailed the curator asking how the museum had acquired the piece and was told it had been purchased by a Denver art dealer in 1967 from the estate of "Ad Spaugh" in Lusk, Wyoming. Applying my research methods to this discovery took me to several ranches pioneer Addison Spaugh had owned north of the small village of Manville, about ten miles west of Lusk. Spaugh had come north on trail drives from Texas as a young man and then founded Manville, which he named for John B. Kendrick's partner, Hiram S. Manville. After identifying what I thought was the correct property, I found the name of the current owner, Bud R. Reed, and cold-called him, asking if I could email him the picture to identify the ranch, only to learn that he had no internet or cell coverage at the remote location. I sent him a copy of the drawing and my 1994 Houghton article. A month later, I talked with Reed and was delighted to learn that it was indeed his ranch (see figure 5.1). In fact, Reed told me that his grandparents had first leased the 77 Ranch directly from Spaugh in 1936 and he bought it in 1948, moving into the log buildings visible in the drawing. He told me that he and his father had razed those buildings in

1953 to build the modern house where he still lived. It was an amazing story. He was excited that I had contacted him, the museum appreciated the details about its piece, and I was thrilled to have identified a previously unknown illustration. Then, after plotting the new location on my Houghton map, I discovered that it was the easternmost illustration in that part of Wyoming, suggesting the possibility that more Houghton sketches might still be in that area.[5]

The second connection occurred after I learned that Houghton had attended Olivet College in southern Michigan during the Civil War. Olivet still existed, so I emailed Hannah Mellino, the administrative and communications assistant for the Olivet College Archives, to see if they knew anything about Houghton. Although nothing surfaced about Houghton, Mellino related that in 1864, the college had hired Sarah Benedict, a recent graduate, to be an art instructor and that it was possible that Houghton might have known her. Further, Mellino connected me to two other researchers, Ed Bentley and Ed Dobbins, who were investigating Benedict and two other artists who had been Houghton's classmates: photographer John Harvey Scotford and bird's-eye–view illustrator Czar J. Dyer, who had made sketches in Arizona. After contacting these two men, I learned more about Houghton's potential art training and peers as well as gaining some sense of what Olivet had been like during the Civil War. It was an amazing sharing of disparate pieces of a history, and it enriched all of our work.[6]

The third instance concerned a Houghton sketch of *Greenacres, Washington*. I had photographed this

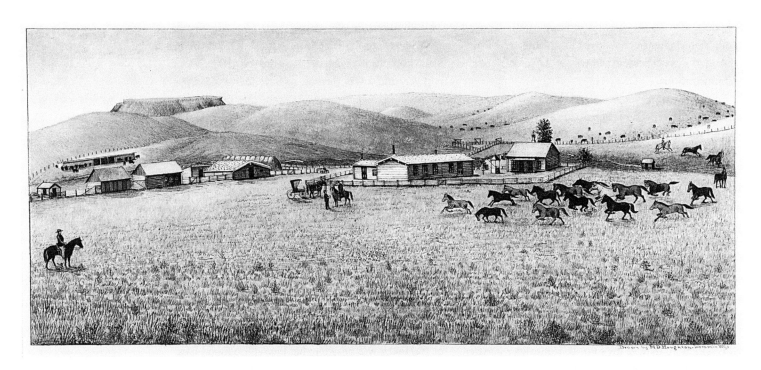

FIGURE 5.1. Although the Amon Carter Museum lists this image simply as *Ranch Scene* and its creation date as 1875, my research, including talking to the current owner, identifies it as the Addison Spaugh 77 Ranch near Lance Creek, Wyoming, and Houghton most likely sketched it in 1905. *Ranch Scene*, ca. 1875, ink and ink wash on paper mounted on paperboard, Amon Carter Museum of American Art, Fort Worth, Texas, 1967.33.

drawing in 1993 at Marlene's Restaurant in Spokane. Fast-forward twenty-eight years and I decided to see if Marlene's Restaurant still had its Houghton. Unfortunately, I learned that the restaurant had closed in 2017 and that Marlene had died in 2019. I read an online obituary and learned that her husband, Robert Nordby, was still alive, and I located his phone number in Idaho. My call reached an answering machine, and I left an odd message explaining that I was interested in a sketch I had seen in Marlene's Restaurant almost thirty years earlier. To my delight, Robert Nordby returned my call and told me he had always loved the sketch. After Marlene passed, he donated it to the cemetery where she was buried. I texted him other Houghton Spokane views, and a month later he texted me photos he had taken of the drawing. It's comforting to know that *Greenacres* remains in good shape (see figure 5.2).[7]

The final example happened when I contacted Registrar Mariah Emmons at the Wyoming State Museum about using its images in this book. When I told her I had recently viewed the museum's Houghton exhibit, she reported that after another patron viewed it, he decided to donate a Houghton watercolor that had

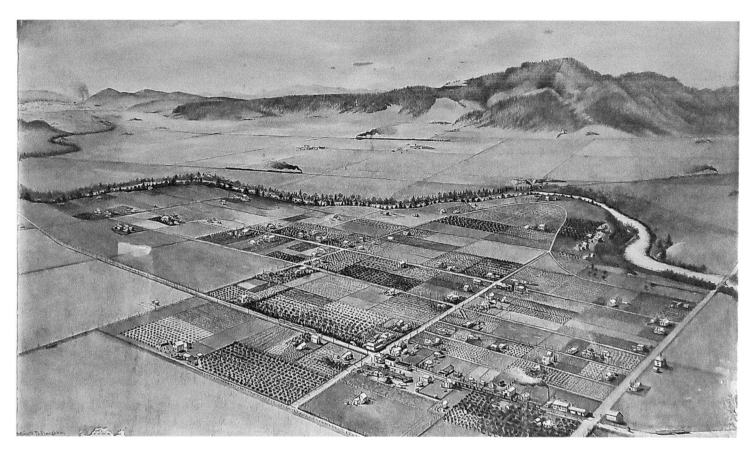

FIGURE 5.2. *Greenacres, Washington*. Author's collection, courtesy, St. Joseph Cemetery, Spokane Valley, WA.

been in his family for over a century. His ancestor had worked for Wyoming senator John B. Kendrick at his ranch east of Sheridan, and someone there gave him the 1906 painting *Helping the Messwagon*. The painting shows a man in a wagon full of bedrolls and other objects being pulled up a hill by a team of four horses assisted by three mounted cowboys with long ropes attached to the wagon. A lone cowboy astride his horse looks on from the hilltop while several other wagons eye the process from further down the hill.

This painting is significant for a few reasons. First, it's amazing to see a new Houghton image. Second, the fact that it is a watercolor action scene is most unusual in the Houghton catalog and is more like a Charley Russell painting. It's also further northeast than any other known Houghton, which suggests

there could be more such views in the area. Finally, its 1906 date adds to the conclusion reached in chapter 4 that Houghton did not return to Laramie that year but stayed in northern Wyoming.

As I review Houghton's life and work, I realize that it's been thirty-four years since I first saw his view of Buffalo, Wyoming. That's about the same span that Houghton had to look back on his sketch career when he died in 1919. I've also pondered why it's taken me so long to complete this work and why no one else has taken it on. To that end, I think that Houghton's work is inherently *local* in nature but *regional* in scope, requiring a researcher who is comfortable with both provincial details in five states and broader understandings across time and space.

It is my hope that this book will give Houghton's art the attention it deserves and bring forward more examples of unknown works. When I first wrote about Houghton in 1994, I thought I had seen all of his work and knew everything there was to know. Now, in 2022, I have learned that there is more to know and to see. If anyone reading this book knows of a Houghton drawing not discussed here, please email an image with details to Michael.Amundson@nau.edu.

In the meantime, I hope this book connects the dots for those interested in Merritt Dana Houghton's life and work. Never as well-known as a Charley Russell or Frederick Remington, Houghton deserves a second look for having sketched more than 200 scenes in the northern Rockies between 1878 and 1919. His views of towns, ranches, forts, mines, and animals continue to provide a window into the West of a century ago. For these reasons, a book on the life and art of Merritt Dana Houghton is long overdue.

Helping the Messwagon

FIGURE 5.3. *Helping the Messwagon.* This newly discovered Houghton image shows cowboys at work on either John B. Kendrick's ranch on Hanging Woman Creek or the LX Bar Ranch on Powder River. Courtesy, Wyoming State Museum, Cheyenne.

Portfolio Samples from the Houghton Portfolio

Of Merritt Dana Houghton's roughly 200 known illustrations, perhaps 100 remain more than a century after his death. Of those, about two thirds are found in archives and museums. Single images are found in city halls, businesses, and local museums. Another third, mostly ranch views, remain in the hands of individuals, usually descendants or neighbors of the original owners. When I completed my catalog of Houghton views in the early 1990s, I compiled a Houghton collection of my own from images obtained from these various sources as well as from individuals who brought their treasures to my public presentations and allowed me to photograph them. When possible, I cite the current owner of each image below; when it is not possible to do so, I say "author's collection." This portfolio of surviving sketches and paintings includes samples from each of the main themes in Houghton's work: bird's-eye views of cities and towns, mining views, ranch views, business views, topographical views, historical views, and animal sketches.

Bird's-Eye Views of Cities and Towns

Although he created about three dozen bird's-eye drawings of towns in Colorado, Wyoming, Montana, Idaho, and Washington State, Houghton is barely known for them as an artist. In his *Union Catalogue* of such views, historian John W. Reps includes only Houghton's sketch of Fort Collins. Perhaps because his illustrations represent the lesser-known Intermountain West or because Spokane is the largest city he drew, Houghton has mostly been forgotten. But of all his subjects, the highest percentage of remaining illustrations are these perspective drawings, probably because they were commissioned by city leaders or local newspapers and have survived in the towns depicted. His views of Spokane, Sheridan, and Fort Collins are as good as any other artist's work, while his scenes of smaller towns like Rambler and Walcott are often the only such period drawings.

Reps explains that such illustrations can be used to examine many aspects of urban history, including how towns were laid out; the distribution of architectural styles in a community; where businesses, residences, governments, and religious buildings were found; what types of transportation systems were available, and other aspects. When paired with a period Sanborn map or census records, more information can be corroborated. Historical preservationists can pair these sketches with Google Earth and record what remains and what has been lost over the last century. Depictions of places that are ghost towns today, including Carbon, Dietz, and Rambler, are even more important as surviving visual documents.

https://doi.org/10.5876/9781646423668.c006

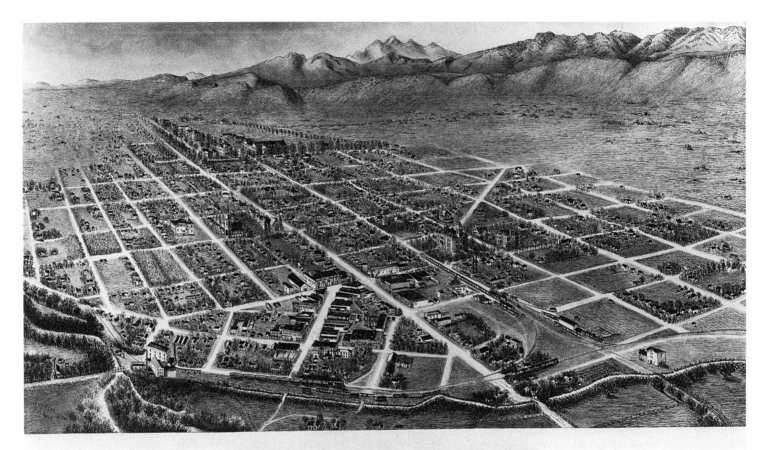

FORT COLLINS, COLO. 1899.

PLATE 1. *Fort Collins, Colo., 1899*

Houghton's view of the northern Colorado city looks over today's Old Town toward Long's Peak in the distance. Colorado A&M (now Colorado State University) can be seen at the edge of town. This is the only Houghton sketch listed in John Reps's *Union Catalog of Views and Viewmakers.* Courtesy, Geography and Map Division, Library of Congress, Washington, DC.

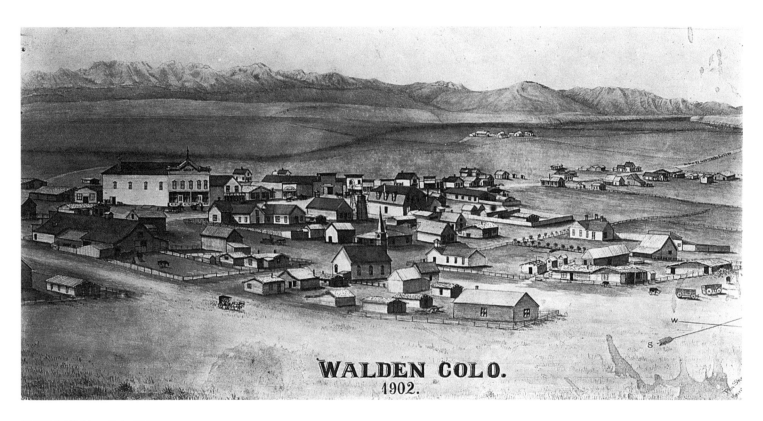

WALDEN COLO.
1902.

PLATE 2. *Walden, Colo., 1902*

Walden is in Colorado's North Park and is the southern-most of Houghton's Encampment views. The artist proba-bly ventured to the community while promoting a railroad from Laramie, though it did not actually arrive until 1911. The two-story Mosman Mercantile with the second-floor Oddfellows Hall on the left of the main street was constructed in 1900 and still stands today. The compass figure in the lower right is unusual in Houghton's images. Courtesy, Denver Public Library, Denver, CO.

Houghton

"Battle"

PEN SKETCHES OF WYOMING

PLATE 3. *Rambler, 1903*

Houghton's view of the Sierra Madres mining camp shows a small main street carved from the surrounding forest. The town had been started in 1902 to house workers at the nearby Doane-Rambler Mine and was located south of today's Battle Highway, just east of the Continental Divide above Battle Lake. A close look shows telephone poles, a horse and buggy, and what could be Merritt and Frances just to the left of the man on the horse. By 1912, Rambler was deserted. Courtesy, Wyoming State Museum, Cheyenne.

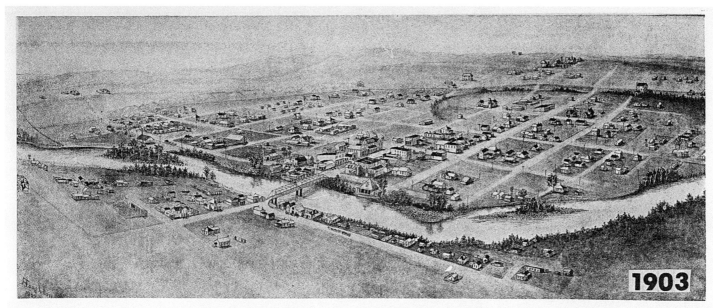

Coypright Applied for, 1903, by M. D. HOUGHTON

SARATOGA, WYOMING

Elevation 6,700. Population 1,000.
$20,000 Bonds voted for water system.
Water Power practically unlimited.
Extensive Lime Quarries.
Coal supply 12 miles northwest.
Land under successful cultivation 15,000
 acres.
Telephone System.
Two Churches.

Located in Copper Region of Southern Wyoming, on North Platte river, 21 miles from Union Pacific R. R. Six-horse Concord coaches carrying passengers, U. S. Mail and Pacific express runs daily between U. P. Ry., Saratoga, and Grand Encampment. Large tracts of unoccupied Government Land Suitable for Alfalfa, Grain, Sugar beet culture, requiring large investments of capital to irrigate. Wheat and oats from here took first prize at the World's Fair. Ranch property has more than doubled in value during the past three years.

Hot Sulphur Springs.
Pupils from Public School enter Preparatory Department of University.
Pupils enrolled 188. Teachers 3.
Tie Cutting an Important Industry.
Irrigated hay and pasture land 30,000
 acres.
Capacity of Electric Plant 1,200 lamps.
 700 lamps in operation.

PLATE 4. *Saratoga, Wyoming, 1903*

This 1903 view updated an 1898 version of the community along the North Platte River. The town grid is clearly visible, and at the center of the view is the 1893 Hotel Wolf, still standing in 2022. The promotional material included shows how local boosters used Houghton's images to promote their towns. The original brass engraving plate for this figure survives, enabling a modern printer to make new prints from the 1903 original. Courtesy, Dick Perue/ Bob Martin Collection, Historical Reproductions by Perue, Saratoga, WY.

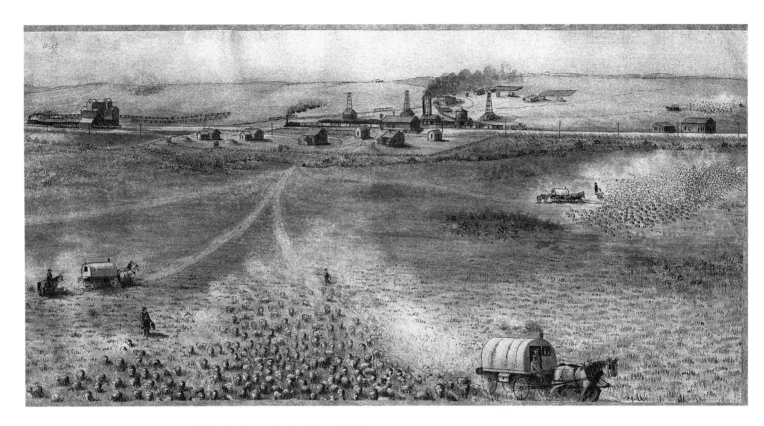

PLATE 5. *Flocks on the Red Desert, 1903*

This view of several sheep bands looks north to what was at the time called Washakie Station and is now the small community of Wamsutter, Wyoming. The derricks in view across the Union Pacific tracks were for water wells—an important commodity in the community, which sits within the Great Divide Basin, where no water flows into or out to other streams. This is one of several Houghton views depicting Wyoming sheep, in an era when range wars between cattlemen and sheepmen were hotly contested. Courtesy, Wyoming State Museum, Cheyenne.

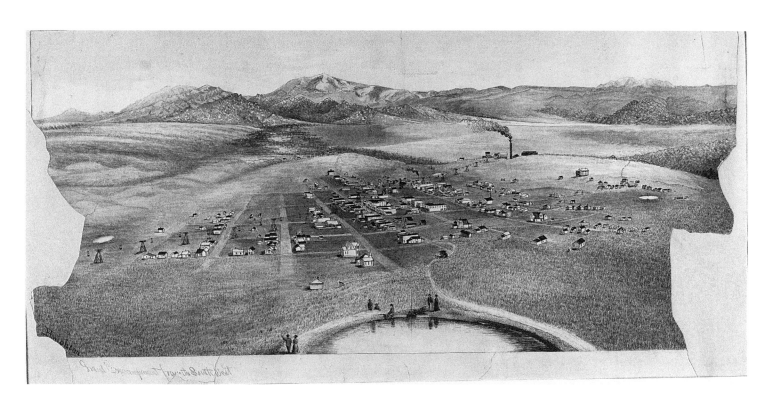

PLATE 6. *Grand Encampment from the South West, 1904*

Unlike his industrial portrait of the town, with the smelter at center, Houghton sketched this view as more of a pastoral look at the community, with a small pond at the lower center. A close look reveals the aerial tramway snaking through town left to right as well as a self-portrait of Merritt and Frances left of the pond. Courtesy, Wyoming State Museum, Cheyenne.

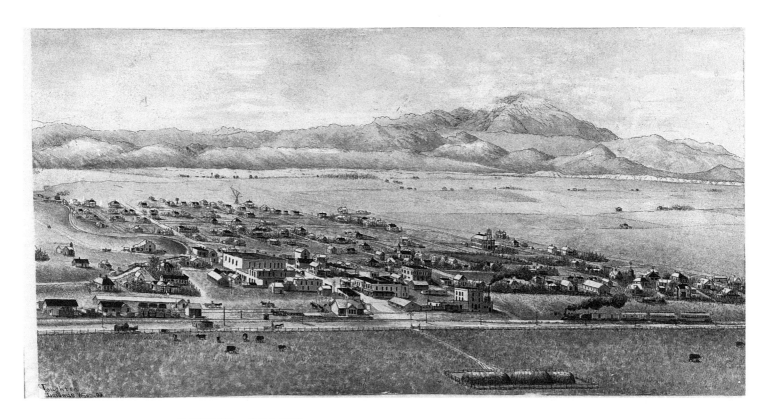

PLATE 7. *Wheatland, 1905*

Houghton's view of Wheatland looks northwest toward Laramie Peak. The Wheatland Development Company had hired the artist to sketch the town shortly after it was incorporated. Houghton placed both the main irrigation channel and the railroad, the two most important contributors to the town's development, at the center of his sketch. A close look shows the results—farmers bringing loaded wagons into town. Courtesy, Wyoming State Museum, Cheyenne.

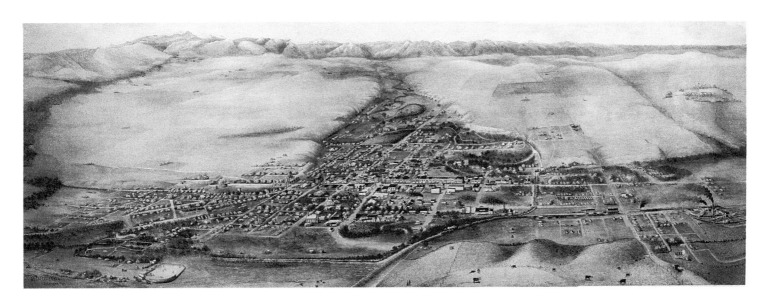

PLATE 8. *Bird's-Eye View of Sheridan, Wyoming, 1905*

At four feet tall and eight feet wide, this illustration is the largest known Houghton sketch. The view looks west toward the Bighorn Mountains and places the community along Big Goose Creek between Little Goose Creek at left and Soldier Creek at right. The *Sheridan Post* reported that the artist spent two weeks sketching every house in town to prepare for this view. A close look reveals historical structures including (at right) the Sheridan Inn, the train depot, and Fort MacKenzie (now the Sheridan Veterans Administration Medical Center). The town's Main Street is visible (center), and the Sheridan County Courthouse can be seen at left. Notable features no longer present include the roundhouse (lower right) and the ballpark (lower left). Those looking for John B. Kendrick's Trail End home will note its absence among the bends of Big Goose Creek because it was not constructed until 1908. Author's collection.

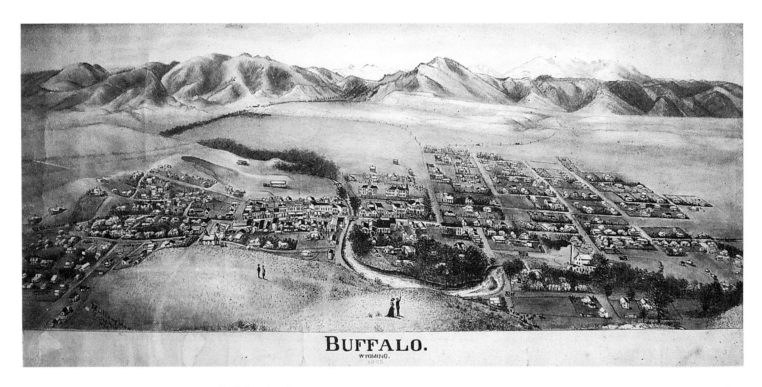

BUFFALO.
WYOMING.
1905.

PLATE 9. *Buffalo, Wyoming*

I first saw this view looking down at Buffalo in 1988. As in many such sketches, Houghton has placed himself and his wife, Frances, in the center foreground, lifting his cane and pointing to the town below. The town's main street is visible, as is Clear Creek as it bends its way through the community. The Bighorn Mountains rise in the distance. Courtesy, Jim Gatchell Memorial Museum, Buffalo, WY.

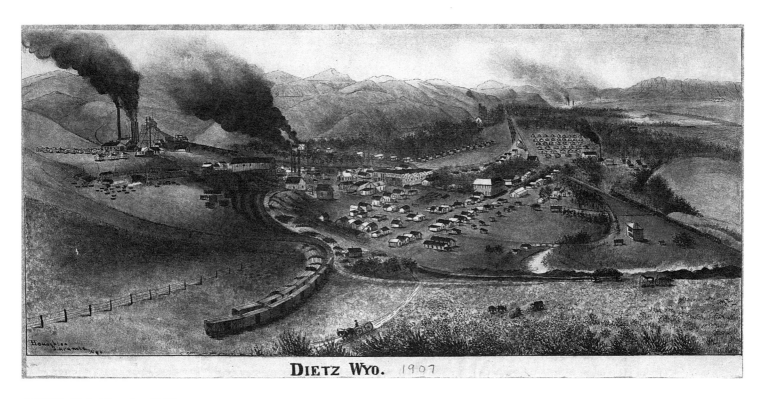

DIETZ WYO. 1907

PLATE 10. *Dietz, Wyoming, 1906*

The small coal mining community of Dietz was actually two camps located four miles north of Sheridan. Houghton's bird's-eye view shows both mines as they belched out smoke, at left, and the communities with their business district and houses, at right. Courtesy, Wyoming State Museum, Cheyenne.

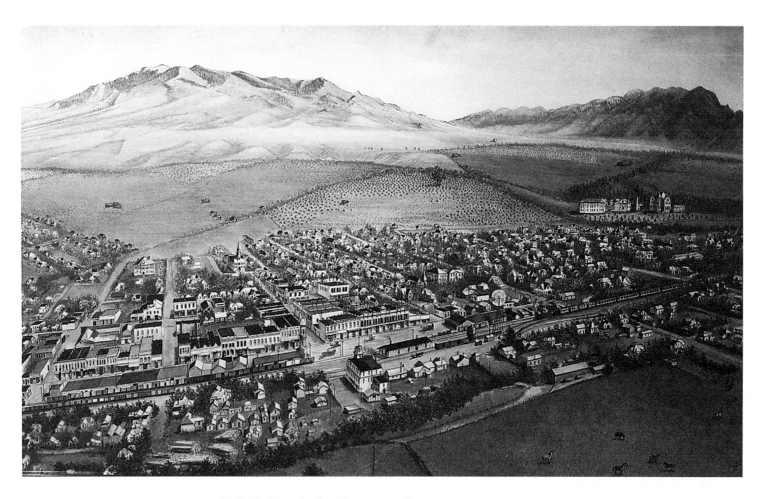

PLATE 11. *Bird's-Eye View of Dillon, Montana, 1906*

At four feet wide and two feet high, this sketch of Dillon is one of two surviving Houghton town sketches in Montana. The artist's drawing shows the railroad's "T" town layout, with streets running perpendicular to the tracks. A close look reveals the downtown business district, the Beaverhead County Courthouse (left center), and the campus of the State Normal College, now the University of Western Montana (upper right). The historic Metlen Hotel, with its distinctive Second Empire mansard roof (bottom center), also survives today. Courtesy, Beaverhead County Museum, Dillon, MT.

PLATE 12. *Mullan, Idaho, 1907*

One of only two surviving sketches in Idaho, this illustration looks down on the small mining community from high on a mountain. After two decades in Wyoming, Houghton passed through Montana and Idaho in the summer of 1907 before settling in Spokane. In July of that year, Merritt used Mullan as a home base and ran ads in its local newspaper under the headline "mine and landscape illustrator." Courtesy, Northwest Museum of Arts and Culture, Spokane, WA.

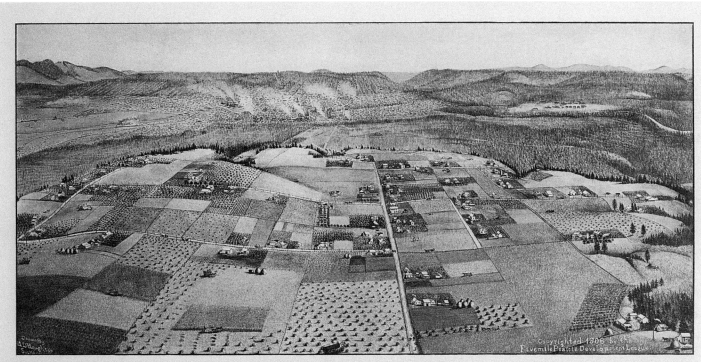

FIVE MILE PRAIRIE, WASHINGTON

PLATE 13. *Five Mile Prairie, Washington, 1908*

Five Mile Prairie is a rural neighborhood on the north-west side of Spokane. After moving to the city in 1908, Houghton completed his sketch for the Fivemile Prairie Development League, a coalition of farmers and other residents who advocated for better roads and an electric streetcar line to connect the area to Spokane. The view looks south toward Spokane. Courtesy, Northwest Museum of Arts and Culture, Spokane, WA.

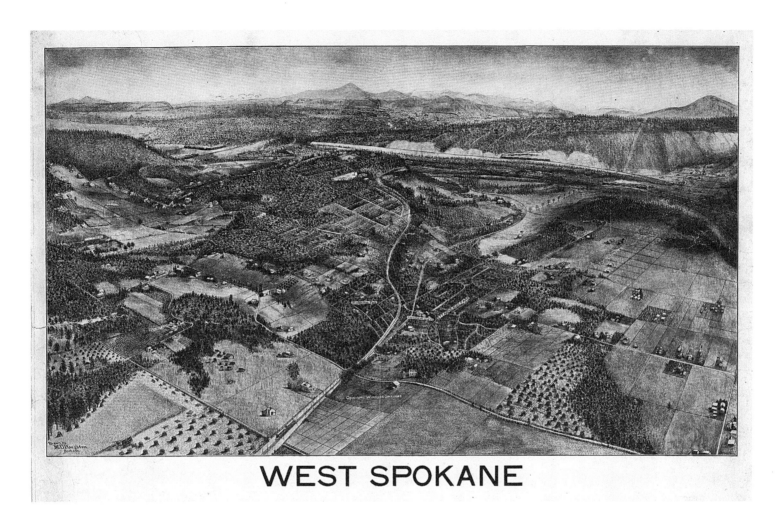

WEST SPOKANE

PLATE 14. *West Spokane, 1910*

According to a National Register nomination, the barn at the original Windsor Gardens at lower center is now located at 4311 S. Abbot Road, placing the location of this view just southeast of Interstate 90 and the Spokane International Airport. The drawing looks northeast toward the city. Like Houghton's other sketches of Spokane's hinterlands, this view can be read as a visual map of the built environment as it existed more than a century ago. Author's collection.

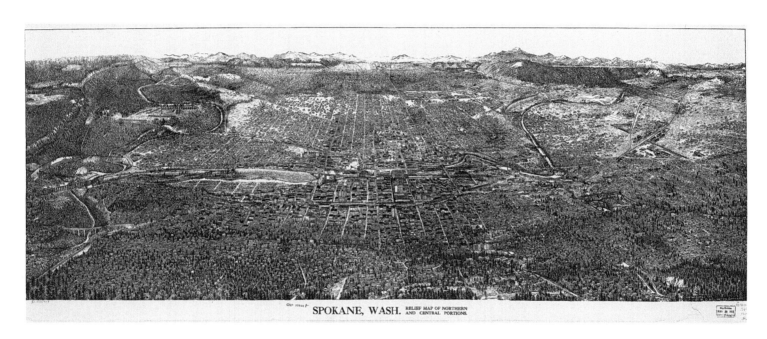

SPOKANE, WASH. RELIEF MAP OF NORTHERN AND CENTRAL PORTIONS.

PLATE 15. *Spokane, Wash. Relief Map of Northern and Central Portions, 1915*

Houghton sent a copy of this final known sketch to the Library of Congress in May 1915. The view looks north from the city's southern neighborhoods, perhaps about at today's Twenty-ninth Avenue. Spokane Valley stretches off to the right and Nine Mile Falls to the left. Mount Spokane looms over the far horizon. The drawing's focus is the central business district as it hugs the river through town. Visible landmarks include, from left to right, the Latah Creek Bridge, Spokane City Hall, the Great Northern Railroad Depot and Clock Tower, Union Station, and Gonzaga College. Many other unique buildings, bridges, and houses are represented, adding to the sketch's importance as a visual document in Spokane's history. Courtesy, Geography and Map Division, Library of Congress, Washington, DC.

Mining Views

Houghton's illustrations of mining areas are essentially bird's-eye views or portraits of rural industrial areas. Original drawings of mining properties are rarer today than his city views, probably because they were sold directly to mine owners and most prospects were short-lived. The earliest was his view of the *Keystone 20-Stamp Gold Mill* that appeared in his 1891 *Wyoming Illustrated Monthly*.

In Houghton's era, these sketches were useful because they provided mine owners with idealized visual documents to show potential investors remote places that were difficult to reach and document otherwise. The mine views typically feature smoke billowing from the stacks, indicating that they are always working. Grounds are clutter free, and buildings are neat and tidy. It is also interesting to note the various form of technology present, including steam boilers, stamps, aerial cable systems, dredges, and others that have been painstakingly brought to such remote areas. In short, Houghton portrays the mines in their best possible light and as good investments.

Today's viewers also notice the environmental impact the mines had on neighboring forests, which are often shown as cut over. Like the city views, researchers can use these mining illustrations to document locations and mining artifacts. Forestry officials can also use them to identify lost shafts and other safety issues.

The legal trouble documented in chapter 3 regarding the owners of the Empire Coal and Coke Company, who fraudulently embellished their mining investments, raises questions about whether Houghton visited all the sites he depicted or if he embellished them for owners. Though he was never personally connected to the scandal that sent two men to prison, it raises doubts about the accuracy of his sketch, not only there but elsewhere.

PLATE 16. *Keystone 20-Stamp Gold Mill, 1891*

Houghton included this sketch, presumably made from a photograph, in his short-lived 1891 newspaper *Wyoming Illustrated Monthly*. Keystone was a small placer gold mining community west of Laramie in the Medicine Bow Mountains. Because of its 1891 publication date, this sketch was reproduced as a line engraving rather than with the half-tones made popular by 1900. This process used individual black lines for shading, with many spaced close together for darker regions and fewer set farther apart for lighter areas. Houghton's signature is found at lower center. Courtesy, Wyoming Digital Newspaper Collection.

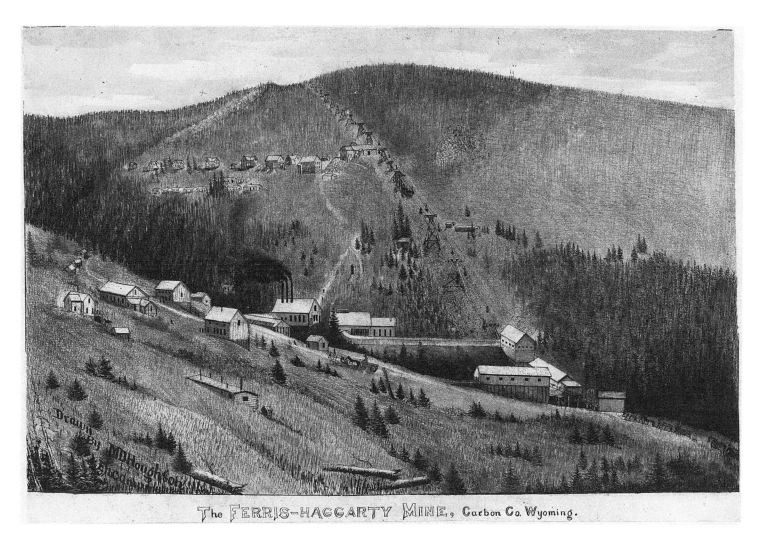

The FERRIS-HAGGARTY MINE, Carbon Co. Wyoming.

PLATE 17. *The Ferris-Haggarty Mine, Carbon Co. Wyoming, 1902*

This sketch shows the centerpiece of the Grand Encampment copper boom, with smoke belching from the stacks and the aerial tramway climbing over the mountain. Company buildings and miners' housing dot the cut-over forest. Courtesy, Wyoming State Museum, Cheyenne.

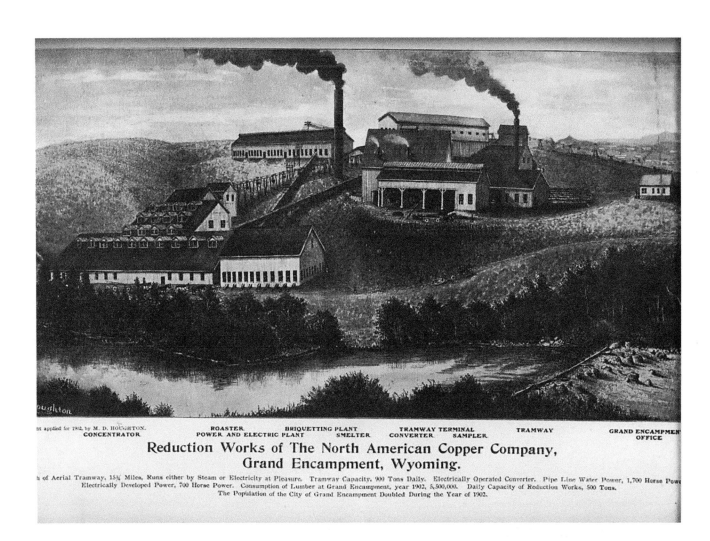

**Reduction Works of The North American Copper Company,
Grand Encampment, Wyoming.**

h of Aerial Tramway, 15¼ Miles, Runs either by Steam or Electricity at Pleasure. Tramway Capacity, 900 Tons Daily. Electrically Operated Converter. Pipe Line Water Power, 1,700 Horse Power,
Electrically Developed Power, 700 Horse Power. Consumption of Lumber at Grand Encampment, year 1902, 5,500,000. Daily Capacity of Reduction Works, 500 Tons.
The Population of the City of Grand Encampment Doubled During the Year of 1902.

PLATE 18. *Reduction Works of the North American Copper Company, Grand Encampment, Wyoming*

Although Houghton had included this smelter in his Encampment town views, he isolated the plant in this view and included captions below identifying the purposes of each building. As always, the artist pictured the works with black smoke belching into the sky, suggesting it was busily working. The Encampment River can be seen at the bottom of the sketch. Courtesy, Grand Encampment Museum, Encampment, WY.

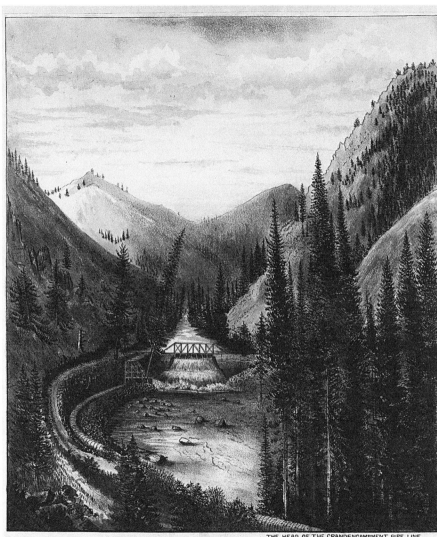

MINING ILLUSTRATIONS

THE HEAD OF THE GRANDENCAMPMENT PIPE LINE

H. D. Houghton
Grand Encampment
Wyo.

PLATE 19. *Head of the Encampment Pipe Line, 1902*

This sketch depicts a scene upriver from town where the Encampment River had been dammed to divert water to the smelter through a pipeline. This pipeline then supplied both water and power to the smelter and the town. Why Houghton chose to sketch this scene is not known, though it was probably a commission from the copper company to show potential investors its infrastructure. Courtesy, Wyoming State Museum, Cheyenne.

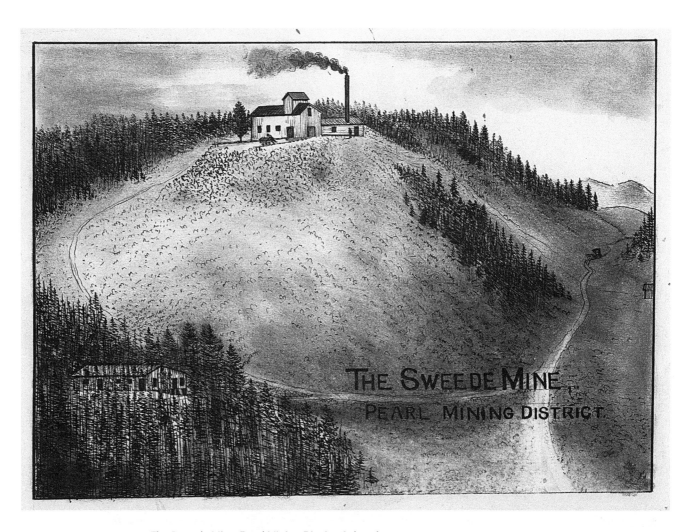

PLATE 20. *The Sweede Mine, Pearl Mining District, Colorado, 1903*

The Pearl Mining District was about twenty miles south of Encampment in northern Colorado, and Houghton included it in his two books. This view of the Sweede Mine shows a small operation atop a cut-over hillside. In the distance, what appears to be Houghton's horse and buggy can be seen approaching on the mine road. Courtesy, Wyoming State Museum, Cheyenne.

PLATE 21. *The Discovery Shaft, ca. 1903*

This sketch depicts a generic mining shaft with a
small mine railway. Courtesy, Wyoming State Museum,
Cheyenne.

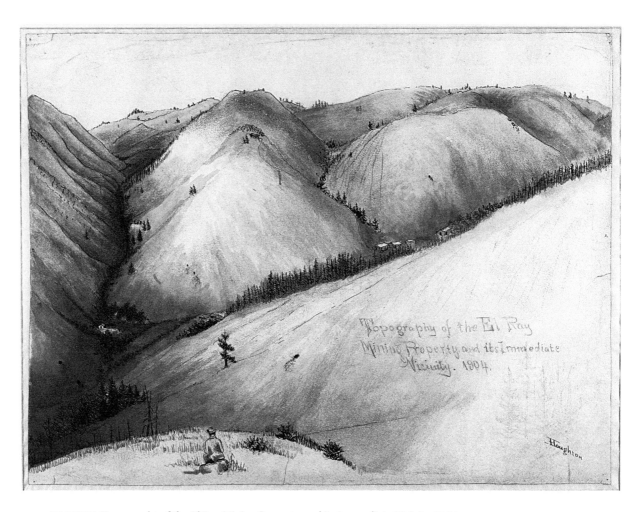

PLATE 22. *Topography of the El Ray Mining Property and Its Immediate Vicinity, 1904*

In this unique sketch, Houghton included himself drawing the scene before him. The El Ray Mining District was another short-lived prospect south of Encampment. Courtesy, Wyoming State Museum, Cheyenne.

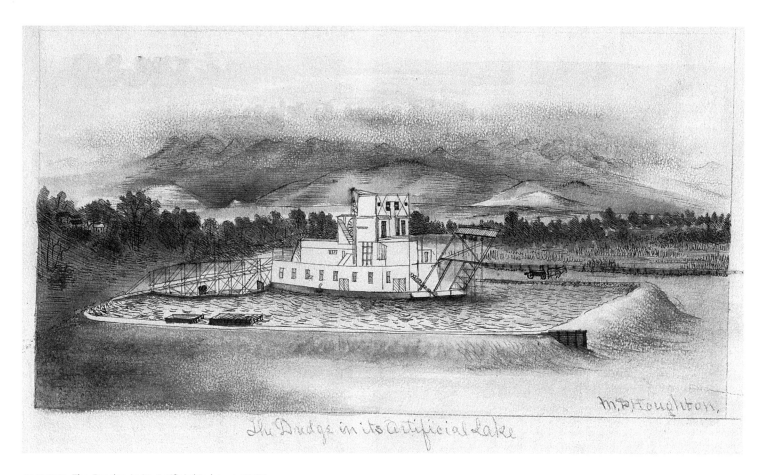

The Dredge in its Artificial Lake

PLATE 23. *The Dredge in its Artificial Lake, ca. 1907*

Although it is not known where Houghton sketched this scene, gold dredges such as this were not in use in the copper mining region of Encampment. I suspect that it depicts a scene in Shoshone County, Idaho, which Houghton would have seen as he was moving north to Spokane in 1907. The fact that the state of Wyoming purchased it after the artist's death also suggests that it was made after he left Wyoming. The idleness of the scene is unusual in Houghton's drawings. Courtesy, Wyoming State Museum, Cheyenne.

PLATE 24. *Hunter Mining District, Chloride Hill, in the Coeur D'Alenes, 1907*

In this view, Houghton looks over the small Idaho panhandle mining town of Mullan. But unlike his bird's-eye view of the town (see plate 12), Houghton focuses here on twenty-five mining areas he labeled A–Y in the caption below. Like his topographical mining sketches in Encampment, this view is a guide to prospective investors.

This is confirmed by the title at the top and a key that helps viewers distinguish one mine from another while the town's buildings are too nondescript to do the same. Courtesy, Idaho State Archives. Hunter Mining District, Chloride Hill, in the Coeur D'Alenes. MAP G4272.H1 C63 1901.

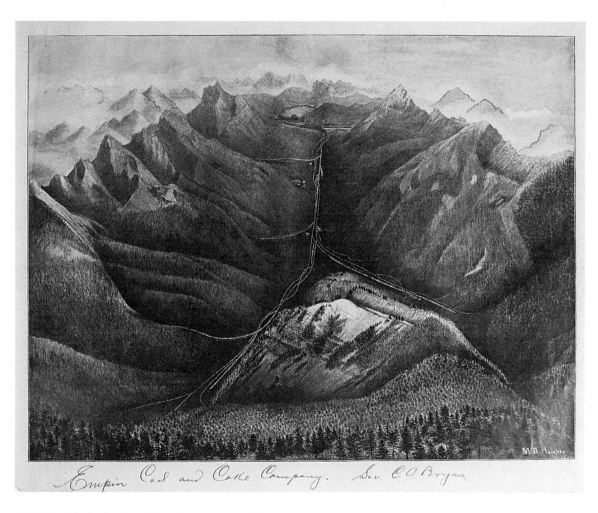

PLATE 25. *Empire Coal and Coke Company, ca. 1910*

This sketch depicts what seems to have been a fraudulent "paper company" at the Crowsnest, a pass on the border between Alberta and British Columbia, Canada. As discussed in chapter 4, neither Houghton nor the "C. A. Bryan" mentioned below the sketch was included in the fraud, though two other mine promoters received jail sentences. This is the last known Houghton mine illustration, though there is no record, other than the sketch, that he ever visited the site. Courtesy, Northwest Museum of Arts and Culture, Spokane, WA.

Ranch Views

Houghton's ranch views are the most numerous subject in his portfolio. His earliest surviving sketches date to 1891, and he often made them while working as an itinerant schoolteacher. Although his largest concentration of known ranch sketches is on the Laramie Plains, he also drew ranches near Encampment, Douglas, Elk Mountain, Casper, Big Piney, Daniel, Sheridan, and Farson in Wyoming and near Lewistown, Montana.

Houghton employed two different composition techniques in his ranch drawings: the wide-angle topographical view, which placed the ranch into the broader landscape and included nearby fields, and the smaller-size portrait, which focused on the ranch buildings and adjacent pens. The larger-size sketches of the N. K. Boswell Ranch and the Christ King Ranch represent the first technique, though smaller works like the J. M McIntosh Ranch also fit. Most ranch illustrations are smaller in size and follow the portrait format, providing greater detail to the ranch house and outbuildings.

All of Houghton's ranch views show the West after the Open Range era, so they detail cowboys not only herding cattle in fenced-in pastures but also putting up hay in closed-off fields. Folklorists can examine the details of such things as fence types, livestock breeds, and architecture to determine where ranchers came from and what they were doing. As depictions of a settler society, scholars can also use Houghton's ranch drawings as visual documents of settler colonialism in the West.

Most of Houghton's ranch views are pen and ink sketches on standard art paper about one foot by two feet in size, though rare exceptions include the Boswell Ranch view that is almost six feet wide and a handful of watercolor paintings, including those of the J. M. McIntosh Ranch, the K. P. Nickell Ranch, and the Boot Jack Ranch, as well as the Harvy DeKalb painting.

Houghton usually made these sketches for the families that owned the ranches, and his work has often been handed down through generations as important family heirlooms. It is hoped that this publication will unearth even more.

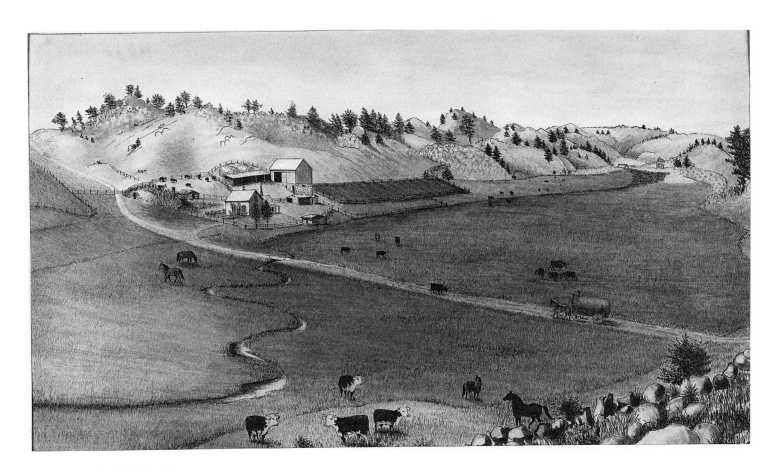

PLATE 26. *Unidentified Ranch, ca. 1904*

This Houghton sketch of an unidentified ranch is listed as located at Tie Siding, south of Laramie. It is typical of Houghton's wide-angle approach to ranch drawings, providing the broad view with the ranch buildings set amid small hills and a green valley. Perhaps a reader can identify the location. Courtesy, Wyoming State Museum, Cheyenne.

PLATE 27. *J. M. McIntosh Ranch, 1899*

This forty-inch-wide watercolor is one of only a handful of known ranch paintings. The location is just northwest of today's Jeffrey City, along the Sweetwater River. Another wide-angle view, Houghton placed the ranch buildings at center in the picture but visually small in the landscape of hills and fields. A close look shows wagons on the roads, cattle herds, fencing, and cowboys. Houghton made this view on an 1899 trip west across Wyoming, sketching ranches along the Green River around the same time. One of Houghton's best ranch views, this painting was shown to me by its owners thirty years ago when I made a presentation about Houghton, and they allowed me to photograph it. Its whereabouts today are unknown to me. Author's collection.

PLATE 28. *Ranch of Roney Pomeroy, Fontenelle Uinta Co. Wyoming, 1899*

When I was working on Houghton back in the 1990s, I was visiting my aunt and uncle Joanne and Gary Zakotnik, ranchers in the small western Wyoming community of Eden, and I told them about the project. A few minutes later, they brought me an original sketch of a small ranch they once owned on Fontenelle Creek. The drawing is typical because its portrait style focuses on the ranch buildings, animals, fences, and close-by fields rather than the topographical view in other sketches. It is also unusual because in lieu of a signature, it simply has a date of July 8, 1899. Houghton has another ranch sketch in the vicinity labeled June 11, 1899. The fact that my relatives casually produced an original Houghton suggests that there may be many more in private hands. Courtesy, Gary and Joanne Zakotnik and the Jonita Sommers Photo Collection.

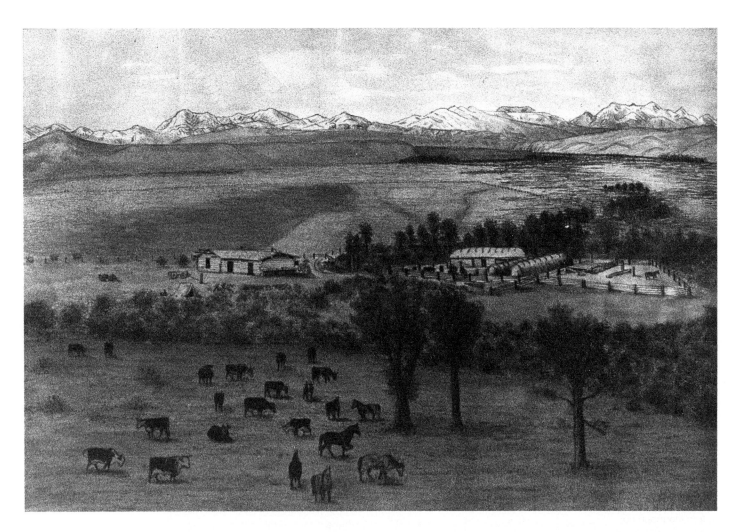

PLATE 29. *Sutton's Boot Jack Ranch, Wyo., 1899*

Houghton painted this watercolor image of the Boot Jack Ranch on the Upper Green River in 1899. A typical setting, Houghton portrays cattle and horses in the nearby fields, ranch buildings at center, and plains and fields spreading across the back to a range of mountains. This was one of several ranch illustrations Houghton made in the Upper Green River area in 1899. Courtesy, Jonita Sommers Photograph Collection, Pinedale, WY.

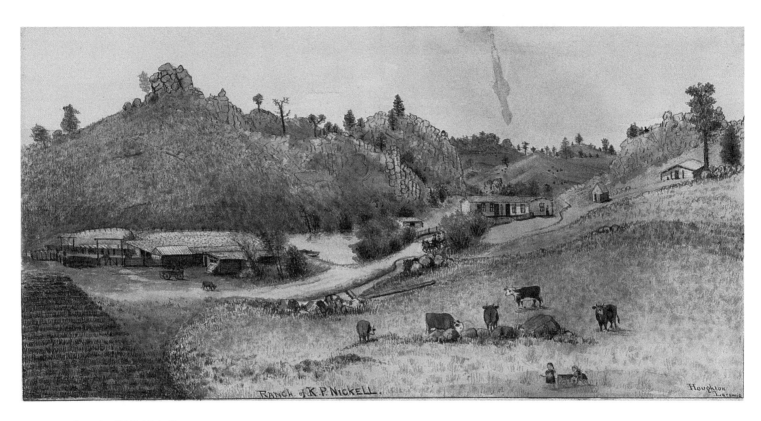

RANCH of K. P. NICKELL.

Houghton
Laramie

PLATE 30. *Ranch of K. P. Nickell, 1902*

Houghton's 1902 watercolor of the K. P. Nickell Ranch at Iron Mountain northeast of Laramie is one of the rare ranch paintings made by the artist. Another portrait-style work, the illustration is most famous today as depicting the site of Tom Horn's 1901 murder of Nickell's fourteen-year-old son Willie. This ranch shows the more meager existence of a small homesteader, with his cabin and outbuildings. Houghton's inclusion of water at the center suggests its importance in this arid land, while the irrigated field at left shows how the desert can be remade. The small children at play in the lower right remind the viewer of the violence that occurred here. Interestingly, K. P. Nickell later moved to Encampment, where Houghton may have again seen him. Courtesy, Wyoming State Museum, Cheyenne.

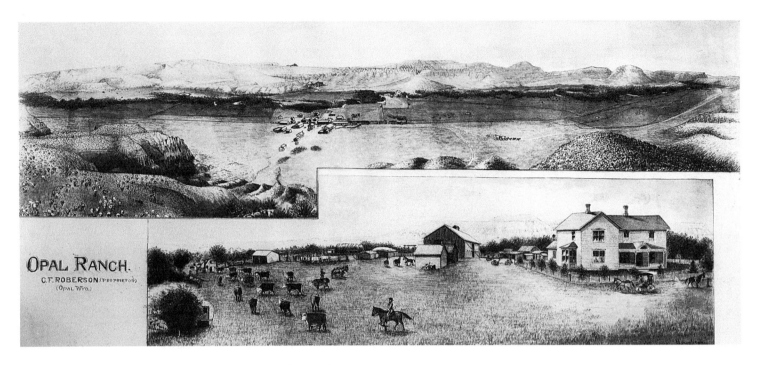

OPAL RANCH.

C.F.ROBERSON.(PROPRIETOR)
(OPAL WYO.)

PLATE 31. *Opal Ranch of C. F. Roberson, ca. 1902*

This unique sketch combines Houghton's two types of ranch drawings—the wide-angle and the closer portrait views—into one. Opal (pronounced Ō-pal) was started in 1890 along the Oregon Short Line in the Ham's Fork River valley and soon became a shipping point for ranches to the north. Houghton probably visited the area in 1899 after sketching twenty miles north on Fontenelle Creek. Evanston's *Wyoming Press* featured the drawing and several others from the area in its *Special Illustrated Edition*

on May 3, 1902. Both a train and a stage are depicted departing from Opal as a herder and his dog tend to their sheep at lower left. The Roberson ranch is behind the town to the right.

The bottom portrait view shows a fine-looking house with a neat and orderly yard with trees and a fence. Barns, outbuildings, farm equipment, sheep wagons, horses, and cattle appear in the field. Courtesy, Jonita Sommers Photograph Collection, Pinedale, WY.

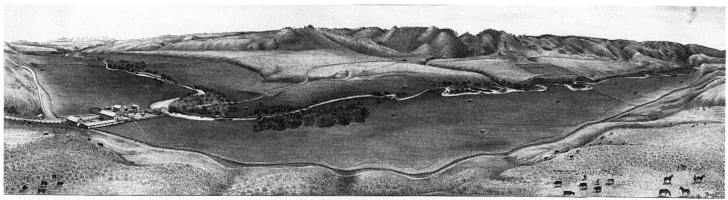

RANCH OF N.K.BOSWELL.
ALBANY CO. WYO.

PLATE 32. *Ranch of N. K. Boswell, Albany Co., Wyo., 1903*

At nearly six feet wide, Houghton's sketch of the N. K. Boswell Ranch on the Big Laramie River near the Colorado border dates to the spring of 1903 just as the artist was preparing his first book on Encampment. Nathaniel Kimball Boswell had served in the Civil War and then came to Wyoming in 1867. He was a vigilante, served as the first Albany County sheriff, swore in the world's first female jury, and was an important rancher and merchant.

For his sketch, Houghton used a wide-angle composition for the drawing, placing the ranch in the river's broad valley and showing both tinted hayfields and grazing lands alongside it. The *Saratoga Sun* on April 9, 1903, called the scene "one of the most striking and inviting that this country has to offer to the sight-seeing public." Houghton no doubt made this, his largest ranch drawing, for a truly larger-than-life frontier character.

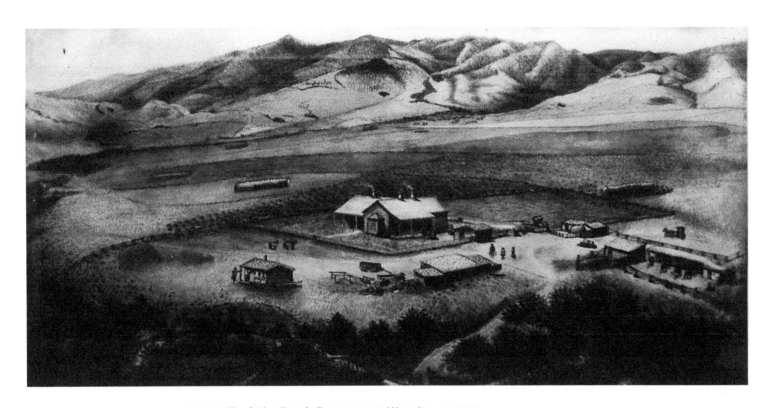

PLATE 33. *Toothaker Ranch, Encampment, Wyoming, ca. 1903*

In a May 1, 1983, *Casper Star-Tribune* story, Encampment historian Candy Moulton described that her neighbor Wilbur Toothaker, born in 1896, was six years old when Merritt Dana Houghton sketched the family ranch east of town. According to the story, Toothaker pointed to the small boy in the drawing and said "that's me." Toothaker described how Houghton sat on a hill above the ranch buildings and sketched the main elements of the ranch layout in pencil. The artist then moved down to the yard to put in detailing, including farm tools and people. After completing the sketch in pencil, Houghton went over it in pen. The result is a typical portrait-style ranch illustration, focusing on the main house and outbuildings, with the fields spreading to the distant mountains. A close look shows several horses, farm equipment, and four people, including Toothaker, lower right, all watching the artist at work. Courtesy, Candy Moulton.

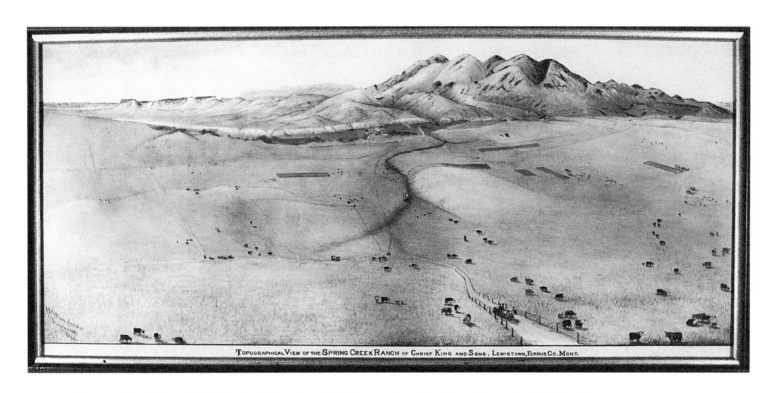

TopographicalView of the Spring Creek Ranch of Christ King and Sons , Lewistown,Fergus Co.Mont.

PLATE 34. *Topographical View of the Spring Creek Ranch of Christ King and Sons, Lewistown, Fergus Co. Mont., 1906*

Like many Houghton drawings, this view of the Montana ranch of Christ King was unknown to me until the owner surfaced after I made a presentation about the artist. In this case, it was my autumn 1994 *Montana: The Magazine of Western History* article and the owner was Marjorie W. King, whose letter to the editor appeared in the winter 1995 issue. The letter featured two 1906 Houghton drawings, this wide-angle topographical one and a tighter-focused portrait of her husband's family's

former Spring Creek Ranch west of Lewistown. The family sold the ranch in 1935 to Hutterites, who founded the King Ranch Colony that year. King related in her letter that the drawings had been stored for a long time until she and her husband found them while doing a family history and decided to frame and display them. I expect that similar Houghton drawings will come forward after this publication. Courtesy, *Montana: The Magazine of Western History.*

Business Views

Houghton's business views are urban versions of his ranch sketches. The sketches were probably ordered by conscription. They are usually narrow in angle, focusing on the business that hired him. Several appeared in his two books.

Both the *Trabing Commercial Co.'s Store* and the Laramie *Soda Works* are images showing the earlier line-type engraving used in his 1891 *Wyoming Illustrated Monthly* rather than the half-tone engraving used by Coutant's *History* in 1899 and thereafter in Houghton's own two books. That would probably make *Soda Works* the oldest surviving Houghton sketch.

As in his mining views, Houghton presented these businesses as neat and orderly, with smoke rising from chimneys and people in the streets. Also as with those sketches, business owners likely hired Houghton to sketch their enterprises, and he handed over the views to them when he was done. Many were lost over time. The Trabing Company Store here is a reproduction but the other three, all originals, come from museums and archives in Wyoming.

PLATE 35. *Trabing Commercial Co.'s Store, Laramie, Wyoming, 1891*

Augustus and Charles Trabing were merchants and freighters in early Wyoming, supplying military posts on the Bozeman Trail. After the completion of the Union Pacific Railroad, the brothers moved their enterprise to Laramie in 1869 and opened a store adjacent to the tracks. They built the store in Houghton's sketch in 1883 on the corner of Second and Garfield in downtown Laramie, selling groceries, wines, liquors, tobaccos, cigars, machinery, and farm wagons. After Charles died in 1885, Augustus consolidated the business and started a ranch and farm outside of town. He also served on the city council and two terms as mayor. Houghton's 1891 sketch of the business is from his short-lived *Wyoming Illustrated Monthly* newspaper and used the line engraving style of reproduction, with its black lines for shading, rather than half-tones made popular by 1900. His sketch showed the building four years before it burned to the ground, at a loss of $132,000. Courtesy, Wyoming Digital Newspapers Project.

PLATE 36. *Soda Works, Laramie, Wyoming, 1891*

Although Houghton did not include this sketch in his 1891 *Wyoming Illustrated Monthly* newspaper, he did write about the Laramie Chemical Works, or Soda Works, in that paper, and its line engraving style fits this early date. According to Houghton, the Union Pacific Railway had started the plant in 1886 one mile north of town and adjacent to both the tracks and the Laramie River, as clearly seen in his sketch. The works occupied several acres and employed fifty-four men who daily produced 3,000 pounds of "custic soda," or lye, used in making candles and glass. Typical of Houghton's boosterism, the sketch shows a dozen stacks billowing smoke into the sky, suggesting that the plant was operating at full capacity, though Houghton's article noted that the works had been mostly idle the previous year. If indeed Houghton drew this for his 1891 newspaper, it may be one of his oldest surviving sketches. Courtesy, Wyoming State Museum, Cheyenne.

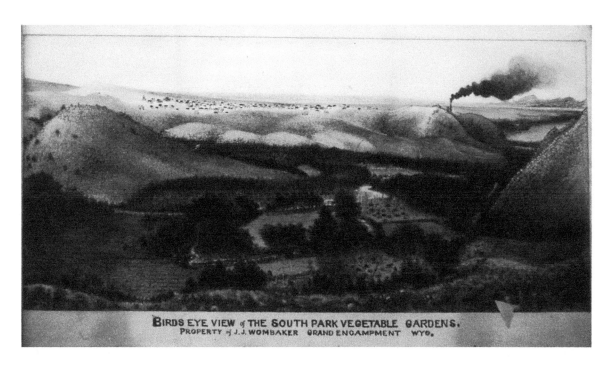

PLATE 37. *Bird's-Eye View of the South Park Vegetable Gardens, Property of J. J. Wombaker Grand Encampment, Wyo., 1903*

As discussed in chapter 3, the August 15, 1902, issue of the *Grand Encampment Herald* described J. J. Wombaker as "the Vegetable Man" and explained that he used a sub-irrigation system to water his 100-acre ranch, which produced thirty-five tons of vegetables in 1901 including radishes, lettuce, cabbage, beans, peas, turnips, parsley, spinach, pumpkins, squash, cucumbers, beets, celery, and potatoes. The article concluded that the gardens were a "welcome sight from the big hills surrounding it" and an "oasis in the desert."

Houghton might have read about Wombaker, or perhaps the "vegetable man" commissioned the artist to draw his business. Houghton's sketch looks north over the gardens, with the barren hills framing the verdant farm. In the distance, Encampment spreads across a hill as smelter smoke billows from a barely visible stack—a constant reminder of why the town and gardens were there. Courtesy, Grand Encampment Museum, Encampment, WY.

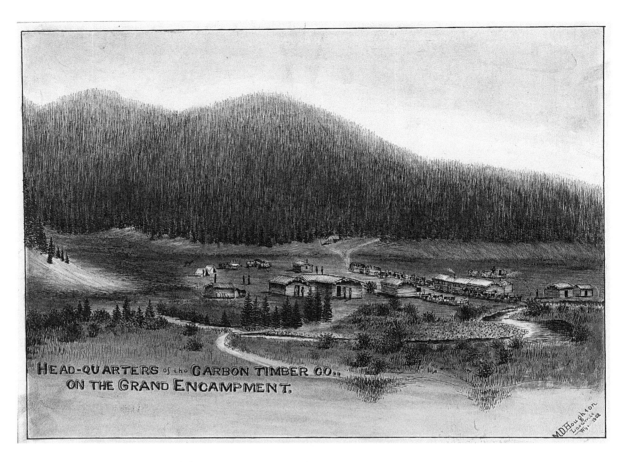

PLATE 38. *Head-quarters of the Carbon Timber Co. on the Grand Encampment, 1902*

Between 1900 and 1916, the Carbon Timber Company employed around 300 "tie hacks" each winter to process railroad ties, mine timbers, and firewood from the forests south of Encampment. The "choppers" worked all winter shaping and stacking the timbers along water sources, then floated them down in the spring runoff to the Encampment River, then the North Platte, and on to Fort Fred Steele, where men fished them from a boom across the river and loaded them onto trains. Houghton sketched both the tie-loading plant and the company headquarters at Hog Park, twenty miles south of Encampment, which served as a commissary for the scattered hacks. Although the camp contained many bachelors and had a rough reputation, Houghton pictured it as a bucolic camp of log buildings and tents set in a forest opening with horses grazing nearby. Courtesy, Wyoming State Museum, Cheyenne.

Topographical Views

The views of the *Grand Encampment Mining Districts, Wyoming* and *Sunset Farms, West Spokane,* Washington, are basically bird's-eye views of larger spaces, incorporating many mines or farms into one broad scene. Put another way, these are spectacular constructions of the imagined western landscape that link the national grid of range, township, and section numbers superimposed on the real "on-the-ground" landscape of mountains and rivers, as well as the "built environment" of mines, ranches, farms, crops, and roads. Geographer John Brinckerhoff Jackson defined a landscape as the "human organization of space," and these two Houghton views bring that definition to reality.[1]

While an individual ranch or mine sketch can be used to locate and document specific items in a sketch, historians and geographers can use these two drawings to find multiple locations, compare the use of land across property lines, and hone in on individual properties. In that sense, these two drawings are indeed maps to the two places where Houghton did most of his work: Grand Encampment and Spokane.

What's even more amazing is the fact that versions of both views survive, the Sunset Farms sketch as a print at the Northwest Museum of Arts and Culture in Spokane and the Grand Encampment view as the original brass engraving plate at a collector's home in Saratoga, Wyoming, in which new "original" copies can still be made to this day.

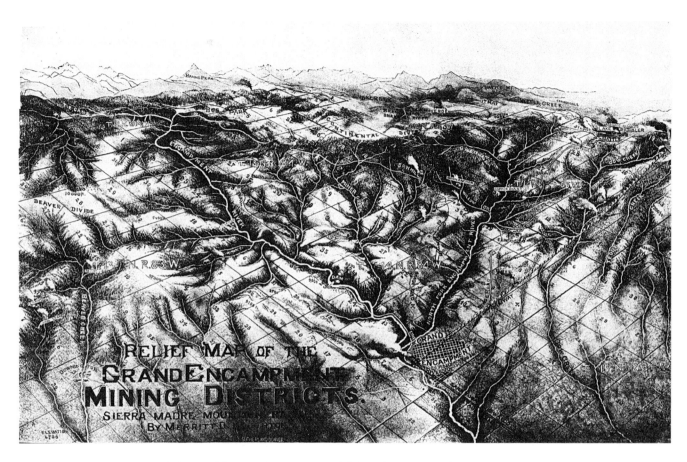

PLATE 39. *Relief Map of the Grand Encampment Mining Districts, Wyoming, 1903*

This drawing might be the most spectacular Houghton sketch. First, it is a bird's-eye view showing the relationship between Encampment and its surrounding topography of mountains, hills, rivers, lakes, watersheds, and creeks. Second, Houghton placed the two-dimensional networks of survey markings in the form of Encampment's town plat and the national grid of ranges, townships, and sections over this topography. Third, the artist added yet another layer showing the area's built environment, including mines, townsites, smelter smoke, a dam, the tie camp, and the aerial tramway. Together, this layering of information is in essence a GIS—geographic information system—map of Houghton's work around Encampment. But Houghton had no satellites, Google Earth, airplanes, or computers; only boots on the ground and existing maps. He then had to bring everything together using just his pencil, pen, and paper. Courtesy, Dick Perue/Bob Martin Collection, Historical Reproductions by Perue, Saratoga, WY.

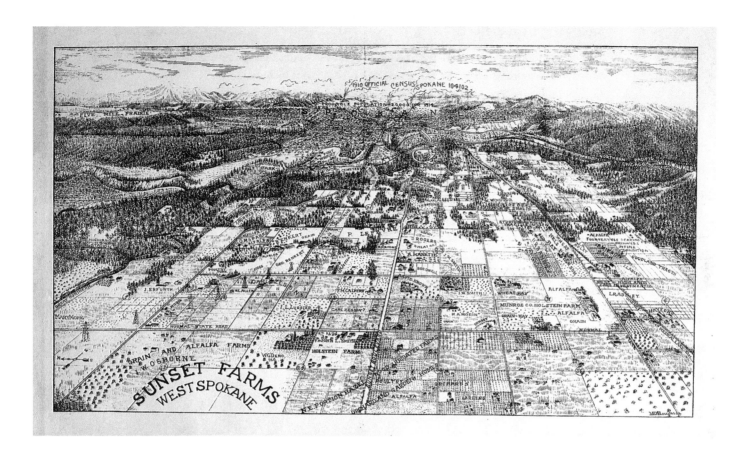

PLATE 40. *Sunset Farms, West Spokane, Washington, 1914*

Houghton's view of *Sunset Farms, West Spokane, Washington,* is equally remarkable as an early twentieth-century GIS map. Houghton first created this bird's-eye view of Spokane-area topography, with its distant mountains, canyons, forests, and farms, from the western neighborhood of Sunset Farms. He added survey lines showing range, township, and section numbers of the national grid. The artist then layered built environment infrastructure, including power lines, roads, and three railroads (Great Northern, Northern Pacific, and Chicago and Milwaukee)

plus the Cheney/Medical Lake Electric trolley line. He then sketched local landmarks, including Fort Wright, Windsor Gardens (featured in the *West Spokane* sketch), and Spokane—both city and name—spread across the distance, with a booster's census count in the clouds. Finally and most amazing, Houghton added in farmers' names and their major crops, such as poultry, wheat, and others. The result is a World War I–era cultural landscape map of a Spokane hinterland. Courtesy, Northwest Museum of Arts and Culture, Spokane, WA.

Historical Views

In 1898 and 1899, Houghton made historical sketches mostly of Wyoming forts and stage stations for C. G. Coutant's *History of Wyoming*. These were not imagined drawings of what he thought the structures might look like but researched drawings based on oral interviews with people who had been there and returned with him to the locations, historical archaeology where he looked for the foundations of historical buildings in the field, and review and revision when he sent his drafts to further eyewitnesses for their comments and revised his sketches accordingly.

Newspapers were so impressed with Houghton's historical sketches that they described them as "restoring" rather than "re-creating" the original posts. Coutant included thirteen illustrations in his book, though Houghton made others such as *Old Fort Collins* and his several views of Fort Bridger that were not included.

Houghton's sketches of scenes along the Platte River Road remind one of the famous photographer and Houghton contemporary William Henry Jackson who, in his late eighties in 1932, began painting scenes he had visited as a young man sixty years prior—except that Houghton did his drawings three decades earlier. Of course, Houghton had not come West as early as Jackson did, but he too had arrived on the transcontinental railroad in the 1870s, possibly traveled the Cheyenne to Deadwood route in 1877, and worked as a photographer in the 1880s.

Unlike his other works, Houghton's historical sketches should not be read as historical documents of the time represented but as historical reproductions of the time in which they were made.

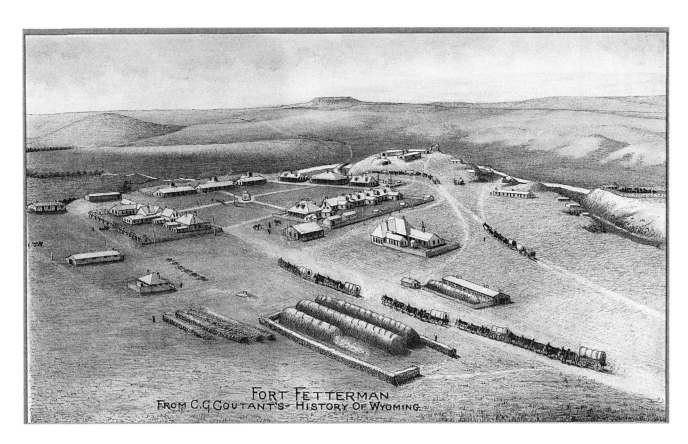

PLATE 41. *Fort Fetterman, from C. G. Coutant's* History of Wyoming, *1898*

The US Army established Fort Fetterman in 1867 on the bluffs south of the North Platte River to protect travelers on the Oregon and Bozeman Trails and to supply soldiers engaging Plains Indians. When the Fort Laramie Treaty of 1868 abandoned forts further north, Fort Fetterman became the starting point for expeditions against the Sioux, Cheyenne, and Arapaho. After the Great Sioux War ended, the army abandoned the post in 1882, and locals dismantled and removed its buildings.

Period newspapers reported that when Houghton visited in March 1898 with "old frontiersmen," he only found foundations and stone fireplaces. He then received descriptions of each building, drew pencil sketches of each one, solicited critiques, and revised the drawings until everyone was satisfied. Houghton then revised the sketch in ink.

The drawing shows a neat and orderly post, bustling with long wagon teams and neat haystacks. Even in this historical "re-creation," Houghton's boosterism shines through. Courtesy, Wyoming State Museum, Cheyenne.

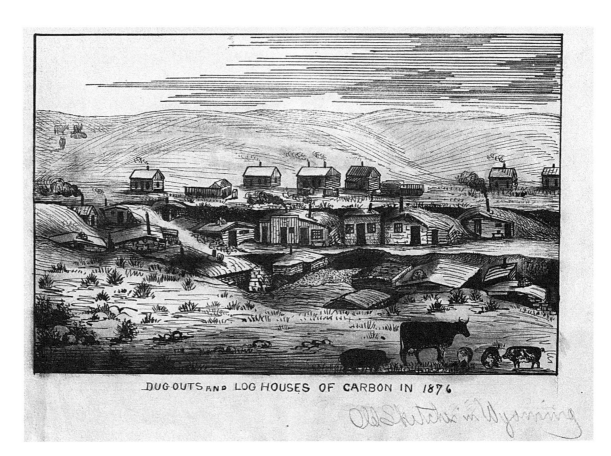

DUG-OUTS AND LOG HOUSES OF CARBON IN 1876

PLATE 42. *Dugouts and Log Houses of Carbon in 1876, c. 1899*

It is not known whether Houghton sketched this scene in 1876 or if it was a later historical drawing that he did in preparation for Coutant's *History.* Houghton might have lived in Carbon when he first arrived in Wyoming. A newspaper clipping from 1878 stated that Mrs. Houghton had arrived in Laramie from Carbon. If indeed this sketch is an original, it would be Houghton's earliest known sketch, predating the next oldest by over a decade. The line shading technique evident in the clouds is more like his 1891 views in his short-lived *Wyoming Illustrated Monthly* newspaper and the *Soda Works* image. If it is a historical sketch, Houghton's penciled-in line "Old Sketches in Wyoming" would support that nostalgic view. Regardless, Houghton's penchant for booster-ism suggests that living conditions in Carbon, whether documented at the time or by memory, were worse than depicted here. Courtesy, Wyoming State Archives, Cheyenne.

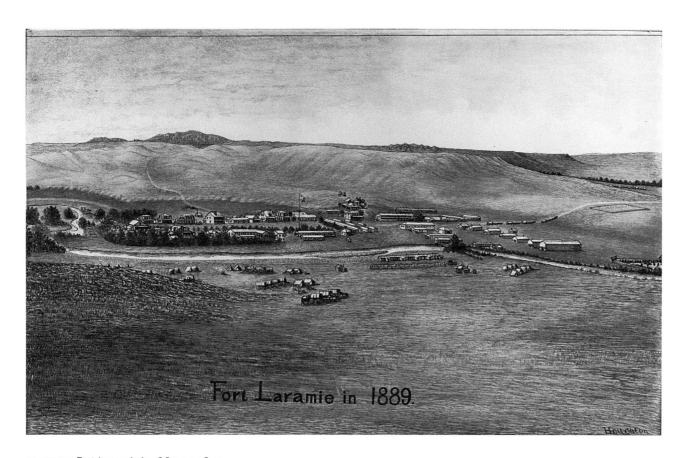

Fort Laramie in 1889.

PLATE 43. *Fort Laramie in 1889, ca. 1899*

Unlike his visit to the site of Fort Fetterman, which had been documented in Wyoming newspapers, there are no records of how Houghton researched and drew this view of Fort Laramie. If the artist did travel to Fort Laramie, he would have found much more in place than a few foundations and chimneys. In fact, although the army had abandoned the fort in 1890, its buildings had been sold to three individuals who each created homesteads on their portions of the grounds. There were also historical photos of the fort that Houghton could have used.

This view is similar to Houghton's wide-angle ranch views that placed the subject in its broader surroundings from a high vantage point. Those knowledgeable about the fort can easily spot iconic buildings, including the sutler's store, Old Bedlam, and the cavalry barracks. Today, only a dozen historical structures remain standing at the site. Courtesy, Wyoming State Museum, Cheyenne.

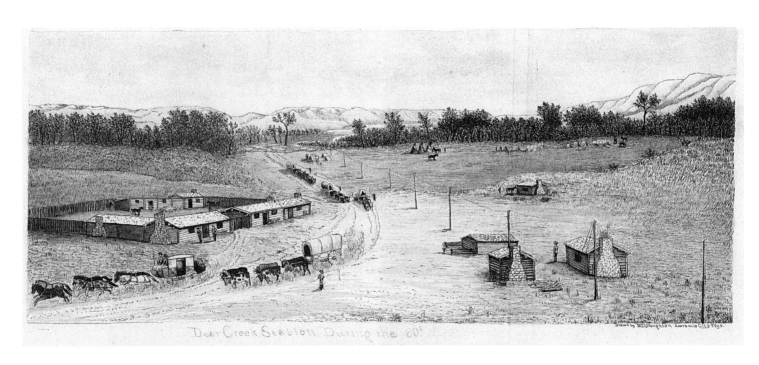

Deer Creek Station During the 60's

Drawn by M.D. Houghton Laramie City, Wyo.

PLATE 44. *Deer Creek Station during the 1860s, ca. 1898*

Deer Creek Station, located in what today is Glenrock, Wyoming, stood on the Oregon-California-Mormon Trail at the confluence of Deer Creek and the North Platte River between 1857 and 1866. It began as a trading post, served as a stage stop, and in 1860 became a station on the short-lived Pony Express. The transcontinental telegraph line then followed nearby, and during the Civil War, the army stationed soldiers across the trail. In 1866, Indians burned the Deer Creek Station to the ground.

No newspapers show that Houghton visited the site or conducted historical archaeology. He did travel along the Platte in 1898 making sketches, so it is possible that he visited the site. His drawing for Coutant is almost a composite view, showing the station's various roles throughout its history. A close look reveals migrant wagons, a stagecoach, a corral with a horse (perhaps for the Pony Express), and a telegraph line stretching into the distance. Courtesy, Wyoming State Museum, Cheyenne.

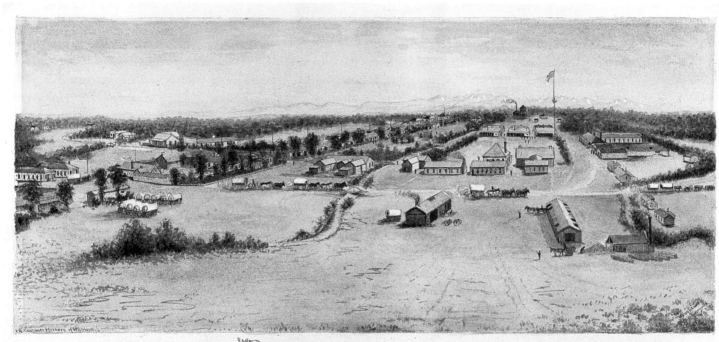

FORT BRIDGER in 1889.

PLATE 45. *Fort Bridger in 1889, ca. 1898*

Fort Bridger, like Fort Laramie, had a long history going back to its founding by Mountain Man Jim Bridger in 1843. It served as a way point for travelers on the Oregon-California-Mormon Trail before being burned by Mormons during the Utah War of 1858. Rebuilt by the army later that year, the fort served as a military post for the army's Indian Wars off and on until the army abandoned it in 1890. Houghton's choice to portray it in 1889 would have been to showcase its last full year in existence.

Like his *Fort Laramie in 1889* view, Houghton painted Fort Bridger from a bird's-eye-view angle, looking down at the fort and showing its main buildings clearly and others less so. The artist's use of watercolor is unusual for a historical view and could be the reason Coutant did not use it in his history. Courtesy, Wyoming State Museum, Cheyenne.

Animal Views

In a 1903 advertisement for his first book on Encampment, Houghton noted that he had included "Animal portraiture" as one of the main illustration themes. As part of the new and growing field of animal history, such sketches provide a visual version of the "historical animal," that is, an understanding of how humans' use of animals over time reflects on human history.

As a frontier artist working in Wyoming, Colorado, Montana, Idaho, and Washington—places with large and powerful stock associations—it made sense for Houghton to include views of both domestic and wild animals in his work. Of the latter, Houghton only made sketches of elk, mountain sheep, and the ubiquitous Wyoming antelope or pronghorn, though for his sketch *Antelope in Pass Creek* he included the phrase "at present the basin is occupied by valuable stock ranches, and antelope have disappeared." Indeed, most of Houghton's animal drawings represent exotic species being transformed into the native as part of the hybrid environment created by Wyoming's settler society.

Animal history does not attempt to anthropomorphize animals so we try and think like they would but instead so we can understand how our relationships with animals have changed over time. Houghton's focus on them is another important part of his story.

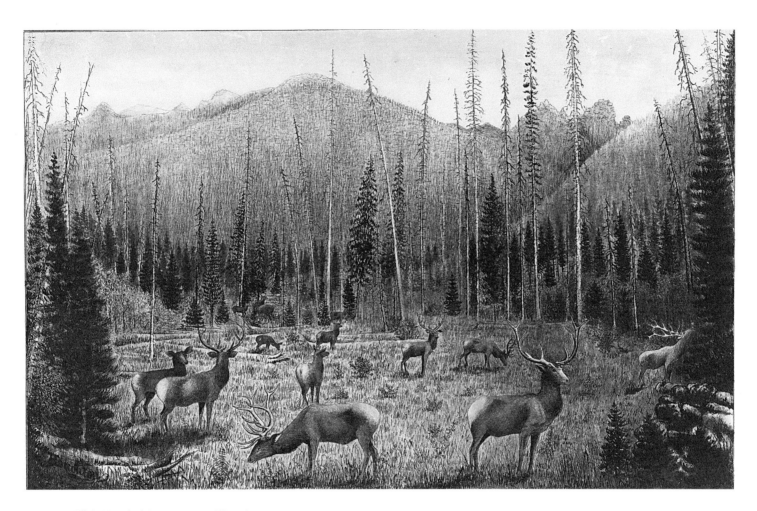

PLATE 46. *Elk in Wooded Country, 1902, Wyoming*

This view of a band of elk in the forest is one of Houghton's most beautiful animal drawings. In his many travels through the mountains and forests of southern Wyoming, Houghton must have come across many scenes such as this. The fact that there are more bulls than cows in the group suggests that the artist probably drew this from his imagination rather than from an actual scene and that perhaps he was going for the majesty of large racks over the accuracy of an actual elk harem. Nevertheless, this sketch shows the power of the wild among Houghton's animal work. Courtesy, Wyoming State Museum, Cheyenne.

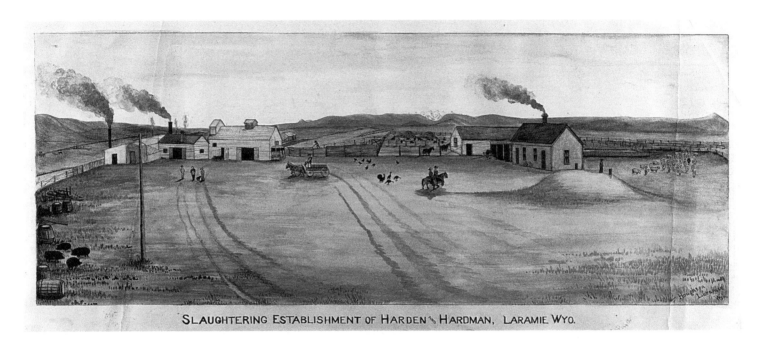

SLAUGHTERING ESTABLISHMENT OF HARDEN & HARDMAN, LARAMIE WYO.

PLATE 47. *Slaughtering Establishment of Harden and Hardman, Laramie, Wyoming, 1903*

According to Laramie newspapers, the slaughterhouse of Charles Harden and J. E. Hartman (not Hardman), located southwest of Laramie along the river, burned to the ground on June 4, 1900. It is safe to assume that this color portrait is of the rebuilt processing facility, and perhaps the partners commissioned Houghton to paint it sometime before they ended their business in January 1906.

There is probably no more prevalent relationship between animals and humans in animal history than that of food. A close look at the painting shows what are probably the partners out front and Houghton's ever-present smoke coming from the chimneys, showing that this is a busy establishment. The artist also included several different animals, including turkeys at left, cattle and horses in the pens at center, and sheep at right. Courtesy, Wyoming State Museum, Cheyenne.

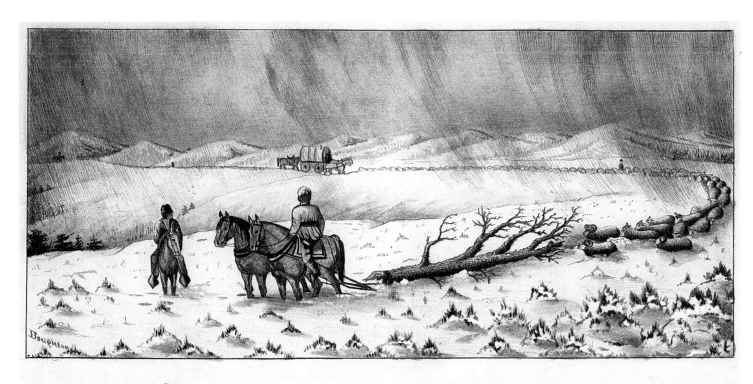

Breaking a Road

PLATE 48. *Breaking a Road, 1903, Wyoming*

This sketch shows another aspect of animal history: using horses and sheep to clear a snowbound road. In this view, most likely made in the Sierra Madres, two men on horses are pulling a dead tree through the snow, followed by hundreds of sheep to pack down the road. The scene is a reminder of innovative ways people have used animals throughout history. Courtesy, Wyoming State Museum, Cheyenne.

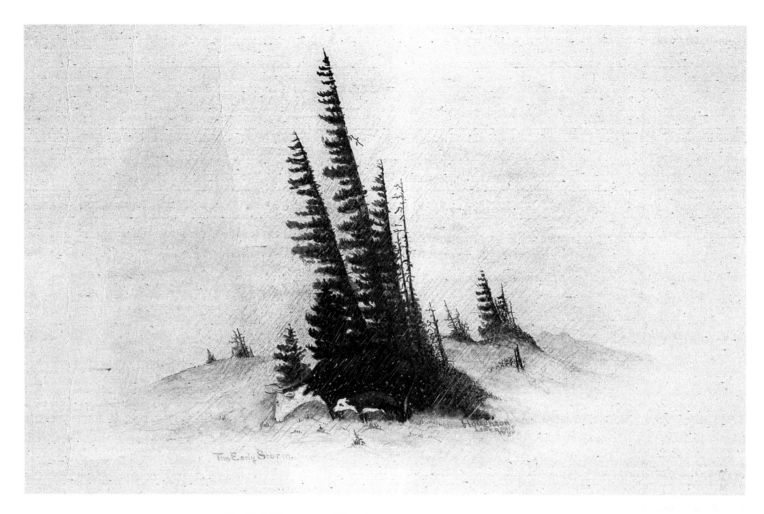

PLATE 49. *The Early Storm, 1903, Wyoming*

In another winter landscape featuring animals, Houghton has painted a typical scene in the high country of southern Wyoming. In this illustration, also known as *The Unexpected Storm*, Houghton shows a Hereford cow and calf caught in an early snowstorm in the mountains. With the one-sided pine trees and blowing snow, one can almost feel the wind as the cattle huddle against the cold. Courtesy, Wyoming State Museum, Cheyenne.

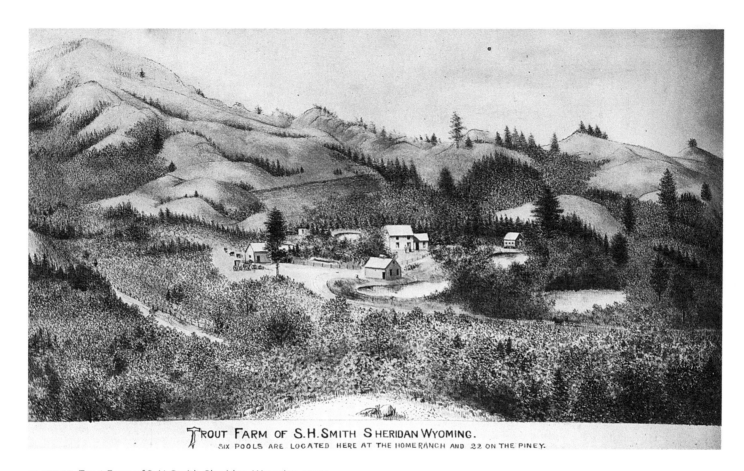

ROUT FARM OF S.H. SMITH S HERIDAN WYOMING.
SIX POOLS ARE LOCATED HERE AT THE HOME RANCH AND 22 ON THE PINEY.

PLATE 50. *Trout Farm of S. H. Smith, Sheridan, Wyoming, 1905*

As discussed in chapter 4, the August 1, 1905, issue of the *Sheridan Post* reported that a local insurance office was displaying this sketch of Sim Smith's fish hatchery. The previous June, the *Post* explained that Smith had sold his Sheridan business in 1904 and purchased a ranch in the nearby hamlet of Banner. He brought in 500,000 Eastern Brook trout and raised them with native trout in six ponds on the property, shipping them out on the railroad in Sheridan. The 1907 *Sheridan City Directory* described

Smith as a "Fish Culturist," and he probably commissioned Houghton to sketch his business.

Houghton drew this bird's-eye view as he had cattle ranches, and the two enterprises were similar. Wyoming ranchers imported exotic Hereford cattle to repopulate the buffalo range, and Smith brought in Eastern Brook trout for better sport fishing. Both used historical animals to transform Wyoming's natural habitat into a hybrid one. Courtesy, Wyoming State Archives, Cheyenne.

Notes

Chapter 1: Introduction

1 "The Portfolio of Views," advertisement, *Grand Encampment Herald*, January 15, 1904, 5; "The Houghton Portfolio," *Saratoga (WY) Sun*, February 11, 1904, 2; *Grand Encampment Herald*, June 10, 1904, 4.

2 Michael A. Amundson, *Merritt Dana Houghton: A Catalogue of Views* (Privately published, 1991).

3 Michael A. Amundson, "Pen Sketches of Promise: The Western Drawings of Merritt Dana Houghton," *Montana: The Magazine of Western History* 44, no. 4 (Autumn 1994): 54–65; Marjorie W. King, "Letters to the Editor," *Montana: The Magazine of Western History* 45, no. 1 (Winter 1995): 88–89.

4 Harold P. Simonson, "Frederick Jackson Turner: Frontier History as Art," *Antioch Review* 24, no. 2 (Summer 1964): 201–211.

5 Patricia Limerick, *The Legacy of Conquest: The Unbroken Past of the American West* (New York: W. W. Norton, 1987); Patricia Limerick, *Something in the Soil: Legacies and Reckonings in the New West* (New York: W. W. Norton, 2001); William Truettner, *The West as America: Reinterpreting Images of the Frontier, 1820–1920* (Washington, DC: Smithsonian, 1991).

6 William Robbins, *Colony and Empire: The Capitalist Transformation of the American West* (Lawrence: University Press of Kansas, 1994); John W. Reps, *Views and Viewmakers of Urban America: Lithographs of Towns and Cities in the United States and Canada, Notes on the Artists and Publishers, and a Union Catalog of Their Work, 1825–1925* (Columbia: University of Missouri Press, 1984); John W Reps, *Bird's Eye Views: Historic Lithographs of North American Cities; Panoramas of Promise: Pacific Northwest Cities and Towns on Nineteenth-Century Lithographs* (Princeton, NJ: Princeton Architectural Press, 1998).

7 Margaret D. Jacobs, *White Mother to a Dark Race: Settler Colonialism, Maternalism, and the Removal of Indigenous Children in the American West and Australia, 1880–1940* (Lincoln: University of Nebraska Press, 2011); Walter L. Hixson, *American Settler Colonialism: A History* (New York: Palgrave Macmillan, 2013), 113–144; Settler Colonial Art History, http://settler-colonial.mystrikingly.com/, accessed February 13, 2020.

8 Mark Junge, *J. E. Stimson: Photographer of the West* (Lincoln: University of Nebraska Press, 1985); Michael A. Amundson, *Wyoming Revisited: Rephotographing the Scenes of Joseph E. Stimson* (Boulder: University Press of Colorado, 2014).

Chapter 2: Finding Vantage Points

1 1850 United States Census, Otsego, Allegan County, Michigan, digital image s.v. "Merritt Houghton," Ancestry.com.

2 "Early Days, Chapter XV," *Black Hills Daily Times* (Deadwood, SD), March 21, 1880, 1. Family trees on Ancestry.com allege that his father died in Cleveland in 1865 and his mother in 1890 in Illinois.

3 After the Civil War broke out, George enlisted as a private in Company D of the Illinois 104th Infantry Regiment on August 12, 1862, and served under General George Henry Thomas in the Western Theater, where he saw action in Tennessee. On July 2, 1863, as the Battle of Gettysburg raged in Pennsylvania, George earned the Medal of Honor at Elk River, Tennessee, after he voluntarily joined a small group of men who captured a stockade while under heavy fire, preserving a bridge for Union troops. He remained in service for three years before being discharged in June 1865. Ancestry.com; Historical Data Systems, comp. U.S., Civil War Soldier Records and Profiles, 1861–1865, Provo, UT, USA, Ancestry. com Operations Inc., 2009; https://web.archive.org/web/20140728055807/http://projects.militarytimes.com/citations-medals-awards/recipient.php?recipien-tid=1115, accessed February 18, 2020.

4 https://www.olivetcollege.edu/about/our-history/, accessed February 18, 2020; *Olivet College 1864 Catalog*, Ancestry.com, U.S., School Catalogs, 1765–1935 [database online]; Provo, UT, USA, Ancestry.com, U.S., School Catalogs, 2012, 9; *Olivet College 1865 Catalog*, Ancestry. com, U.S., School Catalogs, 1765–1935 [database online]; Provo, UT, USA, Ancestry.com, U.S., School Catalogs, 2012, 8; *Olivet College 1866 Catalog*, Ancestry.com Operations, Inc., 9. The 1867 catalog did not list either Merritt or Julia as students.

5 Edward P. Bentley, "Profile of Sarah Anna Benedict" and "Profile of John Harvey Scotford," unpublished articles emailed to me by the author, December 3, 2020; Ed Dobbins, "Profile of Czar J. Dyer," unpublished article emailed to me by the author, December 4, 2020; "John Harvey Scotford" and "Merritt Dana Houghton," Research Completion Forms, Hosford History Center and Lawrence Archives, Olivet College, emailed to me by Olivet Archives Administration and Communications Assistant Hannah Mellino, December 3, 2020.

6 "Normal Drill," *Ottawa (Illinois) Free Trader*, September 19, 1868, 5.

7 "The County Fair," *Ottawa (Illinois) Free Trader*, September 16, 1871, 5; "Early Days, Chapter XV," *Black Hills Daily Times* (Deadwood, SD), March 21, 1880, 1; Omaha, Nebraska, *City Directory*, 1874, Ancestry.com, U.S. City Directories, 1822–1995 [database online]; Provo, UT, USA, Ancestry.com Operations, Inc., 2011.

8 *Omaha City Directory for 1872–73* (Omaha: Briggs and Lowry, 1873), 133, U.S. City Directories, 1822–1995 [database online]; Provo, UT, USA, Ancestry.com Operations, Inc., 2011; J. M. Wolfe, *Wolfe's Omaha Directory for 1874–5* (Omaha: J. M. Wolfe, Publisher, 1875), 131–132, U.S. City Directories, 1822–1995 [database online]; Provo, UT, USA, Ancestry.com Operations, Inc., 2011; "Early Days, Chapter XV," *Black Hills Daily Times* (Deadwood, SD), March 21, 1880, 1; C. Exera Brown, *Brown's Directory of Omaha, Nebraska* (Omaha: C. Exera Brown, Publishers, 1876), 151, U.S. City Directories, 1822–1995 [database online]; Provo, UT, USA, Ancestry.com Operations, Inc., 2011.

9 Marriage License, Merritt D. Houghton to Miss Fanny Apley, July 22, 1875, Omaha, Douglas County, Nebraska, Marriage Records, 1855–1908, Library and Archives of the Nebraska State Historical Society, Lincoln. 1850 United States Census, Hillsborough, Highland, Ohio, digital image s.v. "Frances Apley." 1870 United States Census, Douglas, Omaha, Nebraska, digital image s.v. "Fanny Apley Creed." All from ancestry.com.

10 "Noted Artist Here," *Butte (MT) Daily Post*, September 5, 1906, 10.

11 "Early Days Chapter XV," *Black Hills Daily Times* (Deadwood), March 21, 1880, 1.

12 "Visitors Present," *Laramie Daily Sentinel*, February 22, 1878, 4; "Teachers' Institute," *Laramie Daily Sentinel*, May 16, 1878, 3.

13 I discuss all of this regarding Houghton's contemporary, Cheyenne photographer J. E. Stimson, in Michael A.

Amundson, *Wyoming Revisited: Rephotographing the Scenes of Joseph E. Stimson* (Boulder: University Press of Colorado, 2014), 16. Also T. A. Larson, "Introduction," in Mark Junge, *J. E. Stimson: Photographer of the West* (Lincoln: University of Nebraska Press, 1985), x.

14 Merritt D. Houghton to Mrs. Mary G. Bellamy, January 26, 1914, letter, Houghton File, Wyoming State Archives, Cheyenne; Lori Van Pelt, "Fort Reno and Cantonment Reno: Indian Wars Outposts on Powder River," WyoHistory.org website, https://www.wyohistory.org/encyclopedia/fort-reno-and-cantonment-reno, accessed March 28, 2020; "Personal," *Black Hills Daily Times* (Deadwood), May 31, 1878, 1.

15 "Carbon County Republican Ticket," *Laramie Daily Sentinel*, October 18, 1878, 4.

16 Over his lifetime, Houghton ran as a Republican, a Democrat, a Populist, and a Socialist.

17 "The Teachers' Institute," *Laramie Sentinel*, May 16, 1879, 3; "Historical Decennial Census Population for Wyoming Counties, Cities, and Towns," http://eadiv.state.wy.us/demog_data/pop2000/cntycity_hist.htm; Wyoming Department of State / US Census Bureau [retrieved June 30, 2008]. Although Rawlins by this time had grown out of its creation as the Union Pacific's Rawlins Springs construction camp to a community of about 1,400 and the seat of Carbon County, it was still a rough place, as shown by the lynching of infamous outlaw "Big Nose" George Parrott in 1881, the removal of Parrot's brain for study by Rawlins doctor John E. Osborne (later Wyoming's third territorial governor), and the making of skin from the outlaw's thighs into a pair of shoes. See "Bones of Notorious Outlaw Found in Rawlins Rum Keg," *Casper Tribune-Herald*, May 12, 1950, 18.

18 1880 United States Census, Rawlins, Carbon County, Wyoming, digital image s.v. "Merritt Houghton," Ancestry.com; Ida Purdy Harrell, WPA Biographical Sketch on Merritt D. Houghton, Houghton File, Wyoming State Museum, Cheyenne.

19 "Supt. Houghton's Say," *Carbon County Journal* (Rawlins), September 4, 1880, 3. The January 1, 1881, issue of the Rawlins newspaper was the last to list Houghton as the Carbon County superintendent of schools.

20 "Photographic Rooms at Houghton's," *Carbon County Journal* (Rawlins), January 17, 1880, 4.

21 "Local Intelligence," *Uintah Chieftain* (Evanston, WY), March 24, 1883, 3.

22 "Home Happenings," *Carbon County Journal* (Rawlins), June 16, 1883, 3.

23 "Don't Care Much," *The Weekly Boomerang* (Laramie), November 8, 1883, 2; "Out and About," *Carbon County Journal* (Rawlins), December 21, 1883, 3; "M.D. Houghton, Photographer," advertisement, *Carbon County Journal* (Rawlins), December 21, 1883, 4.

24 The largest collection of Houghton photographs is in the Wyoming State Archives Photo Collection, Cheyenne. Others were found online, at the Amon Carter Museum of American Art in Fort Worth, Texas, and at the Carbon County Museum in Rawlins, Wyoming. After these photographs, Houghton never again photographed or sketched Native peoples or their communities. This absence is striking, especially given the fact that he spent the rest of his life near reservations in the West. In fact, the only mention of any interest in anything Native occurred in 1909 when he registered for a drawing for lands being severed from the Coeur d'Alene Reservation in eastern Washington. This lack of interest in Native peoples and extensive documentation of settlers suggests a tie to settler colonialism.

25 The *Carbon County Journal* for June 14, 1884, on page 3 under the headline "Carbon Currency," notes that "Fred M. Baker, our eminent photographer, and champion horse breaker," was suffering from mountain fever.

26 "Saturday's Sayings," *Carbon County Journal* (Rawlins), January 12, 1884, 3; "Home Happenings," *Carbon County Journal* (Rawlins), January 12, 1884, 3; "Buffalo Echo," *Carbon County Journal* (Rawlins), February 2, 1884, 4.

27 "M.D. Houghton, Photographer, Buffalo, Wyo.," advertisement, *Big Horn (WY) Sentinel*, September 13, 1884, 1.

28 John Carter, *Solomon D. Butcher: Photographing the American Dream* (Lincoln: University of Nebraska Press, 1985), 10.

29 T. A. Larson, *History of Wyoming*, 2nd ed. (Lincoln: University of Nebraska Press, 1981 [1965]), 268–284.

30 "The Ice Walk: An Almost Unknown Canon of the Platte with Walls Three Thousand Feet in Height," *The Daily Boomerang* (Laramie), December 9, 1886, 4. This location is now under the Pathfinder Reservoir.

31 "Bird's Eye View of Laramie," *The Daily Boomerang* (Laramie), December 14, 1887, 4. This view is not known today. His later bird's-eye view drawing of Laramie has several of these features but looks the other direction toward the Laramie Plains and the Medicine Bow Mountains.

32 "Bird's Eye View of Laramie," 4.

33 John W. Reps is the dean of bird's-eye view historians. Two of his many books include *Views and Viewmakers of Urban America: Lithographs of Towns and Cities in the United States and Canada, Notes on the Artists and Publishers, and a Union Catalog of Their Work, 1825–1925* (Columbia: University of Missouri Press, 1984) and *Panoramas of Promise: Pacific Northwest Cities and Towns on Nineteenth Century Lithographs* (Pullman: Washington State University Press, 1984). The Library of Congress also has a website devoted to such images in its collection based on John R. Hébert, *Panoramic Maps of Anglo-American Cities: A Checklist of Maps in the Collections of the Library of Congress, Geography and Map Division* (Washington, DC: Library of Congress, 1974). See "Panoramic Maps," https://www.loc.gov/collections/panoramic-maps, accessed July 19, 2020.

34 Reps, *Views and Viewmakers of Urban America*, 17–23.

35 Candy Moulton, "Ranch Artist," *Wyoming Horizons* 3 (May 1, 1983): 10.

36 A YouTube search for "pen and ink drawing" or "ink wash" provides modern videos of these techniques. "Drawing of Fort Fetterman," *Daily Boomerang* (Laramie), March 21, 1898, 2.

37 "A Fine Picture of Sheridan," *Sheridan Post*, July 25, 1905, 1. A modern approach to similar scenes is explained in Jason Blevins's book about an artist who painted ski resorts, *The Man Behind the Maps: Legendary Ski Artist James Niehues* (Italy [no city]: Open Road Ski Company, 2019), 20–37.

38 Merritt Dana Houghton, *Wyoming Illustrated Monthly* (Laramie), January 1891. Ricker's sketch is discussed in "The City Council," *Weekly Boomerang* (Laramie), December 20, 1888, 5; "Ott Isn't Pleased," *Daily Boomerang* (Laramie), December 21, 1888, 2; "The Boomerang's Boom," *Daily Boomerang* (Laramie), December 24, 1888, 4. Although the actual image could not be found in the paper, it is available as a print from online art dealers such as Vintage City Maps at https://www.vintagecitymaps.com/product/laramie-wy-1889/, accessed September 19, 2021. It is also discussed in "Out on Monday," *Laramie Daily Boomerang*, April 13, 1889, 4.

39 Reps, *Views and Viewmakers*, 24–44.

40 "History of Wyoming Heraldry," http://www.hubert-herald.nl/USAWyoming.htm, accessed July 22, 2020.

41 The Albany County Historical Society website contains much local information on Laramie history. See https://www.wyoachs.com/, accessed July 22, 2020. Also Timothy H. Evans, "Piece-Sur-Piece Horse Barns on the Laramie Plains of Southeastern Wyoming: Cultural Interplay and Adaptation," *Material Culture* 38, no. 1 (Spring 2006): 54–87; Robert Homer Burns, Andrew Springs Gillespie, and Willing Gay Richardson, *Wyoming's Pioneer Ranches* (Laramie, WY: Top-of-the-World Press, 1955), 266–276.

42 M. D. Houghton, "Wyoming Illustrated," *Wyoming Illustrated Monthly* (Laramie), January 1891, 8.

43 Houghton, "Wyoming Illustrated," 8.

44 "Illustrated Monthly," *The Boomerang* (Laramie), January 15, 1891, 2; *Buffalo (WY) Bulletin*, January 15, 1891, 2; *Carbon County Journal* (Rawlins), January 17, 1891, 3; "Wyoming Illustrated Monthly," *Laramie Weekly Sentinel*, January 3, 1891, 3.

45 Houghton, "Wyoming Illustrated," 8; *Newcastle (WY) News*, January 30, 1891, 5; "Illustrated Monthly," *Laramie Boomerang*, January 15, 1891, 2.

46 *Carbon County Journal* (Rawlins), May 16, 1891, 2.

47 "Carbon Outings," *Carbon County Journal* (Rawlins), February 28, 1891, 3; "Rawlins Republican," *Laramie Daily Boomerang*, April 11, 1891, 4; "To Illustrate Buffalo," *Laramie Boomerang*, February 26, 1891, 2.

48 1900 United States Census, Laramie, Albany County, Wyoming, digital image s.v. "Merritt Houghton," Ancestry.com; "A 1907 Sanborn Fire Insurance Map from Laramie, Albany County, Wyoming," Library of Congress Geography and Map Division, Washington, DC, http://hdl.loc.gov/loc.gmd/g4264lm.g097661907, accessed July 19, 2020.

49 "In Social Circles," *Laramie Republican*, May 26, 1900, 1; "In the Social Realm," *Daily Boomerang* (Laramie), July 28, 1900, 4; "This, That, and the Other," *Laramie Boomerang*, August 2, 1894, 2; "This, That, and the Other," *Laramie Boomerang*, August 30, 1894, 2.

50 Ida Purdy Harrell, WPA Biographical Sketch on Merritt D. Houghton, Houghton File, Wyoming State Archives, Cheyenne.

51 "History of Woods Landing Resort," https://woodslanding.com/history/, accessed July 19, 2020.

52 "A Few Chosen," *Laramie Boomerang*, October 13, 1892, 2.

53 "People's Party Men," *Laramie Boomerang*, March 30, 1893, 12.

54 "Vote of Albany County Election—1902," *Laramie Weekly Boomerang*, November 20, 1902, 6.

55 Harrell, WPA Biographical Sketch.

56 *Laramie Weekly Sentinel*, October 18, 1890, 3; "Our Literary Ladies," *Laramie Boomerang*, May 2, 1892, 1; "Ladies Literary Club," *Laramie Weekly Sentinel*, December 16, 1893, 3; "In Social Circle," *Laramie Daily Boomerang*, October 12, 1895, 3; "Clubdom," *Laramie Daily Boomerang*, October 13, 1900, 4; "Clubdom," *Laramie Weekly Boomerang*, May 17, 1900, 3; "Clubdom," *Laramie Daily Boomerang*, February 12, 1900, 2; "Local Brevities," *Laramie Boomerang*, May 28, 1903, 4; "Personal Paragraphs," *Laramie Republican*, October 11, 1900, 1; "This, That, and the Other," *Laramie Daily Boomerang*, October 31, 1898, 3; "Laramie's Night School," *Laramie Daily Boomerang*, April 5, 1899, 3; "Slater in Laramie," *Cheyenne Daily Sun-Leader*, March 30, 1897, 4; "The World of Spirits," *Laramie Semi-Weekly Boomerang*, April 1, 1897, 8. In 1884, Frances wrote an erudite 900-word letter to the editor in Rawlins supporting women's suffrage in Wyoming. See "Woman Suffarage [*sic*]," *Carbon County Journal* (Rawlins), June 14, 1884, 4.

57 Burns, Gillespie, and Richardson, *Wyoming's Pioneer Ranches*.

58 Chip Carlson, *Tom Horn: "Killing Is My Specialty"* (Cheyenne, WY: Beartooth Corral, 1991).

59 "History of Wyoming," *The Daily Boomerang* (Laramie), January 5, 1897, 3.

60 "History of Wyoming," *Laramie Republican*, June 29, 1897, 4.

61 "Colonel Coutant and His History," *Wyoming Derrick* (Casper), December 9, 1897, 5.

62 "Fort Caspar Restored," *Cheyenne Daily Sun-Leader*, December 9, 1897, 4; "History of Wyoming," *Newcastle (WY)-News-Journal*, December 17, 1897, 4.

63 *Wheatland (WY) World*, February 18, 1898, 3; *Wyoming Derrick* (Casper), March 17, 1898, 5.

64 "Drawings of Fort Fetterman," *The Daily Boomerang* (Laramie), March 21, 1898, 2.

65 *Wyoming Derrick* (Casper), April 14, 1898, 5; "A Health Resort," *Wyoming Derrick* (Casper), September 1, 1903, 1; Lori Van Pelt, *Dreamers and Schemers: Profiles from Carbon County, Wyoming's Past* (Glendo, WY: High Plains Press, 1999), 75–80, 130–132, 136, 153–160.

66 "Painting Landmarks," *Cheyenne Daily Sun-Leader*, June 22, 1898, 4.

67 "History of Wyoming," *Saratoga (WY) Sun*, July 21, 1898, 4; "Briefly Mentioned," *Laramie Republican*, July 23, 1898, 4.

68 "Personal," *The Weekly Courier* (Fort Collins, CO), December 22, 1898, 1; "Home and County News," *Fort Collins Express and the Fort Collins Review*, January 14, 1899, 1; "Home and County News," *Fort Collins Express and the Fort Collins Review*, January 28, 1899, 1.

69 "Pioneer Days Recalled," *The Weekly Courier* (Fort Collins, CO), July 27, 1899, 2.

70 "History of Wyoming," *Laramie Daily Boomerang*, March 9, 1899, 2.

71 C. G. Coutant, *A History of Wyoming from the Earliest Known Discoveries*, volume 1 (Laramie, WY: Chaplin, Spafford, and Mathison, Printers, 1899).

72 Coutant, *History of Wyoming*. Miller's interior view of Fort Laramie can be found at https://art.thewalters.org /detail/31458/interior-of-fort-laramie/, accessed June 22, 2021.

73 *Laramie Daily Boomerang*, March 16, 1899, 3; *Wyoming Press* (Evanston), June 24, 1899, 4.

74 Jonita Sommers to Michael A. Amundson, thirty-six emails between July 18 and August 17, 2021; Ann Chambers Noble and Jonita Sommers, *Homesteading and Ranching in the Upper Green River Valley* (Laguna Beach, CA: Laguna Wilderness Press, 2021), 103–106, 160–161.

75 Will Bagley, "Fort Bridger," WyoHistory.org, https://www .wyohistory.org/encyclopedia/fort-bridger, accessed July 30, 2020.

76 Mary Bellamy was an old friend of the Houghtons in Laramie and at that time was collecting materials for Wyoming historian Grace Raymond Hebard, who was writing her own history of the state. See Merritt D. Houghton to Mrs. Mary Bellamy, letter, January 26, 1914, Houghton File, Wyoming State Archives, Cheyenne; "Wyoming Postscripts: Writing an 'Authentic' History of Wyoming: Charles G. Coutant," https://wyostate archives.wordpress.com/tag/cg-coutant/, accessed April 20, 2020.

77 "Local News Items," *Laramie Daily Boomerang*, February 9, 1900, 3; "Personal Mention," *Laramie Daily Boomerang*, April 3, 1900, 2; "Personal Mention," *Laramie Weekly Boomerang*, April 5, 1900, 1; "Centennial Notes," *Laramie Daily Boomerang*, April 10, 1900, 2; "May Buy Real Estate," *Laramie Daily Boomerang*, May 19, 1900, 4

78 *Laramie Republican Industrial Edition*, December 1, 1901.

79 *Wyoming Press Special Illustrated Edition* (Evanston), May 3, 1902, 2–3, 15; "Amos W. Smith," *Wyoming Press Special Illustrated Edition* (Evanston), May 3, 1902, 16.

Chapter 3: The Grand Encampment Boom

1 "History of Wyoming," *Saratoga (WY) Sun*, July 21, 1898, 4; Lori Van Pelt, "Encampment, Wyoming: Copper, Lumber and Rendezvous," WyoHistory.org, https:// www.wyohistory.org/encyclopedia/encampment-wyoming, accessed May 16, 2020; Candy Moulton, *The Grand Encampment: Settling the High Country* (Glendo, WY: High Plains Press, 1997); Robert A. Trennert, *Riding the High Wire: Aerial Mine Tramways in the West* (Boulder: University Press of Colorado, 2001), 77–79.

2 "May Buy Real Estate," *Laramie Daily Boomerang*, May 19, 1900, 4

3 "Topographical Sketch of the Laramie Plains," *Laramie Republican*, April 22, 1902, 1; *Laramie Semi-Weekly Boomerang*, April 28, 1902, 6.

4 Frank R. Hollenback, *The Laramie Plains Line* (Denver: Sage Books, 1960); Kenneth Jessen, *Railroads of Northern Colorado* (Boulder: Pruett, 1982), 242–279.

5 *Grand Encampment Herald*, August 1, 1902, 5; *Grand Encampment Herald*, August 15, 1902, 4.

6 "Fine Sulphine Ore," *Grand Encampment Herald*, September 5, 1902, 1; "Ferris-Haggarty Copper Mine," *Grand Encampment Herald*, September 26, 1902, 1.

7 "Town of Grand Encampment," *Wyoming Industrial Journal* (Cheyenne), November 1, 1902, 9.

8 *Saratoga (WY) Sun*, January 15, 1903, 4.

9 William Cronon, *Nature's Metropolis: Chicago and the Great West* (New York: W. W. Norton, 1992), 295–310; Leo Marx, *The Machine in the Garden: Technology and the Pastoral Idea in America* (New York: Oxford University Press, 1964).

10 *Saratoga (WY) Sun*, January 15, 1903, 4; *Grand Encampment Herald*, January 23, 1903, 1; "From a Prospect to a Valuable Mine," *Grand Encampment Herald*, January 23, 1903, 1; Robert L. Brown, *Colorado Ghost Towns: Past and Present* (Caldwell, ID: Caxton, 1972), 197–201; "State News," *Laramie Republican*, January 26, 1903, 3.

11 "News of the Town," *Grand Encampment Herald*, February 6, 1903, 5; "The Town of Saratoga," *Saratoga (WY) Sun*, February 12, 1903, 1; "Have Some Weather over at Saratoga," *Laramie Republican*, February 16, 1903, 1; "Social Happenings," *Laramie Republican*, February 28, 1903, 3; "Laramie and Saratoga," *Laramie Republican*, March 9, 1903, 3.

12 "A Fine Picture," *Saratoga (WY) Sun*, April 9, 1903, 1. The sketch can be found at https://artsandculture.google.com/asset/ranch-of-n-k-bowswell-albany-county-wyoming/GgEk36kni6NewQ, accessed July 7, 2022.

13 "Beautiful Animal Pictures," *Laramie Boomerang*, April 26, 1903, 1.

14 Susan Nance, "Introduction," in *The Historical Animal*, ed. Susan Nance (Syracuse, NY: Syracuse University Press, 2015), 1–16.

15 "A Thirty Foot Lead!" *Grand Encampment Herald*, October 3, 1902, 1; "The Chicago Venture, North Fork and Green Mountain," *Grand Encampment Herald*, May 1, 1903, 1; "Canvassing for Portfolio," *Saratoga (WY) Sun*, May 7, 1903, 1; "Doings at Dillon," *Grand Encampment Herald*, May 8, 1903, 7.

16 *Saratoga (WY) Sun*, May 14, 1903, 1.

17 "Concentrates," *Grand Encampment Herald*, July 17, 1903, 5.

18 "Riverside Doings," *Grand Encampment Herald*, July 24, 1903, 4; "Houghton Preparing Collection of Views," *Grand Encampment Herald*, July 24, 1903, 1.

19 "Houghton Getting up Fine Book of Views," *Grand Encampment Herald*, August 21, 1903, 1.

20 "The Portfolio of Views," advertisement, *Grand Encampment Herald*, August 28, 1903, 3.

21 For example, the November 6, 1903, issue of the *Grand Encampment Herald* featured one story stating that Houghton was in Saratoga ("Concentrates," 5), another reporting that he had been in Pearl where he produced about thirty sketches ("Pearl Notes," also on page 5), a third story suggesting that readers would want to get a copy of the book ("Book of Views to Be Printed Soon" on page 1), and finally an advertisement for the project on page 8. The *Saratoga (WY) Sun*, in a November 5, 1903, story on page 2, noted that the completed portfolio "will be the greatest advertising card for this country . . . and everyone should endeavor to have his mining claim or ranch in it."

22 *Grand Encampment Herald*, August 28, 1903, 1; "Rambler Mining Company," *Grand Encampment Herald*, September 11, 1903, 2; "North American Company Making 99.3% Blister Copper," *Grand Encampment Herald*, September 18, 1903, 1, 6; "Yesterday and Today," *Grand Encampment Herald*, December 18, 1903, 1.

23 "Portfolio Is on the Market," *Grand Encampment Herald*, January 1, 1904, 5.

24 I discuss these ideas more broadly in Michael A. Amundson, " 'The Most Interesting Objects That Have Ever

Arrived': Imperialist Nostalgia, State Politics, Hybrid Nature, and the Fall and Rise of Arizona's Elk, 1866–1914," *Journal of Arizona History* 61, no. 2 (Summer 2020): 255–294. The antelope drawing was first described in the *Laramie Semi-Weekly Boomerang*, January 14, 1895, 8.

25 "Houghton's Portfolio of Views for 1904," advertisement, *Grand Encampment Herald*, January 15, 1904, 5; "The Houghton Portfolio," *Saratoga (WY) Sun*, February 11, 1904, 2; *Grand Encampment Herald*, June 10, 1904, 4.

26 "Laramie and Rawlins," *Laramie Republican*, February 8, 1904, 3; "Concentrates," *Grand Encampment Herald*, April 1, 1904, 5; "Pearl," *Grand Encampment Herald*, May 6, 1904, 1; *Grand Encampment Herald*, June 10, 1904, 5.

27 *Grand Encampment Herald*, July 1, 1904, 1, 5.

28 "Short Stories," *Rawlins Republican*, September 10, 1904, 4.

29 The *Grand Encampment Herald* ran advertisements for Houghton's "Portfolio of Views for 1904" throughout September, October, and November.

30 "Certificates of Nomination," *Laramie Boomerang*, October 28, 1904, 3.

31 "Vote for Your Own Principles" *Laramie Boomerang*, November 6, 1904, 3.

32 "Returns Are Unchanged by Other Precinct Reports," *Laramie Boomerang*, November 10, 1904, 1.

33 *Saratoga (WY) Sun*, November 10, 1904, 4.

34 *Grand Encampment Herald*, November 11, 1904, 4.

35 "Southern Wyoming," *Saratoga (WY) Sun*, November 24, 1904, 1.

36 "His Second Book," *Rawlins Republican*, November 26, 1904, 1; *Wyoming Industrial Journal*, December 1, 1904, 2. For example, see the ad "Houghton's Second Book of Views," *Grand Encampment Herald*, December 23, 1904, 3.

37 In historian John W. Reps's works on bird's-eye view artists, none of the Houghton images from this period are represented.

38 Works Progress Administration, *Wyoming: A Guide to Its History, Highways, and People* (New York: Oxford University Press, 1941), 243.

39 "Pearl," *Grand Encampment Herald*, May 6, 1904, 1; *Grand Encampment Herald*, June 10, 1904, 4.

40 Candy Moulton, "Ranch Artist: M.D. Houghton Captured the Images of Early Wyoming Ranches," Wyoming Horizons section, 10, *Casper Star-Tribune*, May 1, 1983.

41 "The Vegetable Man," *Grand Encampment Herald*, August 15, 1902, 1.

42 Frances E. Strayer-Hanson, *Medicine Bow Valley Pioneers: Closing the Overland Trail/Opening the Union Pacific* (n.p.: iUniverse, 2009), 65, 76–80.

43 "Advertise Wyoming," advertisement, *Saratoga (WY) Sun*, January 5, 1905, 2.

44 Examples of the first ad, "Houghton's Second Book of Views," ran in the *Grand Encampment Herald* on January 6, 13, and 20, 1905, all on page 4. The second ad, "Houghton's Portfolio of Wyoming Views for 1904," also ran in the *Grand Encampment Herald* each week from January 6, 1905, to April 14, excluding April 7, 1905, also on page 4.

45 "His Second Book," *Rawlins Republican*, November 26, 1904, 1.

46 Moulton, *Grand Encampment*, 154–157.

Chapter 4: New Horizons

1 Ads for Houghton's second book continued to appear in the *Saratoga (WY) Sun* in January and in the *Grand Encampment Herald* from January 6 to April 14. See "Advertise Wyoming," *Saratoga (WY) Sun*, January 5, 1905, 5, and, for example, "Houghton's Portfolio of Views for 1904," *Grand Encampment Herald*, April 14, 1905, 4. Also see "Personal Paragraphs," *Laramie Republican* May 29, 1906, 3; "Local Brevities," *Laramie Boomerang*, March 29, 1905, 4; "Here for a Visit during the Blockade," *Laramie Republican*, April 24, 1905, 4. George L. Houghton

received a US patent for this globe on June 12, 1900. See https://patents.google.com/patent/US651804A/en, accessed July 1, 2020.

2 "Making Wheatland Views," *Wyoming Tribune* (Cheyenne), May 15, 1905, 3.

3 "What Happens: Wheatland and Vicinity in Brief," *Wheatland (WY) World*, May 19, 1905, 7.

4 *Bill Barlows Budget* (Douglas, WY), June 7, 1905, 4.

5 "Laramie and Casper," *Laramie Republican*, June 12, 1905, 3.

6 *Wyoming Derrick* (Casper), June 15, 1905, 4.

7 Con Trumbell and Kem Nicolaysen, *Images of America: Casper* (Charleston, SC: Arcadia, 2013), 2; *Sanborn Fire Insurance Map from Casper, Natrona County, Wyoming*, Sanborn Map Company, September 1907, map, https://www.loc.gov/item/sanborn09750_003/, accessed July 7, 2022

8 "A Fine Picture of Sheridan," *Sheridan Post*, July 25, 1905, 1.

9 "Some of Artist Houghton's Work," *Sheridan Post*, August 1, 1905, 1.

10 "Local Brevities," *Laramie Boomerang*, August 3, 1905, 4; "The Week in Society," *Laramie Republican*, September 2, 1905, 3; "The Week in Society," *Laramie Republican*, September 23, 1905, 3.

11 *Bill Barlow's Budget* (Douglas, WY), August 16, 1905, 5; *Guernsey (WY) Gazette*, October 26, 1905, 1; *Wyoming Industrial Journal* (Laramie), August 1, 1907, 4; *Buffalo (WY) Voice*, December 16, 1905.

12 In addition to the newspapers mentioned in note 11, the *Sheridan Post*, January 19, 1906, 8, notes his work on the hotel. The *Wyoming Industrial Journal* (Laramie) of May 1, 1906, features Sheridan County and includes Houghton sketches of the county courthouse on page 11 and the Great Western Hotel on page 13.

13 Michael A. Amundson, "These Men Play Real Polo: The History of an Elite Sport in the 'Cowboy' State, 1890–1930," *Montana: The Magazine of Western History* 59, no.

1 (Spring 2009): 3–22; Michael A. Amundson, "The British at Big Horn: The Founding of an Elite Wyoming Community," *Journal of the West* 40, no. 1 (Winter 2001): 49–55; Michael A. Amundson, "The Rise and Fall of Big Horn City, Wyoming," *Wyoming Annals* (Spring–Summer 1994): 10–25.

14 Stanley A. Kuzara, *Black Diamonds of Sheridan: A Facet of Wyoming History* (Cheyenne: Pioneer Printing and Stationery Co., 1977), 148–169.

15 Kuzara, *Black Diamonds*, 54–103.

16 Hubert Howe Bancroft, *The Works of Hubert Howe Bancroft: History of Nevada, Colorado, and Wyoming*, volume 25 (San Francesco: History Company, 1890), 728–729n27, 792–793n14; "New Hardware Firm," *Buffalo (WY) Bulletin*, February 15, 1891, 3; "State News," *Laramie Boomerang*, June 22, 1893, 12; "May Be Necessary to Abandon Burning Mine," *Butte (MT) Miner*, October 25, 1906, 1.

17 "Some of Artist Houghton's Work," *Sheridan Post*, August 1, 1905, 1; Sheridan, Wyoming, *City Directory*, 1907, 195. "Local Notes," *Sheridan Post*, May 26, 1905, 8, shows the Sumption and Kay business. Sim Smith's pioneer trout farm is discussed in "Twelve Acres of Fish," *Sheridan Post*, June 17, 1904, 6; "New Fish Hatchery," *Sheridan Post*, November 29, 1904, 1; "Visited Sim Smith's Trout Farm," *Sheridan Post*, August 11, 1905, 1.

18 The history of the state fish hatchery at Wolf can be followed through the Sheridan and other northern newspapers. See especially, "Work Begun at the Hatchery," *Sheridan Post*, May 16, 1895, 5; "The Sheridan Fish Hatchery," *Newcastle (WY) New Journal*, May 22, 1896, 5; "Wolf Creek Development," *Sheridan Post*, December 11, 1908, 5; "State Fish Hatchery," *Sheridan Post Industrial Edition*, September 30, 1903, 31; "Game Warden's Report," *Sheridan Post*, November 30, 1906, 12; Mrs. W. C. Dinwiddie, "Summer Resorts," *Sheridan Enterprise*, May 1, 1908, 14; "Fish Hatchery Contract Let," *Sheridan Post*, June 4, 1909, 1.

19 Susan Nance, ed., *The Historical Animal* (Syracuse, NY: Syracuse University Press, 2015).

20 *Sheridan Post*, January 19, 1906, 8. In fact, while proofreading this manuscript, I discovered two new Houghton drawings of Sheridan sites printed in the *Wyoming Industrial Journal* (Laramie) on May 1, 1906. See note 12, this chapter.

21 "A Magnificent Present," *Sheridan Post*, February 20, 1906, 1. An online inflation calculator suggests that $2 in 1906 would be worth $57.29 today. See https://www.official data.org/us/inflation/1906?amount=2, accessed July 31, 2020.

22 "Local and Personal," *Billings Weekly Gazette*, April 27, 1906, 6.

23 "Big Timber Zephyr," *Big Timber (MT) Pioneer*, May 10, 1906, 5; "Big Timber Zephyr," *Big Timber (MT) Pioneer*, May 17, 1906, 5; "Big Timber, the Progressive," *Big Timber (MT) Pioneer*, December 13, 1906, 1. The included image is from the *Billings Weekly Gazette*, May 24, 1914, 103.

24 Federal Writers' Project of the Work Projects Administration for the State of Montana, *Montana: A State Guide Book* (New York: Viking, 1939), 196–198, http://www .bigtimber.com/historical-sites, accessed June 29, 2021.

25 "Of Local Interest," *Fergus County Democrat* (Lewistown, MT), July 3, 1906, 5; "Additional Local," *Fergus County Democrat* (Lewistown, MT), August 14, 1906, 1; "Of Local Interest," *Fergus County Democrat* (Lewistown, MT), August 21, 1906, 3; "Of Local Interest," *Fergus County Democrat* (Lewistown, MT), September 4, 1906, 8.

26 "Kindschy-Camastral," *Fergus County Argus* (Lewistown, MT), April 26, 1905, 7; "Christ King Passes Away," *Fergus County Democrat* (Lewistown, MT), January 8, 1907, 4; Joseph King, "History of the King Ranch," Central Montana Historical Documents, Montana Memory Project, https://mtmemory.org/digital/collection/p15018coll36 /id/13899, accessed July 6, 2020; Marjorie W. King, "Letters to the Editor," *Montana: The Magazine of Western History* 45, no. 1 (Winter 1995): 87–91. Family histories can also be found in Babbie Deal and Loretta McDonald, eds., *The Heritage Book of the Original Fergus County Area* (n.p.: Bi-Centennial Fergus County Heritage Committee, 1976), 53–54, 189–196, 364–367.

27 "Noted Artist Here," *Butte Daily Post*, September 5, 1906, 10.

28 "Noted Artist Here," 10.

29 "Noted Artist Here," 10.

30 "Houghton on Desert Strip," *Cheyenne Daily Leader*, September 9, 1906, 5.

31 "Gives State Hearty Rap," *Laramie Republican*, September 12, 1906, 3.

32 "New Picture of Dillon," *Dillon (MT) Tribune*, October 19, 1906, 3.

33 "Birdseye of Dillon, Looking Southwest," *Dillon (MT) Tribune*, December 21, 1906, 1.

34 "Gift of Books to Public Library," *Laramie Republican*, March 20, 1906, 4; "Benefit of Women's Club," *Laramie Boomerang*, March 26, 1906, 1; " 'Twas a Stunner," *Laramie Republican*, March 28, 1906, 1; "The Week in Society," *Laramie Republican Weekly Edition*, April 12, 1906, 3; "The Week in Society," *Laramie Republican Weekly Edition*, May 3, 1906, 3; "Personal Paragraphs," *Laramie Republican*, May 29, 1906, 3; "Personal Paragraphs," *Laramie Republican*, June 14, 1906, 3; "The Week in Society," *Laramie Republican*, June 30, 1906, 3; "Here to Attend Summer School," *Laramie Republican*, July 2, 1906, 3; "The Week in Society," *Laramie Republican Weekly Edition*, July 5, 1906, 3; "The Week in Society," *Laramie Republican*, July 28, 1906, 3; "The Week in Society," *Laramie Republican Weekly Edition*, August 2, 1906, 3; "Personal Paragraphs," *Laramie Republican*, September 20, 1906, 3; "For Sale—Household Goods," *Laramie Republican*, December 18, 1906, 4; "For Sale—Household Goods," *Laramie Republican*, December 19, 1906, 6; "For Sale—Household Goods," *Laramie Republican*, December 20, 1906, 6; "For Sale—Household Goods," *Laramie Republican*,

December 21, 1906, 5; "For Sale—Household Goods," *Laramie Republican*, December 22, 1906, 3; "The Week in Society," *Laramie Republican*, December 29, 1906, 3.

35 "The Week in Society," *Laramie Republican Weekly Edition*, January 3, 1907, 3; "Old Residents Leave," *Laramie Boomerang*, January 19, 1907, 1; "Old Residents Leave," *Laramie Semi-Weekly Boomerang*, January 21, 1907, 1.

36 "Compliments of the Cuban Republic Mining Co., Ltd., Wallace, Idaho," Hunter Mining District, Chloride Hill, in the Coeur d'Alenes, Shoshone County, Idaho, Idaho State Archives, Boise; "Like Western Idaho," *Laramie Boomerang*, May 24, 1907, 1.

37 "The Silver Valley," https://westernmininghistory.com /state/idaho/, accessed July 24, 2020.

38 "Mine Sketches from Nature," *Wallace (ID) Miner*, July 11, 1907, 1.

39 "Pen and Ink Drawings/M.D. Houghton," advertisement, *Wallace (ID) Miner*, July 25, August 1, and August 8, 1907, 4.

40 "Drawing of Mullan, Idaho, 1907," https://www2.north westmuseum.org/museum/detail-drawing-of-mullan -idaho-1907-22610.htm, accessed July 7, 2020.

41 "Compliments of the Cuban Republic Mining Co., Ltd., Wallace, Idaho," Idaho, Idaho State Archives, Boise.

42 Clark C. Spence, *A History of Gold Dredging in Idaho* (Boulder: University Press of Colorado, 2016), 167–178.

43 "Society Events of the Week," *Laramie Republican*, November 9, 1907, 3; "Around the Town," *Laramie Boomerang*, January 14, 1908, 4; "Fourteen Sales Total $30,000," *Spokane Spokesman-Review*, November 5, 1907, 9; *Spokane City Directory*, 1908, 31.

44 Ida Purdy Harrell, WPA Biographical Sketch on Merritt D. Houghton, Houghton File, Wyoming State Archives, Cheyenne.

45 D. W. Meinig, *The Great Columbian Plain: A Historical Geography, 1805–1910* (Seattle: University of Washington Press, 1995), 322–323, 362–364, 459–468; William Cronon,

Nature's Metropolis: Chicago and the Great West (New York: W. W. Norton, 1992), 295–310.

46 Work Projects Administration, *Washington: A Guide to the Evergreen State* (Portland, OR: Binfords and Mort, Publishers, 1941), 252; Carlos A. Schwantes, *The Pacific Northwest: An Interpretive History* (Lincoln: University of Nebraska Press, 1989), 197–198.

47 Todd Hays, "Five Mile Prairie," *Spokane Magazine*, http:// www.gospokanemagazine.com/five-mile-prairie.html, accessed July 8, 2020; "Five Mile Prairie Wants Electric Line," *Spokane Daily Chronicle*, March 28, 1906, 1.

48 "City News in Brief," *Laramie Boomerang*, April 24, 1908, 4; Bessie Bailey Cook, "Society Events of the Week," *Laramie Republican*, August 1, 1908, 3; quotation in Jim Kershner, "Spokane Neighborhoods: Hillyard— Thumbnail History," HistoryLink.org Essay 8406, https://www.historylink.org/File/8406, accessed July 8, 2020.

49 "Post Falls," *Rathdrum (ID) Tribune*, February 12, 1909, 1.

50 R. Cotroneo Ross and Jack Dozier, "A Time of Disintegration: The Coeur D'Alene and the Dawes Act," *Western Historical Quarterly* 5, no. 4 (October 1974): 405–419; "Choice Land Falls to Early Winners: Though Little Chance for Second List—Keen Interest Manifested," *Spokane Evening Chronicle*, August 11, 1909, 11; "Official List Coeur d'Alene Reservation," *Coeur d'Alene Evening Press*, August 12, 1909, 1.

51 "New Incorporation Formed," *The Missoulian* (Missoula, MT), April 6, 1909, 4.

52 "Freewater News Notes," *Evening Statesman* (Walla Walla, WA), September 4, 1909, 8.

53 "To Develop Coal Lands," *Spokesman-Review* (Spokane), December 15, 1909, 8.

54 "Says Coal Stock Is Valueless," *Spokesman-Review* (Spokane), April 10, 1912, 8; "Mining Stock at Sheriff's Sale," *Spokesman-Review* (Spokane), January 5, 1913, 10; "Labyrinth of Mine Companies to Defraud Unwary, Is Charge,"

Spokesman-Review (Spokane), January 14, 1914, 6; "Say Got Rich Quick," *Spokane Chronicle*, April 22, 1914, 13.

55 Quotation in "Defrauded Many, Is Finding of Jury," *Spokane Chronicle*, May 4, 1914, 2; "Rudkin Denies New Trial to Spokane Men," *Spokane Chronicle*, June 17, 1914, 1; "Year in Prison, Belden Sentence; Wayland to Jail," *Spokane Chronicle*, June 19, 1914, 1; "Denies Men a Retrial," *Spokesman-Review* (Spokane, WA), June 20, 1914, 7.

56 Bates Harrington, *How 'Tis Done: A Thorough Ventilation of the Numerous Schemes Conducted by Wandering Canvassers Together with the Various Advertising Dodges for the Swindling of the Public* (Chicago: Fidelity Publishing Company, 1879), 40–54, https://archive.org/details/how tisdonethorouooharr/page/n9/mode/2up, accessed June 29, 2021. This classic exposé details how such a pictorial fraud could have occurred.

57 1910 United States Census, Spokane, Spokane, Washington, digital image s.v. "Merritt Houghton," *Ancestry.com*.; R. L. Polk and Co.'s, *Spokane City Directory 1911* (Spokane: R. L. Polke and Company, 1911), 597; R. L. Polk and Co.'s, *Spokane City Directory 1912* (Spokane: R. L. Polke and Company, 1912), 644; Harrell, WPA Biographical Sketch on Merritt D. Houghton, Wyoming State Archives, Cheyenne. One historian suggested that many of the early residents of Morgan Acres "had grown up on farms and likely retained a fondness for growing things and caring for livestock." See Stephen B. Emerson, "Morgan Acres (Spokane County) Thumbnail History," https://www.historylink.org/File/9035, accessed July 2, 2021. Interestingly, Emerson further states that Dixwell Street was one of the main north-south streets in the area along with Weile and Houghton Streets running east and west.

58 "Name the Judges," *Spokane Chronicle*, October 17, 1912, 11; "Budget of News from Morgan Park," *Spokane Chronicle*, June 14, 1913, 7; "Budget of News from Morgan Park," June 14, 1913, 7; July 18, 1913, 3; July 26, 1913, 8; August 19, 1913, 11; September 13, 1913, 7; *Spokane Chronicle*, August 1, 1913, 11; "Budget of News from Morgan Park," *Spokane Chronicle*, September 3, 1913, 8; "Budget of News from Morgan Park," *Spokane Chronicle*, September 13, 1913, 7; "County Precinct Clerks Get Busy," *Spokane Chronicle*, January 3, 1916, 5; "Sheriff Hastens Army Draft Plan," *Spokesman-Review* (Spokane), May 23, 1917, 7; "Fill Army Registrar List," *Spokesman-Review* (Spokane), May 29, 1917, 10; "County Is Ready to Handle Draft," *Spokesman-Review* (Spokane), August 15, 1918, 6.

59 This sketch can be found at the Northwestern Museum of Arts and Culture in Spokane.

60 N. W. Durham, *History of the City of Spokane and Spokane County, Washington: From Its Earliest Settlement to the Present Time, Illustrated, Volume II* (Spokane: S. J. Clarke, 1912), 143–144. I found the former owner of Marlene's Restaurant, and he told me that he donated the sketch of Greenacres to the cemetery after his wife, Marlene's, death. Robert Nordby to Michael A. Amundson, telephone call, July 2, 2021.

61 "Then and Now: Hazelwood Farms," *Spokesman-Review* (Spokane), February 4, 2013, https://www.spokesman.com/then-and-now/hazelwood-farms/, accessed July 10, 2020; "Government Officials in New York Buy 100 Acres Near Spokane," *Spokesman-Review* (Spokane), August 13, 1911, 31; "Plan for Model Farm," *Spokesman-Review* (Spokane), November 7, 1911, 9; "Hazelwood Irrigated Farms," advertisement, *Spokesman-Review* (Spokane), March 17, 1907, 28; "The Nearby Irrigated Tract," advertisement, *Spokesman-Review* (Spokane), March 31, 1907, 32.

62 The approximate GPS coordinates for this location are 117°34'57.02"W, 47°38'34.40"N.

63 Houghton's brother George had died in February 1917, in Orting, Washington, a community just east of Olympia. See Ancestry.com; *Washington, Select Death Certificates, 1907–1960* [database online], Provo, UT, USA: Ancestry.com Operations, Inc., 2014, accessed July 2, 2021.

64 History.com editors, "Spanish Flu," https://www.history.com/topics/world-war-i/1918-flu-pandemic#section_4, accessed July 2, 2021.

65 University of Michigan Center for the History of Medicine, "Spokane, Washington," entry in the American Influenza Epidemic of 1918–1919: A Digital Encyclopedia, https://www.influenzaarchive.org/cities/city-spokane.html#, accessed July 12, 2020; Nicholas Deshais, "The Doctor and the Pandemic: Spokane's 1918 Fight against the Spanish Influenza," *Spokesman-Review* (Spokane), January 20, 2019, https://www.spokesman.com/stories/2019/jan/20/the-doctor-and-the-pandemic-spokanes-1918-fight-ag/, accessed July 12, 2020.

66 The 1920 federal census lists Hildor and Beryl Satter as residing at 202 Dixwell Street, which is now known as Altamont Street and is two blocks west of Morgan Acres Park. Interestingly, the next main east-west street to the north is Houghton Street. Year: 1920; Census Place: Mead, Spokane, Washington; Roll: T625_1940; Page: 10B; Enumeration District: 129.

67 "Death Claims Man and Wife on Same Day," *Spokane Chronicle*, March 7, 1919, 16; "Realize in Death a Lifelong Wish," *Spokesman-Review* (Spokane), March 7, 1919, 1; "Deaths and Funerals," *Spokesman-Review* (Spokane), March 9, 1919, 7; "Fannie Houghton and M.D. Houghton to Beryl Satter," Warranty Deed, February 28, 1919, Recorder's Office, Spokane County, Spokane, WA.

68 Although William Henry Jackson was much better known in his own heyday, his 1940 autobiography, written when he was ninety-seven, introduced his life and portfolio to new generations. See William Henry Jackson, *Time Exposure* (New York: G. P Putnam's Sons, 1940).

Chapter 5: Drawing Conclusions

1 University of Michigan Center for the History of Medicine, "Spokane, Washington," entry in the American Influenza Epidemic of 1918–1919: A Digital Encyclopedia, https://www.influenzaarchive.org/cities/city-spokane.html#, accessed July 12, 2020; Nicholas Deshais, "The Doctor and the Pandemic: Spokane's 1918 Fight against the Spanish Influenza," *Spokesman-Review* (Spokane), January 20, 2019, https://www.spokesman.com/stories/2019/jan/20/the-doctor-and-the-pandemic-spokanes-1918-fight-ag/, accessed July 12, 2020.

2 Both Frances and Merritt were old friends of Mary Bellamy, who had grown up in Laramie in the 1870s, graduated from Laramie High School, and taught school in town. She married civil engineer Charles Bellamy. She helped form the Laramie Woman's Club and was elected Albany County superintendent of schools. She and Frances are often mentioned together in the society pages, and both Merritt and Charles worked for the People's Party in 1896. In 1914, Mary Bellamy was famous for having become the first woman elected to the Wyoming State House of Representatives, serving from 1910 to 1912. In 1914, she was helping University of Wyoming librarian and historian Grace Raymond Hebard conduct research for a forthcoming book.

3 Merritt D. Houghton to Mrs. Mary G. Bellamy, Hillyard, WA, January 26, 1914. Series II: Correspondence, Charles G. Coutant Collection, Wyoming State Archives, Cheyenne.

4 "Burglar Braves Anti-Germ Fumes," *Spokesman-Review* (Spokane), March 11, 1919, 6; Accession Records from the Wyoming State Archives, Cheyenne.

5 Michael A. Amundson email to Allison Olivarez, associate archivist and special collections manager, Amon Carter Museum of American Art, Fort Worth, Texas, September 2, 2020; Michael A. Amundson to Bud Reed, telephone conversation, September 1, 2020; Anne Willson Whitehead, *A History of Manville, Wyoming and the Manville Ranching Community* (Cheyenne, WY: Pioneer Printing and Stationery Co., Inc., 1998). Ad Spaugh's life up to about 1890 is told in Frazier Hunt, *The Long Trail from*

Texas: The Story of Ad Spaugh, Cattleman (New York: Doubleday, Doran, and Company, Inc., 1940).

6 Michael A. Amundson email to Hannah Mellino, administrative and communications assistant for the Olivet College Archives, March 10, 2020; Hannah Mellino email to Michael A. Amundson, December 2, 2020; Edward P. Bentley email to Michael A. Amundson, December 3, 2020; Ed Dobbins email to Michael A. Amundson, December 4, 2020.

7 Michael A. Amundson to Robert Nordby, telephone conversation, July 2, 2021.

Portfolio

1 John Brinckerhoff Jackson, *Discovering the Vernacular Landscape* (New Haven, CT: Yale University Press, 1984), 1–8.

Bibliography

Amundson, Michael A. "The British at Big Horn: The Founding of an Elite Wyoming Community." *Journal of the West* 40, no. 1 (Winter 2001): 49–55.

Amundson, Michael A. *Merritt Dana Houghton: A Catalog of Views*. Privately published, 1991.

Amundson, Michael A. "'The Most Interesting Objects That Have Ever Arrived': Imperialist Nostalgia, State Politics, Hybrid Nature, and the Fall and Rise of Arizona's Elk, 1866–1914." *Journal of Arizona History* 61, no. 2 (Summer 2020): 255–294.

Amundson, Michael A. "Pen Sketches of Promise: The Western Drawings of Merritt Dana Houghton." *Montana: The Magazine of Western History* 44, no. 4 (Autumn 1994): 54–65.

Amundson, Michael A. "The Rise and Fall of Big Horn City, Wyoming." *Wyoming Annals* (Spring–Summer 1994): 10–25.

Amundson, Michael A. "These Men Play Real Polo: The History of an Elite Sport in the 'Cowboy' State, 1890–1930." *Montana: The Magazine of Western History* 59, no. 1 (Spring 2009): 3–22.

Amundson, Michael A. *Wyoming Revisited: Rephotographing the Scenes of Joseph E. Stimson*. Boulder: University Press of Colorado, 2014.

Anderson, Nancy F. *Lora Webb Nichols: Homesteader's Daughter, Miner's Bride*. Caldwell, ID: Caxton, 1995.

Bancroft, Hubert Howe. *The Works of Hubert Howe Bancroft: History of Nevada, Colorado, and Wyoming*, volume 25. San Francisco: History Company, 1890.

Blevins, Jason. *The Man Behind the Maps: Legendary Ski Artist James Niehues*. Italy (no city): Open Road Ski Company, 2019.

Brown, Robert L. *Colorado Ghost Towns: Past and Present*. Caldwell, ID: Caxton, 1972.

Burns, Robert Homer, Andrew Springs Gillespie, and Willing Gay Richardson. *Wyoming's Pioneer Ranches*. Laramie, WY: Top-of-the-World Press, 1955.

Carlson, Chip. *Tom Horn: "Killing Is My Specialty."* Cheyenne, WY: Beartooth Corral, 1991.

Carter, John. *Solomon D. Butcher: Photographing the American Dream*. Lincoln: University of Nebraska Press, 1985.

Coutant, C. G. *A History of Wyoming from the Earliest Known Discoveries*, volume I. Laramie, WY: Chaplin, Spafford, and Mathison, Printers, 1899.

Cronon, William. *Nature's Metropolis: Chicago and the Great West*. New York: W. W. Norton, 1992.

Deal, Babbie, and Loretta McDonald, eds. *The Heritage Book of the Original Fergus County Area*. N.p.: Bi-Centennial Fergus County Heritage Committee, 1976.

Dunning, Forest B. *Slaughter on the Otter: The Kendrick Sheep Raid*. Helena, MT: Sweetgrass Books, 2019.

https://doi.org/10.5876/9781646423668.c007

Durham, N. W. *History of the City of Spokane and Spokane County, Washington: From Its Earliest Settlement to the Present Time, Illustrated, Volume II.* Spokane: S. J. Clarke, 1912.

Erb, Louise Bruning, Ann Bruning Brown, and Gilberta Bruning Hughes. *The Bridger Pass Overland Trail, 1862–1869.* Greeley, CO: Journal Publishing Co., 1989.

Evans, Timothy H. "Piece-Sur-Piece Horse Barns on the Laramie Plains of Southeastern Wyoming: Cultural Interplay and Adaptation." *Material Culture* 38, no. 1 (Spring 2006): 54–87.

Federal Writers' Project of the Work Projects Administration for the State of Montana. *Montana: A State Guide Book.* New York: Viking, 1939.

Georges, Cynde A. *One Cowboy's Dream: John B. Kendrick, His Family, Home, and Ranching Empire.* Virginia Beach, VA: Donning Company Publishers, 2004.

Harrington, Bates. *How 'Tis Done: A Thorough Ventilation of the Numerous Schemes Conducted by Wandering Canvassers Together with the Various Advertising Dodges for the Swindling of the Public.* Chicago: Fidelity Publishing Company, 1879. https://archive.org/details/howtisdonethorouooharr/page/n9/mode/2up. Accessed June 29, 2021.

Hébert, John R. *Panoramic Maps of Anglo-American Cities: A Checklist of Maps in the Collections of the Library of Congress, Geography and Map Division.* Washington, DC: Library of Congress, 1974.

Hollenback, Frank R. *The Laramie Plains Line.* Denver: Sage Books, 1960.

Houghton, Merritt Dana. *A Portfolio of Wyoming Views: The Platte Valley and the Encampment Mining District: Saratoga, Pearl, Dillon, Battle, Rambler, Rudefeha.* Self-published, 1903.

Houghton, Merritt Dana. *Views of Southern Wyoming: Copper Belt Edition.* Self-published, 1904.

Hunt, Frazier. *The Long Trail from Texas: The Story of Ad Spaugh, Cattleman.* New York: Doubleday, Doran and Company, Inc., 1940.

Jackson, John Brinckerhoff. *Discovering the Vernacular Landscape.* New Haven, CT: Yale University Press, 1984.

Jackson, William Henry. *Time Exposure.* New York: G. P. Putnam's Sons, 1940.

Jacobs, Margaret D. *White Mother to a Dark Race: Settler Colonialism, Maternalism, and the Removal of Indigenous Children in the American West and Australia, 1880–1940.* Lincoln: University of Nebraska Press, 2011.

Jessen, Kenneth. *Railroads of Northern Colorado.* Boulder: Pruett, 1982.

Junge, Mark. *The Grand Encampment.* Encampment, WY: Grand Encampment Museum, 1972.

Junge, Mark. *J. E. Stimson: Photographer of the West.* Lincoln: University of Nebraska Press, 1985.

King, Joseph. "History of the King Ranch." Central Montana Historical Documents, Montana Memory Project. https://mtmemory.org/digital/collection/p15018coll36/id/13899, accessed July 6, 2020.

King, Marjorie W. "Letters to the Editor." *Montana: The Magazine of Western History* 45, no. 1 (Winter 1995): 88–89.

Kuzara, Stanley A. *Black Diamonds of Sheridan: A Facet of Wyoming History.* Cheyenne, WY: Pioneer Printing and Stationery Co., 1977.

Larson, T. A. *History of Wyoming,* 2nd ed. Lincoln: University of Nebraska Press, 1981.

Limerick, Patricia. *The Legacy of Conquest: The Unbroken Past of the American West.* New York: W. W. Norton, 1987.

Limerick, Patricia. *Something in the Soil: Legacies and Reckonings in the New West.* New York: W. W. Norton, 2001.

Marx, Leo. *The Machine in the Garden: Technology and the Pastoral Idea in America.* New York: Oxford University Press, 1964.

Meinig, D. W. *The Great Columbian Plain: A Historical Geography, 1805–1910.* Seattle: University of Washington Press, 1995.

Moulton, Candy. *The Grand Encampment: Settling the High Country.* Glendo, WY: High Plains Press, 1997.

Moulton, Candy. "Ranch Artist." *Wyoming Horizons* 3 (May 1, 1983): 10.

Moulton, Candy, and Terry A. Del Bene. *Images of America: Grand Encampment.* Charleston, SC: Arcadia, 2012.

Nance, Susan, ed. *The Historical Animal.* Syracuse, NY: Syracuse University Press, 2015.

Noble, Ann Chambers, and Jonita Sommers. *Homesteading and Ranching in the Upper Green River Valley.* Laguna Beach, CA: Laguna Wilderness Press, 2021.

Patera, Alan H. *Grand Encampment Copper Towns.* Lake Oswego, OR: Raven Press, 1991.

Reps, John W. *Bird's Eye Views: Historic Lithographs of North American Cities; Panoramas of Promise; Pacific Northwest Cities and Towns on Nineteenth-Century Lithographs.* Princeton, NJ: Princeton Architectural Press, 1998.

Reps, John W. *Panoramas of Promise: Pacific Northwest Cities and Towns on Nineteenth Century Lithographs.* Pullman: Washington State University Press, 1984.

Reps, John W. *Views and Viewmakers of Urban America: Lithographs of Towns and Cities in the United States and Canada, Notes on the Artists and Publishers, and a Union Catalog of Their Work, 1825–1925.* Columbia: University of Missouri Press, 1984.

Robbins, William. *Colony and Empire: The Capitalist Transformation of the American West.* Lawrence: University Press of Kansas, 1994.

Ross, R. Cotroneo, and Jack Dozier. "A Time of Disintegration: The Coeur D'Alene and the Dawes Act." *Western Historical Quarterly* 5, no. 4 (October 1974): 405–419.

Sandoval, Judith Hancock. *Historic Ranches of Wyoming.* Casper, WY: Mountain State Lithographing Company, 1986.

Schwantes, Carlos A. *The Pacific Northwest: An Interpretive History.* Lincoln: University of Nebraska Press, 1989.

Simonson, Harold P. "Frederick Jackson Turner: Frontier History as Art." *Antioch Review* 24, no. 2 (Summer 1964): 201–211.

Spence, Clark C. *A History of Gold Dredging in Idaho.* Boulder: University Press of Colorado, 2016.

Spokesman-Review. *Images of Greater Spokane: A Pictorial History of the Early Years in Spokane and Spokane County.* N.p.: Pediment Publishing, 2017.

Strayer-Hanson, Frances E. *Medicine Bow Valley Pioneers: Closing the Overland Trail Opening the Union Pacific Railroad.* N.p.: iUniverse, 2009.

Trennert, Robert A. *Riding the High Wire: Aerial Mine Tramways in the West.* Boulder: University Press of Colorado, 2001.

Truettner, William. *The West as America: Reinterpreting Images of the Frontier, 1820–1920.* Washington, DC: Smithsonian, 1991.

Trumbell, Con, and Kem Nicolaysen. *Images of America: Casper.* Charleston, SC: Arcadia, 2013.

Van Pelt, Lori. *Dreamers and Schemers: Profiles from Carbon County, Wyoming's Past.* Glendo, WY: High Plains Press, 1999.

Whitehead, Anne Willson. *A History of Manville, Wyoming and the Manville Ranching Community*. Cheyenne, WY: Pioneer Printing and Stationery Co., Inc., 1998.

Works Progress Administration. *Wyoming: A Guide to Its History, Highways, and People*. New York: Oxford University Press, 1941.

Work Projects Administration. *Washington: A Guide to the Evergreen State*. Portland, OR: Binfords and Mort, Publishers, 1941.

Wyckoff, William. *Creating Colorado: The Making of a Western Landscape, 1860–1940*. New Haven, CT: Yale University Press, 1999.

Newspapers

COLORADO
Fort Collins Express and the Fort Collins Review, 1899
Larimer County Independent (Fort Collins), 1899

IDAHO
Coeur d'Alene Evening Press, 1909
Rathdrum Tribune, 1909
Wallace Miner, 1907

ILLINOIS
Ottawa Free Trader, 1868, 1871

MONTANA
Big Timber Pioneer, 1906
Billings Weekly Gazette, 1906, 1914
Butte Daily Post, 1906
Butte Miner, 1906
Dillon Tribune, 1906
Fergus County Argus (Lewistown), 1905
Fergus County Democrat (Lewistown), 1906, 1907
The Missoulian, 1909

SOUTH DAKOTA
Black Hills Daily Times (Deadwood), 1880

WASHINGTON
Evening Statesman (Walla Walla), 1909
Spokane Chronicle, 1912–1914, 1916
Spokane Daily Chronicle, 1906
Spokane Evening Chronicle, 1909, 1919
Spokane Review, 1907, 1911, 2013
Spokesman-Review (Spokane), 1907, 1909, 1911, 1913, 1914, 1917–1919, 2013, 2019

WYOMING
Big Horn Sentinel, 1884
Bill Barlows Budget (Douglas), 1905
Buffalo Bulletin, 1891
Buffalo Voice, 1905
Carbon County Journal (Rawlins), 1880, 1883, 1884, 1891
Casper Star-Tribune, 1983
Casper Tribune-Herald, 1950
Cheyenne Daily Leader, 1906
Cheyenne Daily Sun-Leader, 1897, 1898
Grand Encampment Herald, 1902–1905
Guernsey Gazette, 1905
Laramie Boomerang, 1891–1894, 1903–1908
Laramie Daily Boomerang, 1887–1889, 1891, 1892, 1895, 1897–1900
Laramie Daily Sentinel, 1878
Laramie Republican, 1897, 1898, 1900–1908
Laramie Republican Weekly Edition, 1906, 1907
Laramie Republican Industrial Edition, 1901

Laramie Semi-Weekly Boomerang, 1895, 1902, 1907

Laramie Sentinel, 1879

Laramie Weekly Boomerang, 1883, 1886, 1887, 1888, 1897, 1898, 1900, 1902

Laramie Weekly Sentinel, 1890, 1891, 1893

Newcastle News, 1891

Newcastle-News-Journal, 1896, 1897

Rawlins Republican, 1904

Saratoga Sun, 1898, 1903–1905

Sheridan Post, 1895, 1903–1906, 1908, 1909

Uintah Chieftain (Evanston), 1883

Wheatland World, 1898, 1905

Wyoming Derrick (Casper), 1897, 1898, 1903, 1905

Wyoming Illustrated Monthly (Laramie), January 1891

Wyoming Industrial Journal (Laramie), 1902, 1904, 1907

Wyoming Press (Evanston), 1899, 1902

Wyoming Press Special Illustrated Edition (Evanston), 1902

Wyoming Semi-Weekly Tribune (Cheyenne), 1905

Wyoming Tribune (Cheyenne), 1905

Unpublished Materials

Amundson, Michael A., email to Allison Olivarez, associate archivist and special collections manager. Amon Carter Museum of American Art, Fort Worth, TX, September 2, 2020.

Amundson, Michael A., to Bud R. Reed. Telephone conversation, September 1, 2020.

Bentley, Edward P. "Profile of Sarah Anna Benedict" and "Profile of John Harvey Scotford." Unpublished articles emailed to me by the author, December 3, 2020.

Dobbins, Ed. "Profile of Czar J. Dyer." Unpublished article emailed to me by the author, December 4, 2020.

Harrell, Ida Purdy. WPA Biographical Sketch on Merritt D. Houghton. Houghton File, Wyoming State Archives, Cheyenne.

Houghton, Fannie, and M. D. Houghton to Beryl Satter. Warranty Deed, February 28, 1919. Recorder's Office, Spokane County, Spokane, WA.

Houghton, Merritt D., to Mrs. Mary Bellamy. Letter, January 26, 1914. Series II: Correspondence, Charles G. Coutant Collection, Wyoming State Archives, Cheyenne.

Mellino, Hannah. "John Harvey Scotford" and "Merritt Dana Houghton." Research Completion Forms, Hosford History Center and Lawrence Archives, Olivet College, Olivet, MI. Emailed to me by Olivet Archives administration and communications assistant Hannah Mellino, December 3, 2020.

Nordby, Robert, to Michael A. Amundson. Telephone call, July 2, 2021.

Websites

Albany County Historical Society (https://www.wyoachs.com/)

Ancestry.com

Historical sites in Sweet Grass County (http://www.bigtimber.com/historical-sites)

History.com

Idaho State Historical Society (https://history.idaho.gov/)

Influenza Archive (influenzaarchive.org)

Library of Congress (loc.gov)

Montana Memory Project (https://mtmemory.recollectcms.com/)

Newspapers.com

Northwest Museum of Arts and Culture (https://www
.northwestmuseum.org/)

Olivet College (olivetcollege.edu)

Online Washington Encyclopedia (https://www.history
link.org/Search)

Western Mining History (https://westernmininghistory
.com/)

WyoHistory.org. (https://www.wyohistory.org/)

Wyoming Digital Newspaper Collection (https://wyo
mingnewspapers.org/)

Wyoming State Archives (https://wyoarchives.wyo.gov/)

Wyoming State Museum (https://wyomuseum.wyo
.gov/)

Index

A

Absaroka Mountains (MT), 108
Addison Spaugh 77 Ranch (WY), 127–128
Addison Spaugh 77 Ranch (drawing), *128*
aerial tramway, 6, *52, 54, 59, 60, 62, 64, 86, 151, 176*
Airway Heights (WA), 121
Albany County (WY), 25, 26, 28, 45, 56, 76, 167, 194*n41*, 195*n48*, 203*n2*; map showing locations of ranch drawings, *26*
Alcova (WY), 13, 33, 34
Alcova Hot Springs (drawing), *34*
Allegan County (MI), 11
Almy coal mines (WY), 15
Alpha Literary Society (Laramie), 25
American Heritage Center (University of Wyoming), 31, 53, 126
Amon Carter Museum of American Art (Fort Worth), 18, 126–128
Anderson's Farm Gardens, Grand Encampment, Wyoming (drawing), *82, 83*
Andrew Olson's Ranch (drawing), *60, 68, 70, 76, 90*
Andrus Ranch (WY), 38, *40, 41*
animal history, 57–58, *59, 70, 71, 86, 87, 101, 105, 106, 107,* 126, *138, 184, 186–187, 189, 199n17, 199n18*
Antelope in Pass Creek Basin (drawing), *70, 71, 184*

Antelope Springs military outpost drawn while Cantonment Reno was being built in 1877 (drawing), *13, 126*
Antelope Springs (WY), 13, 126
Antoine Peak (WA), 121
Apley, Lorain, 12
Apley, Mary, 12
Arapahoe (Native American group), 15
Arizona Territory, 12
Arlington (WY), 46
Arrival of John Philipps at Horse Shoe Station (drawing), *37*
Attending the Indian Races (photograph), 15, *16*
Averill, James, 33
A. W. Smith Mule Shoe Ranch (drawing), *39, 41, 48*
A. W. Smith Old 67 Ranch (drawing), *39, 41, 48*

B

Baggs (WY), 44, 51, 86–88, 126
Baggs, Wyoming (drawing), *88*
Baggs at the time of the Meeker Massacre (drawing), *44*
Baker, Jim, 37, 39, 77
Banner (WY), 105–106, 189
Battle (WY), 52–53, *54*, 63, 68

Battle Basin, The (drawing), *85*
Battle Lake (WY), 51, 60, 62, 77, 80, 82, 84, 85, 136
Battle Lake Basin, The (drawing), *80, 82, 84, 85*
Beaver Creek (WY), 89
Belcher, H. F., 14
Belden, R. G., 118–119
Bellamy, Charles, 203*n1*
Bellamy, Mary G., 44, 125, 196*n76*, 203*n2*
Benedict, Sarah Anna, 12, 127
Bentley, Ed, 127
Beaverhead County Courthouse (Dillon, MT), *112, 144*
Beaverhead County Museum (Dillon, MT), *112, 144*
Beginning of a Prosperous Copper Mining Camp in the Encampment Copper District, The, 85
Ben Hur and Black Foot Mines, The (drawing), *78, 79*
Big Bend region (WA), 116
Big Creek Mine, The (drawing), *77, 78*
Big Creek Ranch, The (drawing), *68, 69*
Big Goose Creek (WY), 97–98, *141*
Big Goose Valley (WY), 102
Bighorn Basin (WY), 107
Big Horn City (drawing), *102*

Big Horn City (WY), 17, 101–102
Big Horn Mercantile (WY), 101, 102
Big Horn Mine (WY), 78, 79
Big Horn Mine, The (drawing), 79
Bighorn Mountains (WY), 3, 17, 97, 99, 141, 142
Big Laramie River (CO, WY), 25, 28, 45, 56–57, 167
Big Laramie Valley (WY), 57
Big Piney (WY), 39, 41, 42, 48, 160
Big Timber (MT), 108, 126
Big Timber Museum (MT), 108, 126
Billings (MT), 108
bird's-eye view drawing technique, 19–21, 33
Bird's Eye View of Big Timber, Montana, 1906 (drawing), 108
Bird's Eye View of Buffalo, Wyoming, 1905 (drawing), 2, 101, 142
Bird's Eye View of Casper, Wyoming, 1905 (drawing), 98
Bird's Eye View of Dillon, Montana, Looking Southwest, 1906 (drawing), 112, 144
Bird's Eye View of Encampment (drawing), 63
Bird's-Eye View of Fort Collins, Colorado, 1899 (drawing), 3–4, 5, 34–35, 37, 47, 112, 133, 134
Bird's-Eye View of Laramie (drawing), 47, 52
Bird's Eye View of Mullan, Idaho (drawing), 6, 113, 114, 145, 158
Bird's Eye View of Saratoga, 1898 (drawing), 34, 80
Bird's-Eye View of Saratoga, 1903 (drawing) 56
Bird's-Eye View of Sheridan, Wyoming, 1905 (drawing), 5, 97, 99, 106, 124, 141

Bird's Eye View of the South Park Vegetable Gardens, Property of J. J. Wombaker Grand Encampment, Wyo. (drawing), 89–90, 91, 173
Bird's Eye View of Wheatland, Wyoming, 1905 (drawing), 32, 93, 96, 97, 140
Bird's Eye View of Wolcott (drawing), 80, 81, 133
bird's eye views, significance of, 19
Black Hills (SD, WY), 12–14, 19, 95
Blacks Fork (WY), 42
Blacktail Mountains (MT), 112
Bohn Hotel (Encampment, WY), 52, 61, 75
boosterism, 8, 19, 20, 21, 23, 51, 56, 69, 92, 103, 137, 172, 177, 179, 180
Boot Jack Ranch (WY), 38–39, 40, 41, 160, 164
"Boot Jack" Ranch on the Upper Green River (watercolor), 40, 164
Boston-Wyoming Company, 52, 53
Boswell Ranch (WY), 56, 57, 160, 167
Boswell, Nathanial Kimball (N. K.), 56–57, 160, 167
Bothwell, A. J., 33
Boulder (WY), 39
Bozeman Trail, 13, 17, 171, 179
Branger, John, 109–110
Breaking a Road (drawing), 58, 59, 126, 187
Bridger, Jim, 37–38, 42–44, 126, 178, 183
Bridger's Ferry (drawing), 37, 38
Brookfield (IL), 11
Bryan, C. A., 118–119, 159
Budd Ranch (WY), 39, 41, 42, 48
Buffalo (WY), 2, 3, 13, 16–18, 24, 49, 93, 99, 100, 101, 102–103, 126, 130, 142
Burns, Robert Homer, 4, 27
Butte (MT), 110–113

C

Cabin of M. Hanley, Purgatory Gulch (drawing), 64, 67, 78
Cache La Poudre River (CO), 4, 35
Calf Creek (WY), 82
Camastral, John, 109
Camastral and Kindschy Ranch (MT), 109
Camel Rock (WY), 27
Canadian Rockies, 118, 124
Cantonment Reno on Powder River drawn in 1877 while it was in the process of construction (drawing), 13, 126
capitalism, 8, 23, 111, 191n6
Carbon County (WY), 3, 14–15, 17, 24–25, 62, 90–92, 126
Carbon County Museum (Rawlins, WY), 3, 17, 91, 92, 126
Carbon Timber Company (WY), 71, 72, 76, 85, 90, 174
Carbon (WY), 13, 24, 38, 48, 51, 91, 126, 133, 180
*Carbondale Coal Camp (WY), 58, 60, 84
Carbondale Coal Mines, The (drawing), 60
Carey, John M., 96
Carey, Joseph, 96
Careyhurst (WY), 96
Carpenter, C. E., 21
Carter (WY), 42
Casper Mountain (WY), 31, 32, 97, 98
Casper (WY), 16, 31–33, 37, 43, 89, 96, 98, 113, 160, 168
Cassidy, Butch, 100
Cattle, 4, 7, 13, 15, 18, 26, 29, 38, 45, 49, 51, 69, 70, 91, 101, 102, 106, 109, 160, 162, 164, 166, 186
Centennial (WY), 30, 38, 39, 45–46, 47, 52
Centennial Valley (WY), 45, 52

Chaplin, W. E., 45

Cheeseborough, Edward, 90–92. *See also* UL ranch

Cheyenne (WY), 3, 4, 9, 12, 13, 28, 31, 32, 34, 39, 96, 111, 113, 114, 126, 178

Cheyenne and Northern Railway, 96

Chicago, Burlington, and Quincy Railroad, 102

Chicago and North Western Railroad, 97, 98

Christ King Ranch (MT), 9, *109*, *110*, 160, 169

Civil War, 7, 11, 35, 48, 51, 95, 127, 167, 182, 192*n*3

Clear Creek (WY), 2, 3, 13, 17, 99, 142

coal and coal mining, 13, 15, 23, 52, 58, 60, 84, 89, 100–102, *103*, *104*, 105, 111, 118, *119*, 126, 143, 149, 159

Coalmont coalfields (CO), 89

Cody, William F. "Buffalo Bill," 55–56

Coeur d'Alene (ID), 121

Coeur d'Alene and Spokane Railway, 121

Coeur d'Alene Mountains (ID), *114*, *115*, 121, *158*

Coeur d'Alene Reservation (WA), 117

Coldwater Mine (drawing), 55

Columbia River, 116

Colville (WA), 116

Continental Divide, 52, 60, 62, 87

Copper Giant Mine, The (drawing), 55, *56*, *64*, 68

Copperton (WY), 58

Coutant, Charles Griffen (C. G.), 3, 4, 28, 31, 32–37, 42, 44, 51, 96, 125, 126, 170, 178–180, 182–183

cowboys, 5, 9, 18, 28, 29, 30, 40, 41, 42, 43, 44, 46, 49, 69, 70, 74, 84, 92, 104, 109, 110, 128, 131, 161, 162, 163, 164, 165, 166, 167, 169, 186

Cows and cattle, 4, 7, 13, 15, 18, 26, 27, 28, 29, 30, 32, 38, 39, 40, 41, 42, 43, 44, 45, 46, 49, 51, 59, 69, 70, 71, 74, 84, 91, 92, 101, 102, 103, 104, 105, 106, 109, 110, 128, 140, 141, 143, 144, 160, 161, 162, 163, 164, 165, 166, 167, 168, 169, 170, 186, 188, 189

Crook, George, 13

Curtis, Edward S., 8

Covid-19 pandemic, 125

Creed, Charles, 34

Cronon, William, 55

Crowsnest (pass in the Canadian Rockies), 118–119, 159

D

Dale Creek (WY), 26, 113

Dam at the Head of the Pipeline (drawing), 67. *See also* Head of the Encampment Pipe Line, 1902

Daniel (WY), 38, 41, 160

Davis, John C., 11

Dawes Act, 117

Dayton (WY), 101, 102

Dayton, Wyoming in 1905 (drawing), *102*

Deadwood (SD), 11–14, 178

Deer Creek Station (WY), 33, *182*

Deer Creek Station during the 1860s, ca. 1898 (drawing), *182*

D. Frank Crout Ranch, The (drawing), 68, *69*

Dekalb Ranch (WY), 39, *41*, 160

Democratic Party, 25

Denver Public Library (CO), 126

Devil's Gate (WY), 33

Devil's Tower National Monument (WY), 13

Dietz (WY), 101, 102, 104, 126, 133, 143

Dietz, Wyoming, 1906 (drawing), *104*, *143*

Dillon (MT), *112*, *144*

Dillon (WY), 58, 60, 61, 63, 68, 80, 84, 85

Dillon, Wyoming in 1903 (drawing), *61*

Discovery Shaft, The (drawing), *155*

Dixon (WY), 39, 86, 87, 88, 126

Dixon, Wyoming (drawing), *88*

Doane, George, 51

Doane-Rambler Mine (WY), 51, 136

dogs, 58, 70, 83, *84*, *166*

Douglas (WY), 32, 96, 99, 160

Dr. Dunsmore's Ranch (drawing), 68, *70*

Dredge in its Artificial Lake, The (drawing), 114, *115*, 149, *157*

Dugouts and Log Houses of Carbon in 1876 (drawing), 12, 126, *180*

Duke, a Prized Hereford (drawing), 59, 70, *71*

Dyer, Czar J., 12, 127

E

E&H Building, The (drawing), 71, *73*

Early Pen Drawing of Encampment, 1902 (drawing), 52, *53*

Early Storm, The (watercolor), 58, *59*, 70, 128, *188*

Earnest, Napoleon Bonaparte "Boney," 33

Eaton Brothers Ranch (WY), 106, *107*

Ed P. Steele Ranch (watercolor), 38, *41*

Eden (WY), 163

El Ray Mining Property (drawing). *See Topography of the El Ray Mining Property and Its Immediate Vicinity, 1904*

elk, 39, 57, 58, 60, 83, 126, 184, 185, 197–198*n*25

Elk in Wooded Country (drawing), 58, 83, *185*

Elk Mine, The (drawing), *62*

Elk Mine (WY), 61, 62, 64

Elk Mountain (WY), 51, 62, 67, 70, 90, 91, 92, 160

Elk Mountain (WY town), *70, 83, 90*

Emmons, Mariah, 128

Empire Coal and Coke Company (WA), *118, 119, 149, 159*

Empire Coal and Coke Company (drawing), *119, 159*

Encampment (WY), *3–4, 6, 7, 9, 49, 51–52, 53, 54, 55, 56–62, 63, 64, 65–67, 68, 69–72, 73, 74–85, 86, 87–90, 91, 95–96, 100, 106, 114–116, 118, 121, 126, 135, 139, 151, 152, 154, 156–158, 160, 165–168, 173, 174–175, 176, 184*

Encampment from the Southwest (drawing), *86*

Encampment Mining Company (WY), *53–54*

Encampment River (WY), *52, 54, 58, 64, 82, 89, 152, 153, 174*

Evanston (WY), *14–15, 38, 48, 166*

Evening Star Mine, The (drawing), *64, 65, 78*

F

Fairbanks (WY), *100, 101*

Fairbanks, Wyoming (drawing), *100*

Farson (WY), *160*

Ferris Haggarty Mine (WY), *54, 55, 58, 60, 62, 67, 77–78, 151*

Ferris Haggarty Mine, The (drawing), *55, 151*

fish hatcheries, *101, 105, 106, 107, 189, 199n17, 199n18*

Five Mile Prairie, Spokane (WA), *116, 117, 121, 146*

Five Mile Prairie, Washington (drawing), *117, 146*

Flagstaff (AZ), *125*

Flocks on the Red Desert (drawing), *86, 87, 126, 138. See also* Wamsutter

Fontenelle (WY), *41, 42, 163, 166*

Fort Bridger (WY), *42, 43, 44, 126, 178, 183*

Fort Bridger as a U.S. Fort (watercolor), *43, 44, 126*

Fort Bridger in 1850 (drawing), *43*

Fort Bridger in 1889 (watercolor), *44, 183*

Fort Caspar (Platte Bridge) (drawing), *32, 37*

Fort Collins, Colo., 1899 (drawing), *5, 37, 134*

Fort Collins (CO), *3–4, 5, 34–35, 36, 37, 47, 95, 112–113, 133, 134*

Fort Fetterman (drawing), *33, 179*

Fort Fetterman (WY), *20, 32, 33, 37, 96, 179, 181*

Fort Fred Steele (WY), *51, 60, 62, 71, 72, 75–76, 90, 174*

Fort Laramie (WY), *4, 32, 37, 38, 179, 181, 183*

Fort Laramie in 1836 (painting), *4, 37*

Fort Laramie in 1889 (drawing), *37, 38, 181, 183*

Fort Laramie Treaty (1868), *179*

Fort MacKenzie (WY), *4, 98, 99, 141*

Fort McKinney (WY), *13, 103*

Fort Reno (WY), *13, 37*

Fort Sanders near Laramie (drawing), *44*

Fort Steele Tie Loading Plant of the Carbon Timber Company (drawing), *71, 72, 76, 90*

Fort Supply (drawing), *42, 43, 44, 126*

Fort Washakie (WY), *15, 16*

Fort Wright (WA), *121, 177*

Fossil (WY), *126*

Freewater (OR), *118*

Fremont, John C., *31*

Front Range of the Rocky Mountains, *4, 5, 35, 36, 37, 97, 134*

G

Garrett (WY), *45, 46*

Gem City, *18. See also* Laramie (WY)

General Land Office, *125*

geographic information system (GIS), *176–177*

Gillespie, Andrew Springs, *4, 27*

Glenrock (WY), *32, 182*

gold and gold mining, *16, 22, 23, 45, 52, 90, 113, 114, 115, 149, 150, 157*

Gold Hill (WY), *45, 52*

Gold Hill in 1900 (drawing), *45, 52*

Gonzaga College (today, Gonzaga University) (Spokane, WA), *123, 148*

Google Earth, *121, 125, 133, 176*

Google Maps, *121*

Grand Canyon of the Platte (WY), *33, 34*

Grand Central Hotel (Casper), *97, 98*

Grand Encampment (drawing). *See* Encampment

Grand Encampment from the South West (drawing), *139*

Grand Encampment Mining Districts, Wyoming (drawing), *4, 6, 64, 121, 175, 176*

Grand Encampment Museum (Encampment, WY), *6, 7, 55, 73, 126*

Grand Encampment (WY). *See* Encampment

Grand Hotel (Big Timber, WA), *108*

Grants Pass (OR), *44*

Great Northern Railroad, *117–118, 123, 148, 177*

Great Sioux War, *179*

Great War (World War I), *123, 177*

Great Western Hotel (WY), *100, 106*

Greeley (CO), *29, 113*

Greenacres (development near Spokane, WA), *121, 127, 129*

Greenacres, Washington (drawing), *129*

Green River, Wyoming (river), 16, *18*, 38, 40, *42*, 48, *162*, *164*

Guernsey (WY), *99*, 100, 101

Guernsey, Wyoming (drawing), *99*

Guernsey Dam (WY), 101

H

Haggard, H. Rider, 81

Haggarty, Ed, 51–52, 54, 55, 58, 60, 62, 67, 77, 78, 151

Haglund, Erick, 90–92

Haglund, Hans, 90–92

Ham's Fork River valley (WY), 42, *43*, *166*

Hanging Woman Creek (WY), 131

Harden, Charles, 186

Hardman, James, 29, 186

Harper A47 Ranch (watercolor), 38

Harrell, Ida Purdy, 24–25

Hartman, J. E., 186

Hazelwood Farms (dairy in Spokane, WA), 121

Head of the Encampment Pipe Line, 1902 (drawing), *153*

Head-quarters of the Carbon Timber Company (drawing), *72*, *138*, *174*

Hebard, Grace Raymond, 126

Helena (MT), 109–110

Helping the Messwagon (painting), *129*, 131

Herbert King Ranch on Rock Creek (drawing), *46*

Hereford cattle, 26, 38, 42, 43, 70, 71, 106, *188*, 189

High Plains, 21

Hillyard (WA), 117–123

Hill, James J., 117

historiated letters, 74, 83, 84

Hog Park (WY), 67, 72, *174*

Hole in the Wall (drawing), *101*

Hole in the Wall (WY), 100, *101*, *126*, *177*

Holliday, W. H., 47, 48, 83

Holstein cattle, 6, 8, 122

Home and Pole Camp of John Sublette, The (drawing), *83*

Horn, Tom, 3, 28, 165

Horsetooth Mountain (near Fort Collins, CO), 35, *36*, *37*, *134*

horses, 4, 5, 9, 15, 16, *18*, 21, 23, 26, 27, 28, 29, 30, 31, 32, 33, 34, 36, 38, 39, 40, 41, 42, 43, 44, 45, 46, 47, 48, 49, 53, 54, 55, 56, 57, 58, 59, 61, 62, 63, 65, 66, 67, 68, 69, 70, 71, 72, 73, 74, 78, 79, 80, 81, 82, 83, 84, 85, 87, 88, 89, 90, 91, 92, 97, 98, 99, 100, 101, 102, 103, 104, 105, 106, 107, 108, 109, 110, 112, 115, 117, 122, 123, 128, 129, 131, 134, 135, 136, 137, 138, 139, 140, 141, 142, 143, 144, 146, 147, 151, 154, 157, 161, 162, 163, 164, 165, 166, 167, 168, 169, 171, 174, 177, 179, 182, 183, 186, 187, 189

Hotel Metlen (Dillon, MT). *See* Metlen Hotel

Hotel Wolf (Saratoga, WY), 34, 56, 60, 71, 74, 137

Hotel Wolf, The (drawing), *56*, *74*, *137*

Houghton, Fannie (also Frances or Fanny)(wife), 12, 13, 14, 18, 24, 25, 34, 86, 93, 95, 98, 99, 112, 113, 115, 116, 120, 123, 124, 136, 139, 142

Houghton, George L. (brother), 11, 14, 95

Houghton, Julia (sister), 12

Houghton, Lucy (mother), 11

Houghton, Merritt Dana, childhood, 11; college years, 11–12; comments on Wyoming, 110–112; death during 1919 flu epidemic, 124; in Idaho, 113–115; marriage, 12; in Omaha, Nebraska, 12; in Montana, 108–113; photographs of, *6*, *25*, *77*; photography advertisement, 14; photography career, 14–19;

publishes first book, 60–75; publishes illustrated newspaper, 20–24; publishes second book, 75–93; self portraits in sketches, *2*, *5*, *68*, *86*, *93*, *99*, *101*, *136*, *139*, *141*, *142*, *156*; teaching career, 4, 12–14, 19, 24, 26, 48–49, 160; in Washington state, 115–124; in Wyoming, 12–107

Houghton, Rufus (father), 11

Hoyt, John W., 14, 24

Hunter Mining District, Chloride Hill, in the Coeur d'Alenes, Shoshone County, Idaho (drawing), *114*, 115, *158*

Hutterites, 110, 169

I

Idaho panhandle, 6, 113–114, 145, 158

Idaho State Historical Society (Boise), 113–114

Independence Mining Company, The (drawing), *78*, 79

Indian Wars, 13, 36, 183

Inland Empire (WA), 95, 116

Interior of the Copper Bar Shaft House (drawing), *64*, 66

Intermountain West, 133

Iron Mountain (WY), 3, 5, 27–28, 32, 160, 165

J

Jack Pot Mining and Milling Company property (drawing), 77–78, *79*

Jackson, William Henry, 124, 178

James Hardman Ranch on Sand Creek (drawing), *29*

James May Ranch, The, 39

James Mickelson Circle Ranch (drawing), *39*, *41*, 42

Jeffrey City (WY), 38, *162*

Jelm Mountain (WY), 25, 45, *46*

Jessie Mines, The (drawing), 64, *66*

J. H. McShane and Company (Dayton, WY), 101

Jim Abner Ranch (WY), 32

Jim Baker Residence/Jim Baker's Cabin, The, 37, 39, 77, *126*

Jim Gatchell Memorial Museum (Buffalo, WY), 2, 3, 101, 126, 142

J. M. McIntosh Ranch (WY), 38, 40, 41, 42, 160, *162*

J.M. McIntosh Ranch (painting), *40, 162*

John Branger Ranch (MT), 109–110

John Goetz Ranch (drawing), 26, 27, *29*

John Reid Ranch (drawing), *29*

Johnson County War (1892), 18, 26

K

Kaycee (WY), 100–101

Kendrick, John B., 98, 127, 129, 131, 141

Keystone gold region (WY), 20–21, 22, 23, 149, *150*

Keystone 20-Stamp Gold Mill (drawing), 21, 22, *150*; *Stamp Room, 22*; *Vanner Room, 22*

Kindschy, Emil, 109

Kindschy, Ursula, 109

King, Christ or Chris, 9, *109*, *110*, 160, *169*

King, Marjorie W., 110, 169

King Ranch (MT). *See* Christ King

King Ranch Colony (MT), 110, 169

K. P. Nickell Ranch (WY), 3, 5, 27, 28, 32, 160, *165*

L

La Bonte Stage Station on the Overland (drawing), *37*

Lake Coeur d'Alene (ID), 113, 117

Lance Creek (WY), 128

Lander (WY), 28

Laramie, Hahn's Peak and Pacific Railroad, 47, 52, 89

Laramie (WY) (Gem City), 3, 4, 12, 13, 14, 18–20, 21, 22, 23–33, 36, 38, 44–46, 47, *48*, 49, *42*, 54, 55–57, 75–76, 80, 83, 89, 95, 96, 98–100, 108, 111–113, 115–117, 124, 130, 135, 150, 160–161, 165, 170, *171, 172*, 180, *186*

Laramie Chemical Works (Soda Works), 170, 172, 180

Laramie City Council (WY), 20, 25

Laramie High School (WY), 24

Laramie Peak (WY), 31, 45, 97, 98, 140

Laramie Plains (WY), 4, 26, 27, 28, 29, 30, 44–45, 160

Laramie River (WY), 20, 25, 28, 29, 30, 38, 45, 56, 96, *167, 172*

Laramie River Dude Ranch (WY), 28. *See also* Tatham Brothers Ranch

Laramie Union Presbyterian Church (WY), 98

Laramie Woman's Club (WY), 25

Larimer County Courthouse (Fort Collins, CO), 5, 35, 37, *134*

Larson, T. A. (Taft Alfred), 13

LaSalle County (IL), 12

Latah Creek Bridge (Spokane, WA), 123, *124, 148*

Lewistown (MT), 6, 108–110, 160, 169

Library of Congress (Washington, DC), 5, 36, 37, 113, 122, 124, 126, 134, 148

Limerick, Patricia, 8

line engraving, 20, 21, 22, 23, 150, 170–171, 172

line type. *See* line engraving

Little Box Elder Creek (WY), 32

Little Goose Creek (WY), 5, 97, 99, 101, 102, 141

Little Laramie River (WY), 29, 30, 38

Little Rock Creek (MT), 109

Little Snake River Museum (Savery, WY), 39, 88

Little Snake River Valley (CO and WY), 39, 87

Long's Peak (CO), 35, 36, 37, 134

longhorn steer, 74, 83

Lumber and Building Department of the W. H. Holliday Company of Laramie (drawing), 47, *48*, 83

Lundquist "Wooden Shoe" Ranch (drawing), 4, 5, 26, *28*

Lusk (WY), 127

LX Bar Ranch (WY), *131*

M

Magpie Mine, The (drawing), 78, *79*

Mandeville, John H., 35

Manville, Hiram S., 127

Manville (WY), 127

Marlene's Restaurant (Spokane, WA), 121, 128

Mather, Eugene B., 102

McIntosh, J. M., 38, 40, 41, 42, 160, 162

McIntosh Ranch (WY), 38, 40, 41–42, 160, *162*

McNeil Island (WA), 119

Medicine Bow (WY), 45

Medicine Bow Mountains (WY), 30, 45, 47, 67, *150*

Medicine Bow River (WY), 92

Medieval period, 74

M. E. Nellis Ranch (drawing), *30*

Mellino, Hannah, 127

Metaline (ID), 116

Metlen Hotel (Dillon, MT), *112, 140*

Mickelson Circle Ranch (WY), 39, 41, 42

Miller, Alfred Jacob, 37

Missoula (MT), 113

Moccasin Mountains (MT), *9, 109, 169*

Mohawk Mine, The (drawing), *58, 64, 66, 76*

Monarch (WY), 101–102, *103*, 126

Monarch, Wyoming in 1905 (drawing), *103*

Moncreiffe, Malcolm, 101

Moncreiffe, William, 101

Montezuma and the Almeda Mines, The (drawing), *78, 79*

Moon Anchor Mine (WY), *62*, 84

Moon Anchor Mine, The (drawing), *62*

Morgan's Acres (neighborhood west of Hillyard, WA), 102

Mormon War (1857), 43

Mosman Mercantile (Walden), 89, *90*, 135

Moulton, Candy, 89, *91*, 168

Mount Spokane (WA), *122, 123, 148*

Mountain Sheep, 48

Muddy Gap (WY), 38

Mule Shoe Ranch (WY), 39, *41*, 48

Mullan (ID), 6, 113, *114, 145*, 158

Munkers coal mine (WY), 100, 102, 103, *104*

Munkers Coal Mine, 1905 (drawing), *104*

N

narrow-gauge railroad, 45, 52

Native Americans, *15, 16*, 43, 49

Natrona Hotel (Casper, WY), *97, 98*

New Bohn Hotel (Encampment, WY), 52, *61*, 75

New Rambler Mine (WY), *64, 65*, 76, *78*, 85

New Rambler Mine, The (drawing), *65*

New Western History, 8

Nickell, K. P., 3, 5, 27, 28, 32, *160*, 165

Nickell, Willie, 3, 28, 165

Nine Mile Falls (near Spokane, WA), *123, 148*

N. K. Boswell Ranch (WY), *56, 57, 160, 167*

Nordby, Marlene, 128

Nordby, Robert, 128

North American Copper Company Smelter, *51, 54, 55, 62, 152*

North Fork of the Encampment River (WY), *58*

North Park (CO), 23, 51, 135

North Platte River, *34, 38, 51, 55, 56*, 68, 71, *72, 93, 96, 99, 100, 101, 137, 174, 179, 182*

Northern Arizona University (Flagstaff), 125

Northern Pacific Railroad, 108, *177*

Northwest Museum of Arts and Culture (Spokane, WA), 6, 8, *41*, 114, 117, 119, 120, 122, 126, *145, 146, 159*, 175, *177*

O

Old Bedlam (Fort Laramie, WY), 183

Old Fort Caspar (WY), *31, 32, 33*, 37, *96*

Old Fort Collins (CO), 34, 35, *36*

Old Fort Collins in 1865 (drawing), *36*

Old Fort Reno (drawing), *37*

Old National Bank (Spokane, WA), 116

Old 67 Ranch (WY), 39, *41*, 48

Old Town (Fort Collins), 35, *134*

Olivet College (MI), 11, 127

Olivet College Archives (MI), 127

Olson, Andrew, 60, 68, 70, 71, 76, *90, 91*

Omaha, Nebraska, 7, 12, 48, 95, 116

Opal (WY), 42, 43, 48, *168*

Opal Ranch of C. F. Roberson (Proprietor) (Opal, Wyo.) (drawing), *43, 166*

Open Range period, 13, 26, 35, 69, *160*

Oregon-California-Mormon Trail, 28, 34, 36, 38, 42, 43, *182, 183*

Oregon Railroad and Navigation Company, 118

Oregon Short Line Railroad, 42, 43, *166*

Orin (WY), 38

Orting (WA), 116

Osborne, John E., 193*n17*

Otsego (MI), 11

Ottawa (IL), 12

P

Parrott, George "Big Nose," 193*n17*

Pass Creek Basin (WY), 60, 70, 71, *91*, 184

Pathfinder Reservoir (Alcova, WY), 133, 194*n30*

Pearl (CO), 51, 53, 62–64, 67, 75, 77, 78, 86, 87, *89*, 113, 115, *154*

Pearl, Colorado, in 1904 (drawing), *89*

Pearl Mining District (CO), 51, 62, 75, 77, *154*

Pearl Smelter, The (drawing), *78*

pen and ink drawing technique, 20, 111, 194*n36*

Pen Sketch of Centennial, 47

People's Party, 25, 76, 203*n2*

Perue, Dick, 4, 6, 34, 56, 64, 88, 137, *176*

Peryam's Hotel, Encampment (drawing), *71, 73*

photoengraving, 19

Pinedale (WY), 127, 164, *166*

Pine Mountain (WY), 16

Pinkham's Castle (CO), 23

Plains Indian Wars, 13, 36, 183

Planing Mills and Lumber Yard of the W. H. Holliday Company, Laramie (drawing), 47, 48, *83*

Platte River, 18, 31, 34, 55, 56, *100, 101, 137, 178, 179, 182*

Platte River Canyon (WY), 18, 34

Platte River Road (WY), 178. *See also* Oregon-California-Mormon Trail

Pluto Mine, The (drawing), 78, 79

Politics, 7, 23–25

polo, 101

Pony Express, 34, 37, *182*

Portfolio of Saratoga Valley project, 57

Portfolio of Wyoming Views, A, 4, 5, 51, 54, 56, 58, 60–75, 80, 84

Portland (OR), 95

Portrait View of the Christ King Ranch (drawing), *110*

Post Falls (ID), 117

post–Open Range period, 26, 45, 57, 69, 109, 160

Powder River (WY), 13–14, 126, 131

Powell, D. Frank "White Beaver," 55

Presbyterian Missionary Society (Laramie), 113

Prohibitionist ticket (political affiliation), 76

Puget Sound (WA), 119

R

Rambler Mining Company's tunnel (drawing), *62*

Rambler (WY), 60, 63, *68*, 81, 133, 136

Rambler, 1903 (drawing), *68*, *136*

Ranch of A. H. Huston (drawing), *68*, 69

Ranch of D. B. Budd (drawing), 39, 42, 48

Ranch of George R. Brown, The, or *George R. Brown's Ranch* (drawing), *68*, 70

Ranch of H. Ralph Hall (drawing), 46

Ranch of Harvy Dekalb (watercolor), 39, 41, 160

Ranch of Jones and Williams, The (drawing), 81, 82

Ranch of K. P. Nickell (watercolor), 5, *165*

Ranch of Mrs. J. D. Baily and Son (drawing), 46

Ranch of N. K. Boswell, The (drawing), 57, *167*

Ranch of Roney Pomeroy, Fontenelle, Uinta Co. (drawing), 41, 42, *163*

Ranch of T. E. Andrus (watercolor), 38, *40*

Ranch Scene. See Addison Spaugh 77 Ranch

Rathdrum (ID), 117

Rawlins (WY), 3, 13–16, 8, 24, 38, 49, 51, 71, 75–77, 91–93, 95, 126, 193n17; Methodist Church, 17

Red Buttes (WY), 20–21, 23

Red Desert (WY), 17, 86, 87, 126, *183*

Red Sandstone Rocks at Red Buttes (drawing), 23

Reduction Works of the North American Copper Company, Grand Encampment, Wyoming (drawing), 55, *152*

Reed, Bud R., 127

Relief Map of the Grand Encampment Mining Districts (engraving), 4, *6*, 64, *121*, 176

Remington, Frederick, 130

rephotography, 3

Reps, John W., 8, 19, 133, 134, 191n6, 194n33

Republican party, 14, 25, 75

Residence of C. E. Carpenter (drawing), 21

Residence of N. F. Spicer (drawing), 22

Richards & Cunningham Company (Casper), 97, 98

Richardson, Willing Gay, 4, 27

Richmond's Livery Feed and Sale Stable (drawing), 71, 73

Ricker, J. A., 20, 194n38

Riverside (WY), 59, 60, 68, 80

Riverside (drawing), 68

Riverside Park Cemetery (Spokane, WA), 124

Rocky Mountain Copper Company, 60

Rocky Mountains, 4, 5, 19, 30, 31, 35, 36, 37, 45, 47, 51–52, 53, 54, 55, 56, 57, 58, 59, 60, 61, 62, 63, 64, 65, 66, 67, 68, 69, 70, 71, 72, 73, 74, 78, 79, 80, 81, 82, 83, 85, 86, 87, 88, 89, 90, 91, 92, 93, 97, 98, 108, 112, 114, 115, 118, 119, 121, 134, 135, 136, 139, 140, 144, 145, 150, 151, 152, 153, 154, 155, 156, 157, 158, 159, 160, 162, 163, 164, 165, 166, 167, 168, 172, 173, 174, 176, 182, 183, 185, 186, 187, 188

Round Up Kitchen, Cowboys at the Chuckwagon (photograph), *18*

Roycrofters, 25

Ruby Range (MT), *112*

Rudefeha (WY), 58, 63

Rudefeha Mine (WY), 58, 63

Russell, Charley, 129–130

S

Salt Creek (WY), 123

Salt Lake City (UT), 43

Sand Creek (WY), 26, 27, 29

Saratoga and Encampment Railway, 80, 84

Saratoga Valley (WY), 34, 57, 60

Saratoga (WY), 3, 4, 6, 34, 47, 51, 54–55, 56, 57–61, 63–64, 68, 70, 71, 73, 74, 75–76, 80, 84, 88, 92, 137, *167*, 175, 176

Saratoga, Wyoming, 1898 (drawing), 34

Saratoga, Wyoming, 1903 (drawing), 56, *137*

Satter, Beryl, 123–124, 126

Savery (WY), 39, 88

Scotford, John Harvey, 12, 127, 192n5

Second Ward (Laramie, WY), 25

settler colonialism, 8, 27, 45, 49, 70, 160, 184, 191n7, 193n24

sheep and sheepherders, 13, 48, 51, 57, 58, 59, 60, 70, 71, 83, 86, 91, 106, 126, 138, 166, 184, 186, 187

Sheep Bridge / Mountain Sheep (drawing), 60, 70, 71

Sheep Mountain (WY), 38, 39

Sheepherder's Home, The (drawing), 58, 70, 83

Sheridan (WY), 3, 4, 5, 20, 93, 97–101, 105–109, 112, 123, 124, 133, *141*, 143, 160, 189

Sheridan area, 93, 101, 106

Sheridan City Hall (WY), 97

Sheridan County Courthouse (WY), 98, 100, *141*

Sheridan Inn and Depot (WY), 4, 5, 98, *141*

Sheridan State Fish Hatchery District 2 (drawing), 106, *107*

Sheridan Veterans Administration Medical Center (WY) (formerly Fort McKenzie), 4, 5, 98, *141*

Shoshone (Native American group), 14, *15*, 16

Shoshone County (ID), 157

Shoshone National Forest (WY), 13

Sierra Madres (WY), 19, 51, 52, 53, *54, 55*, 56, *57, 58, 59*, 60, 61, 62, *63, 64, 65*, 66, 67, 68, 69, 70, 71, 72, 73, 74, 78, 79, 80, 81, 82, 83, 85, 86, 87, 88, 89, 90, 91, 92, 93, 97, 98, 108, 112, 114, 115, 119, 134, 135, 136, 139, 140, 144, 145, 150, 151, 152, 153, 154, 155, 156, 157, 158, 159, 160, 162, 163, 164, 165, 166, 167, 168, 172, 173, 174, 176, 183, 185, 186, 187, 188

Silver Lake (WA), 121

Silver Valley (ID), 113

Sketches of Dillon, Wyoming, 1903 and 1904 (drawing), *80*

Slade's Horseshoe Ranch (WY), 33

Slaughtering Establishment of Harden and Hardman, Laramie, Wyoming (drawing), *186*

Smith, Sim (Simeon) H., 98, *105*, 106, *186*

Snow, 39, 58, 60, 83, 84, 106, *187, 188*

Snowy Range (WY), 62

SO Ranch (WY), 96

Socialists (political affiliation), 25, 117

Soda Works (drawing), 170, *172*, 180

Soldier Creek (WY), 97, *141*

Sommers, Jonita, 38, 40–43, 126, 163, 164, 166

South Fork (of the Encampment River) (WY), 54, 89–90

South Fork Canyon (WY), 54

South Pass City (WY), 16, *18*

Spanish-American War (1898), 34

Spanish Influenza, 9, 123, 125, 126

Spaugh, Addison, 127–128

Spence, Clark C., 115

Spicer, N. F., 21–22

Spokane (WA), 4, 6, 8, 9, 93, 95, 106, 108, 113–121, 122, 123, 124, *125*–126, 128, 129, 133, *145, 146, 147, 148*, 157, 159, 175, 177

Spokane, Wash., Relief Map of Northern and Central Portions (drawing), 122, *124, 148*

Spokane area, 116, 177

Spokane City Hall (WA), 123, *148*

Spokane County (WA), 119

Spokane River (WA), 117, 120–121

Spokane Valley (WA), 117, 121, 123, 19, *148*

Spokane Valley Land Company (WA), 121

Spring Creek Ranch (MT), 9, 109, 110, 160, *169*

St. Joseph Cemetery (Spokane Valley, WA), 121, 129

Stamp Room, Keystone Gold Mill (drawing), 21, 22

State Agricultural College (today, Colorado State University) (Fort Collins), 4, 35, *37*, 134

State Normal College (today, University of Western Montana) (Dillon), *112, 144*

Steele Ranch (WY), 38, *41*

Stimson, Joseph E., 3, 9

Story (WY), 106

sub-irrigation, 90, 173

Sublette County (WY), 38

Sulphur Springs Stage Station (drawing), 44

Sumption and Kay insurance office (Sheridan), 105

Sun, Tom, 33

Sunset Farms (New York City company), 121

Sunset Farms (WA), 6, 8, 121, 122, 175, 177

Sunset Farms, West Spokane (drawing), 8, *122, 177*

Sunset High School (Sunset Farms, WA), 121

Sutton's Boot Jack Ranch on the Upper Green River, Wyo. (painting), *40*, 164

Sutton, William, 38, 164

Sweede Mine, The (drawing), 64, 67, 154

Sweet Grass County (MT), 108

Sweetwater River, 3, 38, 40, 162

Sybille Creek (WY), 96

T

Tatham Brothers Ranch (drawing), *28*

teamster, 33, 34, 36, 48, 53, 54, 55, 56, 61, 65, 66, 68, 73, 78, 80, 81, 83, 100, 104, 131, 136, 137, 143, 151, 152, 179, 183

Teller City silver camp (CO), 23

tie industry, 4, 6, 51, 60, 71, 72, 75, 76, 83, 90, 126, 174, 176

Tie Siding (WY), 45, *46*, 161

Toll Gate, Green River, Wyoming (silver print), 1, *18*

Tongue River (WY), 101–103

Toothaker Ranch, The (drawing), 89, *91, 168*

Toothaker, Wilbur, 89, 168

Topographical sketches, 4, 6, 8, 9, 64, 109, *121, 122, 169, 175, 176, 177*

Topographical View of the Spring Creek Ranch of Christ King and Son, Lewiston, Fergus Co. Mont. (drawing), 9, *109, 169*

Topography of the El Ray Mining Property and Its Immediate Vicinity, 1904 (drawing), 19, *91, 93, 156*

Town of Battle, The (drawing), 52, *54*

Trabing, Augustus, 171

Trabing, Charles, 171

Trabing Commercial Co.'s Store (drawing), *170, 171*

Trail End home (Sheridan, WY), 98, *99, 141*

Tramway Station #2 (drawing), 52, *54, 60, 64*

Treaty of 1889, 117

Trout Farm of S. H. Smith, Sheridan, Wyoming (drawing), 98, *105, 106, 189,* 199*n7*

Twenty-first New York Cavalry, 35

U

Uinta County (WY), 14, 38, 41, 42, 63

Unexpected Storm or The Early Storm, An (drawing), 58, *59, 70, 126, 188*

Unidentified Ranch (drawing), *161*

Union (US Civil War contexts), 11

Union Pacific Railroad, 13, 28, 29, 36, 38, *47, 51, 62, 71, 80, 81, 111, 138, 171, 172*

University of Wyoming, 3, 6, 13, 18, 19, 23, *24, 26, 31, 45, 47, 53, 96, 126*

Upper Green River valley (WY), 38, 40, *42, 48, 162, 164*

Upper North Platte (WY), 51, 68, 93

Upper Prairie Dog Creek (WY), *105–106*

US Army, 13, 43, 126, 179, 181, 182, 183

US Forest Service, 78

urban history, 133

Utah War (1858), 183

V

Valentine (drawing), *120, 121*

Vanner Room, Keystone Gold Mill (drawing), *21, 22*

Vauxhall Mine, The (drawing), 64, *65*

View of the Ranch of Haglund Brothers, Carbon County, Wyo. (drawing), 90, *91, 92*

View of the UL Ranch (drawing), 90, *91, 92*

Views of Southern Wyoming: Copper Belt Edition, 4, 6, 51, 60, 76–85, 87, 89, 92, 113

vignettes (drawings), *74, 83*

V R Ranch (WY), 32

Vyvey VX Ranch, The (drawing), 89, *91*

Vyvey, Fox, 19–20, 89

W

Walcott, Wyoming (spelled Wolcott by Houghton), 80, *81, 133*

Wallop, Oliver, 101

Walden (CO), 23, 52, 86–89, 90, 135

Walden, Colorado, 1902 (drawing), 90, *135*

Walla Walla (WA), 118

Wallace (ID), 113–114

Wamsutter (WY), 51, 86, *87, 126, 138*

Warren, Frances E., 96

Washakie (portrait), *15*

Washakie (Shoshone chief), 15

Washakie Station (WY), 86, *87, 138. See also* Wamsutter

Washington State, 7, *8,* 41, 93, *95,* 108, 114–116, *117,* 118–120, *122, 124, 127, 129, 133, 146, 175, 177, 184*

watercolors, 3, 5, 6, 20, 26, 27, 32, 38, *39, 40, 41, 43, 44, 49,* 58, *59,* 126, *128, 129, 131, 160, 162, 164, 165, 172, 183, 186, 187, 188*

Watson, "Cattle Kate" Ellen, 33

Wayland, A. E., 118–119

Webel Commercial Company (Casper), 97, *98*

Wee-a-wah or Whitehorse (photograph), *15, 16*

Wee-a-wah, or Whitehorse (Shoshone man), 15, *16*

West Spokane (drawing), *123, 147*

Western History, 7–9

W. H. Wolfard Ranch (drawing), 68, *69*

Wheatland (WY), 31–32, 93, 96, *97, 140*

Wheatland, 1905 (drawing), *97, 140*

Wheatland Flats (WY), 96

White, Aubrey Lee, 121

white-faced cattle. *See* Hereford cattle

William Kenney Ranch on Cottonwood Creek (drawing), *31*

William Maxwell Ranch at Tie Siding, 46

Williams, E. C., 98

Williams Ranch (WY), 26

Wind River Reservation (WY), 15–16

Windsor Gardens (WA), 122, *147, 177*

Wolbol Ranch on North Fork (drawing), *30*

Wolf (WY), 106, *107,* 199*n18*

Wolverine Mine, The (drawing), 64, *66, 76, 78*

Woman's Club (Laramie, WY), 25–26, 203*n2*

Woman's Missionary Society (Laramie), 25–26, 98

Wombaker, J. J., 89–90, *91*, 173

Women's Christian Temperance Union (Laramie, WY), 25–26

Women's Relief Corps (Laramie, WY), 113

Woods, Samuel, 25

Woods Landing (WY), 20–21, 23, 25

Woods Landing (drawing), 23

World Systems Theory, 8

World War I (the Great War), 123, 177

World War II, 4

Wyoming Coal Mining Company, 102, *103*

Wyoming Collegiate Institute, 101

Wyoming Council for the Humanities, 3

Wyoming Development Company, 96

Wyoming Historical Board, 126

Wyoming Illustrated Monthly, 20–24, 45, 149, 150, 170, 171, 172, 180

Wyoming Industrial Convention, 44

Wyoming Range, 39, *41*

Wyoming State Archives, 15, 16, 18, 25, 32, 34, 65, 77, 89, 100, 105, 107, 114, 126, 180, 189

Wyoming State House of Representatives, 203n2

Wyoming State Museum, 4–6, 32, 33, 38, 39, 43, 44, 55, 57–59, 67, 68, 72, 81, 85–87, 93, 97, 101, 103, 104, 115, 126, 128, 131, 136, 138–140, 143, 151, 153–157, 161, 165, 172, 174, 179, 181–183, 185–188

Wyoming State Highway 70, 81

Wyoming Territorial Prison, 47

Wyoming Territorial Seal, 21

Wyoming Territory, 13, 28, 36

Y

Yarmouth, Nova Scotia, 11

Yellowstone National Park (WY), 13, 23, 107, 108

Yellowstone River (MT, WY), *108*

Young, Brigham, 43

YouTube (social media platform), 194n36

Z

Zakotnik, Gary, 42, 163

Zakotnik, Joanne, 42, 163

Zoom (online communication platform), 125

Zulu, 81–82